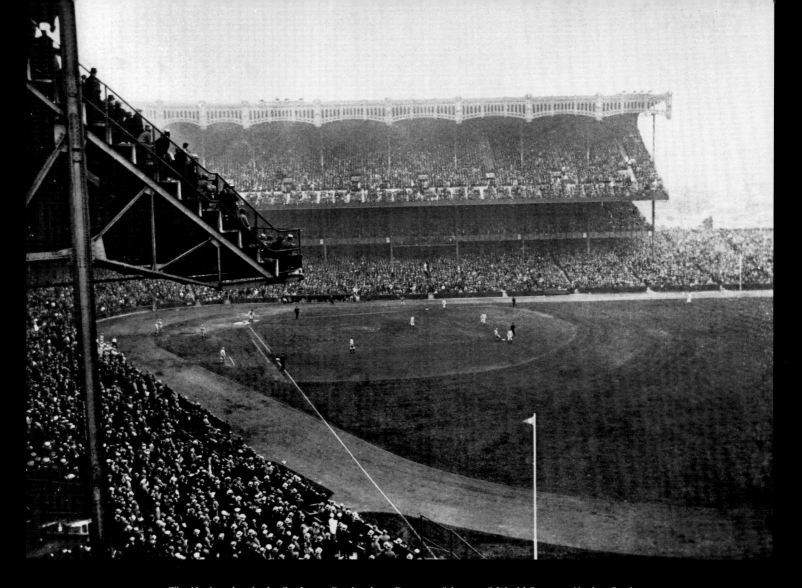

The Yankees battle the St. Louis Cardinals in Game 2 of the 1926 World Series at Yankee Stadium.

The Official Retrospective

Yankee STADIUM

Mark Vancil and Alfred Santasiere III

POCKET BOOKS

New York Toronto Sydney London

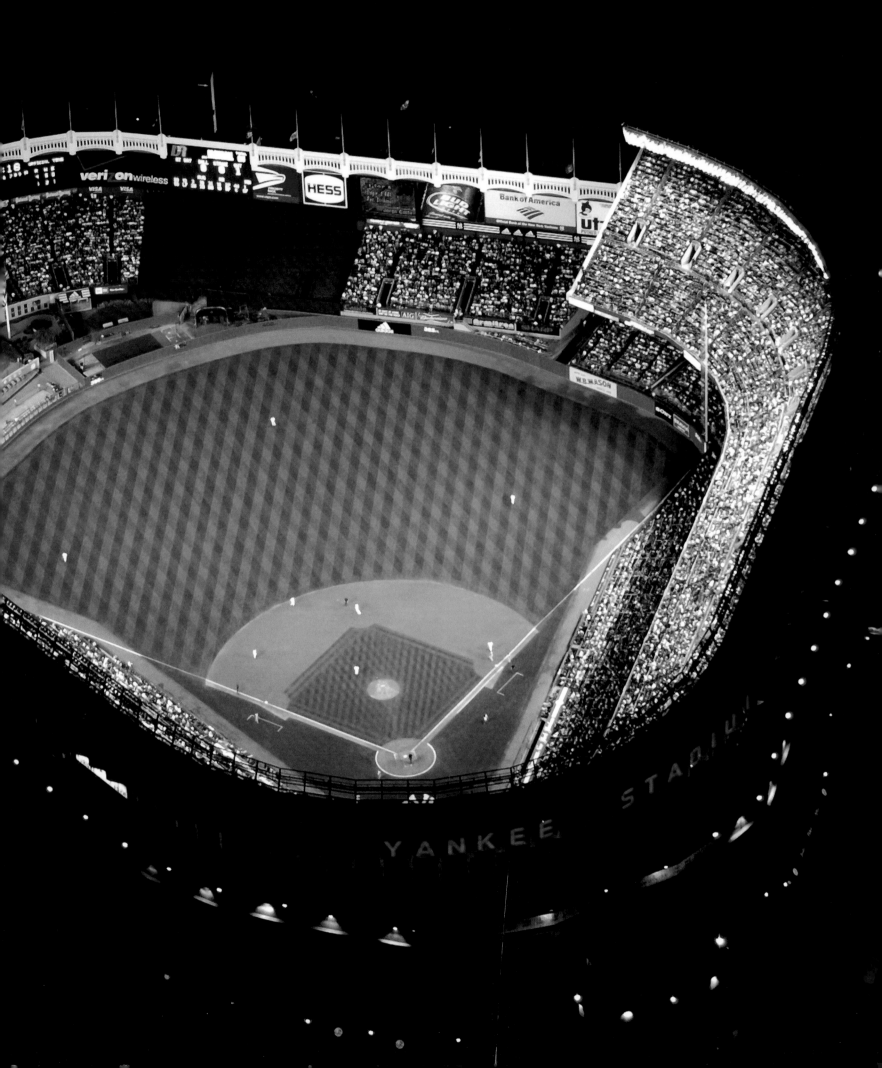

RARE AIR BOOKS

A Division of Rare Air Media

Yankee Stadium — The Official Retrospective
Created and Produced by Rare Air Books

Pocket Books
A Division of Simon & Schuster, Inc.
1230 Avenue of the Americas
New York, NY 10020

First Pocket Books hardcover edition April 2008

POCKET and colophon are registered trademarks of Simon & Schuster, Inc.

For information about special discounts for bulk purchases, please contact Simon & Schuster Special Sales
at 1-800-456-6798 or business@simonandschuster.com

Designed by Rare Air Media
Printed and bound in Singapore

10 9 8 7 6 5 4 3 2 1

Library of Congress Cataloging-in-Publication Data

ISBN-13: 978-1-4165-4779-2
ISBN-10: 1-4165-4779-7

SPECIAL THANKS:
Ernie Accorsi, Jean Afterman, Jim Appleby, Harris Atkins, Kevin Behan, Doug Behar, Michael Bonner, Emil Calcano, Tony Carbonetti,
Michael Carney, Brian Cashman, Craig Cartmell, Dan Cunningham, Gordon Curry, Edward Cardinal Egan, Mark Feinsand, Jason Feneque,
Joe Flannino, Harvey Greene, Howard Grosswirth, Sam Gruen, Neal Gulkis, William Halsey, Sonny Hight, Mike Hopper, Brad Horn,
Mike Huang, Jeff Idelson, Adam Jordan, Dave Kaplan, Brian Kelly, Pat Kelly, Joseph P. Kennedy III, Greg King, John Labombarda,
Robert Lamour, Randy Levine, Seth Levit, Nathan Maciborski, Marc Miller, Brendan Moore, Brian O'Connor, George Olynyk, Matt Perachi,
Rafael Prieto, Jared Puffer, Dan Quayle, Arthur Richman, Michael Rigby, Chris Romanello, Jim Ross, David Salati, Bill Shanley, Brian Smith,
Emily Snider, Scott Stone, Craig Tapper, Peter Toriello, Ben Tuliebitz, Rob Whalen, Jr., Vinny Wickes, Harvey Winston,
Clinton Wood, Elaine Wood, John Yeager, Monica Yurman, Jason Zillo, Joseph Zwilling

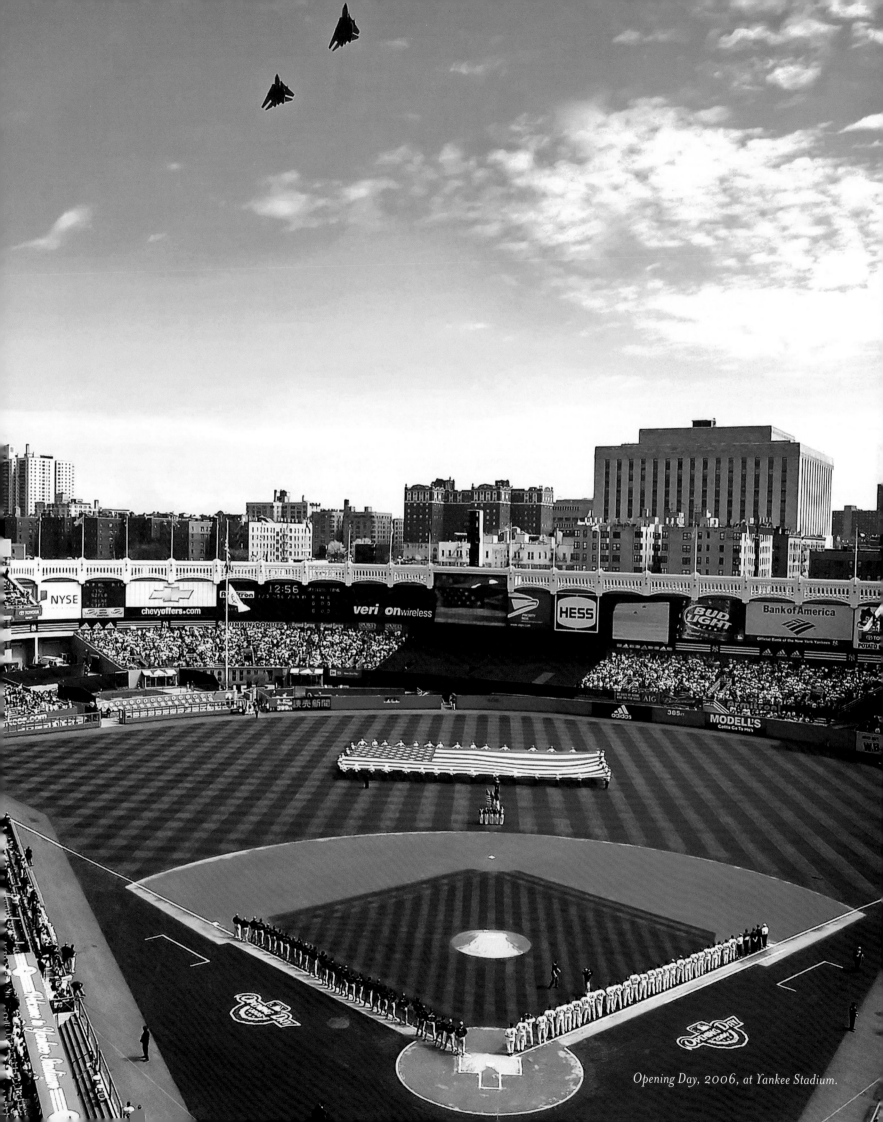

Opening Day, 2006, at Yankee Stadium.

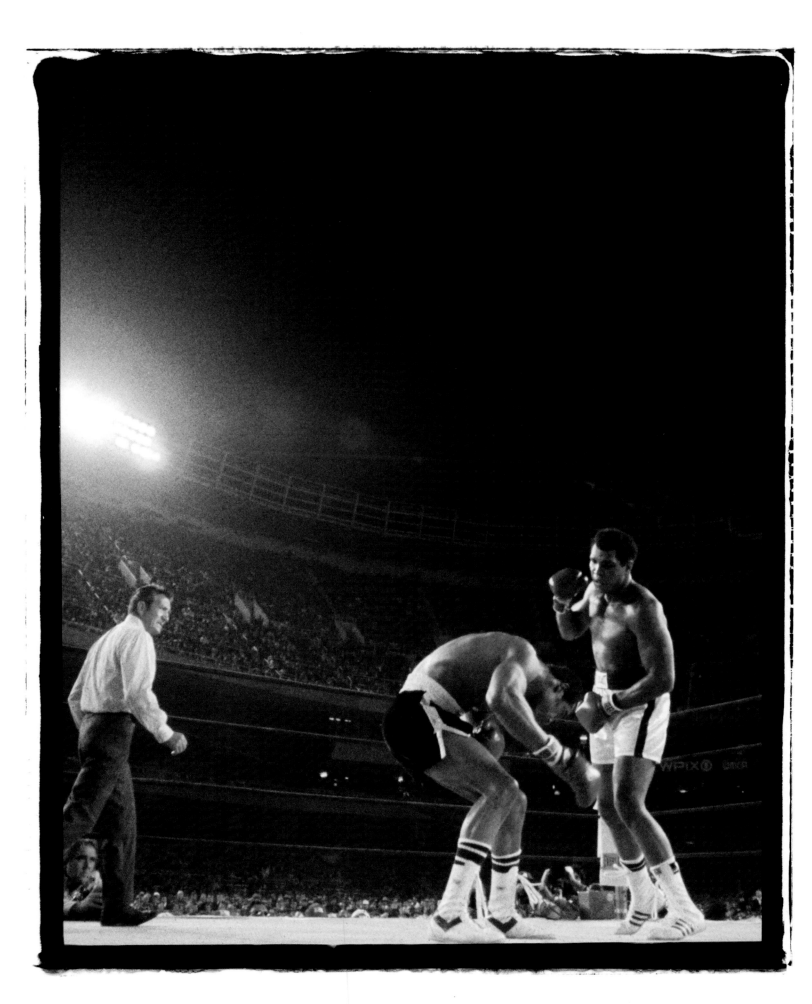

those attributes that defined this trip.

At the Yankees, it all started where many things do: with principal owner George Steinbrenner, and Lonn Trost, the Yankees chief operating officer. Lonn provided a guiding hand throughout the entire process and came to our rescue in every moment of need. Debbie Tymon's kindness and grace is matched only by her insight and dedication. Their impact on the finished product can be seen in the earliest pages, and will be felt long after the book is in the market.

Alfred Santasiere III proved to be as impressive a person as he is a talent. He ran down former U.S. presidents with the same intensity he searched for photographs and double-checked facts. This book would not have been possible without Al's considerable contributions. His staff, as well as the Yankees public relations department, provided critical support along the way. In sponsorship, Michael Tusiani and Natasha Fitzgibbon quickly made it all appear effortless.

At Major League Baseball, Don Hintze and his staff, particularly Mike McCormick, Paul Cunningham, and Rich Pilling, helped make the entire process easy and efficient. Don remains the best there is in any sport at the professional league-office level.

At Simon & Schuster, Louise Burke never failed to see the potential in this project, just as she has never fails to see the potential in her Yankees. Anthony Ziccardi proved once more why he is respected end-to-end in the publishing business. Anybody who ever does a book should have the privilege of working with these people. And Margaret Clark once again pulled it all together amid a myriad of other projects and demands.

And, as always, despite the long days away and the long nights at home, I remain humbled by the love and spirit of The Girls, Laurita, Alexandra, Samantha, and Isabella, and My Boy, Jonah.

MARK VANCIL

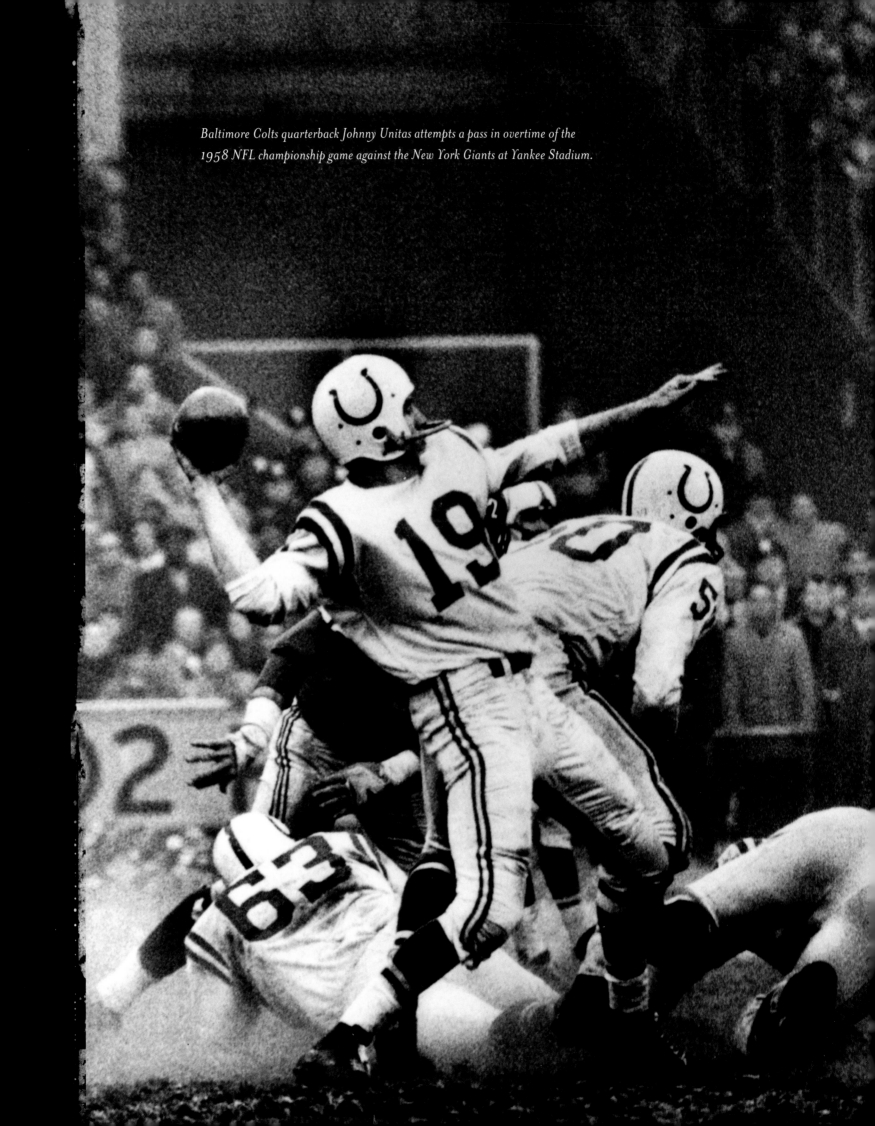

Baltimore Colts quarterback Johnny Unitas attempts a pass in overtime of the 1958 NFL championship game against the New York Giants at Yankee Stadium.

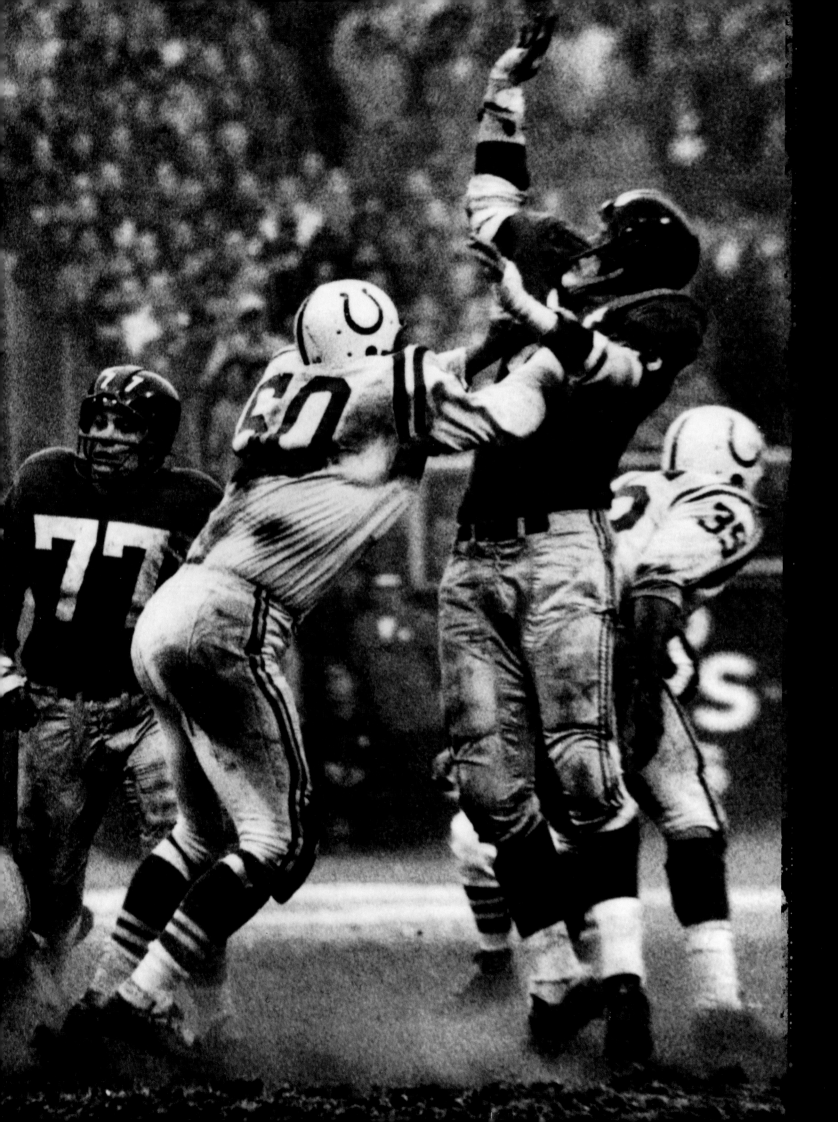

TABLE OF CONTENTS

I HAVE ENJOYED SO MANY MEMORABLE MOMENTS AT YANKEE STADIUM THAT SELECTING A FAVORITE IS AN EXQUISITELY DIFFICULT TASK.

Many of my top Yankee Stadium moments, I remember with perfect clarity. On October 1, 1961, I was sitting along the first-base line when Roger Maris blasted his sixty-first home run of the season into the right-field seats. I watched in awe as Reggie Jackson hit three home runs in Game 6 of the 1977 World Series. As mayor of New York City, I was at Yankee Stadium in 1996 for another Game 6, when Joe Torre led the Yankees to their first World Series championship in eighteen years. I was there on October 30, 2001, when President George W. Bush pitched a strike in a stirring pregame ceremony at the first World Series game played at Yankee Stadium following the terrorist attacks of September 11.

These are all special memories, and Yankee Stadium has been a source of incredible joy for me. But if I must select a single visit to Yankee Stadium that stands out, it would have to be my first.

My father came from Manhattan and was a devoted Yankees supporter. After my parents were married, they moved to Brooklyn, where all of my mother's relatives lived. They lived within a mile of Ebbets Field, and my mother and her entire family were enthusiastic Dodgers fans. My father, never entirely happy about the move away from

his beloved Yankees, decided to exact his revenge by raising me to be a Yankees fan. When I was a toddler, my dad bought me a Yankees uniform and schooled me on the heroes of the Yankees glorious past—Babe Ruth, Lou Gehrig, Bill Dickey, and Waite Hoyt—as well as introduced me to the greats who were playing at that time, such as the incomparable Joe DiMaggio and a promising young catcher named Yogi Berra.

It was dangerous to be a Yankees fan in Brooklyn. People who are not sports fans—or those who have not lived in Brooklyn—might think I'm exaggerating, but the reason my father taught me to box was so I could defend myself against Dodgers fans who spotted me dressed up in my Yankees uniform. Imagine how excited I was when my father told me that he would be taking me to Yankee Stadium for my first Yankees game. The Yankees would be taking on their archrival, the Boston Red Sox.

My father wore a jacket, tie, and hat to the ballpark, as did most men in those days. We rode the train for about an hour and a half from Brooklyn up to the Bronx. And there it was: Yankee Stadium. I had listened to games on the radio, and had seen a few games on television, in black and white, of course. Being there in person, the first thing that

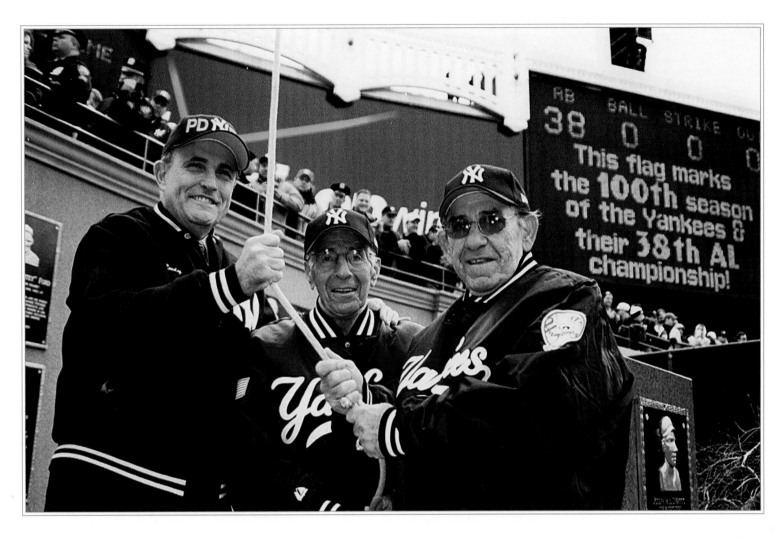

Rudy Giuliani, Phil Rizzuto, and Yogi Berra raise the Yankees American League Championship flag in 2002.

struck me as my dad and I walked to our seats was the vividness of the colors. The grass seemed impossibly green, and the Yankees uniforms iridescently white.

I cannot be sure of the precise date of the game, and box scores from that era are not what they are today. What I do remember is that Joe DiMaggio hit a single to center field, where his brother, Dom DiMaggio, fielded it, and Dom singled to center, where Joe fielded it. Seeing two brothers on opposing teams in my first game helped spark my lifelong interest in the Yankees-Red Sox rivalry.

My father told me to applaud the other pitcher if he threw a good game. He taught me to keep score on the scorecard he bought me, a habit I maintained until recently, sometimes even scoring games at home while following the Yankees on television or radio. I remember my father explaining to me how batting averages were calculated. I recall being surprised that a home run was worth no more than a single. Of course, slugging percentage and other statistical measures better reflect the totality of the game, but I wonder if that first encounter with batting averages helped spark my lifelong belief in establishing objective performance measurements and statistics that correspond with goals.

That first game hooked me for life. I returned to Yankee Stadium as frequently as possible, seeing greats such as Bob Feller, Larry Doby, Nellie Fox, and Al Kaline when the Indians, White Sox or Tigers came

to town. In those days, there was a yearly exhibition game in which the Yankees would take on either the Dodgers or Giants. It was called the "Mayor's Trophy Game," and when it was over, fans were allowed to walk onto the field. The kids would run the bases, and my dad would take me to see the monuments in center field, which were actually on the playing field. We'd look at the plaques of Yankees greats, and the feeling of being on the field itself—the actual ground on which so many Yankees greats created our memories—was awesome. Years later, when I took my son onto the field after the Yankees won the 1996 World Series, I saw the same sense of awe in him that I had experienced years earlier with my own father.

What is so special about Yankee Stadium is that it represents a connection to the greatest team in history and also is home to treasured personal moments. I have a feeling that no matter how much things change, there will always be a kid in a Yankees uniform who is awed by his father's reverence for this hallowed ground and by the green of the grass.

Rudy Giuliani

It's been eighty-five years since Yankee Stadium opened in 1923.
Where did the time go? Soon, the Yankees will leave the field, the fans will file
out and the lights will fade—they won't go out, though, as the lights will never
go out on Yankee Stadium or the New York Yankees.

So many great moments. Too many to list, but suffice it to say they are not forgotten. Off the top of my head, there was Chris Chambliss in 1976, Reggie Jackson in 1977, Ron Guidry in 1978, and Aaron Boone in 2003. If you're fuzzy on the details, keep flipping through the book. Probably my most touching memory came on Opening Day in 2004, when I was giving a television interview in Monument Park and fans broke out in a chant, "Thank you, George!" Never have I felt so embraced and accepted by Yankees fans. I have worked hard at putting the best possible team on the field, and I have high expectations. When the fans thanked me, it took me aback because it confirmed that we all were on the same page and they appreciated my efforts. To them, I graciously say, you're welcome.

Going back to the great moments in Yankee Stadium, let's not forget those that predate me. Babe Ruth's home run on Opening Day in 1923 cemented the Stadium's early status as "The House That Ruth Built." Lou Gehrig started his consecutive-games streak here in 1925.

There was the graceful Joe DiMaggio and his hitting streak in 1941. Mickey Mantle will remain forever youthful to us in his journey to Cooperstown. Roger Maris broke Ruth's home-run record here in 1961. Don't forget, this is where Yogi Berra became, well, Yogi Berra, and the late Phil Rizzuto became the "Scooter." All of them became icons at Yankee Stadium.

There were non-baseball events here as well. Two papal visits; championship bouts featuring Muhammad Ali, Joe Louis, and Rocky Marciano; Knute Rockne's "Win One for the Gipper" speech; and the 1958 NFL championship match between the Baltimore Colts and the New York Giants that goes down as the best football game in history. It all happened at Yankee Stadium, and the list goes on.

That's what brings me to introduce this book. It goes without saying that you, the fan, the reader, share similar memories of "The House That Ruth Built," probably starting with your first visit. What makes it so special, though, is not only the stories collected in this book, but the personal thumbprints of every person who ever passed through the turnstiles, sat in the bleachers, the upper deck, or box seats. Neither the Yankees nor Yankee Stadium would be what they have become without your support. Thank you for your never-ending loyalty. Game after game, year after year, you came back. It's not just the players and moments that you'll see in the following pages, but it's you who built Yankee Stadium, and everyone has a story about this great lady.

After twenty-six World Series championships, most of the stories have a happy ending. But not all of them. We've heard about the last visit from a frail Ruth, and a dying Gehrig's "Luckiest Man" speech. The events of September 11, 2001, happened in our city, and the Yankees were intrinsically linked to the country's subsequent healing. Our three home games during the 2001 World Series were epic, not just because of the postseason hype, but because all eyes were on New York, focused on the dazzling and thriving Yankee Stadium. We—a team, a Stadium, a city, a country—needed those games. They helped us cope. Prior to Game 3, President George W. Bush took the mound for the ceremonial first pitch, gave the fans a thumbs-up, and fired a strike. Fans in attendance roared at the spectacle. It was chilling. We needed leadership, we needed stability, and we needed something to rally around. We needed someone to throw a strike, and we got it that night. Then in Games 4 and 5, we came back from ninth-inning deficits, a feat that had never happened before. It's my feeling that those two comebacks can only be described in metaphor. Every great metaphor ends in hope and triumph, and the country pulled for America's team in the American League winning in America's greatest sports venue in America's greatest city. Hope and triumph. Allow me to say the country's first limping steps after 9/11 happened here. Those three games at Yankee Stadium helped restore the psyche of our country. We also healed after Thurman Munson, our team captain, died in 1979.

Surely, there are more great stories in the pages that follow. Share these with your family and friends. Perhaps you have a memory that is not included. Tell someone about it. And in that tale, Yankee Stadium lives.

There are many sports venues across the land. None of them compare to Yankee Stadium. Millions of fans come to the Bronx each season, and after eighty-five years, one can argue that Yankee Stadium's legacy rivals that of the Colosseum of ancient Rome, which was in use for more than five hundred years. You don't even have to be a sports fan, but you've heard of Yankee Stadium.

It is always difficult to walk away from history and tradition that is loved and appreciated, yet as we have to walk away from Yankee Stadium, a new Yankee Stadium is born at her feet, in her image, and in our hearts. I cannot help but be filled with such great pride and happiness. The prospects for the future look amazing, and I look forward to the new myths and new legends that will perpetuate this great tale that has become the New York Yankees. But to be successful, we cannot move forward, we cannot enter a new era without keeping an eye on where we've been.

So please enjoy the following accounts. I hope it blows the dust off some old memories and opens the door to new ones. I also invite you to join us in our new home, where a new chapter in Yankees history is being written.

George M. Steinbrenner III

A Walk Through Time

ALFRED SANTASIERE III

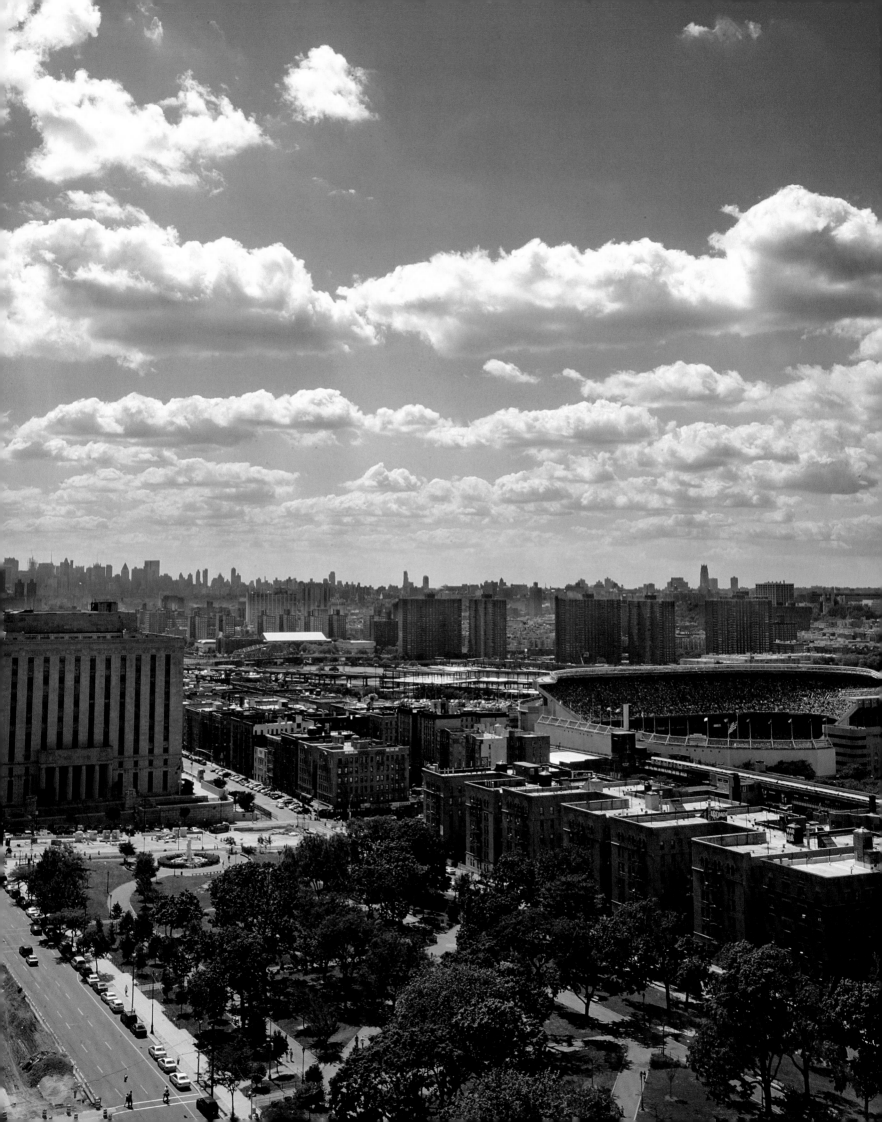

Yankee Stadium

has hosted more iconic events in the last century than any other sports venue in the world. In addition to serving as the home of the greatest sports franchise in on the planet—the twenty-six-time world champion New York Yankees—the big ballpark in the Bronx has seen Pope Paul VI, Pope John Paul II, Muhammad Ali, Joe Louis, Pelé, Knute Rockne, and Billy Graham take center stage.

It's also been the site of some of college football's most monumental contests, and the 1958 National Football League championship game, which is regarded by many as the greatest football game ever played.

Before you become immersed in the history that has set the Stadium apart for more than eight decades, take a gander at the ballpark itself.

No one knows Yankee Stadium like Tony Morante. In 1958, he was sixteen years old and found himself with an opportunity to work part-time as a Stadium usher. He did that until 1973, when the Yankees hired him full-time to work in their group and season sales department. In 1986, he began leading tours of the Stadium in addition to his work in the sales office. Finally, in 1998, he became the director of Stadium Tours, the post he occupies still.

Tony Morante's father, also named Tony Morante, retired after thirty-nine years as an usher at Yankee Stadium. Upon his retirement, his friends from the section he worked in bronzed his usher's hat, and his uniform is on display at the Baseball Hall of Fame.

— Ken Derry

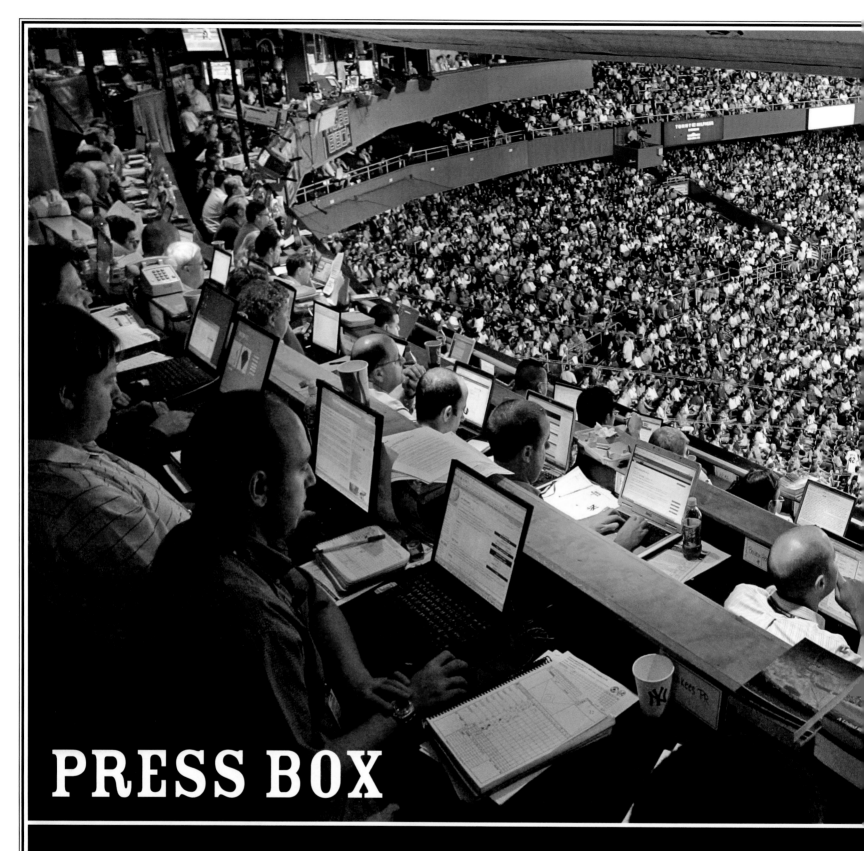

PRESS BOX

The men who do their jobs on the field may be more famous, but the press box has seen its share of household names.

Few voices in baseball and sports in general are more recognizable than that of Yankees public-address announcer Bob Sheppard. In 2007, Sheppard celebrated his fifty-seventh season in the booth.

It started for Sheppard on Opening Day 1951, the only time Joe DiMaggio and Mickey Mantle shared the outfield in the first home game of the season. From that day on, Sheppard became a part of the team's history.

"The first time you hear him announce your name is probably the best memory you have of him because you grow up listening to

his voice," said Yankees captain Derek Jeter.

Sheppard also served as the public-address announcer for the New York Giants football team for fifty years, including the eighteen years they played their home games at Yankee Stadium.

The late Eddie Layton also added to the mystique of the Stadium's press box. Layton

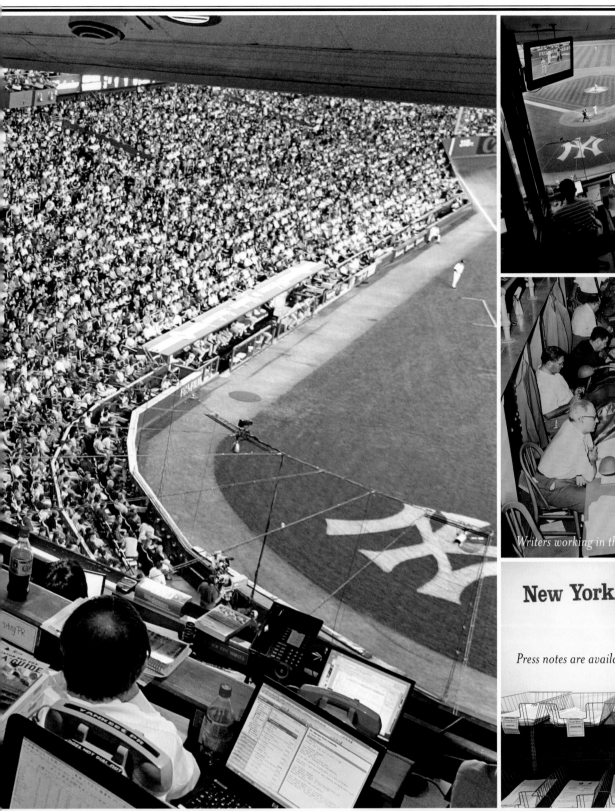

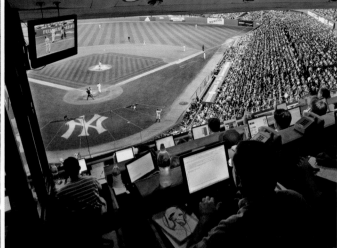

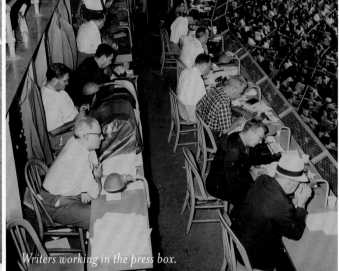

Writers working in the press box.

New York NY Yankees

Press notes are available daily to the working media.

serenaded millions of fans as the Yankee Stadium organist for thirty-seven years.

"Eddie Layton's organ booth and my public-address booth were side by side for thirty-seven years," Sheppard said. "It was always obvious to me that he was a gifted musician. I knew that because every time he played 'Take Me Out to the Ballgame,' the crowd reacted

with a chorus of cheers."

Noteworthy writers, and television and radio broadcasters have also graced the Yankee Stadium press box. The voices that have filled people's homes decade after decade include those of Phil Rizzuto, Red Barber, Bill White, Frank Messer, Billy Martin, and more recently, Michael Kay, Bobby Murcer, Ken Singleton,

Jim Kaat, Paul O'Neill, John Sterling, and Suzyn Waldman.

Yet few broadcasters have ever compared to the "Voice of the Yankees," the late Mel Allen. During his run as a Yankees broadcaster, which spanned more than two decades, Allen became a Yankees trademark. His phrases, "Going, going, gone!" and "How about that!" remain a part of

American culture.

The suite at the far left of the press box is that of Yankees principal owner George Steinbrenner. That's where The Boss entertains the many dignitaries, sports figures, and other entertainers who visit the Stadium.

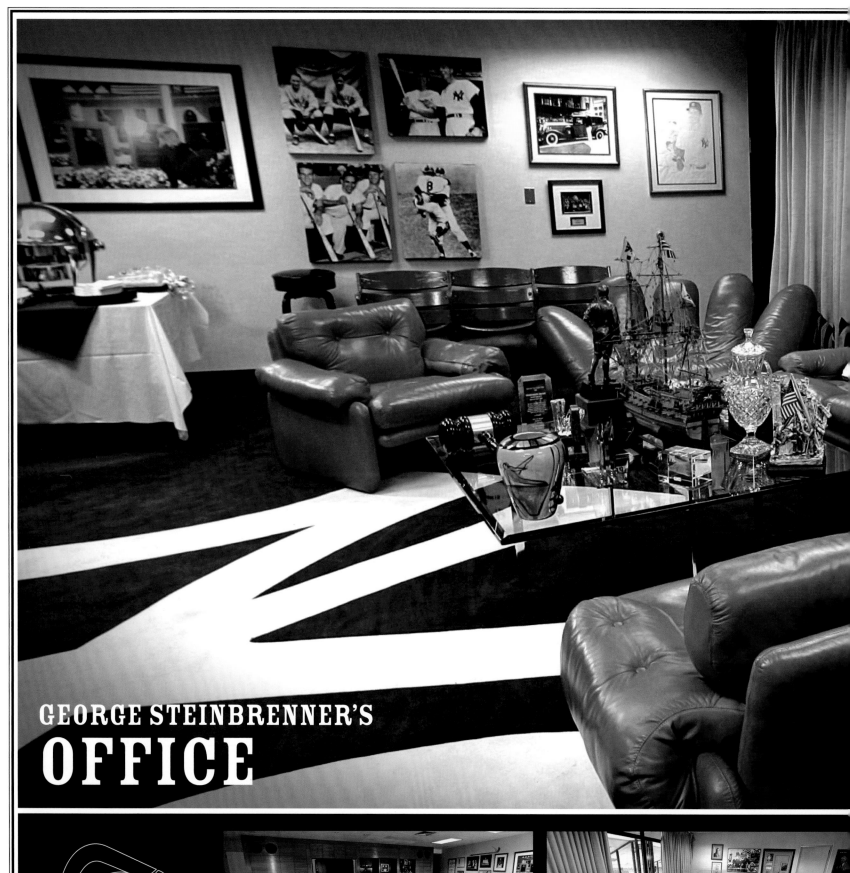

GEORGE STEINBRENNER'S
OFFICE

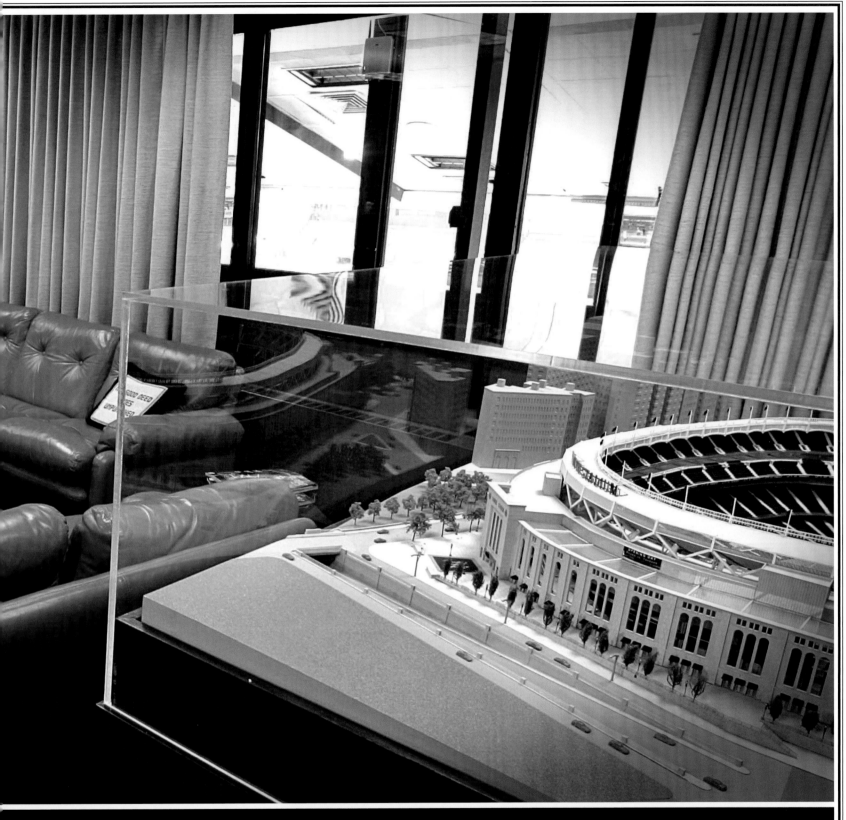

The frieze is the signature of Yankee Stadium. It is arguably the most recognizable element of any sports venue in American history. While Wrigley Field has the ivy and Fenway Park has the Green Monster—both famous for their uniqueness—the frieze has been the backdrop for thirty-seven World Series and an endless list of other events that have helped define professional football, college football, soccer, religion, and pop culture.

The frieze has been a part of the action on two occasions. No one has ever hit a fair ball out of Yankee Stadium, but Mickey Mantle twice hit home runs from the left side of the plate that hit the frieze, then located on the roof overhanging the upper deck. On May 22, 1963, the second time Mantle hit the frieze, the ball came within eighteen inches of leaving the Stadium.

The frieze runs from the left-field corner of the Stadium to the right-field corner above the bleacher area and is a replica of the frieze that used to ring the Stadium in the

THE FRIEZE

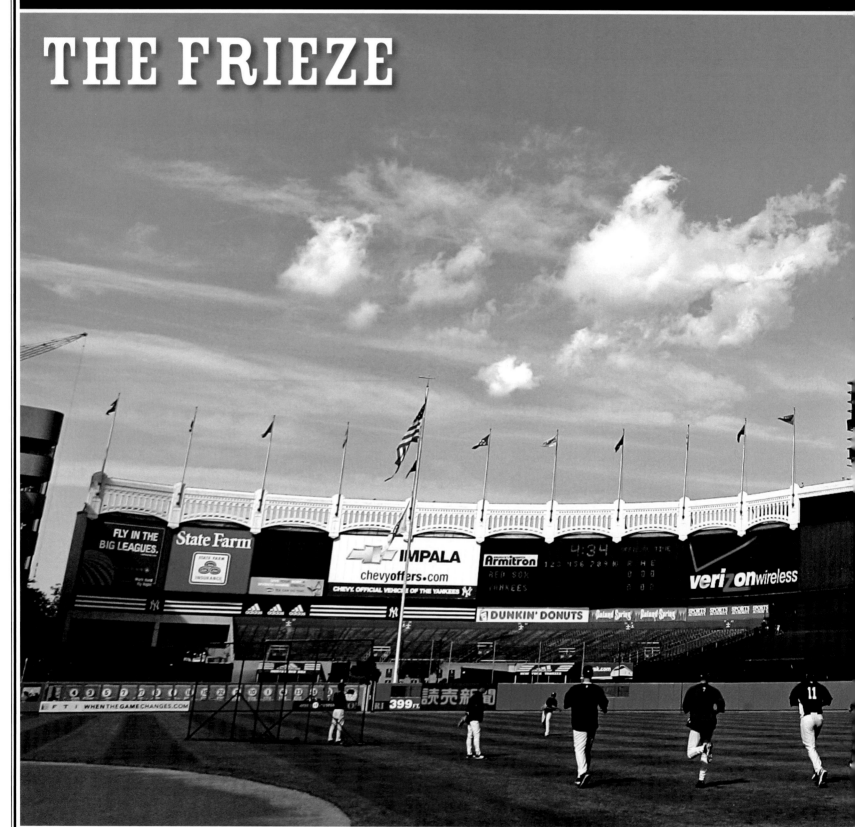

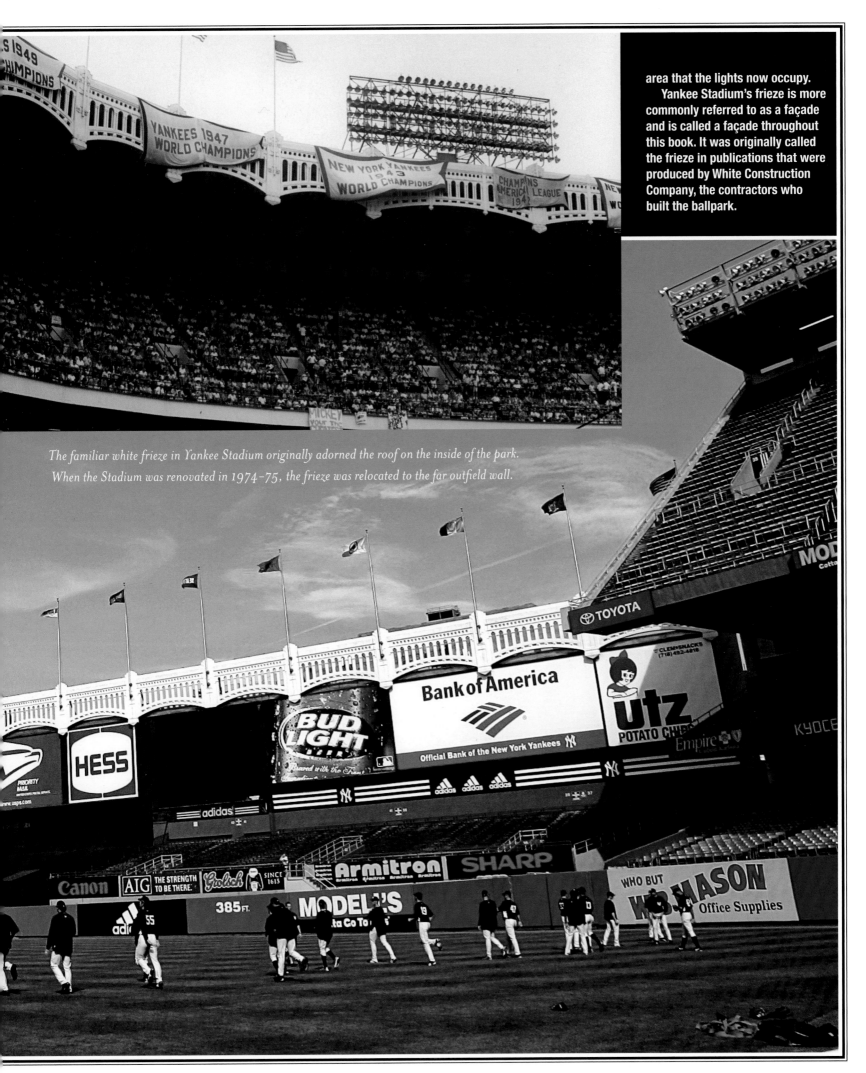

area that the lights now occupy.

Yankee Stadium's frieze is more commonly referred to as a façade and is called a façade throughout this book. It was originally called the frieze in publications that were produced by White Construction Company, the contractors who built the ballpark.

The familiar white frieze in Yankee Stadium originally adorned the roof on the inside of the park.
When the Stadium was renovated in 1974–75, the frieze was relocated to the far outfield wall.

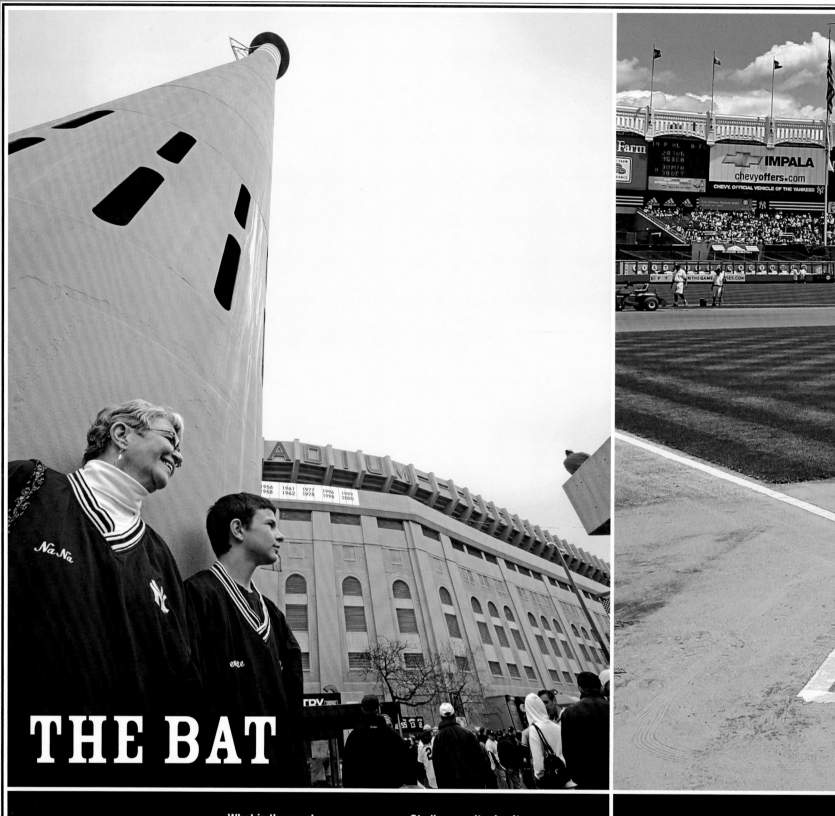

THE BAT

What is the most common phrase among friends, spouses, fathers and sons, mothers and daughters, and any other combination of people who plan to rendezvous at Yankee Stadium?

"Meet Me at The Bat."

The Bat is located a few feet outside of the Stadium, and it has served as a popular meeting place for more than three decades. Because of its immense height, fans circling the exterior of the Stadium can't miss it.

There's usually an added bonus waiting for fans that get to The Bat a few hours before game time. "Freddy Sez," who circles the Stadium during games, inviting anyone and everyone to clank his steel pot with a spoon, starts his daily ritual at The Bat.

The Bat is a smokestack that was made to look like a Louisville Slugger baseball bat in the mid-1970s.

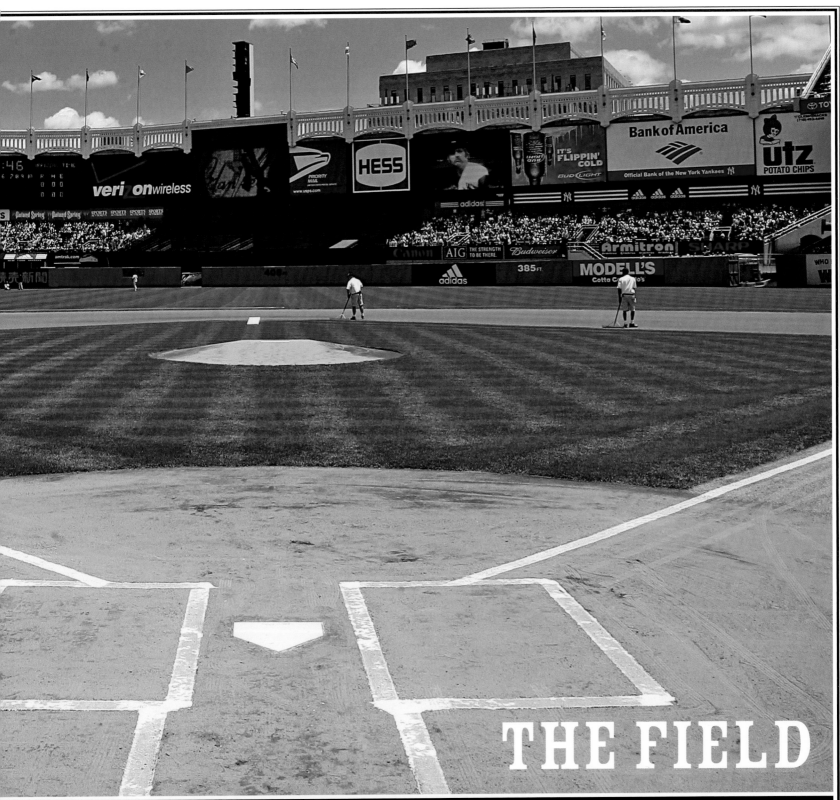

THE FIELD

It seems like every blade of Kentucky bluegrass on the massive Yankee Stadium field represents a spectacular moment that has taken place there.

Babe Ruth ran on to the field for the first time in 1923. Paul O'Neill ran off of the same field for the last time in 2001. Joe DiMaggio patrolled the same grounds as Mickey Mantle and Bernie Williams, and Yogi Berra, Jorge Posada, and Joe Girardi all caught perfect games from the same spot on the same field.

Wade Boggs took a victory lap on a New York Police Department horse on the same soil that Lou Gehrig stood on while making his "Luckiest Man" speech.

In addition to the history that has taken place on the Stadium's sacred sod, the dimensions of the outfield also make it unique. The short right-field porch, which measures 314 feet from home plate, has been a godsend for right-handed power hitters. And the expanse that is left-center field has proved to be a challenge for right-handed power hitters and left fielders alike. Nicknamed "Death Valley," the distance between home plate and the left-center field wall measures 399 feet. Before the Stadium was renovated in the mid-'70s, the left-center field wall stood 460 feet from the dish, and the right-field wall was only 295 feet away.

THE CLUBHOUSE

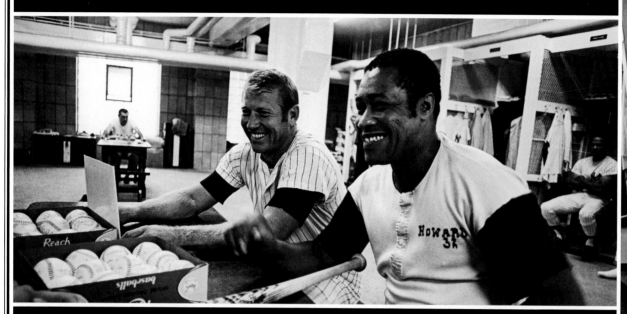

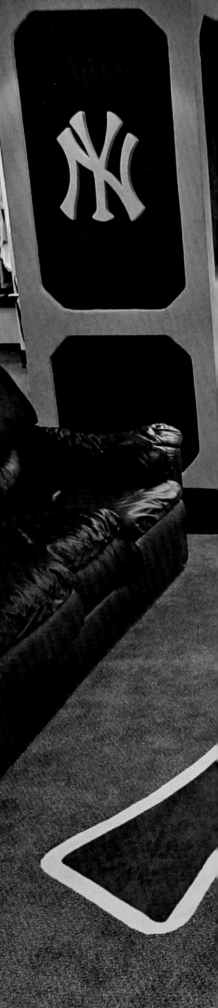

There are few moments more joyous than those that take place after a team has clinched a pennant or a championship. And nowhere in sports have those moments been more frequent than in the home clubhouse at Yankee Stadium.

In the middle of all the champagne-soaked celebrations has been the Yankees interlocking NY logo, which is printed on the carpet of the team's clubhouse.

The logo was created before the Yankees existed. Designed by Louis B. Tiffany in 1877, it was emblazoned on a medal issued to a police officer who was shot in the line of duty while responding to a burglary on the West Side of Manhattan. The Yankees, then called the Highlanders, adopted the logo in 1909.

The lore of the clubhouse doesn't end with the carpet.

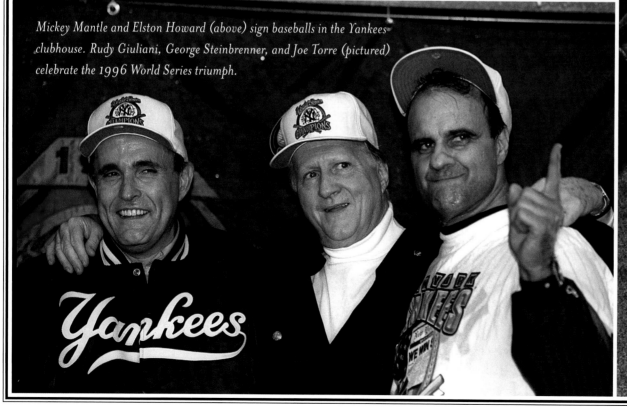

Mickey Mantle and Elston Howard (above) sign baseballs in the Yankees clubhouse. Rudy Giuliani, George Steinbrenner, and Joe Torre (pictured) celebrate the 1996 World Series triumph.

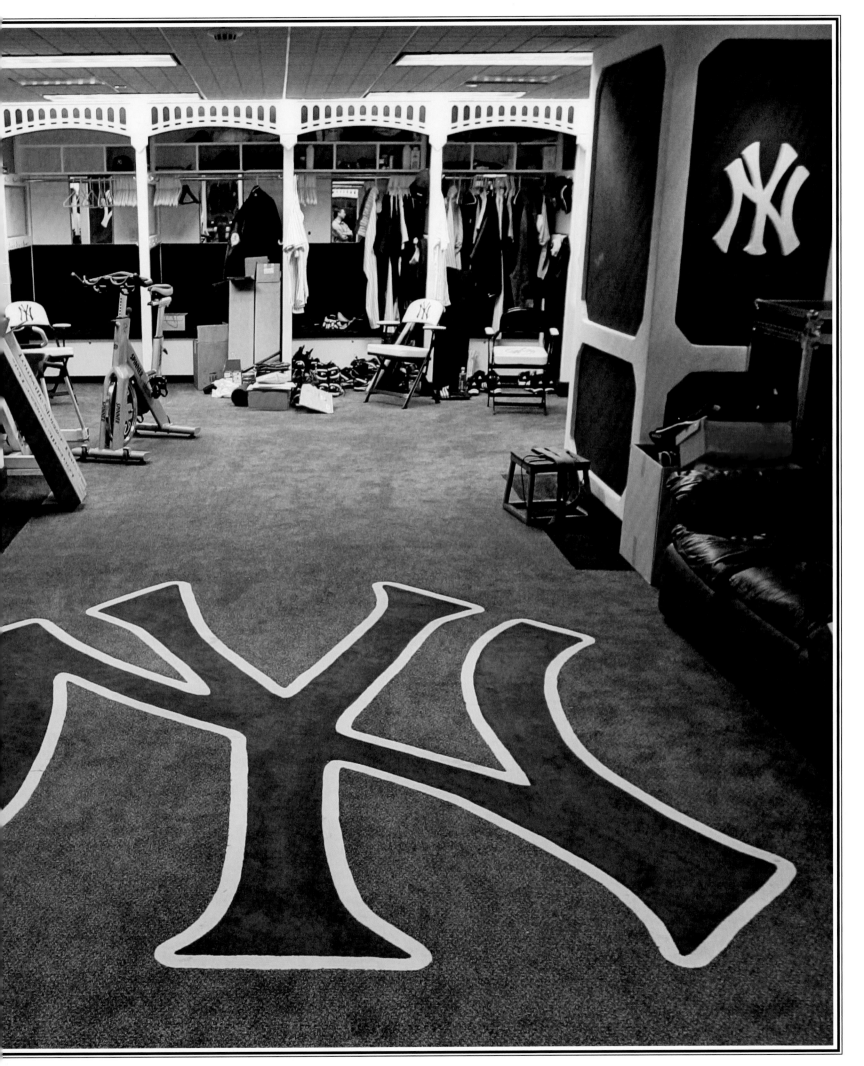

Two lockers remain vacant. One (right) belonged to the late Thurman Munson, who was killed in a plane crash on August 2, 1979. After the catcher's untimely death, the Yankees decided that they would never give his locker to another player.

The vacant locker on the right side of the room was issued to Cory Lidle in 2006. A few days after his first season in the Bronx, Lidle was also killed in a plane crash. His locker has remained empty

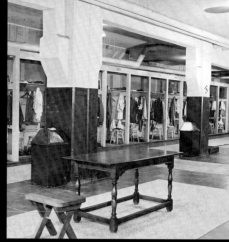

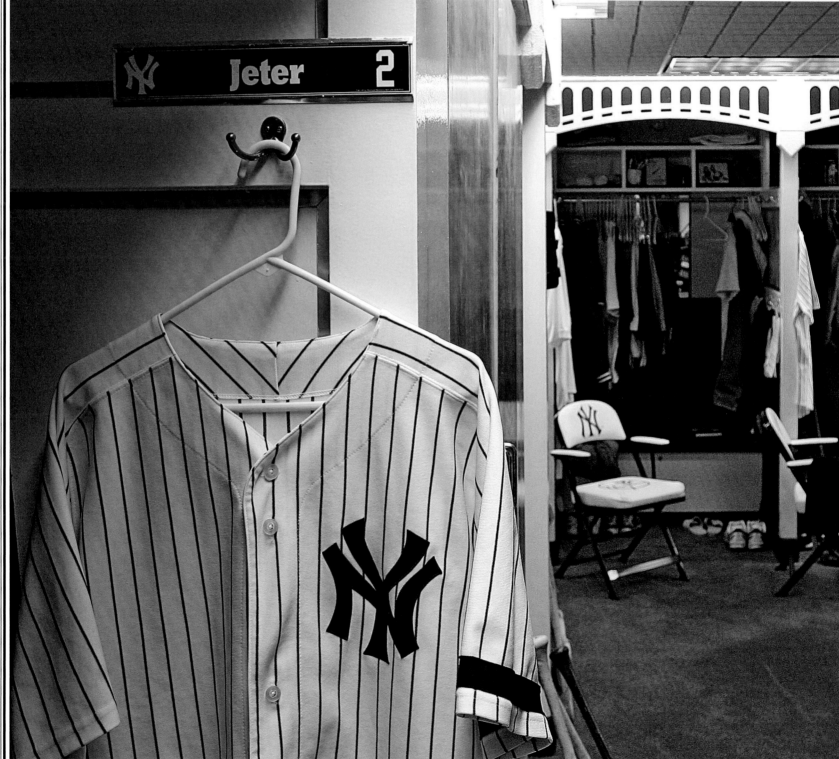

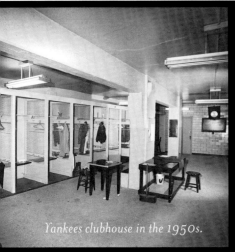

Yankees clubhouse in the 1950s.

since his death.

The manager's office in the home clubhouse at Yankee Stadium is the sports world's version of the Oval Office. The list of skippers who have conducted business from that room reads like a who's who of baseball dignitaries.

Miller Huggins was there from 1918 through 1929, winning three championships along the way. Joe McCarthy took over the post a couple years later, and during his tenure the Yankees won seven titles. Casey Stengel wasn't far behind, taking over in 1949 and promptly winning five rings in five years and two more after that. Ralph Houk captured two championships in the '60s, and Billy Martin and Bob Lemon were triumphant in 1977 and 1978, respectively. In 1996, Joe Torre guided the Yankees to their first World Series championship in eighteen years, then won three straight from 1998 through 2000.

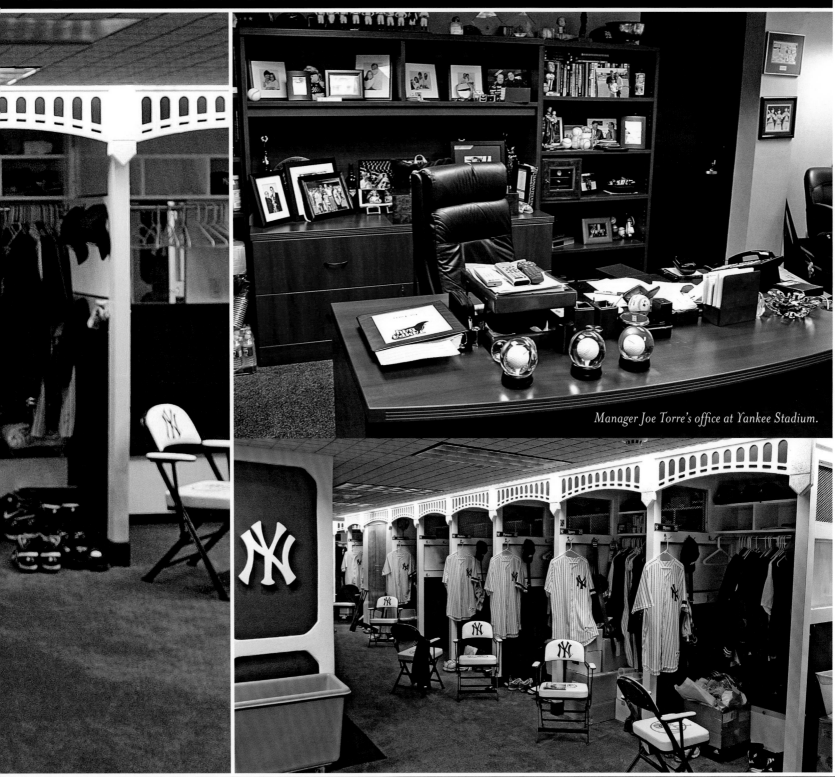

Manager Joe Torre's office at Yankee Stadium.

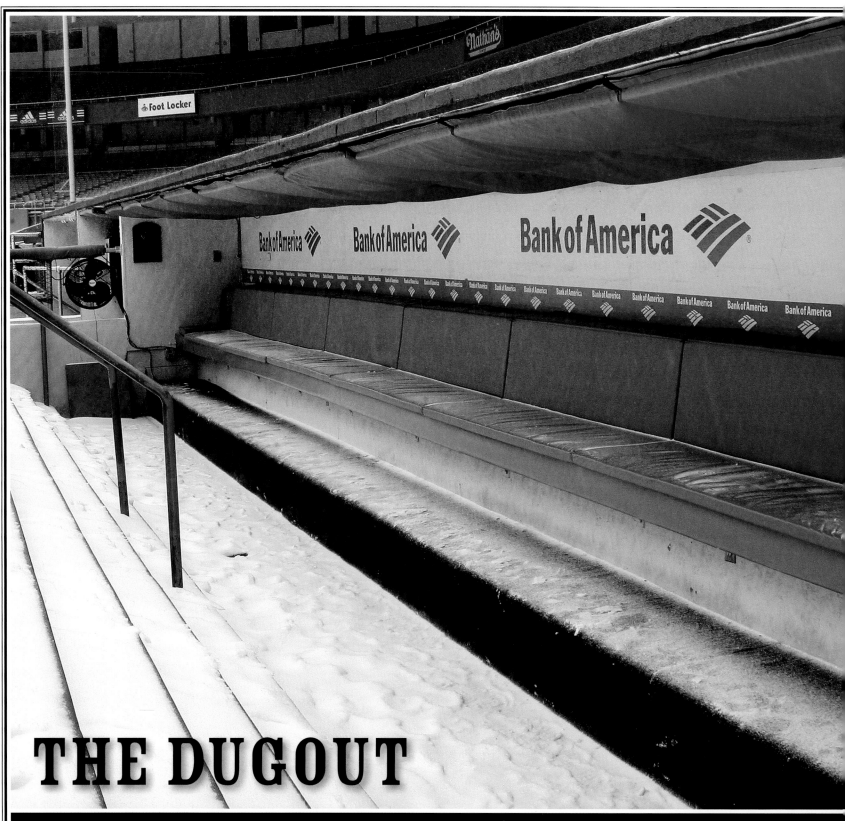

THE DUGOUT

If the dugout walls could talk, an endless number of interesting stories would surely surface, but it is unlikely that any would rival the events that took place in the 1999 postseason.

Former Yankees bench coach Don Zimmer was hit in the head by a line drive off the bat of Chuck Knoblauch. Fortunately, Zimmer was fine, and he later provided his team with a laugh. When Knoblauch came to the plate in the next game, Zimmer took off his cap and replaced it with a green World War II battle helmet with the NY logo stenciled on the front of it.

At the end of season, the organization addressed the situation a little more seriously and installed fences between the field and the benches.

At the end of the home dugout, there is a plaque that honors Pete

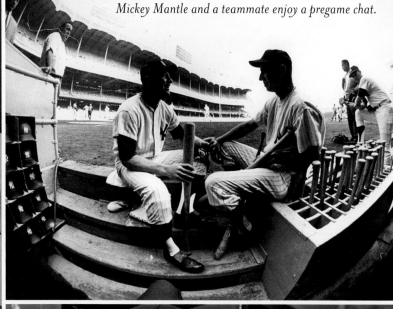

Mickey Mantle and a teammate enjoy a pregame chat.

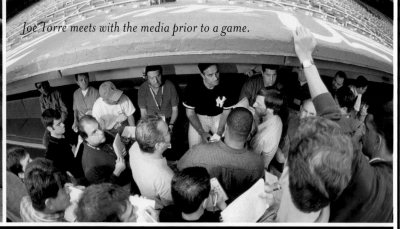

Joe Torre meets with the media prior to a game.

Sheehy, who was the Yankees equipment manager for fifty-eight years. He came aboard in 1927, and he passed away in 1985. Sheehy was so beloved by the players that when he passed, there were two plaques installed in his honor: one on the dugout wall and one on the clubhouse door proclaiming it the Pete Sheehy Clubhouse.

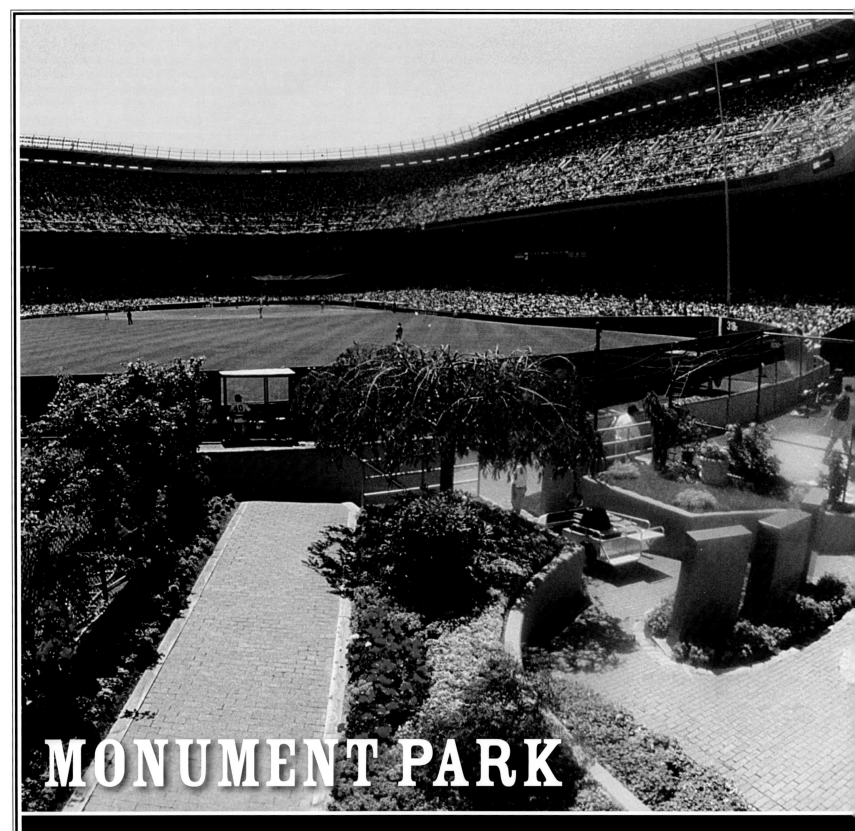

MONUMENT PARK

The most unique part of Yankee Stadium—or any other sports arena for that matter—is Monument Park.

Monument Park is where the Yankees acknowledge the contributions of their greatest players with plaques and monuments. It is also the place where the team's retired uniform numbers are displayed.

Lou Gehrig's number—4—was retired in 1939. He was the first player to receive the honor from the Yankees. Through 2007, the Yankees had retired fifteen other numbers.

Number 8 was retired twice. Catchers Yogi Berra and Bill Dickey helped shape the team's storied history at different times while donning the same digit. In 1972,

the Yankees recognized the contributions of both players by putting the number away for good—twice.

In 1932, Miller Huggins became the first Yankee to be honored with a monument. The manager's stone was placed in center field and remained the lone monument in the outfield for nine years, until July 4, 1941, when the Yankees erected one to honor Gehrig.

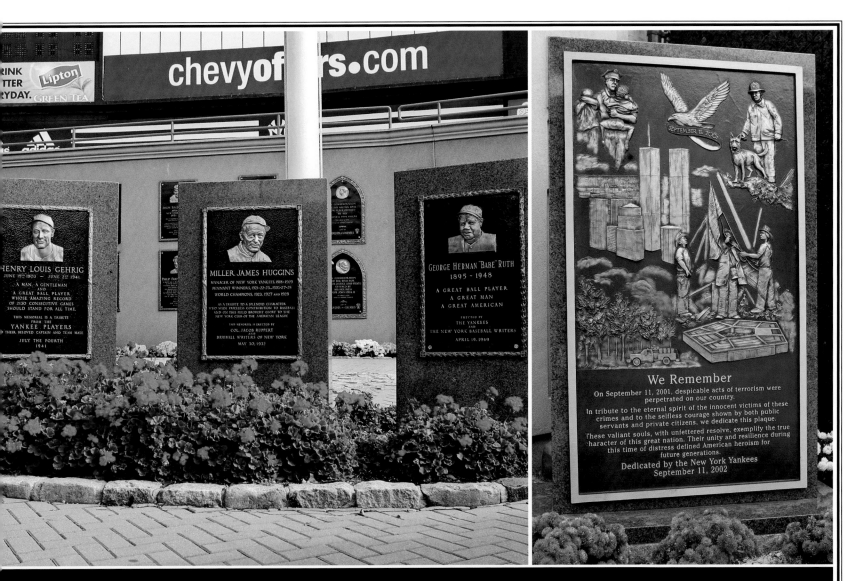

Babe Ruth was the recipient of the third monument, set in place in 1949. The Babe changed the game dramatically with the advent of the colossal home run. Ruth hit fifty-four home runs in his first year with the Yankees, which even by today's standards is rare. When Ruth reached that total in 1920, there were no other teams in the American League except the Yankees that hit more than fifty homers.

The monuments were moved to their present site after major renovations to the Stadium in 1974 and 1975, during which time the Bombers played at Shea Stadium.

The team came home in April 1976 to a completely renovated ballpark. Twenty years later, a monument for Mickey Mantle was erected. In 1999, the Yankees honored Joe DiMaggio by placing a monument for him next to the Mick's.

A year to the day after the tragic events of September 11, 2001, the Yankees dedicated a sixth monument, this one to the victims and heroes of that fateful day.

Plaques on the back wall of Monument Park pay further tribute, not only to great ballplayers, but also to other people who have contributed to the mystique of Yankee Stadium.

Two plaques stand out.

The first papal Mass in the United States was celebrated at Yankee Stadium by Pope Paul VI in 1965, and a plaque commemorating the event was gifted to the Yankees by the Knights of Columbus. In 1979, Pope John Paul II celebrated Mass at Yankee Stadium, and that, too, was commemorated with a plaque that was given to the Yankees by the Knights of Columbus.

In total, there are six monuments and twenty-three plaques in Monument Park.

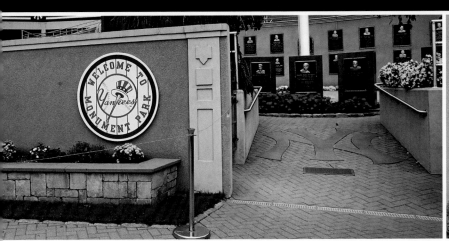

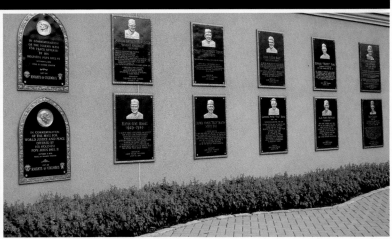

The Birth of a

BALLPARK

❦ BOB KLAPISCH ❦

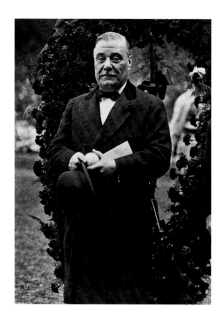

The Yankees moved from Hillltop Park to the Polo Grounds (below) in 1913, where they shared the stadium with the Giants. When Jacob Ruppert (above) bought the franchise in 1915, he envisioned the building of a permanent home for the Yankees.

From the day he took control of the Yankees in 1915, Jacob Ruppert had a vision of a ballpark as breathtaking and powerful as the Roman Coliseum.

Together with co-owner Tillinghast L'Hommedieu Huston, Ruppert knew that in order to grow his franchise or, more simply, to turn a profit, the Yankees needed room to breathe. It would require a venue large enough to generate considerable revenue; the more fans the Yankees could attract, the more money they would have to procure players.

That wasn't the case in Ruppert's early years of ownership. The Yankees were a team without marquee players, drawing power, or even a home they could call their own. They had been sharing the Polo Grounds with the National League Giants since the 1913 season, forced to live in the shadow of their more successful landlord.

In the preceding ten years, the Yankees had played at Hilltop Park (hence their name at the time, the Highlanders). A fire nearly destroyed the Polo Grounds in 1911, and Yankees owner Frank Farrell offered the Giants the use of Hilltop. The Giants returned the favor two years later.

The Giants could afford to be gracious, given the minimal threat the Yankees posed. Ruppert's arrival made no difference in the team's fortunes in 1915. The Yankees were worse than they had been the previous year, finishing fifth with a 69-83 record and barely drawing 250,000 fans to the Polo Grounds. The Yankees were paying $65,000 a year in rent to the Giants, a steep sum for the time, but they had no alternatives.

As much as Ruppert wanted a separate home for his Yankees, finding a site proved to be nearly impossible. There was a near-constant drumbeat of rumors about a new location, but local landowners weren't about to cut Ruppert and Huston a deal. They knew the two were rich and desperate. The project was further delayed when the upstart Federal League took out options on New York-area locations, effectively limiting the Yankees' choices. The Federal League hoped

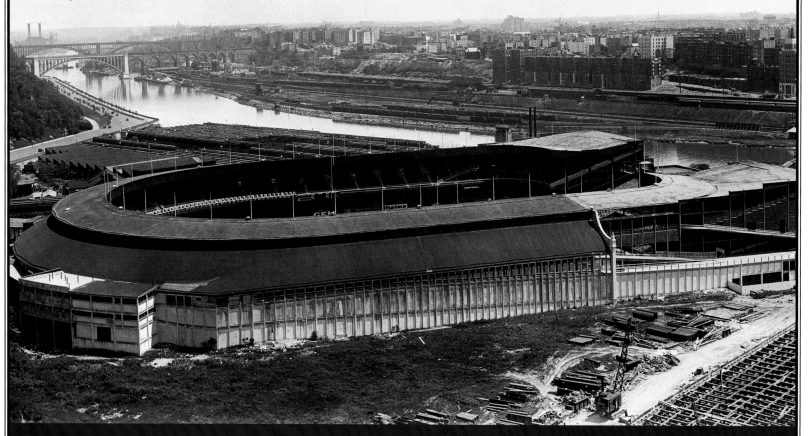

THE YANKEES CONTINUED AS ALSO-RANS FROM 1916-20, FINISHING NO HIGHER THAN THIRD. BUT TWO KEY DEVELOPMENTS DURING THAT PERIOD CHANGED THE FRANCHISE'S COURSE.

to merge with the American and/or National Leagues, and its leaders figured that thwarting Ruppert's plan for his own ballpark would help their cause.

The Yankees continued as also-rans from 1916-20, finishing no higher than third in the standings. But two key developments during that period changed the franchise's course. The first was America's decision to go to war in 1917, prompting Huston to enlist in the military service. That left Ruppert in charge of the Yankees' day-to-day operations, which led to the second significant development: the hiring of Miller Huggins as manager in 1918. Huggins replaced Bill Donovan, who in the three preceding seasons had a .479 winning percentage as the Yankees never made it out of the second division.

Huggins' arrival signaled Ruppert's intent to overhaul the team on his own, without interference from Huston. By 1918, Ruppert had his eye on a charismatic Boston Red Sox pitcher named George Herman "Babe" Ruth, who, because of the player drain during the war, also had been playing another position with regularity. Ruth hit his first home run of the 1918 season against the Yankees at the Polo Grounds on May 4. Two days later, he blasted another homer against the Yankees.

Ruth's display of power confirmed what Ruppert had believed for years: Home runs not only were electrifying displays of athletic skill, but they also were a marketing point for the future. Ever since acquiring the team, Ruppert

had sought left-handed power hitters to take advantage of the Polo Grounds' short right-field fence. Yankees first baseman Wally Pipp led the American League in home runs in both 1916 and 1917, as did the Yankees as a team. But there was something special about Ruth; everyone could see that, especially Ruppert.

The Yankees' acquisition of Ruth from the Red Sox was, as time would tell, a defining moment in baseball history. Not only did Ruth turn the Yankees into a championship-caliber team, he also was the catalyst for the new ballpark Ruppert had been striving to build. The transaction that sent Ruth to New York in 1920 was a complicated one, and not nearly as one-dimensional as has been reported over the years. The Red Sox sent Ruth to the Yankees, in part, as an act of defiance against American League president Ban Johnson, who demanded approval of all player transactions.

As the war ended and players returned to the big leagues, the Red Sox were practically overrun with talent, and the Yankees had a desperate need for stars. Red Sox owner Harry Frazee was troubled by the lack of enthusiasm that Bostonians displayed for Ruth. Despite a stunning season in 1919—.322 average, league-leading 29 home runs, 114 RBIs, and 103 runs scored—Ruth failed to fill up Fenway Park. Indeed, postwar attendance nearly doubled for almost every baseball team, with the exception of Boston.

Frazee feared losing Ruth and not getting

MILLER HUGGINS' RECORD AS YANKEES MANAGER			
YEAR	W	L	FINISH
1918	60	63	4
1919	80	59	3
1920	95	59	3
1921	98	55	1 AL PENNANT
1922	94	60	1 AL PENNANT
1923	98	54	1 WORLD SERIES TITLE
1924	89	63	2
1925	69	85	7
1926	91	63	1 AL PENNANT
1927	110	44	1 WORLD SERIES TITLE
1928	101	53	1 WORLD SERIES TITLE
1929*	82	61	2

* HUGGINS DIED SUDDENLY ON SEPTEMBER 25, 1929, BEFORE THE SEASON ENDED

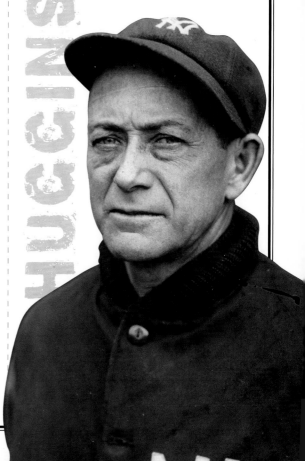

anything in return. He was also concerned about Ruth's perceived bad attitude. The slugger had announced he was no longer interested in pitching, and after the 1919 season had threatened to retire if he didn't get a $20,000 contract. In exchange for the tidy sum of $100,000, Ruth was traded to New York, where he was hardly a stranger to the baseball community.

New Yorkers were already intrigued, if not in love with the Babe. They embraced his swagger, his everyman physique, and his notorious lifestyle—all the characteristics that had been received so coolly in Boston. New York was a bustling metropolis and—in stark contrast to New England's Protestant populace—full of immigrants. The city's robust nightlife—nineteen thousand saloons in 1920, and later, during Prohibition, nearly thirty-five thousand speakeasies—greatly appealed to Ruth. He was ready to play hard, both on and off the field, and the Yankees' dream of a new home was one step closer to becoming a reality.

The Yankees had played respectably in 1919, finishing in third place with an 80-59 record. The Chicago White Sox, who finished seven and a half games ahead of the Yankees and three and a half games ahead of the Cleveland Indians, quickly fell into ruin after eight team members were indicted in a gambling conspiracy in the 1919 World Series. It would be another twenty years before the White Sox would contend, leaving the Yankees and Indians as the league's premier teams.

As Ruppert expected, New York's fascination with Ruth and his impact on the team's success served to dramatically increase the Yankees' popularity. Home attendance for 1920 was 1.3 million, a gain of more than six-hundred thousand from 1919. Even without their own ballpark, the Yankees were the first team to reach one million in attendance.

The Yankees' 1920 gate was 25 percent better than the Giants' attendance, which further strained relations between the two franchises. Yankees fans were greater in number, and—to the disdain of the patrician Giants—loud and unmannered. The Yankees attracted a growing number of Italian-Americans to the ballpark, and the bond would become stronger once the team acquired power-hitting second baseman Tony Lazzeri from the Pacific Coast League in 1925.

Babe Ruth slides safely back to first base in a 1925 game against the Chicago White Sox.

JUNE 11, 1915

PITCHER RAY CALDWELL HIT HIS SECOND PINCH-HIT HOMER IN TWO DAYS AGAINST THE CHICAGO WHITE SOX. ON THE FOLLOWING DAY, CALDWELL HIT A THIRD PINCH-HIT HOMER, THIS TIME AS A STARTING PITCHER AGAINST THE ST. LOUIS BROWNS.

Ruth shakes hands with President Warren G. Harding.

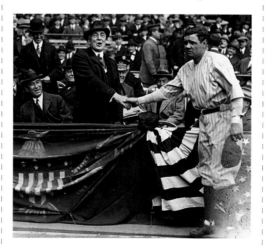

By then, one out of every seven New Yorkers was Italian-American, and the Yankees were their team of choice. Long before Lazzeri's arrival, the Giants realized they could not consider the Yankees to be subordinate tenants. After sharing the headlines with Ruth and the Yankees for just one season, the Giants risked becoming irrelevant in their own ballpark.

Certainly, there was no mistaking the trendline during the summer of 1920, when Ruth virtually exploded onto America's landscape. Anyone who hadn't heard about him by now was hopelessly out of touch, if not socially dead. The Babe's swing was unlike anything the sport had known: long and powerful, concurrently full of grace and fury. Others had hit home runs before Ruth, but none as majestically. His blasts had a signature arc, high and impossibly deep, almost as if the ball had been shot out of a cannon. By the end of 1921, Ruth had hit 113 homers as a Yankee, forever changing the way baseball was played and appreciated.

The only party that failed to embrace Ruth and the suddenly muscular Yankees was, not surprisingly, the Giants. Following their embarrassing defeat at the gate in 1920, the Giants brusquely informed their tenants it was time to leave. Ruppert wasn't caught by surprise. While the Yankees were gaining momentum, he had been busy petitioning the city for a Yankees' haven. New York City politics in the early 1920s were, at worst, a sewer of corruption that could be successfully navigated only through connections and, of course, plenty of cash to curry favor.

The Yankees had money. For the first five years of their ownership, Huston and Ruppert lost a total of $30,000 but gained that back and more in 1920, when the team turned a profit of about $370,000.

In February 1921, Ruppert and Huston announced they had found a location for the ballpark of their dreams. For $675,000, they purchased a ten-acre lot in the Bronx that was owned by the estate of William Waldorf Astor. Directly across the Harlem River from the Polo Grounds, the site had been used as a lumberyard.

The Yankees hoped to break ground in May 1921, but city politics delayed the project for a year. The builder was White Construction, which agreed to a flat fee of $2.5 million.

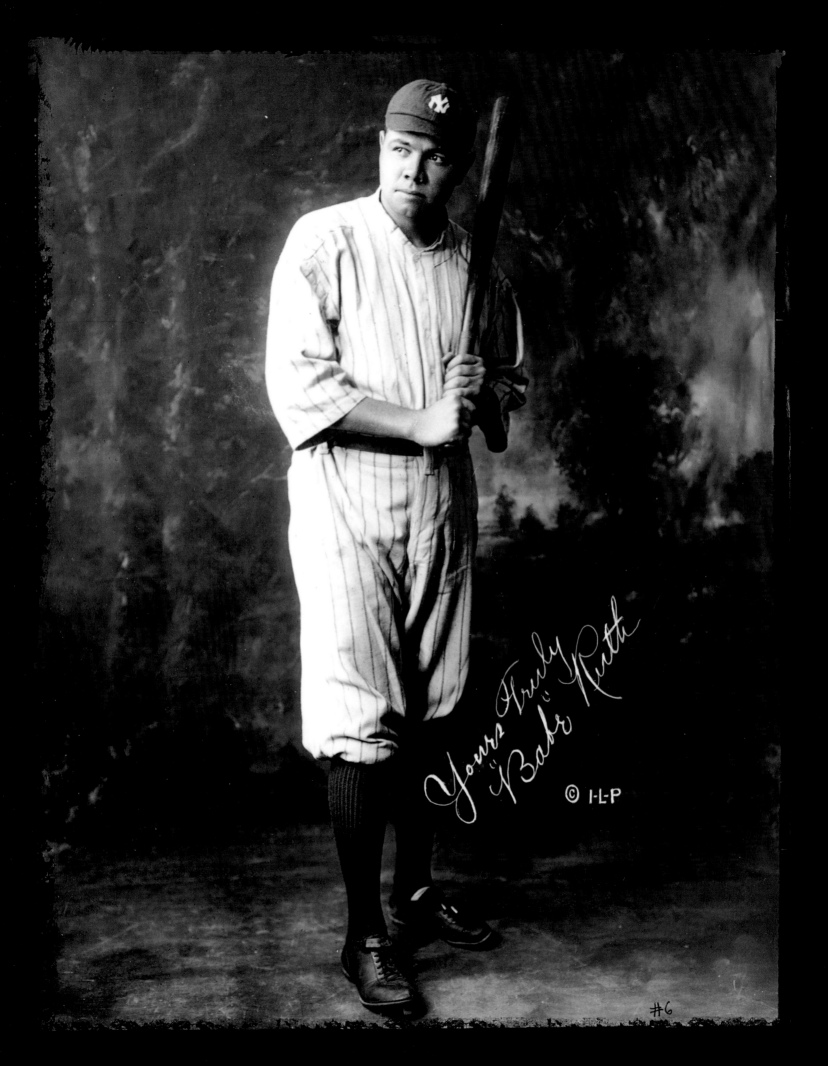

Yours Truly
"Babe" Ruth

© I-L-P

#6

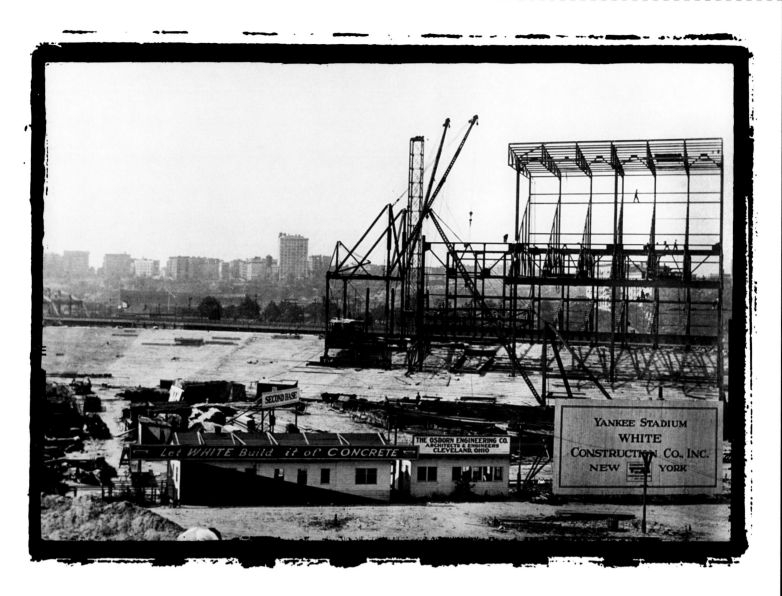

Among the remarkable numbers surrounding the building of Yankee Stadium was the use of one million brass screws and almost four million board feet of lumber.

Ruppert made no secret of his vision for the new structure—he wanted it to be huge. He had the biggest drawing card in baseball with Ruth, and it was only fitting that the great slugger should have a home to match his status and celebrity. The original plans called for the Stadium to be triple-decked and roofed all the way around, like the Yale Bowl, but it was neither upon completion. The grandstands didn't reach either foul pole, and the ballpark was not enclosed. Contrary to the team owners' wishes, games would be visible from the elevated trains that passed by the outfield, as well as from buildings that would spring up across River Avenue.

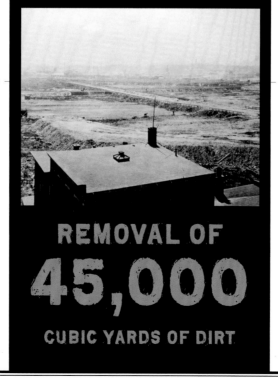

REMOVAL OF
45,000
CUBIC YARDS OF DIRT

Yankee Stadium construction was scaled back because of money and time constraints. The builder was under a strict mandate to finish work in time for Opening Day 1923. Still, there were unique touches that Huston insisted upon, including eight restrooms each for men and women, and a fifteen-foot-deep copper façade along the interior roof that proved to be the Stadium's signature touch.

There was no mistaking that the Stadium was the franchise's centerpiece. The Yankees moved their executive offices from midtown Manhattan into the ballpark, placing them between the main level and mezzanine deck, connected to the main

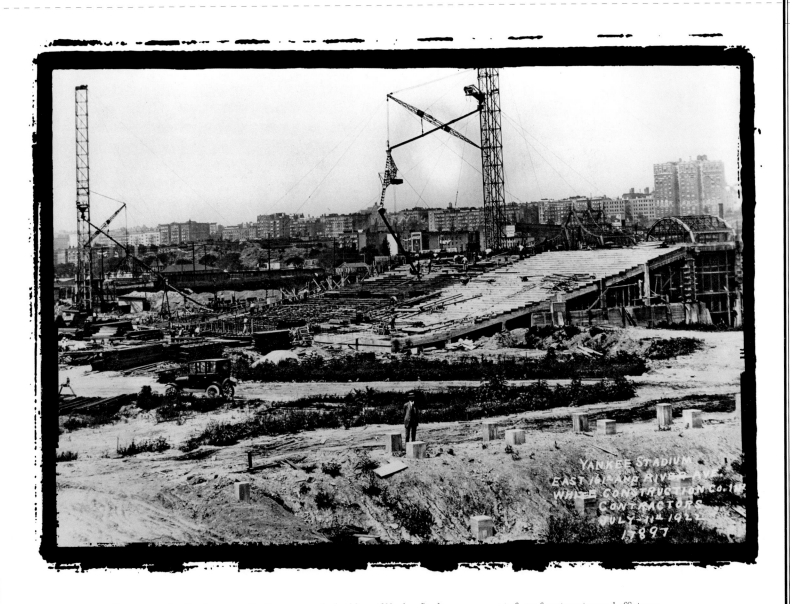

From a patch of land to a world-class venue, the building of Yankee Stadium was an epic feat of engineering and efficiency.

entrance by an elevator.

Everything about the place grabbed the country's attention, including its name. Ballparks had been called Field or Park or Grounds. This was a stadium, and for good reason: It was as big as Ruppert's fantasy. Before construction could begin, 45,000 cubic yards of earth had to be removed. Construction materials included three million board feet of lumber for the structure, 20,000 yards of concrete, 800 tons of rebar, 2,300 tons of mechanical steel, 13,000 yards of topsoil, 116,000 square feet of sod, 950,000 board feet of lumber for the bleachers, and one million brass screws. Incredibly, construction was finished in

800
TONS OF REBAR

just 284 days, and Yankee Stadium was ready for Opening Day in 1923.

Those lucky enough to step inside the Stadium on April 18, 1923, were treated to a breathtaking vista: 10,712 upper-grandstand seats and 14,543 lower-grandstand seats. (Less than twenty years earlier, the Yankees were playing at humble Hilltop Park, which had a capacity of 16,000 and was surrounded by a wooden fence.) The Stadium was a billboard of baseball's growth, not to mention a boon to the Yankees' strengths. The right-field foul pole was only 295 feet from home plate, a distance that could be reached with ease by the left-handed-hitting Ruth.

2,300
TONS OF MECHANICAL
STEEL

Sportswriter Fred Lieb dubbed Yankee Stadium "The House That Ruth Built," but a more apt description might have been "The House Built for Ruth." The short distance to the right-field foul pole actually was longer than at the Polo Grounds, where a home run only had to travel 256 feet. But the Stadium's right-field power alley, at 429 feet, was 20 feet closer than at the Yankees' previous home, another concession to Ruth.

The Yankees did Ruth another favor, calling for the Stadium to be situated so that the sun would set in left field, not right. That spared Babe, a right fielder, the late-afternoon glare that would challenge left fielders for decades to come, starting with his teammate Bob Meusel, in 1923.

The right-handed-hitting Meusel would have other obstacles, as well. His best chance for a home run was a line drive inside the left-field foul pole, only 280 feet away. But a blast to straightaway center field had to travel 487 feet to clear the wall, and the power alley in left-center was 500 feet away, a gap that would be dubbed "Death Valley," for the long fly balls that merely became long outs.

The daunting dimensions would soon become apparent to players and fans alike. But on Opening Day in 1923, all that mattered was the newness of the ballpark. There was an unmistakable buzz throughout the city as final preparations were made. The *New York Times* envisioned the new stadium as a venue for major events, including the Olympic Games.

Indeed, in years to come, the Stadium would play host to boxing matches, Army-Navy and

THE BALLPARK OF HUSTON AND RUPPERT'S

950,000
FEET OF BOARD LUMBER FOR THE BLEACHERS

Army-Notre Dame football games, National Football League championship games (the Giants played there from 1956 through 1973), religious conventions, and the celebration of Mass by two different popes.

Even the Stadium's geographic setting went beyond the ordinary. Compared with the Polo Grounds, whose profile seemed lost against Manhattan's crowded landscape, the Yankees' new ballpark stood out along the Harlem River, dwarfing the stores and apartment buildings that lined River Avenue. Approaching fans didn't have to search hard for the Stadium; they could see it from miles away.

It all started on Opening Day 1923, when the Yankees played host to the Boston Red Sox. The gates were opened at noon, and by two o'clock they were locked shut. Even though a sellout of 74,200 was announced, only 60,000 managed to get inside the Stadium, leaving some 14,000 milling around outside. Those who were lucky enough to witness the Stadium's introduction to the world must have gasped at the novelty of its layout. One of the notable features was the exaggerated warning track with pathways that led to the stands, allowing fans to leave after the game by walking onto the field and heading toward the large exits.

The sight lines were, for the most part, unfettered, although the Stadium was so large that a good number of fans were too far away to appreciate a game's subtleties. The manually operated scoreboard was substantial enough to provide line scores up to twelve innings for every game being played in the major leagues that day.

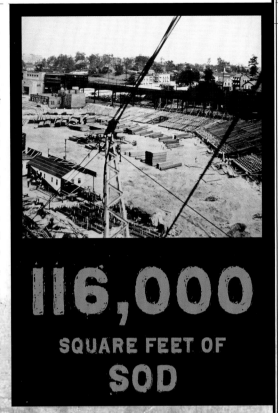

116,000
SQUARE FEET OF
SOD

DREAMS WAS A TEN-ACRE LOT IN THE BRONX.

284
DAYS TO COMPLETE

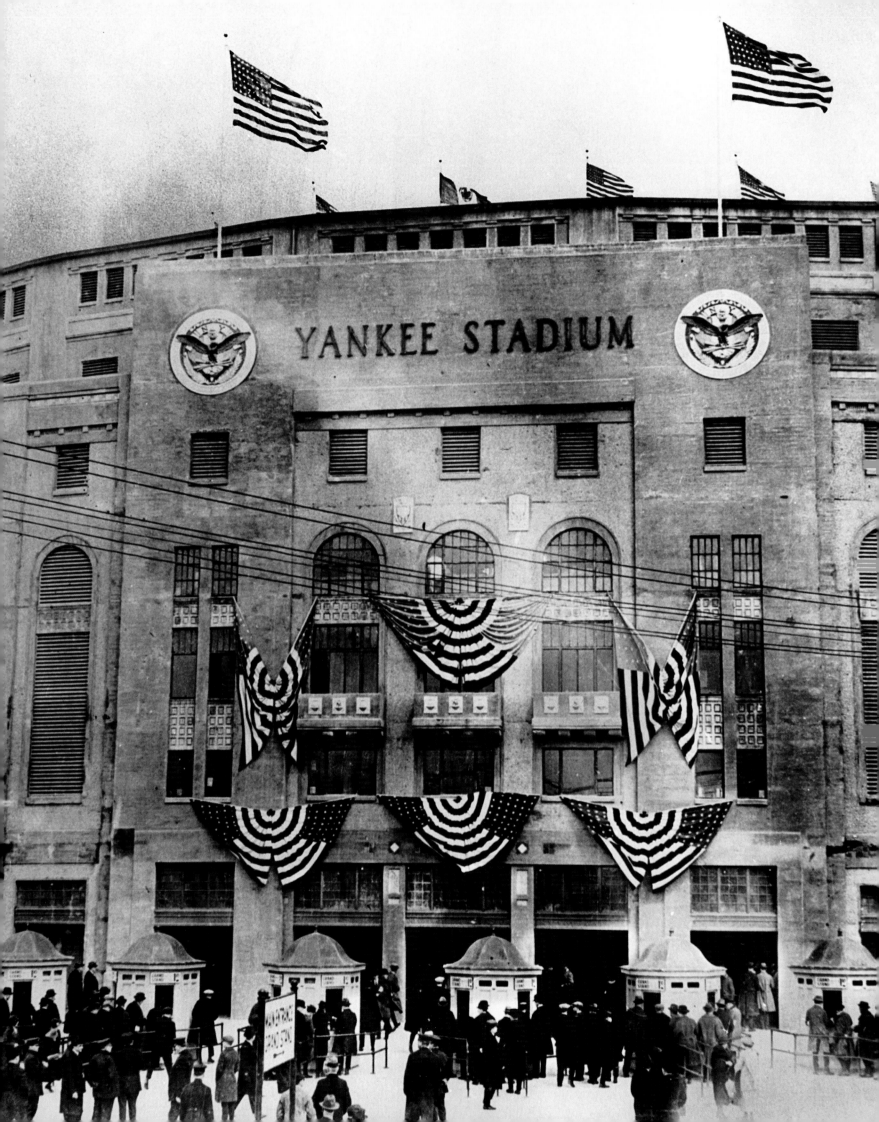

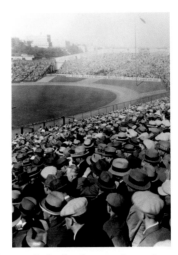

Fans pack the Stadium in the early years.

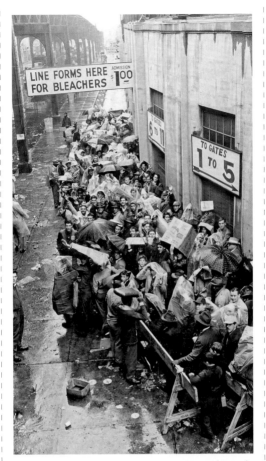

Upper deck down the left–field line.

The Yankees couldn't have made a more theatrical debut in their new home. They had lost the World Series to the Giants in both 1921 and 1922, but this was a new beginning. Marching bands, politicians, and New York Governor Alfred E. Smith were in attendance. With John Philip Sousa directing the music, the 1922 American League championship pennant was raised. Soon after, the Yankees went to work.

Boston's George Burns had the first hit in the Stadium, a second-inning single. Aaron Ward's

Fans wait in line for World Series tickets (above). An aerial view (below) of Yankee Stadium.

third-inning single was the Yankees' first hit, and soon after Ruth slammed the first home run. Batting with two runners on base in the third inning, he knocked a two-and-two pitch from Howard Ehmke ten rows into the lower right-field stands. The Bambino circled the bases, as he had so many times in his first three seasons with the Yankees, but now he was on his own stage.

There was something positively unstoppable

(continued on page 50)

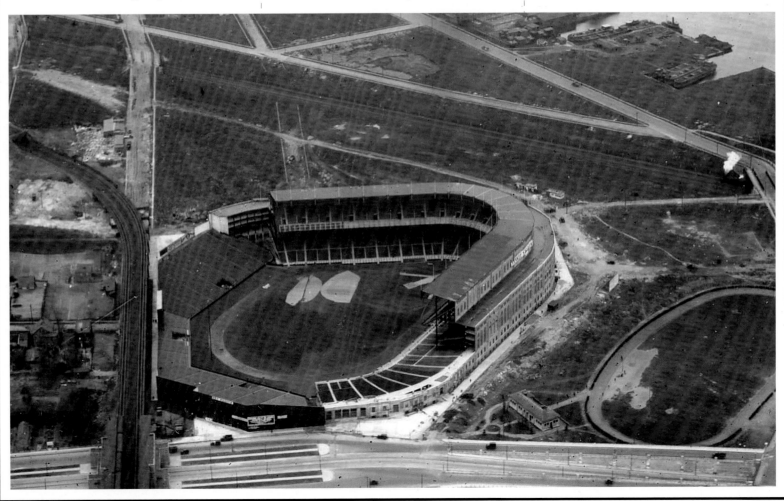

Can't ya

Opening Day, April 18, 1923

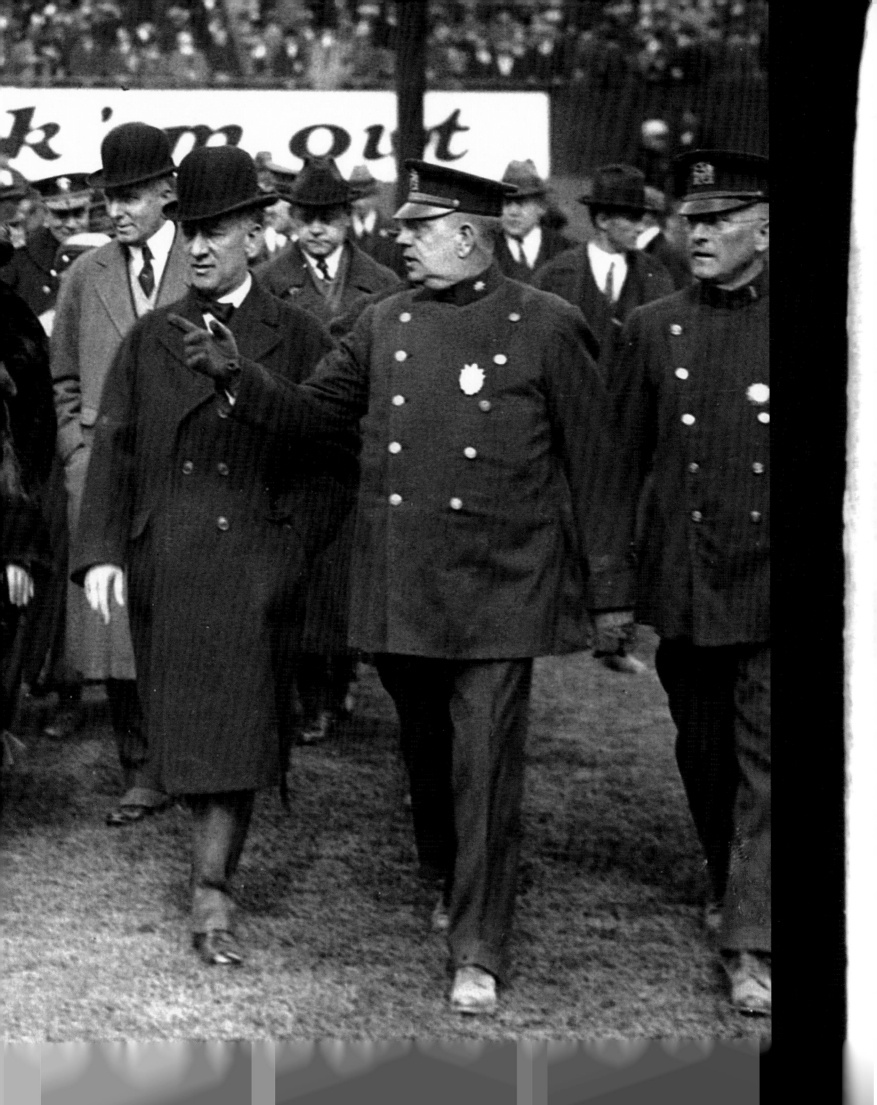

Two men operate the manual scoreboard at Yankee Stadium.

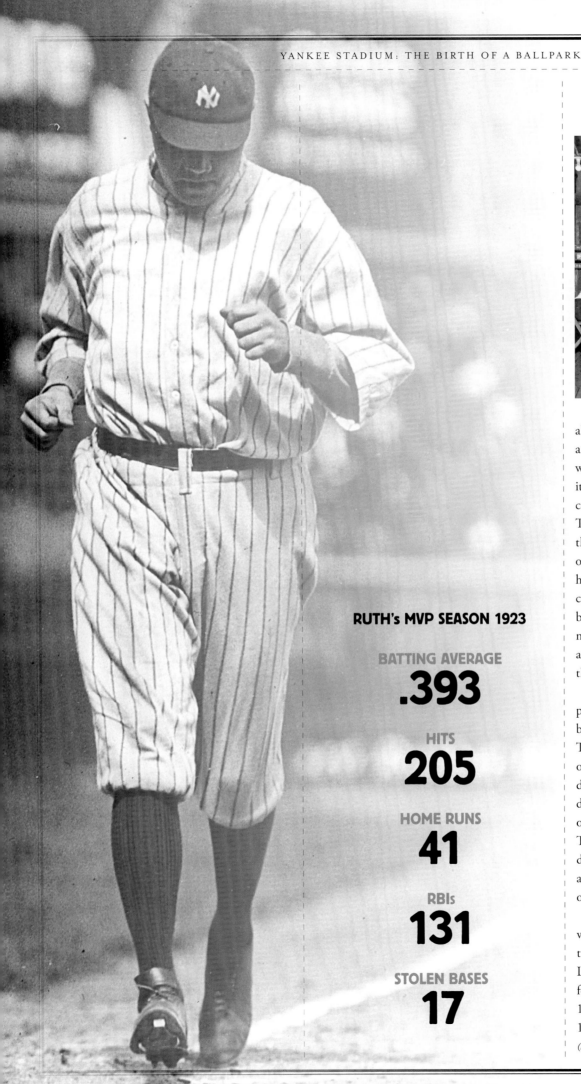

about the Yankees in their 4-1 victory that day and, indeed, for the rest of the season. Maybe it was the endowment of a new ballpark. Or maybe it was the law of averages. The Giants, after all, couldn't keep winning the World Series forever. The events inside the Stadium set the tone for the rest of the season. Ruth finished with forty-one homers, a modest total by his standards, but his .393 average and forty-five doubles would be career bests. The Babe set a major-league mark by reaching base 379 times. The Yankees won ninety-eight games and finished sixteen games ahead of the second-place Tigers, and rolled over the Giants in the World Series in six games.

In one season, the Yankees had remade their profile. They were by far the American League's best team, with more talented players on the way. The success, however, had an unanticipated effect on attendance. The absence of a pennant race discouraged fans from coming to the Bronx, despite the new ballpark. The Yankees topped one million in attendance, but not by much. The Yankees drew almost fewer in the Stadium's debut season than they had drawn in 1922, and attendance would remain flat for the remainder of the decade.

The Yankees blasted through the 1920s, winning three more pennants (1926-28) and two more world championships (1927-28). Ruth, Lou Gehrig, Tony Lazzeri, and Bob Meusel formed the core of the famed Murderers Row in 1927, when the Yankees scored 975 runs and won 110 games. The 1927 Yankees remain one of the

(continued on page 54)

RUTH's MVP SEASON 1923

BATTING AVERAGE

.393

HITS

205

HOME RUNS

41

RBIs

131

STOLEN BASES

17

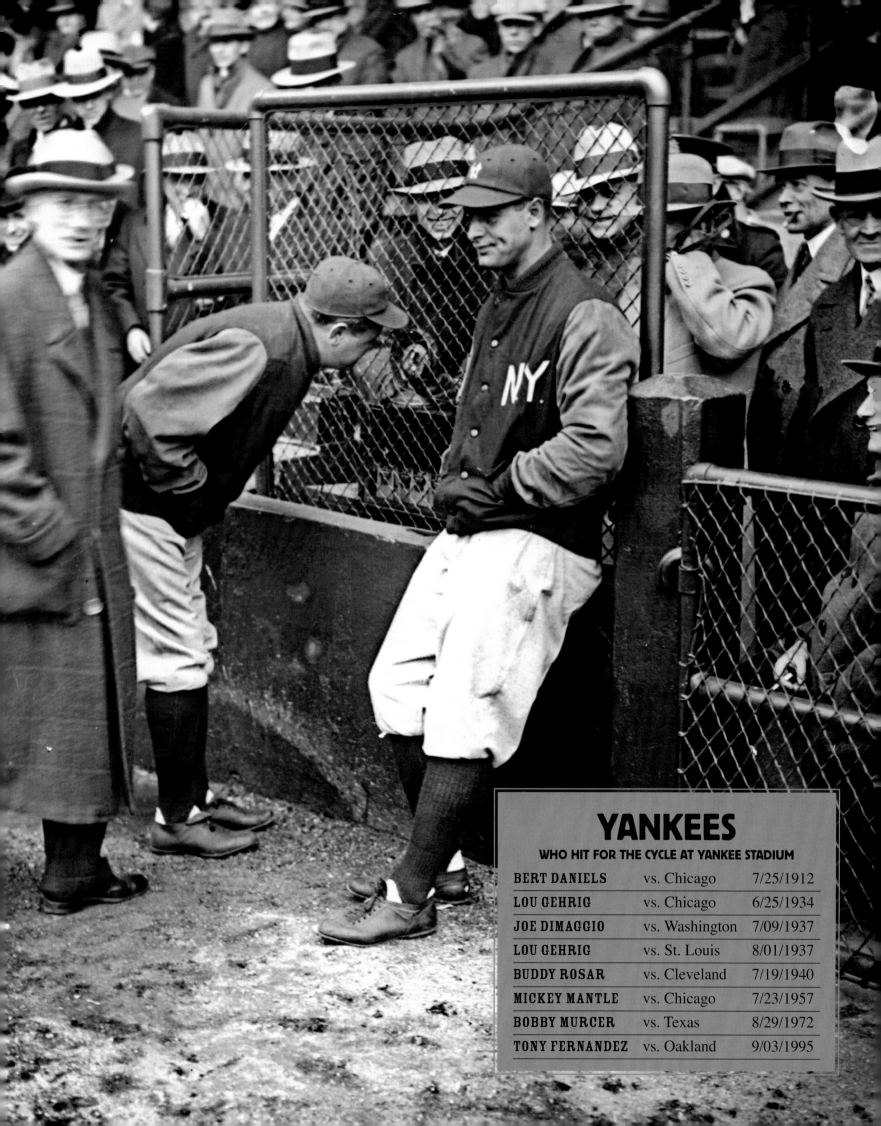

YANKEES
WHO HIT FOR THE CYCLE AT YANKEE STADIUM

BERT DANIELS	vs. Chicago	7/25/1912
LOU GEHRIG	vs. Chicago	6/25/1934
JOE DIMAGGIO	vs. Washington	7/09/1937
LOU GEHRIG	vs. St. Louis	8/01/1937
BUDDY ROSAR	vs. Cleveland	7/19/1940
MICKEY MANTLE	vs. Chicago	7/23/1957
BOBBY MURCER	vs. Texas	8/29/1972
TONY FERNANDEZ	vs. Oakland	9/03/1995

My earliest appreciation of Lou Gehrig—the introverted, quiet hero of so many dynamic Yankees afternoons from 1925 to 1939—grew immeasurably in the spring of 1930. That year of the Great Depression, when Lou hit .379, the highest of his season batting averages, I was eleven years old and a worshipper from afar. A neighborhood friend and I had collected scrapbooks featuring hundreds of big-league players, and many of these men had signed their names across pictures of themselves. But while we had a number of photos of Lou in our collection, we had never obtained his autograph. Of course, that was a wrenching disappointment, for we had Babe Ruth's highly readable autograph, but not Lou's.

There was irony here, too. My friend and I lived in the Columbia University area, where as a Columbia student some seven years before Lou had pumped some of the longest home runs ever seen on South Field. On one occasion, according to legend, Lou had bounced a clout off the white-haired head of Columbia's dean, Herbert Hawkes, as he strolled some four hundred-fifty feet away.

South Field was a two-acre oasis of cinder and chewed-up grass occupying a couple of blocks near Broadway and Amsterdam avenues in Manhattan, close to 115th Street. It was in such an anachronistic urban playground that Lou, an awkward young man in blowsy knickerbockers, first revealed his skills.

One day, my friend suggested we write a letter to Lou at his home in New Rochelle, New York, asking him for an interview. It would be for our Public School 165 newspaper. At the time, we held out scant hope that he would respond. But off the letter went anyway. To our amazement, a handwritten letter adorned with Lou's careful Spencerian penmanship arrived several days later.

"I'll be happy to see you," wrote Lou. "Just use this letter to come to the clubhouse."

We wasted little time—not more than twenty-four hours—hurrying to Yankee Stadium, where the Yankees were playing that afternoon. Yes, we played hooky that day, and we expected to be penalized. But what a small price to pay for a private audience with this greatest of all first basemen. With a soft wind blowing, the day was perfect. Fittingly, the sky was Columbia blue. We arrived early for the 3:30 start of the game. In those days, the Yankees were known as the team of "five o'clock lightning," a nickname derived from the team's late-inning rallies.

However, in our youthful ignorance, we hadn't realized we wouldn't be granted entrance into that wondrous amphitheater. The police officer at the gate said that we could wait outside if we wanted to, and that's what we did. As the afternoon wilted away, we kept listening for crowd noises. Once, when there was a great growling roar, we felt that had to be a Gehrig home run, or perhaps the Babe had just performed his specialty.

Then all was quiet in the ballpark, and we knew the game had ended. As fans emerged, we sensed that the Yankees must have won, for many were smiling and joking. We tried to estimate how long it would take for Lou to shower and dress. We had heard that he didn't usually hang around long after a game, and the rumor proved to be true. Within minutes, Lou appeared. He was hatless, coatless, and tieless, and his thick brown hair was still damp from his postgame shower. He had the kind of deep tan that today's players have forfeited to night baseball.

There were other kids waiting as well, but with our letter in hand, we felt smugly superior to them. As Lou walked by at a fast pace, we set out after him. My friend, less intimidated than me, yelled out Lou's name, causing Lou to stop and look at us. I waved the letter at him, and he looked at it. He realized it was the letter he had written to us.

"Did you boys enjoy the game?" he asked.

When we told him that we hadn't been able to get into the park, he seemed genuinely sorry. Then when we brought up the subject of an interview, he said he was in a hurry to get home and asked if we could try to do it another day. His voice was somewhat high-pitched, but friendly, and true to the sidewalk accents of New York.

"Did you really wait all afternoon?" he asked, at which point he reached into his pants pocket and pulled out two crumpled tickets.

"Yes, we did," I answered, summoning up courage.

Lou handed us the tickets as he stepped into his car, which was not far from the players' entrance. He waved at us and grinned that dimpled grin we had seen in our collection of pictures.

"I'm really sorry," he said as he waved to us.

Then he was gone. It was the last time I saw Gehrig in such close proximity, although in the years to come I went to many games at Yankee Stadium and watched as Lou played out his role as the seemingly indestructible "Iron Horse" of baseball legend.

In the summer of 1938, Lou's body showed signs of failing. The following spring, after playing in eight games, Lou told manager Joe McCarthy that he was going to step out of the lineup after 2,130 consecutive games. Seeking an answer for his problems, Lou went to the Mayo Clinic, where he was examined for six days.

An announcement from the Clinic—in the sterile language of medical public relations—followed. Doctors diagnosed Lou with amyotrophic lateral sclerosis and said he would be unable to continue

playing ball. In subsequent years, ALS would come to be known as Lou Gehrig's Disease.

No one is quite sure just how many around Lou knew he was dying from an incurable disease. Outside of Eleanor, Lou's wife since 1933, Yankees general manager Ed Barrow, and catcher Bill Dickey, Lou's longtime roommate, it's possible that nobody else knew the precise terms of his death sentence. Lou himself may not have been fully aware of the extent of his illness, although he probably suspected what was happening.

Within days, the Yankees, reacting to widespread sympathy and respect for Lou, announced that they would hold a special day to honor their sick captain. The event was scheduled for July 4, 1939, at Yankee Stadium. When I heard about it, I asked a friend if he wanted to accompany me to the Stadium.

"I wonder just how sick Lou is," my friend said when declining the invitation to join me. "Maybe he'll never play again, but I don't think he's dying."

Although I shared that feeling, as so many others did, I was determined to be present to say goodbye to my boyhood hero. I believe that few in the crowd of more than sixty thousand that came to Lou Gehrig Appreciation Day knew that Lou was dying, but that remains just a guess.

I was a right-field bleacherite in those days, paying fifty-five cents for the privilege. In earlier visits to the Stadium, the right-field bleachers were a perch from which I could stare at the number 3 on Babe Ruth's back as he patrolled the right-field sector. On this day, which turned out to be a sunny, glorious July 4, I sat surrounded by others, many under their boaters and felt hats, who had come because of their affection for Lou.

Yankees bleacherites, living in the game's low-rent district, could be coarse, profane, noisy, insulting, loquacious, and, on occasion, pretty funny. But on this melancholy afternoon, they seemed to be more subdued than usual. I shared their tone.

When it came time in between games of the doubleheader with Washington to commence the ceremony, most of the gang from the celebrated Murderers' Row of 1927 were on hand. From where I sat, I couldn't see the expressions on the faces of Herb Pennock, Earle Combs, Bob Meusel, Tony Lazerri, Mark Koenig, Waite Hoyt, Benny Bengough, George Pipgras, Joe Dugan, and others, who had come from near and far. And I couldn't see how Lou reacted to the Babe when Ruth threw a bear hug around him. But newspaper photos made the moment memorable, for the two men hadn't had much to say to each other for years.

The crowd sat through brief speeches by diminutive New York City Mayor Fiorello La Guardia, who later would hire Lou for the New York Parole Board, and Postmaster General James A. Farley, who had started out life in Grassy Point, New York, wanting to be a ballplayer.

Then came manager McCarthy, whose voice quavered. Lou had been his favorite player; now he was bidding him farewell.

"Lou, what else can I say except that it was a sad day in the life of everybody who knew you when you came to my hotel room that day in Detroit and told me you were quitting as a ballplayer because you felt yourself a hindrance to the team," McCarthy said. "My God, man, you were never that."

Following McCarthy's heartfelt words, gifts were presented to Lou, mainly from the club's employees. Other gifts came from the Yankees' friendly enemies at the Polo Grounds, the New York Giants.

John Kiernan, an erudite sports columnist for the *New York Times* who was a neighbor of Lou's, wrote a touching poem that appeared on a trophy from Lou's teammates. "Always you were the leader, and ever you played the game," the poem began, and that captured the sad event more than any other words.

Many in the crowd began to chant, "We want Lou; we want Lou."

What began as a murmur spread into a loud, importunate shout throughout the ballpark. Many of us in the bleachers took up the theme. If I recall correctly, I was almost too touched to join in. Sid Mercer, a sportswriter who was serving as master of ceremonies, told the crowd that Lou was moved to speak. In fact, the night before, Lou had written a few remarks, helped along by Eleanor.

But now it looked as if Lou would be unable to deliver his remarks. He hadn't wanted to speak in the first place. For a brief moment, the crowd remained hushed. Then they watched as Lou stepped forward, somewhat uncertainly. Fearful that Lou might stumble, McCarthy leaned over to Babe Dahlgren, who was Lou's successor at first base, and whispered, "Catch him if he goes down."

Finally at the microphone, Lou drew a handkerchief from his pocket, wiped his eyes, and cleared his throat. Summoning what strength he still had, Lou held up his hand to the fans as if to ask for their patience, and then delivered his words without halting and without a note to read from. There was no slurring of words, often so typical of ALS sufferers.

The speech forever after has been included in many anthologies of famous addresses. I have repeatedly referred to it, without reservation, as baseball's Gettysburg Address.

When Lou finished, the crowd emitted a roar of approval for what they had just heard. I stood along with thousands of others, my own eyes misty.

Years later, author Wilfrid Sheed wrote, "All present in Yankee Stadium that day had been given a license to love a fellow human being without qualification."

"All true stories end in death," the sports-minded Ernest Hemingway once said. "But some people put on a very fine performance en route to the grave."

In Gehrig's case, in the months preceding his death on July 2, 1941, his behavior was in no way a "performance." He simply didn't abide hokum. He was an authentic man for his entire life, in good times and bad.

Ray Robinson is a longtime New York sportswriter.
He authored a critically acclaimed biography on Lou Gehrig.

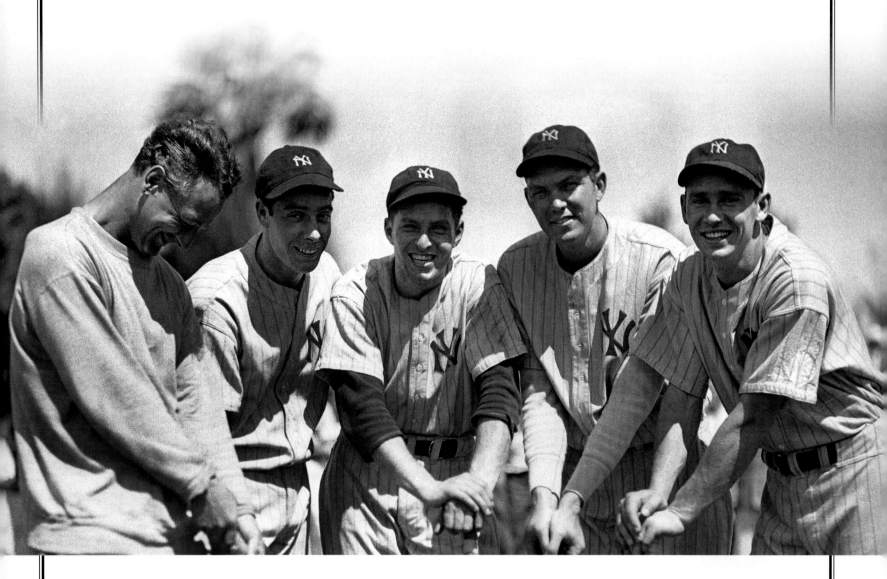

Lou Gehrig, Joe DiMaggio, Thomas Henrich, Bill Dickey, and Joe Gordon pose for the cameras during spring training in 1939.

game's most famous teams, yet only 1.1 million fans watched their home games.

The Yankees were baseball's most famous franchise, but sports were one of many entertainment choices in New York's cultural revolution. The city had become a twenty-four-hours-a-day metropolis, where you could find bars, restaurants, and jazz clubs open at any time. The Yankees' success became so routine that only hard-core loyalists could be counted upon to attend games regularly.

Despite the flatline attendance revenue—and an increasing payroll—Ruppert gave the Stadium its first major facelift in 1928, spending $400,000 to extend the grandstand in left field beyond the foul pole. Several rows of box seats were removed in left field to accommodate extending the foul-pole distance from 281 to 301 feet. Nine years later, right field was similarly revamped, thus allowing for upper-deck home runs in both directions. Also in 1937, wooden bleacher supports were replaced by a concrete structure, and the distance to center field was shortened from 487 feet to 461. Seating capacity was reduced from eighty thousand to seventy thousand.

Hardly any of the Yankees from the Stadium's debut were around by the late 1930s. And little did anyone know that Lou Gehrig, the carryover legend from the 1920s, was in the throes of a mysterious disease—amyotrophic lateral sclerosis—that would take his life in 1941. Even though the Stadium's novelty had worn off, a trip to the Bronx still ranked among baseball's finest pleasures. The Yankees won five world championships in a decade under manager Joe McCarthy, and a new gate attraction, a graceful rookie named Joe DiMaggio, was introduced to New York in 1936. The Depression, however, had taken its toll on attendance throughout baseball, and even the Yankees were not immune. After topping one million fans in nine of the previous eleven seasons, the Yankees fell to 912,437 in 1931. Two years later, the home-crowd count was 728,014, an average of just 9,579 a game.

Still, the Yankees were drawing twice as

many fans as the American League average, which spoke volumes about New Yorkers' love for baseball—and the extent to which the national economy had become paralyzed. The Stadium remained an inner-city mecca, one of three havens for New York's baseball addicts, along with the Polo Grounds and Ebbets Field. The Giants, still in the Polo Grounds, were one of the National League's best-drawing teams, and they won three pennants and a World Series in the 1930s.

The Brooklyn Dodgers played at Ebbets Field, as homey and neighborhood-rooted as Yankee Stadium was majestic. The Dodgers weren't much of a factor in the 1920s and 1930s, finishing in the first division only once (1933) between 1924 and 1938. Ebbets Field had fewer than half as many seats as the Stadium, and the Dodgers were consistently outdrawn by the Yankees. Still, there was a unique charm about baseball in the Flatbush section of Brooklyn, on a block bounded by Sullivan Place, Bedford Avenue, Montgomery Street, and McKeever Place. Ebbets Field was cozy, if not a tight fit altogether. There was practically no foul territory, allowing for extremely close viewing by those in field-level box seats. The contrast between Ebbets Field and Yankee Stadium was never more stark than in the span of 1947-56, when the Dodgers

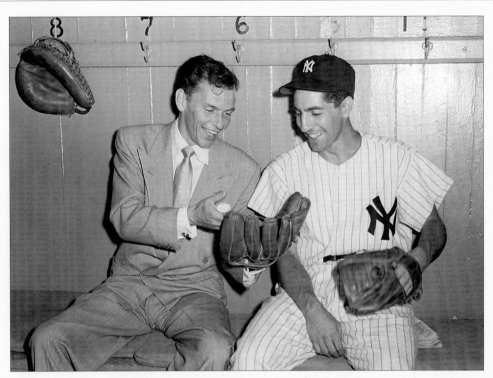

Frank Sinatra and Phil Rizzuto (above) talk baseball.
Joe DiMaggio (below) swings for the fences in a game at Yankee Stadium.

★ FIRST PERSON ★ PHIL RIZZUTO ★★

When I was a kid, my uncle used to take me to Yankee Stadium, and I was fortunate enough to see the Murderers' Row teams, and then to see Joe DiMaggio come along. Five years later, I made the team and found myself to be Joe's teammate. Holy cow!

We opened the 1941 season in Washington, and then went home for what would be my first time in the Yankees clubhouse. It was on the third-base side and up a flight of stairs. We each had metal lockers with doors, not like the stalls they have today. I was in awe of everything. I can remember just staring at DiMaggio shaving. It was my final proof that I was really an "insider," really part of the team. It was a relief to get out on the field, where at least I knew what I was doing.

I loved how perfectly smooth the infield was maintained, and how the grass was cut just right for my bunting game. But I'd never played on a field that big, with triple-tiered stands and an outfield that went on forever. I thought, "Well, I doubt I'll ever hit a home run in this park." But I did.

"THE GREAT PART ABOUT PLAYING THOSE GUYS [THE DODGERS] WAS THAT WE DIDN'T HAVE TO TRAVEL. THE WHOLE SERIES WAS OVER IN A WEEK BECAUSE WE DIDN'T HAVE TO GET ON A TRAIN TO GO ANYWHERE." — YOGI BERRA

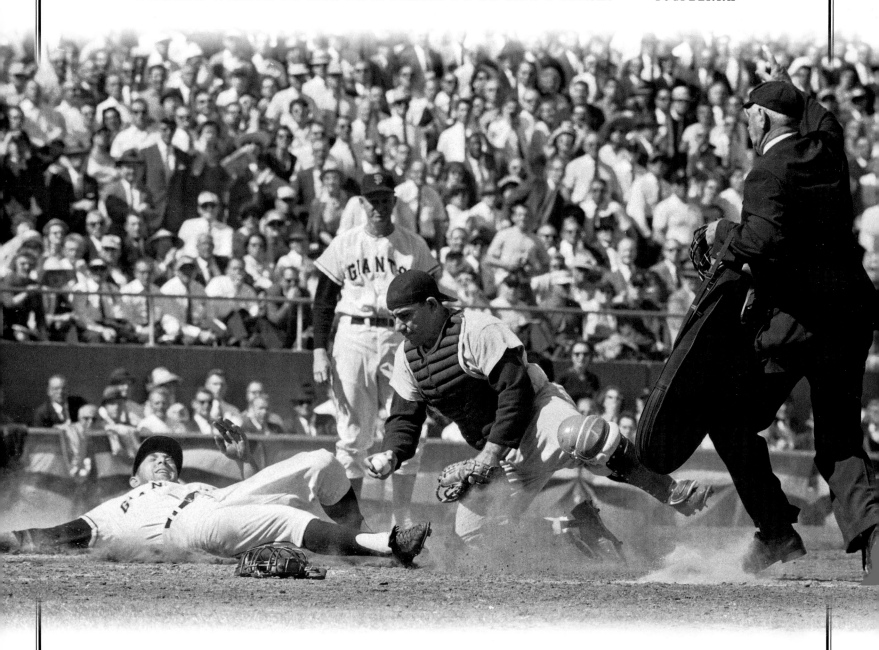

Yankees catcher Yogi Berra eliminates a potential run against the San Francisco Giants in Game 2 of the 1962 World Series.

and Yankees met in the World Series six times. That was the original Subway Series. Fans took the Jerome Avenue IRT to get to the Stadium, and hopped on either the Franklin Avenue IRT or the Prospect Park BMT to get to Ebbets Field.

Yogi Berra said, "The great part about playing those guys was that we didn't have to travel. The whole Series was over in a week because we didn't have to get on a train to go anywhere."

By the time the Yankees and Dodgers had established a rivalry, nighttime baseball had become a part of the major-league landscape. The first game played under the lights was on May 24, 1935, at Cincinnati's Crosley Field, where the Reds played host to the Philadelphia Phillies. Yankee Stadium's first night game was on May 28, 1946, when the Washington Senators beat the Yankees, 2-1.

By then, fans had grown accustomed to another personal touch in Yankee Stadium: the monuments in center field, commemorating some of the franchise's stars, which were in the field of play. The first monument was placed in 1932 in honor of Miller Huggins, who had died suddenly in 1929, and similar granite pieces were added for Babe Ruth and Lou Gehrig, and later for Joe DiMaggio and Mickey Mantle. Many others are

remembered with plaques. Monument Park, as the area came to be known, had been fenced in by the time the Stadium was renovated in the mid-1970s, and then was moved to an area behind the left-center field fence.

During the Stadium's facelift in 1974-75, the Yankees played their home games at Shea Stadium, home of the New York Mets. No one questioned the Stadium's need for renovation, especially George Steinbrenner, the managing partner of a group that had purchased the Yankees in January 1973.

The previous summer, New York City announced plans for a $100 million renovation of the Stadium, prompting the Yankees to agree to a thirty-year lease, beginning in 1976. Everyone looked forward to the modernization of the Stadium, which was now fifty years old, even

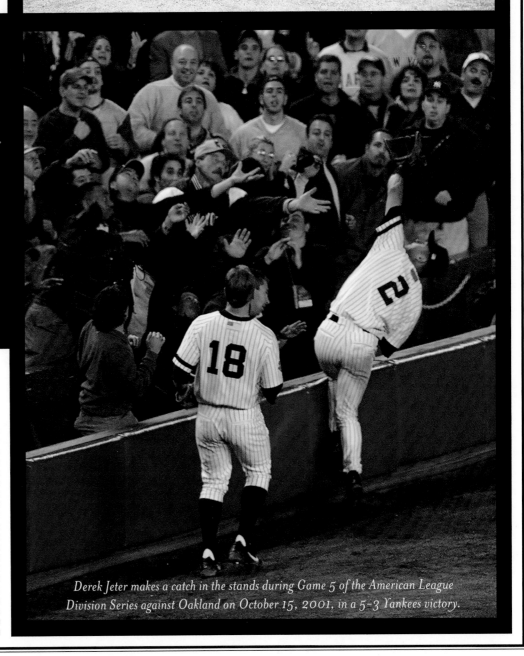

Then-Yankees co-owners Dan Topping and Del Webb pay their respects at the Yankee Stadium center-field monuments on Opening Day in 1953.

> "THE VISITING BULLPEN IS REALLY CLOSE TO THE MONUMENTS. THE FIRST TIME I WALKED OUT OF THE DUGOUT, I COULDN'T GET OVER HOW CLOSE THE STANDS WERE TO THE FIELD. THE WAY THE STANDS TAPER TOWARD THE THIRD- AND FIRST-BASE LINES IS REALLY DIFFERENT FROM ANYWHERE ELSE I'VE PLAYED. THE WAY IT WAS BUILT BRINGS FANS CLOSER TO THE ACTION."
>
> — TREVOR HOFFMAN

if meant trekking to Queens for two years. As much as the Yankees wanted upgrades to the Stadium, they insisted that its signature touches be retained. Ballpark architecture was changing in the mid-1970s, but the Yankees had no interest in following the crowd.

Except for Royals Stadium in Kansas City, which opened in 1973, there were no baseball-only venues constructed between 1962 (Los Angeles' Dodger Stadium) and 1991 (Chicago's Comiskey Park). Instead, the new venues were indistinguishable, synthetic-looking ballparks built for both baseball and football. Riverfront Stadium in Cincinnati bore a striking resemblance

(continued on page 62)

Derek Jeter makes a catch in the stands during Game 5 of the American League Division Series against Oakland on October 15, 2001, in a 5–3 Yankees victory.

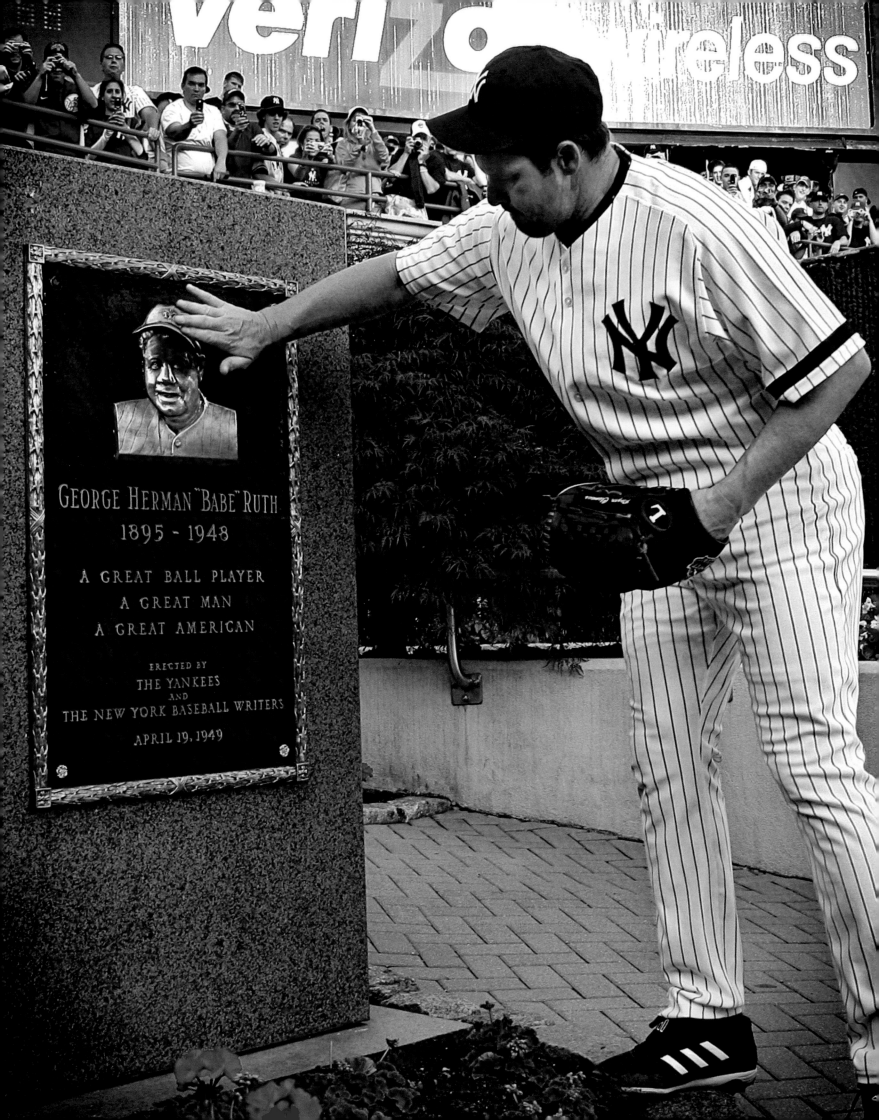

IN THE UNITED STATES, YANKEE STADIUM IS THE NUMBER ONE SPORTS VENUE.

I have three memories of Yankee Stadium that stand out. I was there with my son, Andrew, who is now the New York state attorney general, when Mickey Mantle hit a home run in a World Series game. Andrew fell asleep before the game was over. I will never forget that.

I have two special memories from my youth. I was at an exhibition that had been set up to promote the sale of war bonds in 1942, which was the last time Babe Ruth appeared in a uniform at Yankee Stadium. The guy who pitched to the Babe in that game was Walter Johnson. The Babe hit a ball into the lower right-field seats. The crowd started chanting for him to run, and he didn't want to. Finally, he began to jog around the bases, and the crowd went crazy.

I saw Joe DiMaggio play at Yankee Stadium after he had just come back from the war. A fellow who had worked in my father's grocery store took me to that game. I couldn't believe I was watching Joe DiMaggio in person. I will never forget the way he ran after a fly ball. He was so smooth, so elegant. He made everything look so easy. I was surprised by the width of his batting stance.

I had the privilege of watching a World Series game at Yankee Stadium with Joe DiMaggio at the request of HBO, which made the documentary, *Where Have You Gone, Joe DiMaggio?* Joe didn't understand that the title was meant to help solidify his iconic status. His thoughts were: "I am very much alive, and this indicates that I have died."

I told him, "Martin Luther King had been murdered, John F. Kennedy had been murdered, then Bobby Kennedy, and there are no more heroes. They are yearning for you. They know that you are still around, and they love you. This is a compliment."

That didn't faze him though. He wouldn't cooperate with the film. Maybe he was a little stubborn, but imagine how stubborn you have to be to hit in fifty-six consecutive games.

When you see the Stadium for the first time—I was coming from South Jamaica, Queens, and was used to playing baseball on an old lot where we had to watch out for broken bottles—it made an impression that never went away. When I walked into Yankee Stadium for the first time, I couldn't get over the beauty of it. It was—and still is—magnificent.

I was there for Opening Day and a lot of other games when I was the governor of New York. There is nothing like being at a baseball game at Yankee Stadium. You can't get the feel of it unless you are at the game. You can't appreciate the distances and the dimensions of the game on television.

The Stadium is a great place. I learned a lot when I was the governor about what distinguishes New York City and New York state from all other places. No matter how you measure it, Yankee Stadium deserves a place on the honor roll. It has created jobs, helped commerce, and it's been a valuable entertainment venue. The reputation Yankee Stadium has built for New York City and New York state from a historical standpoint has been significant. The Stadium deserves a place on all the lists of honor, in terms of what has been important to our culture in this city and this state.

I played baseball, I've written essays about baseball, and I love the game. There has never been anyone like Joe DiMaggio, and I suspect there never will be. And there will never be another place quite like Yankee Stadium.

Mario Cuomo is a former governor of New York.

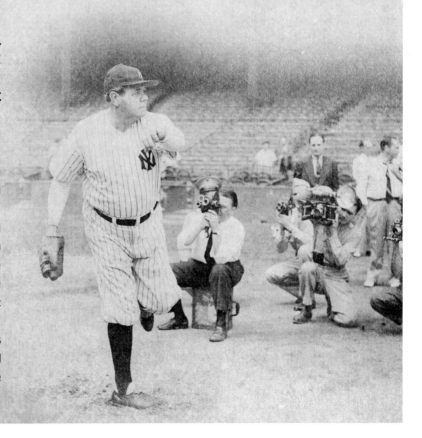

THE ROAD TOWARD A NEW YANKEE STADIUM BEGAN WITH BAT DAYS IN THE EARLY 1970s.

The promotional day, beloved by fans and a favorite of newspaper photographers, brought with it a ritual in which young fans would tap their bats in unison against the concrete beneath their feet, hoping to stir a Yankees rally. The pounding created a dangerous situation. Concrete chips from the mezzanine and upper decks began to fall. No one was ever hurt, but Yankees officials were prompted to bring in building engineers for an evaluation.

The conclusion: Yankee Stadium was beginning to fall apart. By 1973, it would be fifty years old. By building standards of the 1920s, that was a good run.

Michael Burke, who ran the Yankees for the CBS ownership, went to New York Mayor John Lindsay to report on the Yankees needs. Lindsay knew and cared little about baseball, but he didn't want the Yankees packing up and leaving on his watch.

Burke and Lindsay hatched a plan under which the city would condemn the existing structure, acquire it, and finance the rebuilding. Yankee Stadium would no longer be owned by the team. Approximately $24 million was the estimated price—the same figure it cost to build Shea Stadium a decade earlier. The final bill topped $100 million. Inflation wasn't kind to ballpark planning.

The renovation began after the 1973 season, the Stadium's fiftieth anniversary. It took two and a half years to rebuild. In the meantime, the Yankees shared Shea Stadium with the New York Mets.

I was the assistant public relations director, reporting to the legendary Bob Fishel, when we announced this plan early in 1972 during a promotional tour we called our annual Yankee Caravan.

By the time the 1972 *Yankees Yearbook* was published, we had an architect's rendering available. To Burke's credit, he fought and clawed with the city, and insisted that the historical façade design remain, albeit across the outfield billboards, as the new roof would not support an exact match. Burke held firm; the city gave in, and the design survived.

In January 1973, a group headed by George M. Steinbrenner III purchased the Yankees from CBS and inherited the rebuilding plan.

The final game of the 1973 season was on September 30. Everyone in attendance received the record album, *Sounds of 50 Years of Yankee Stadium.*

A crowd of 32,328 showed up for the final game. Among them was John Drebinger, who covered the game for the *New York Times*, as he had in 1923 when the Stadium opened.

The game was uneventful. The Yankees lost, 8-5, to Detroit, with Duke Sims, the Yankees catcher, hitting the final home run. In a six-run Tigers' eighth, Yankees manager Ralph Houk was forced to walk to the mound to remove Lindy McDaniel, to a chorus of boos. Fishel told me how much it hurt him that Houk had to make that trip, knowing the fans had turned on him and would rain boos upon him.

After the game, Houk quit. Still in uniform and with tears in his eyes, after thirty-four years in the organization, he walked away.

While the news conference was going on, an estimated twenty thousand fans were all over the field, some carrying seats they had pulled and twisted out of the concrete, breaking off the steel legs in the process. The seats that were salvageable were acquired by the department store E.J. Korvettes and sold for $7.50 each.

The next morning, with the Stadium looking like a war zone, a ceremony was held, with Mayor Lindsay presenting first base to Mrs. Lou Gehrig and home plate to Mrs. Babe Ruth. As the dignitaries departed, demolition work began. Approximately 105 pillars were removed. The engineering feat of supporting stacked decks and a roof without pillars was not available in 1923. That was the major structural difference. The outer shell remained, but the inner Stadium felt new and modern.

As the Yankees played at Shea for two seasons—I succeeded Fishel during that time—work progressed on schedule in the Bronx. A ticket kiosk went to the Smithsonian. The foul poles went to a Japanese baseball team. The monuments and plaques were carefully stored for what would be the new Monument Park. Periodically, I led a small band of writers, all in hard hats, on progress tours. It felt great to be there, even though it was a sea of mud and chaos.

Just before spring training in 1976, we took our final tour. At a photographer's request, I threw a pitch from where the mound would be. Was it the first in the new park? I can't say for sure. I suspect the workmen had some fun during breaks.

The Stadium reopened on April 15, 1976. Not everything was ready, but it was ready enough. George Steinbrenner personally choreographed the ceremonies, inviting not only Mrs. Ruth, Mrs. Gehrig, Joe DiMaggio, Mickey Mantle, Yogi Berra, Phil Rizzuto, and Don Larsen, but also Joe Louis, who fought there, Frank Gifford, Kyle Rote, Johnny Lujack, Weeb Ewbank, and Arnold Tucker, who played and coached football there, and others who were part of the great history. Bob Shawkey, the Opening Day pitcher in 1923, threw out the first pitch. Whitey Witt, the Yankees' leadoff hitter in '23, stood at the plate as his teammates Waite Hoyt, Joe Dugan, Hinkey Haines, and Oscar Roettger looked on.

Behind Shawkey on the mound were four special guests chosen by Steinbrenner: Toots Shor, the restaurateur to the sports crowd; Pete Sheehy, after whom the clubhouse was officially named that day; Jim Farley, the former postmaster general and the team's oldest continuous season-ticket holder; and Mel Allen, the longtime "Voice of the Yankees."

Robert Merrill sang the national anthem, and Bobby Richardson delivered an invocation. Terrence Cardinal Cooke offered a blessing.

Everyone at the sellout game got a reprint of the original 1923 Opening Day program. The scoreboard was not fully operational, so lineups could not be posted, but the score-by-innings board worked fine.

As for the game, which took place in brutally hot weather for April, the Yankees beat the Minnesota Twins, but Dan Ford of the Twins hit the first home run.

Labor-union problems kept the gates shut until just ninety minutes before the start of the game. The Yankees had a new center fielder in Mickey Rivers, a new second baseman in Willie Randolph, a new captain in Thurman Munson—and manager Billy Martin promised good things.

Billy delivered on that promise. The team won its first pennant in twelve years and scaled two million in attendance, the first American League team to do so since the Yankees of 1950.

It was the biggest renovation a ballpark had ever undergone, and it was built with the thought that perhaps two million fans would visit each year. No one anticipated that number eventually would double. The old Stadium lasted fifty-one seasons and the renovated one will have lasted an additional thirty-three.

I'll say this for the renovated one: It brought forth its own, overflowing bank of great moments and happy times shared among fellow fans.

Marty Appel worked for the Yankees from 1968-77 and was the team's third public relations director. He later produced Yankees telecasts for WPIX.

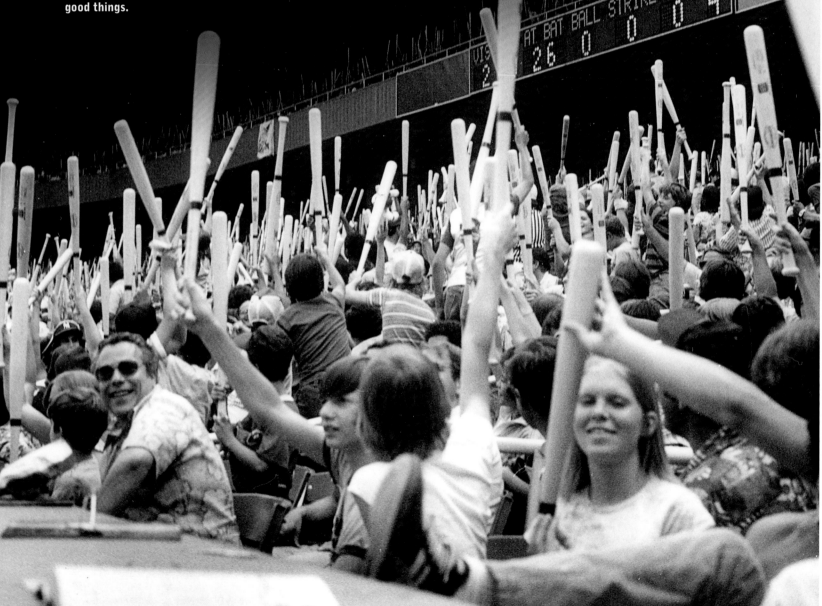

to Pittsburgh's Three Rivers Stadium, which was a clone of Veterans Stadium in Philadelphia. The trend continued in Oakland, St. Louis, and Atlanta.

The Yankees needed to modernize the Stadium, but did not want to turn their tradition-laden ballpark into another soulless slab of concrete. Mayor John Lindsay announced that it would cost $30 million just to prepare the Stadium for renovation. When reconstruction began, eliminating the support columns that obstructed viewing was first on the to-do list.

made for an irresistible tourist attraction, "The Bat" was actually an exhaust for the Stadium's boiler, heating, and air-conditioning systems.

Interesting and collectible items from the old ballpark were plentiful. Cleveland's Cuyahoga Wrecking Company began selling off the last remnants of "The House That Ruth Built," and it wasn't just ordinary fans that became souvenir collectors. Stan Musial bought bleacher seats for his St. Louis restaurant. Whitey Ford and Yogi Berra bought box seats, and Billy Martin bought two stairs and a banister from the dugout. The

it was the right thing to do."

The renovated ballpark was leaner, hipper, and more attuned to the modern game. The Yankees returned to their refurbished home on April 15, 1976, beating the Minnesota Twins, 11-4, in front of a capacity crowd of 57,545. It wasn't until the Stadium reopened that the changes finally sunk in. The façade was gone, although a replica was built atop the new electronic message board and replay screen. Monument Park was off-limits. The field dimensions were radically different, too. The distance to "Death Valley," left-center field, had

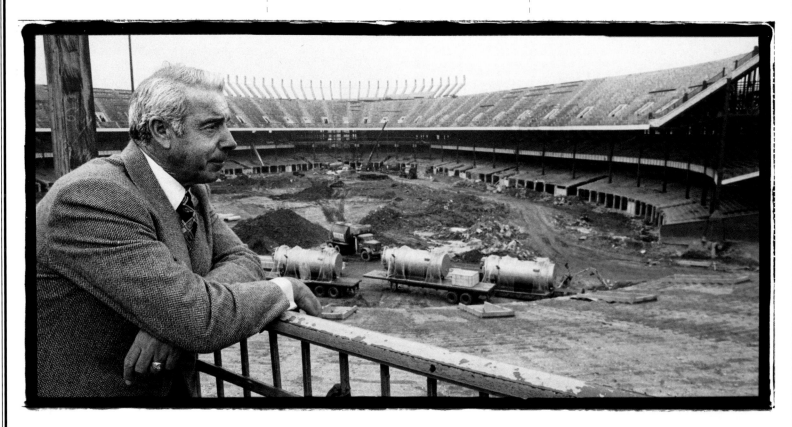

From the elevated train station platform beyond the outfield fence, Joe DiMaggio watches the renovation of Yankee Stadium in July 1974.

The playing field was lowered by five feet to improve sight lines, and eighteen-inch-wide metal seats were replaced by twenty-two-inch plastic seats. The more generous berths served to reduce the Stadium's seating capacity from sixty-five thousand to fifty-four thousand.

Other changes would have no doubt left the likes of Ruth and Gehrig in a state of shock. There were new concession areas, a private club, a public cafeteria, and a section of VIP boxes in the mezzanine area. Most notably, a 138-foot stainless steel and fiberglass smokestack shaped like a Louisville Slugger was placed outside the Stadium by the home-plate entrance. While it

Smithsonian Institute got the Yankees' bat rack, bullpen steps, and a ticket kiosk, and the Museum of the City of New York got a box seat. Home plate was given to Ruth's widow, and Mrs. Lou Gehrig received first base.

Nostalgia for the grand old Stadium even went global—the Osaka team in Japan paid $30,000 for the foul poles. Everything about the rebirth of the Stadium was pricey. In 1978, the *New York Times* pegged the final cost at $95.6 million. Lindsay, no longer the mayor, defended the expenditure, telling the *Times*, "If the Yankees had left New York, it would have been a disaster for the city and particularly for the Bronx. I think

shrunk from 457 feet to 430, and straightaway center field had been reduced from 461 to 417. Right-center field went from 407 feet to 385.

In 1984, left-center was again downsized, this time to 411 feet, and center field was reduced seven feet to 410. The changes made it possible for fans to take a walking tour of Monument Park. For the last twenty years, the left-center power alley has been closer to home plate than the center-field fence, 399 feet to 408. Imagine what Joe DiMaggio's power statistics might have been if the distance to "Death Valley" had been 399 feet when he played.

(continued on page 66)

EVOLUTION OF YANKEE STADIUM

ORIGINAL DESIGN

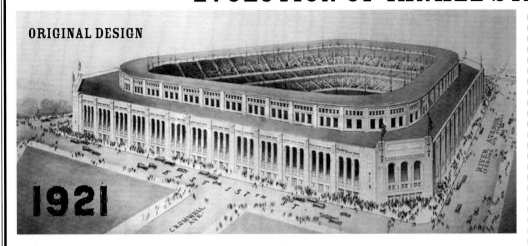

1921

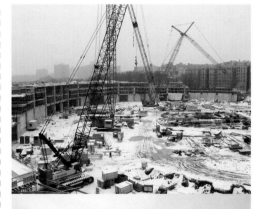

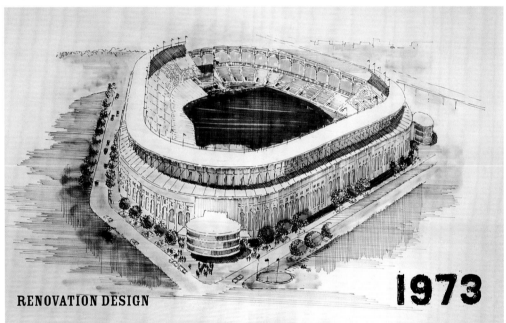

RENOVATION DESIGN

1973

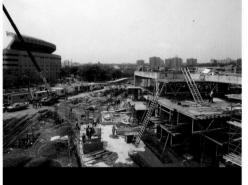

The new Yankee Stadium (above and below) will open in 2009, replacing the third-oldest stadium in the major leagues. Said Yankees president Randy Levine, "This new stadium will present new comforts, new features, and will be state-of-the-art in every way. It will be the most spectacular fan-friendly stadium ever built."

2006

NEW STADIUM DESIGN

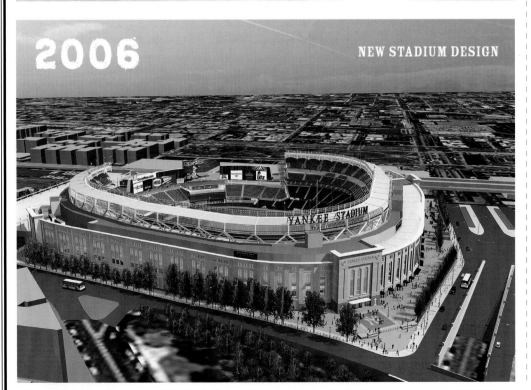

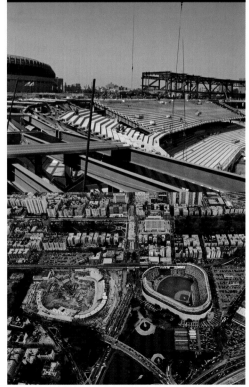

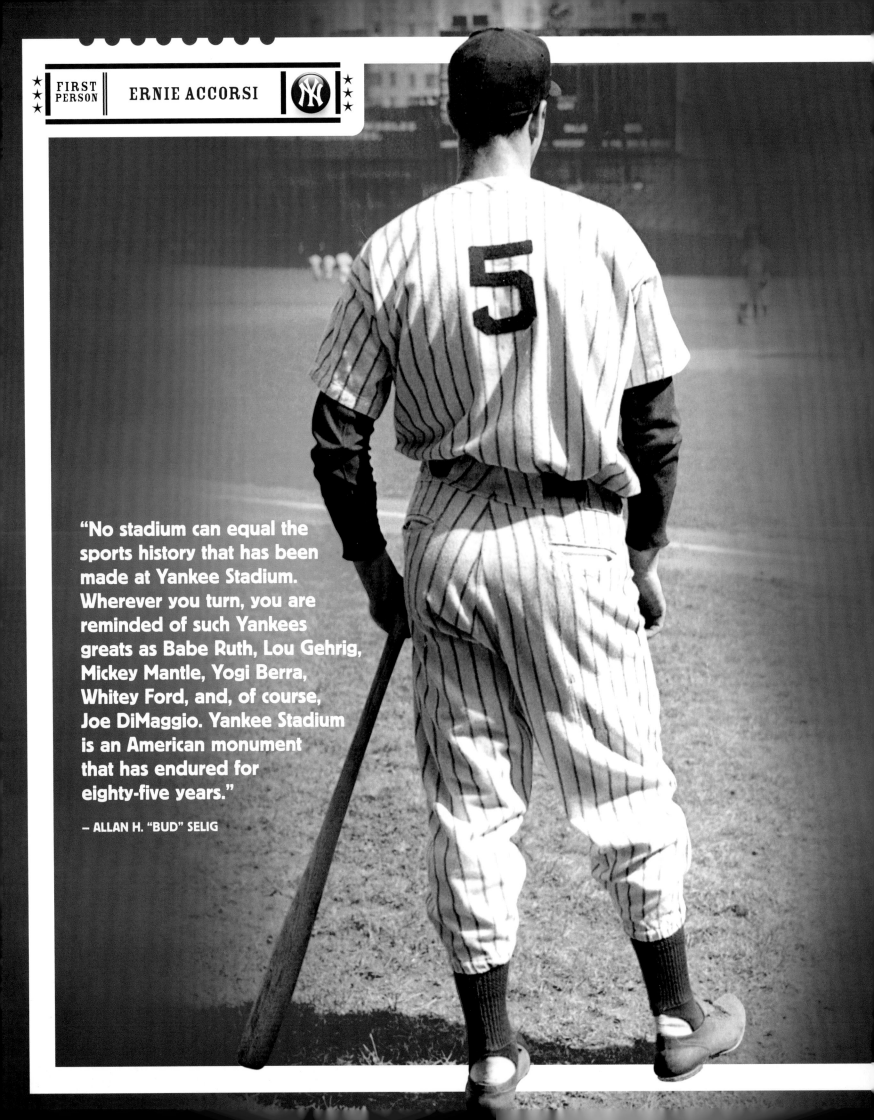

"No stadium can equal the sports history that has been made at Yankee Stadium. Wherever you turn, you are reminded of such Yankees greats as Babe Ruth, Lou Gehrig, Mickey Mantle, Yogi Berra, Whitey Ford, and, of course, Joe DiMaggio. Yankee Stadium is an American monument that has endured for eighty-five years."

– ALLAN H. "BUD" SELIG

I was born in 1941, and in that era, Italian-Americans almost always rooted for the Yankees. My dad started rooting for the Yankees because they had Tony Lazzeri, Frank Crosetti, and Joe DiMaggio. The Yankees always had a lot of Italian-Americans on their teams, so it was just handed down to me.

I remember when it all started for me. In 1949, we didn't have a TV yet. We had a radio, and my dad sat me down and said, "Listen to this game." It was the last game of the 1949 season. In that game, the Yankees had to beat the Red Sox to win the pennant. The Yankees won the game and the pennant that day. That was the first game I ever heard.

In 1951, I went to a Sunday doubleheader in Philadelphia and saw Joe DiMaggio play for the first time. My dad knew DiMaggio was about to retire, and he wanted me to see the great center fielder play in person. DiMaggio went one-for-six in the doubleheader. At that time, Mickey Mantle had been sent back to the minors, so we didn't see him.

On July 2, 1952, I saw the Yankees play again at Shibe Park in Philadelphia, and Gil McDougald and Mickey Mantle hit back-to-back home runs off Bobby Shantz in the first inning. They knocked Shantz out of the game early. I remember Casey Stengel saying that he wanted to knock Shantz out of the game early because he was the starting pitcher in the All-Star Game for the American League two days later.

The first game I saw at Yankee Stadium was on Memorial Day in 1954. It was a doubleheader, and the Yankees played the Washington Senators. Moose Skowron hit the only home run that day.

I can remember every moment of that holiday weekend. The day before we came to the game, my dad took me on a boat tour to show me the entire city. He told me that I was going to see Yankee Stadium and the Polo Grounds from the boat. When that boat headed up the Harlem River, I was shocked because I didn't know that the two ballparks were right across the river from each other. The Giants were playing the Dodgers that day. My dad asked me whether I wanted to see that game, which was a great rivalry, or the Yankees-Senators game on Monday. There was no question as to where I wanted to go. I couldn't wait to see a game at Yankee Stadium. Just seeing it from the boat took my breath away.

We were staying at the Taft Hotel, which was on Seventh Avenue. We got up on Monday morning and took the D-train to Yankee Stadium. I can still remember that the last stop on the subway before the Yankee Stadium stop said "Polo Grounds." Then we got to Yankee Stadium. It was larger than life for me. I can still see the greenish tint on the façade. Yankee Stadium seemed so much bigger than Shibe Park. I have a clear memory of Bob Sheppard's voice because it was so different from any other PA announcer's voice.

Ernie Accorsi was a longtime general manager in the National Football League, with the Baltimore Colts, Cleveland Browns, and New York Giants.

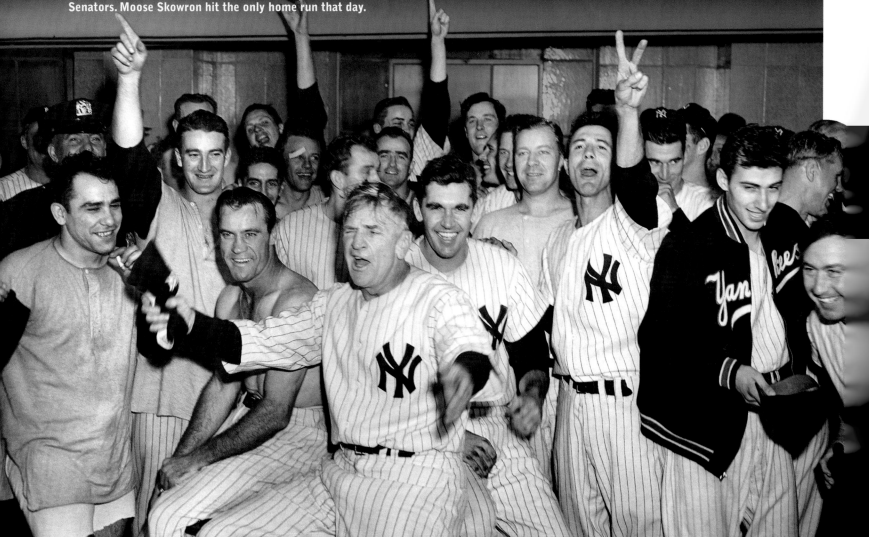

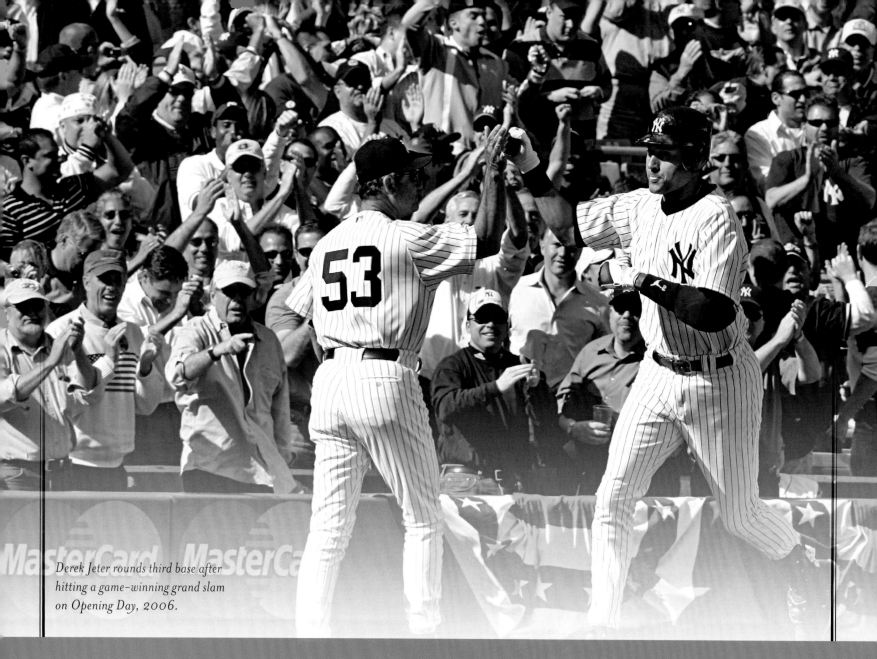

Derek Jeter rounds third base after hitting a game-winning grand slam on Opening Day, 2006.

MOST MULTI-HOME RUN GAMES AT YANKEE STADIUM

 28 — BABE RUTH

22 — LOU GEHRIG

21 — MICKEY MANTLE

 13 — YOGI BERRA

 12 — BILL DICKEY / JOE DIMAGGIO / BOBBY MURCER

In explaining the scaled-down field dimensions of the Stadium, Steinbrenner said in 1984, "It will make it a little more reasonable than it's been for home runs. People want to see home runs. It hasn't been fair to our right-handed hitters. But the main reason is to let people go out there and see the monuments."

The old-guard Yankees would have similarly appreciated the hitting background beyond the center-field wall. Ever since the 1974-75 renovation, there has been nothing but black in that area. It creates an ideal visual contrast for the batter as the ball leaves the pitcher's hand. The black area also serves as a measure for long-ball hitters, although depositing a ball over the center-field fence no longer is as rare as it was in the Stadium's early days, when it required a blast of more than 500 feet.

Reggie Jackson's third home run in Game 6 of the 1977 World Series landed in the black area, some 450 feet from home plate. That blast sealed Jackson's legacy, once and for all. That's when he became Mr. October. Such is the beauty of a Stadium that has endured for generations. From Ruth's sixtieth home run of the 1927 season, to Don Larsen's perfect game

(continued on page 74)

WILLIE RANDOLPH

THE WHOLE FEEL OF YANKEE STADIUM IS SPECIAL. TO ME, IT REPRESENTS BASEBALL. IT'S JUST A GOOD, TRADITIONAL BALLPARK WITH A GREAT HITTING BACKGROUND.

It's cozy in certain ways. It's loud. It gives you a little bit of everything, but more than anything, it gives you that old-school, old-time flavor, which I love.

It's easy to wax poetic about the Stadium, but it's real for me. I have a lot of great memories. I won my first world championship there, and I played in the All-Star Game there in 1977 in front of my family and friends.

Yankee Stadium is a special part of me. I understand that it has to go, but a big part of me feels sad about it.

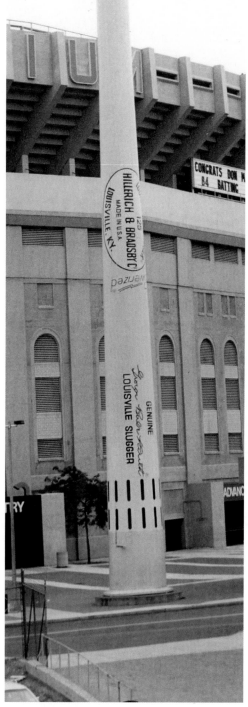

A 138-foot stainless steel and fiberglass smokestack shaped like a Louisville Slugger sits outside the Stadium by the home-plate entrance.

Willie Randolph turns a double play against the Milwaukee Brewers at Yankee Stadium in August 1977.

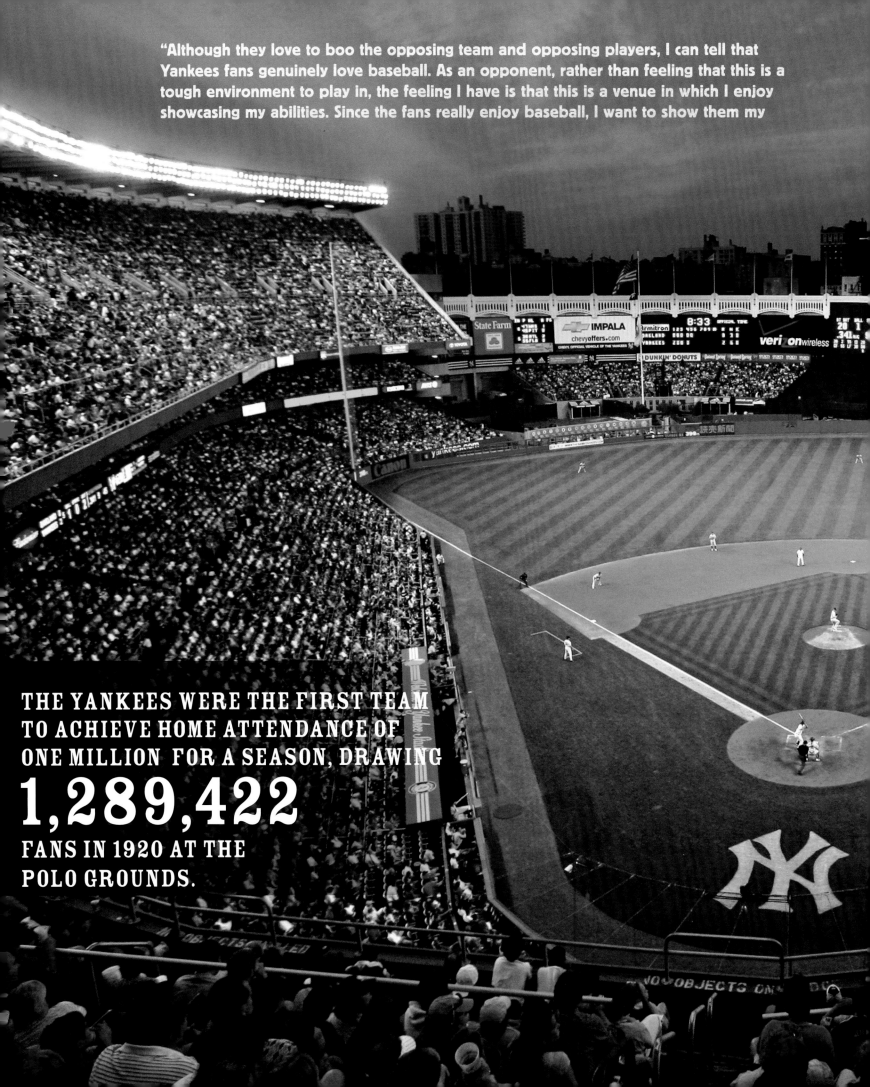

"Although they love to boo the opposing team and opposing players, I can tell that Yankees fans genuinely love baseball. As an opponent, rather than feeling that this is a tough environment to play in, the feeling I have is that this is a venue in which I enjoy showcasing my abilities. Since the fans really enjoy baseball, I want to show them my

THE YANKEES WERE THE FIRST TEAM TO ACHIEVE HOME ATTENDANCE OF ONE MILLION FOR A SEASON, DRAWING

1,289,422

FANS IN 1920 AT THE POLO GROUNDS.

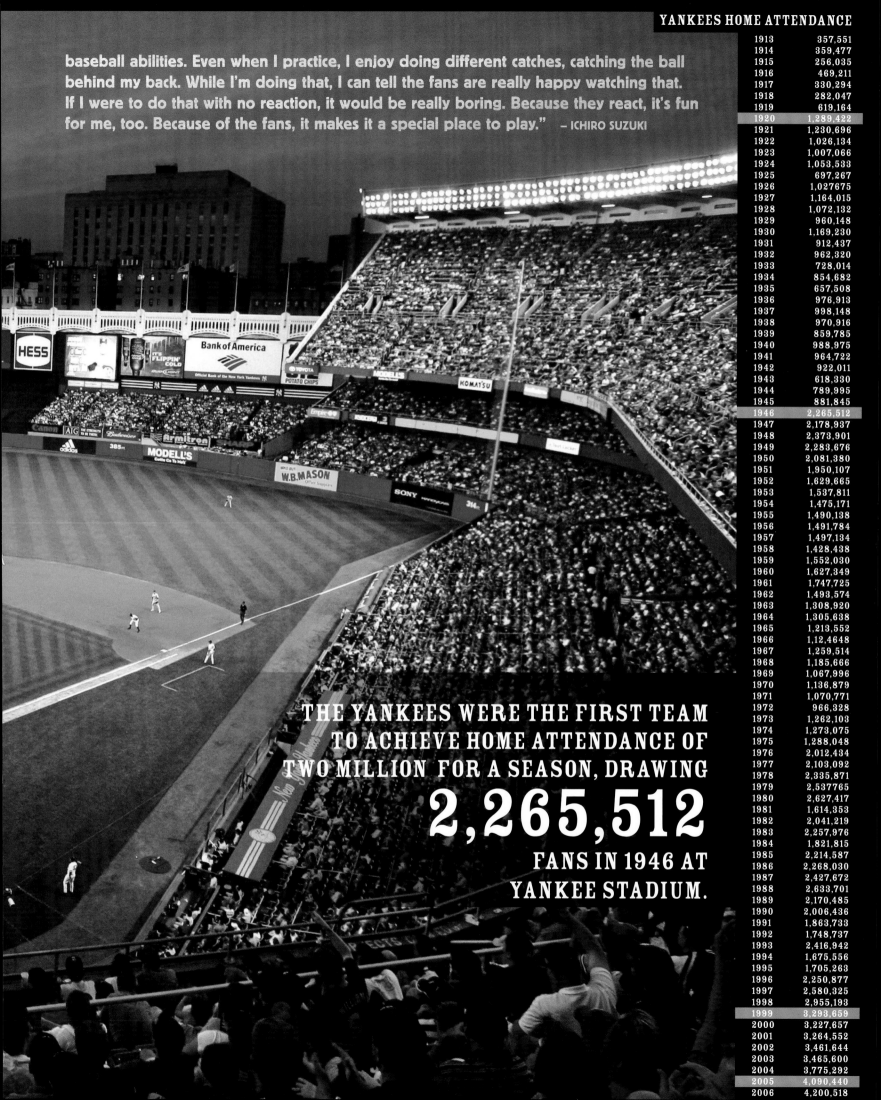

baseball abilities. Even when I practice, I enjoy doing different catches, catching the ball behind my back. While I'm doing that, I can tell the fans are really happy watching that. If I were to do that with no reaction, it would be really boring. Because they react, it's fun for me, too. Because of the fans, it makes it a special place to play." — ICHIRO SUZUKI

THE YANKEES WERE THE FIRST TEAM TO ACHIEVE HOME ATTENDANCE OF TWO MILLION FOR A SEASON, DRAWING

2,265,512

FANS IN 1946 AT YANKEE STADIUM.

YANKEES HOME ATTENDANCE

Year	Attendance
1913	357,551
1914	359,477
1915	256,035
1916	469,211
1917	330,294
1918	282,047
1919	619,164
1920	1,289,422
1921	1,230,696
1922	1,026,134
1923	1,007,066
1924	1,053,533
1925	697,267
1926	1,027675
1927	1,164,015
1928	1,072,132
1929	960,148
1930	1,169,230
1931	912,437
1932	962,320
1933	728,014
1934	854,682
1935	657,508
1936	976,913
1937	998,148
1938	970,916
1939	859,785
1940	988,975
1941	964,722
1942	922,011
1943	618,330
1944	789,995
1945	881,845
1946	2,265,512
1947	2,178,937
1948	2,373,901
1949	2,283,676
1950	2,081,380
1951	1,950,107
1952	1,629,665
1953	1,537,811
1954	1,475,171
1955	1,490,138
1956	1,491,784
1957	1,497,134
1958	1,428,438
1959	1,552,030
1960	1,627,349
1961	1,747,725
1962	1,493,574
1963	1,308,920
1964	1,305,638
1965	1,213,552
1966	1,12,4648
1967	1,259,514
1968	1,185,666
1969	1,067,996
1970	1,136,879
1971	1,070,771
1972	966,328
1973	1,262,103
1974	1,273,075
1975	1,288,048
1976	2,012,434
1977	2,103,092
1978	2,335,871
1979	2,537765
1980	2,627,417
1981	1,614,353
1982	2,041,219
1983	2,257,976
1984	1,821,815
1985	2,214,587
1986	2,268,030
1987	2,427,672
1988	2,633,701
1989	2,170,485
1990	2,006,436
1991	1,863,733
1992	1,748,737
1993	2,416,942
1994	1,675,556
1995	1,705,263
1996	2,250,877
1997	2,580,325
1998	2,955,193
1999	3,293,659
2000	3,227,657
2001	3,264,552
2002	3,461,644
2003	3,465,600
2004	3,775,600
2005	4,090,440
2006	4,200,518

GROWING UP IN WISCONSIN, I WAS A GREAT FAN OF THE NEW YORK YANKEES, AND MY FAVORITE PLAYER WAS THE YANKEE CLIPPER, JOE DIMAGGIO. IN JULY OF 1949, WHEN I WAS FOURTEEN, MY MOTHER, A TREMENDOUS BASEBALL FAN, TOOK ME THERE FOR THE FIRST TIME. I WILL NEVER FORGET THE EXCITEMENT OF WALKING INTO YANKEE STADIUM AFTER READING ABOUT IT AND LISTENING TO GAMES ON THE RADIO. IT REMAINS A POWERFUL MEMORY FOR ME.

I have always been a student of history, and there has been no finer haven for baseball history than Yankee Stadium. Years after seeing my first game there, I had the pleasure to bring the Milwaukee Brewers to New York to play in "The House That Ruth Built." The Brewers and the Yankees developed a terrific rivalry as American League counterparts in the late '70s and early '80s. I considered it a great privilege to watch the Brewers play in a place that I always revered.

The great Yankees teams of the late '90s and into the new millennium produced many magnificent moments, but what has continued to resonate with me most is the 2001 World Series.

The Yankees players and fans splendidly represented the spirit of New York City and the United States after the horrific tragedy of September 11. Those three late-inning victories were as emotional and as electric as I have ever seen. The solidarity in the crowd was truly spectacular. The 2001 World Series served as a poignant reminder of the special place that baseball holds in our great country, and Yankee Stadium was the perfect venue for those improbable comebacks.

Yankee Stadium is an important, historical treasure of Major League Baseball. Like millions of those who love our national pastime, I will always cherish my memories of Yankee Stadium, the most famous sports cathedral in the world.

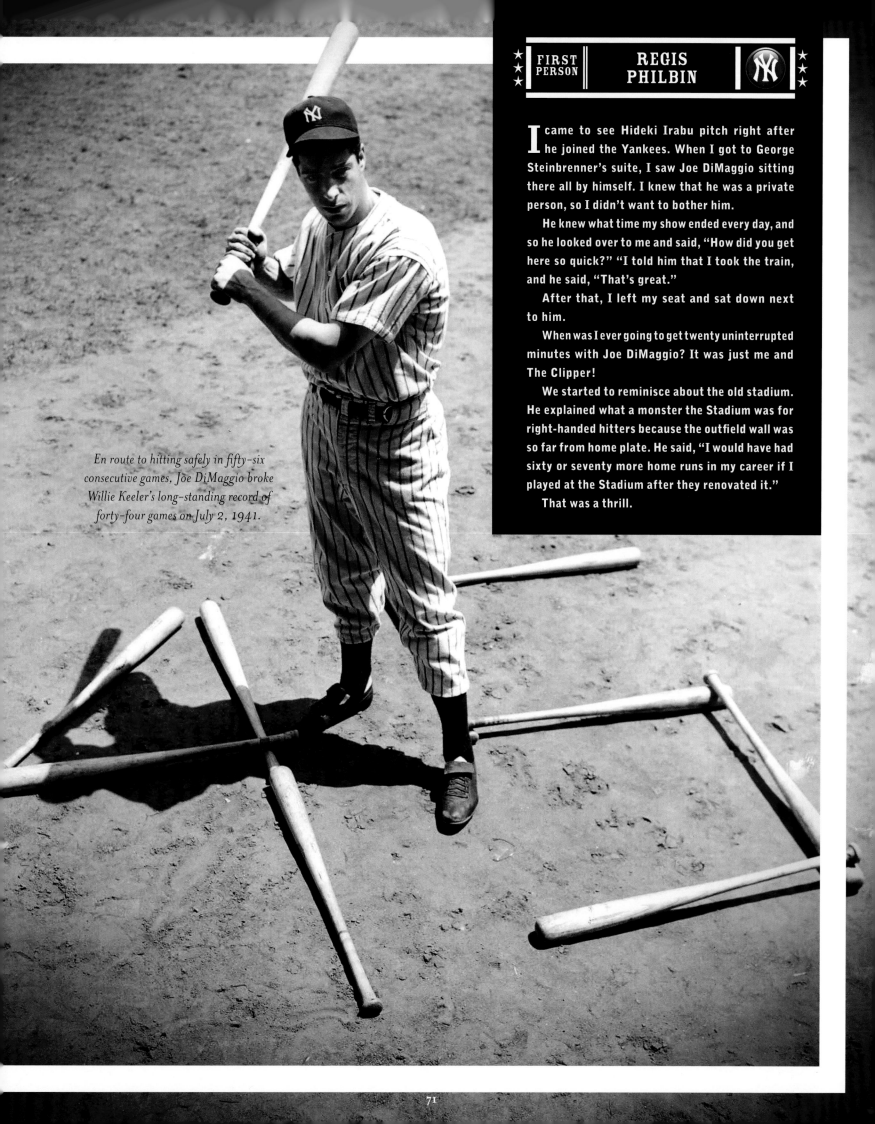

En route to hitting safely in fifty-six consecutive games, Joe DiMaggio broke Willie Keeler's long-standing record of forty-four games on July 2, 1941.

I came to see Hideki Irabu pitch right after he joined the Yankees. When I got to George Steinbrenner's suite, I saw Joe DiMaggio sitting there all by himself. I knew that he was a private person, so I didn't want to bother him.

He knew what time my show ended every day, and so he looked over to me and said, "How did you get here so quick?" "I told him that I took the train, and he said, "That's great."

After that, I left my seat and sat down next to him.

When was I ever going to get twenty uninterrupted minutes with Joe DiMaggio? It was just me and The Clipper!

We started to reminisce about the old stadium. He explained what a monster the Stadium was for right-handed hitters because the outfield wall was so far from home plate. He said, "I would have had sixty or seventy more home runs in my career if I played at the Stadium after they renovated it."

That was a thrill.

What I remember most about Yankee Stadium are the times I took my daughters there. One of the things I will never forget is when Derek Jeter came by to say hello to my daughter. She was beaming. It was almost as if that was the best thing that had ever happened in her life.

When I traveled the world and asked people what they thought of New York, they talked about the Empire State Building and the World Trade Center—before the September 11 tragedy—and Yankee Stadium.

It's not just a stadium; it's an emblem of baseball and America. It says "America" to the world, more so than New York City itself. Yankee Stadium is part of our history.

in the 1956 World Series, to Roger Maris' sixty-first home run in 1961, to Mr. October's feats, to Aaron Boone's eleventh-inning blast that ended the 2003 American League Championship Series, virtually every nook and cranny of the Stadium has created a memory for someone.

Like a grandfather sitting on the front porch recounting stories, the Stadium is full of history. All you have to do is listen to the ghosts.

★★★ FIRST PERSON ★★★ DAN QUAYLE

This is the first time [June 13, 2007] I've been to Yankee Stadium, and it is a thrill.

At first glance, the blue from the seats really sticks out—what a great color. When I was walking around the Stadium, I was really impressed with the way Yankees fans support their team. It seems like everyone is wearing a Yankees hat, and you don't see that much fanfare in other ballparks.

Yankee Stadium is a symbol of America. When I think of Yankee Stadium, I think of baseball and the fighting spirit that the people of New York have.

ICONIC MOMENTS

at the Stadium

§ BOB KLAPISCH §

It was an early afternoon in the Bronx in 1998. The sky was limitless—no clouds, no aircraft, no sound, just a hazy sun, and a perfect silence that descended upon Yankee Stadium like a second skin. Yankees pitcher David Cone was sitting in the dugout, absorbing the ballpark's aura, sensing the ghosts that floated around him.

"There's something different about playing here. It's kind of hard to describe, but it just is," Cone said to a friend. He started to explain, but didn't get very far. He knew it would be impossible to put it into words, yet players say the verdict is practically universal: It's like everyone who's ever knocked the dirt off his cleats in the batter's box, stood on the mound, or patrolled the outfield is still out there, somewhere.

Crazy, but true. Major-leaguers talk about the eerie rush of history that accompanies a trip to Yankee Stadium. Ruth was here, you tell yourself; Gehrig slammed line drives into the power alleys; Don Larsen was right there, sixty feet, six inches away when he created magic in Game 5 of the 1956 World Series. Close your eyes, and you can see Yogi Berra leaping into Larsen's chest as the Yankees broke the Dodgers' hearts one last time before baseball at Ebbets Field and the Polo Grounds packed up and moved out West.

That's what Cone was talking about, how a ballplayer is never really alone in the big ballpark. It wasn't yet four o'clock, more than three hours before that night's first pitch, and all you could see was a sea of blue seats in the upper deck. A few maintenance men were sweeping the stands, and the grounds crew was watering the grass, but otherwise Cone was

left to his imagination. There, he could link up with the Babe and the Iron Horse, Yogi, Reggie, and the rest of the ghosts and memories. The list goes on and on, from Joe DiMaggio's historic hitting streak, to the farewell speeches of both Ruth and Gehrig, and even the events that extended beyond the Yankees' domain.

The plot on East 161st Street and River Avenue has always been America's most important sports stage. A few years after its inception, the place didn't even need its full name anymore. Like all superstars, from Liberace to Sinatra, Pelé to Madonna, it was enough to use a single moniker. Yankee Stadium was cool enough to be called, simply, "The Stadium." That's all you had to say. That's the only introduction it needed.

The Stadium was the site of what is considered the greatest

game in NFL history: the 1958 championship game between the New York Giants and Baltimore Colts. Knute Rockne gave his famous, "Win one for the Gipper" speech there in 1928. Two popes said Mass there. Muhammad Ali fought Ken Norton in 1976. When the country was reeling from the terrorist attacks of September 11, 2001, Americans found comfort in a non-denominational memorial service that filled the ballpark with hope.

For better or worse, in good times and those that are remembered with grief, Yankee Stadium has created memories slightly larger than life. Ghosts work that way in the Bronx. Listen hard enough, and you realize Cone was right: Everyone's still hanging around.

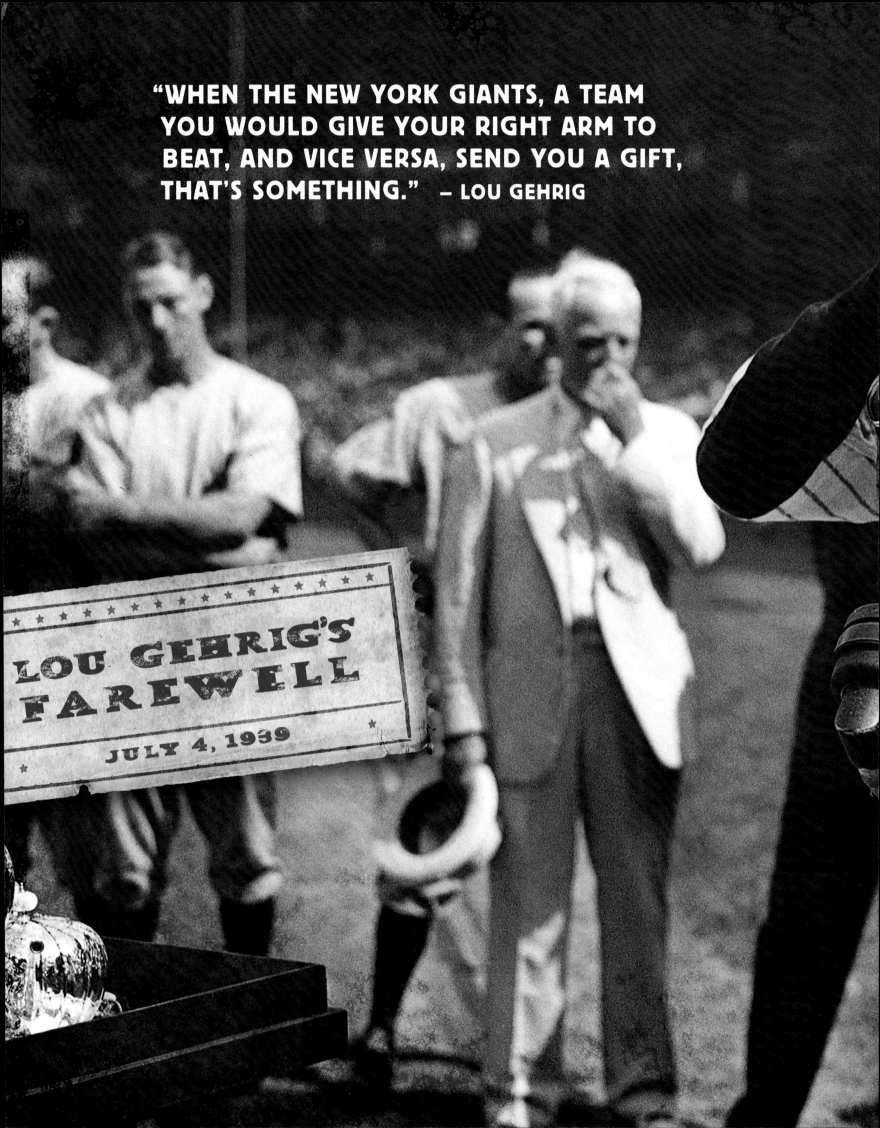

"WHEN THE NEW YORK GIANTS, A TEAM YOU WOULD GIVE YOUR RIGHT ARM TO BEAT, AND VICE VERSA, SEND YOU A GIFT, THAT'S SOMETHING." – LOU GEHRIG

LOU GEHRIG'S FAREWELL
JULY 4, 1939

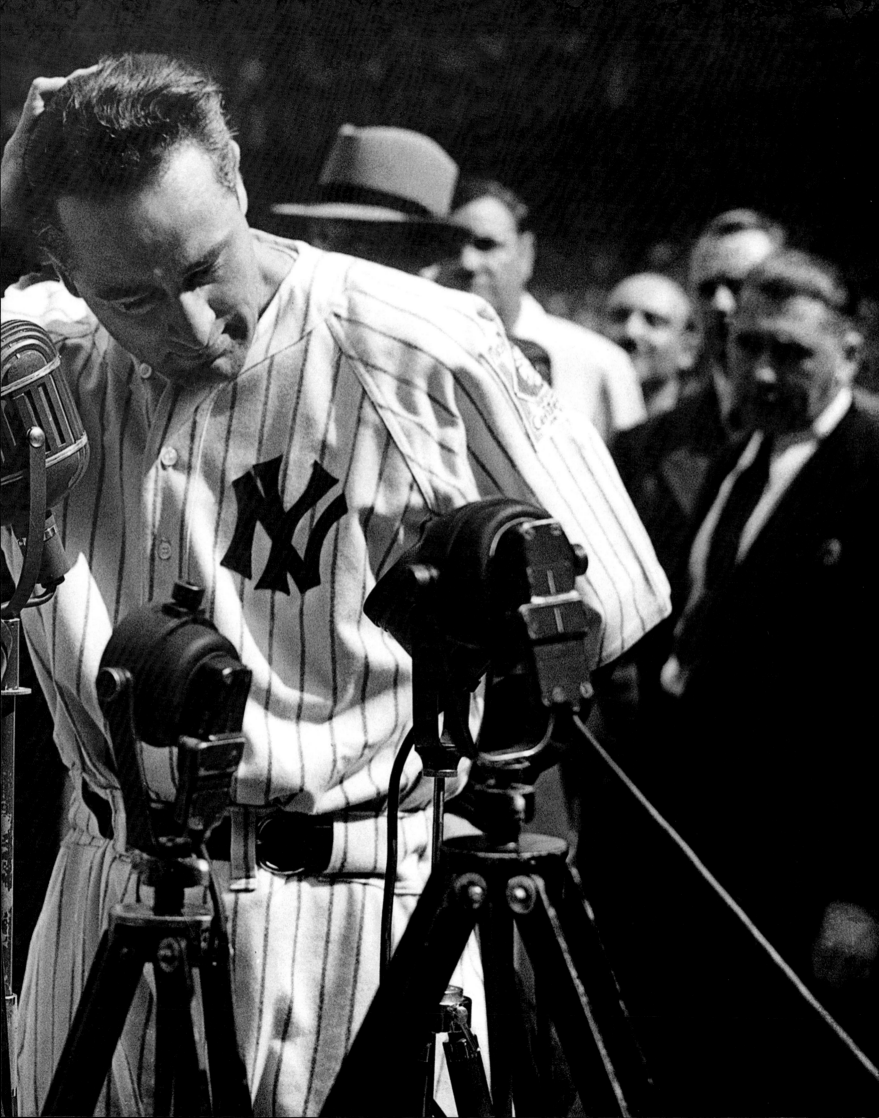

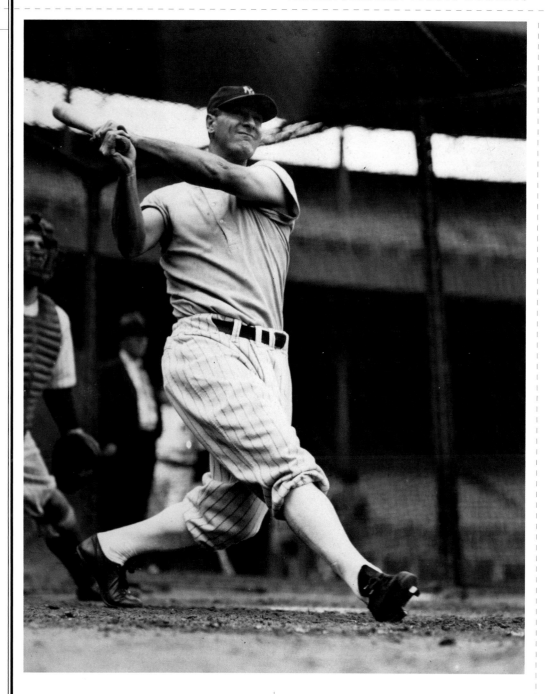

to bear. Some of his teammates from the 1920s arrived at the ballpark on the morning of the scheduled doubleheader against the Washington Senators. Bob Meusel, Tony Lazzeri, Waite Hoyt, Mark Koenig, Herb Pennock, and Joe Dugan—they were all there.

Everyone watched the Yankees lose the first game of the doubleheader, after which it would be time to honor Gehrig.

Dignitaries showed up, including New York City Mayor Fiorello La Guardia, Postmaster General James A. Farley, and Babe Ruth. The Yankees lined up to the left side of the dirt path between home plate and the pitcher's mound. The Senators stood across from them. Everyone else gathered near home plate.

A band marched in from center field, as Gehrig emerged from the dugout. La Guardia, Farley, and Ruth all gave brief speeches, and then gifts were presented to Gehrig. Yankees teammates gave him a fishing rod and tackle. A parchment with the words, "Don't Quit" came from the Senators. There was also a parchment from the Old Timers Association of Denver, a ring from the jewelers Dieges and Clust, a fruit bowl and two silver candlesticks from the New York Giants, a silver pitcher from the Harry M. Stevens firm, a smoking stand from reporters who covered the Yankees, a silver cup from the Yankees front office, and a silver serving set from Yankees management.

Yankees manager Joe McCarthy presented Gehrig with a trophy of an eagle perched atop a baseball. The ailing slugger sheepishly accepted the gifts, all the while looking at the ground. There was no joy in this ceremony. In fact, Gehrig seemed to dread it. A numbing silence came over the ballpark as Gehrig prepared to speak. For several long seconds, he said nothing.

The huge crowd started chanting, "We Want Lou," and McCarthy whispered into Gehrig's ear that everyone was waiting for him to say something. One more time, Gehrig lowered his head, wearily running a hand through his hair. His voice cracking, he finally began to speak.

"Fans, for the past two weeks you have been reading about the bad break I got. Yet today I consider myself the luckiest man on the face of this earth. I have been in ballparks for seventeen years, and have never received anything but kindness and encouragement from you fans.

"Look at these grand men. Which of you

B y the time Lou Gehrig walked to home plate to give his farewell speech, some in the Stadium suspected something was terribly wrong. For the previous year and a half, a mysterious disease had slowed Gehrig, the Yankees' Iron Horse and a living advertisement of the franchise's dominance in the late 1920s and 1930s. It wouldn't be until after Gehrig's death in 1941 that the public knew how devastating amyotrophic lateral sclerosis could be. Fans had been led to believe Gehrig was suffering from a neurological disorder that, although rare and debilitating, was not life-threatening.

Those near Gehrig as he began speaking on Lou Gehrig Appreciation Day could see the difference in his physique. He was no longer the strapping, muscled specimen that had been feared by American League pitchers. Gehrig's chest looked sunken. The uniform he wore that day seemed much too big. Gehrig was still an active Yankee, but he was nothing more than an honorary player. The farewell address was just that—a departure from the life Gehrig knew in baseball, and, ultimately, from life itself.

As Jonathan Eig described in his book, *Luckiest Man*, Gehrig was much too modest to maximize the moment. Even though loving family and friends—not to mention sixty-two thousand fans that idolized him—surrounded him, Gehrig nearly begged off the speech that has become synonymous with heartbreak. Maybe it was a sense of nostalgia that was too much for Gehrig

wouldn't consider it the highlight of his career just to associate with them for even one day? Sure, I'm lucky. Who wouldn't consider it an honor to have known Jacob Ruppert. Also, the builder of baseball's greatest empire, Ed Barrow. To have spent six years with that wonderful little fellow, Miller Huggins. Then to have spent the next nine years with that outstanding leader, that smart student of psychology, the best manager in baseball today, Joe McCarthy. Sure, I'm lucky.

"When the New York Giants, a team you would give your right arm to beat, and vice versa,

send you a gift, that's something. When everybody down to the groundskeepers and those boys in white coats remember you with trophies, that's something. When you have a wonderful mother-in-law who takes sides with you in squabbles with her own daughter, that's something. When you have a father and a mother who work all their lives so you can have an education and build your body, it's a blessing. When you have a wife who has been a tower of strength and shown more courage than you dreamed existed, that's the finest I know.

"So I close in saying that I may have had a tough break, but I have an awful lot to live for."

Cheers filled the Stadium as Gehrig backed away from the microphone. Ruth ended years of antagonism between the two by hugging Gehrig, hamming it up for the photographers. Here was one Yankees icon saying goodbye to another. Gehrig retreated to the dugout, then into the clubhouse, and before long headed for home.

Gehrig would never again set foot in the big ballpark.

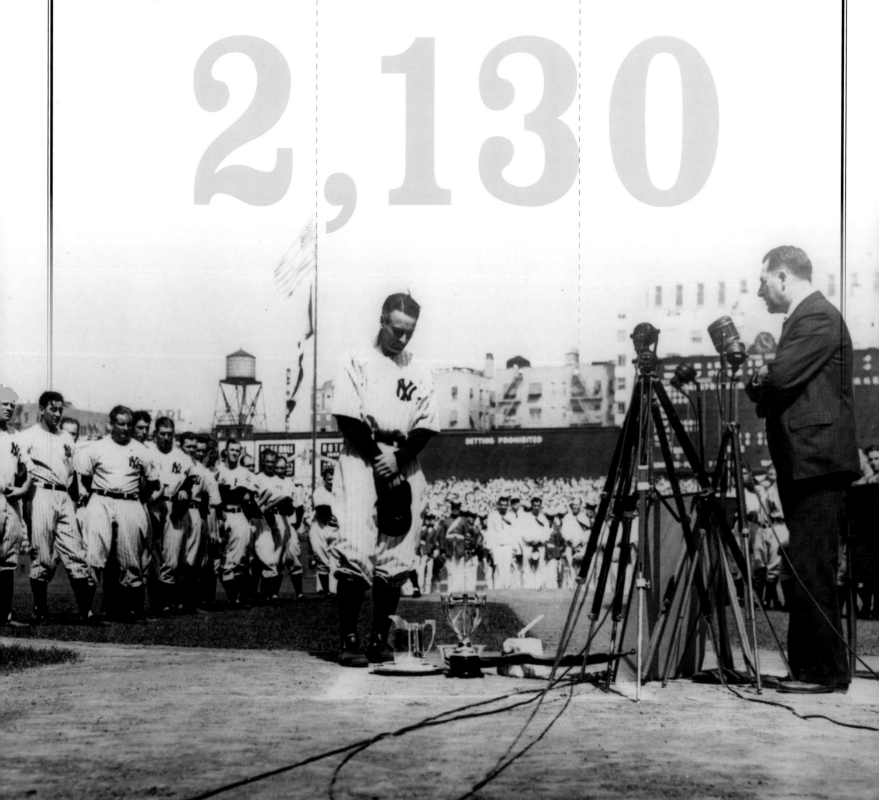

BABE RUTH'S
FAREWELL

APRIL 27, 1947

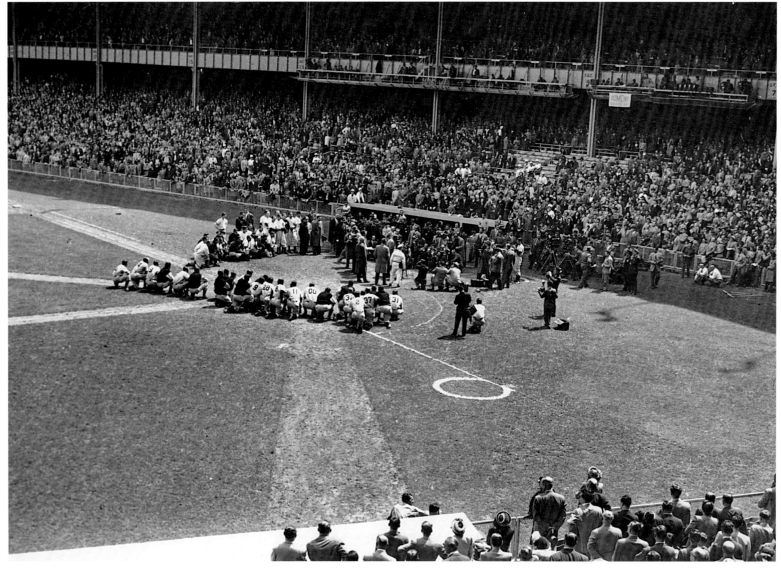

An ailing Babe Ruth thanks fans, who give him a standing ovation at the Stadium.

On some level, Babe Ruth must have known there would be a price to pay for his years of hard living. As immortal as he must have felt in the 1920s, when he ruled the baseball universe, the Bambino was showing signs of decay by 1932, the final championship season of his career. Ruth ballooned to 270 pounds after his retirement in 1935, drinking, eating heartily, playing golf, and otherwise distancing himself from the grace and athleticism that had made him America's most charismatic sports figure. Still beloved and enormously popular into his forties, Ruth nevertheless was a rotund guy looking for a good time.

One day in 1946, Ruth started complaining of an intense pain over his left eye, which doctors attributed to a malignant tumor on the side of his neck that nearly engulfed Ruth's carotid artery. He spent three months in a hospital, and although he would live for two more years, this was the beginning of the end for the great slugger. The robust life that Ruth once knew would never be the same.

There was no mistaking Ruth's decline. By February 1947, he had lost nearly eighty pounds, and the baseball community was preparing for the worst. Commissioner Happy Chandler declared April 27 would be Babe Ruth Day throughout the major leagues, as well as in every organized league in the United States. Naturally, the event would be celebrated in the place the Bambino built, Yankee Stadium.

The public was aware of Ruth's illness, but the sixty thousand fans in attendance were nevertheless shocked at how old and frail he looked that day. In his familiar camel hair topcoat, the Babe looked dishearteningly pale and thin. He had the hue of a man near death. Ruth's voice was little more than a croak. He could have minimized the impact on his followers by keeping his comments to a mere, "Thank you." Ruth could have declined to speak. Certainly no one would have complained. But, as always, the great showman rose to the occasion, opting for the spotlight one more time, even if his tone and message were somber.

Standing in front of a microphone, struggling to make his words clear—his larynx had been surgically removed— Ruth found himself in the same predicament that the dying Lou Gehrig had encountered some eight years earlier. The Babe wanted to thank his family, friends, and fans without sounding maudlin.

"Thank you very much, ladies and gentlemen," he said. "You know how bad my voice sounds—well, it feels just as bad. You know this baseball game of ours comes up from the youth. That means the boys. And if you're a boy and grow up and know how to play ball, then you come to the boys you see representing themselves

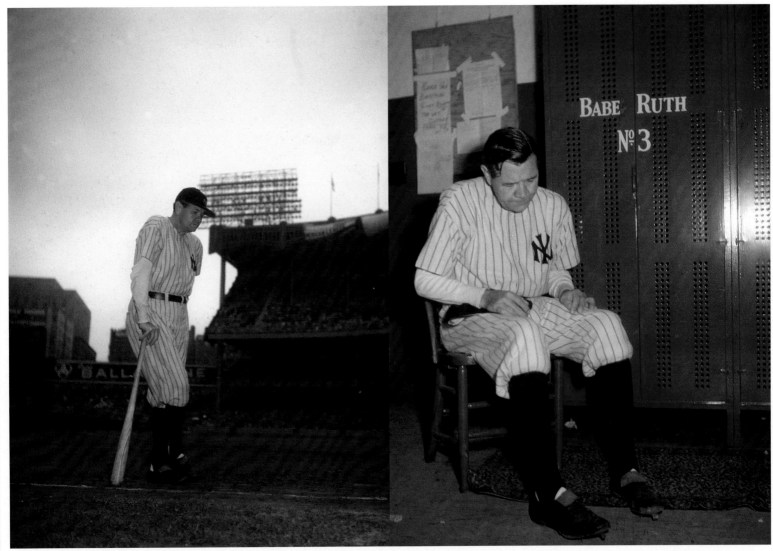

Babe Ruth, ravaged by cancer, braces himself on a bat in a 1948 appearance at the Stadium, and lingers at his locker in the clubhouse.

"JOE, I'M GONE. I'M DONE, JOE." — BABE RUTH

today in your national pastime. The only real game, I think, in the world is baseball. As a rule, some people think that if you give them a football, or a baseball, or something like that, naturally they're athletes right away. But you can't do that in baseball.

"You've gotta start from way down [at] the bottom, when you're six or seven years of age. You can't wait until you're fifteen or sixteen. You gotta let it grow up with you. And if you're successful, and you try hard enough, you're bound to come out on top, just like these boys have come to the top now. There's been so many lovely things said about me, and I'm glad that I've had the

opportunity to thank everybody. Thank you."

Unlike Gehrig, who never returned to the Stadium after his final speech, Ruth was back in June 1948 when the Yankees celebrated the twenty-fifth anniversary of the opening of the ballpark. Members of the inaugural 1923 team gathered at Jacob Ruppert's brewery the night before to reminisce, although Ruth was too sick to attend. He saved his strength for the following afternoon, when many gathered in the clubhouse for handshakes and a team photo. Former teammates Joe Dugan and Wally Pipp had to help Ruth stand upright while photographers snapped away. When it was time for Ruth to head

out to the field, he kept his overcoat on until the last moment.

There was no long speech this time, since it wasn't only Ruth who was being honored. But everyone knew this was it. The slugger said a few hoarse words into the microphone before returning to the dugout. Cancer had gravely robbed the Babe. After the ceremony, Ruth and Dugan sipped on beer in the clubhouse, and Dugan asked his friend how he was holding up.

"Joe, I'm gone," Ruth said. "I'm done, Joe."

Both men started to cry. Two months later, Ruth was dead.

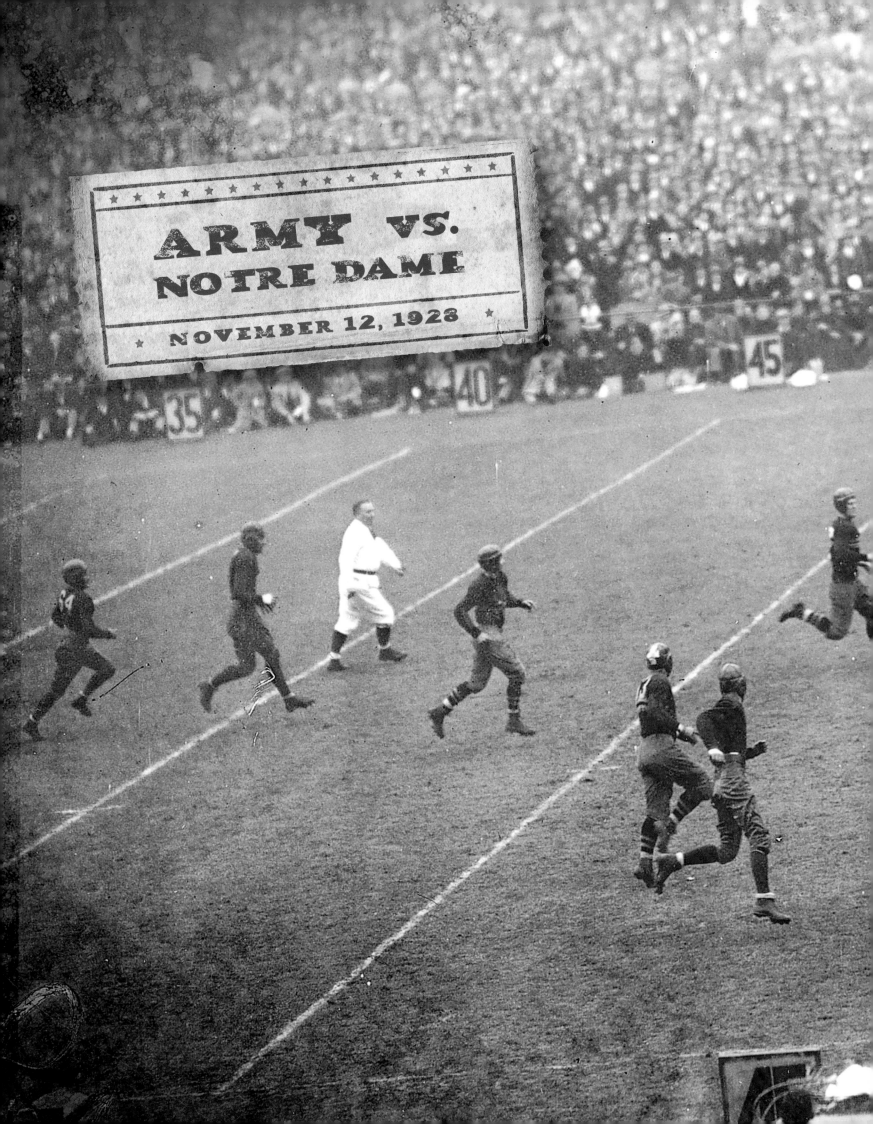

ARMY VS. NOTRE DAME

NOVEMBER 12, 1928

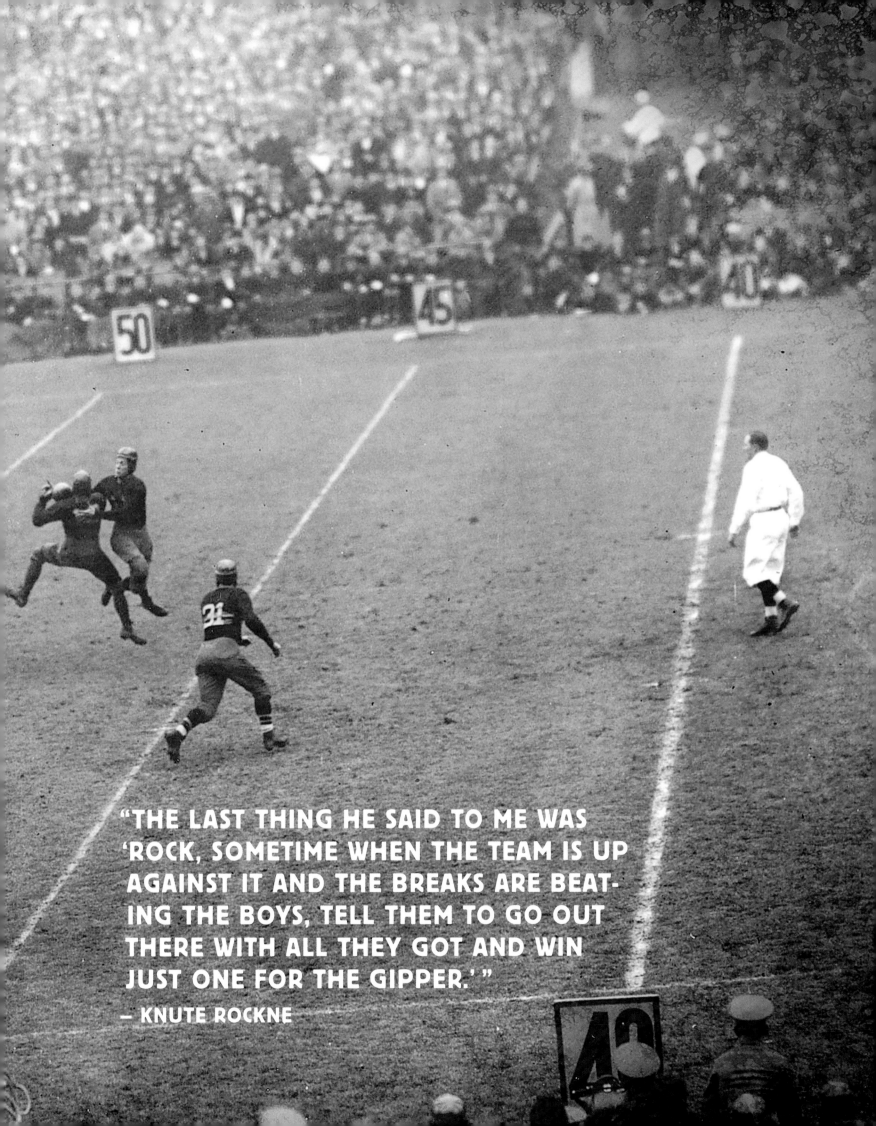

"THE LAST THING HE SAID TO ME WAS 'ROCK, SOMETIME WHEN THE TEAM IS UP AGAINST IT AND THE BREAKS ARE BEATING THE BOYS, TELL THEM TO GO OUT THERE WITH ALL THEY GOT AND WIN JUST ONE FOR THE GIPPER.'"

– KNUTE ROCKNE

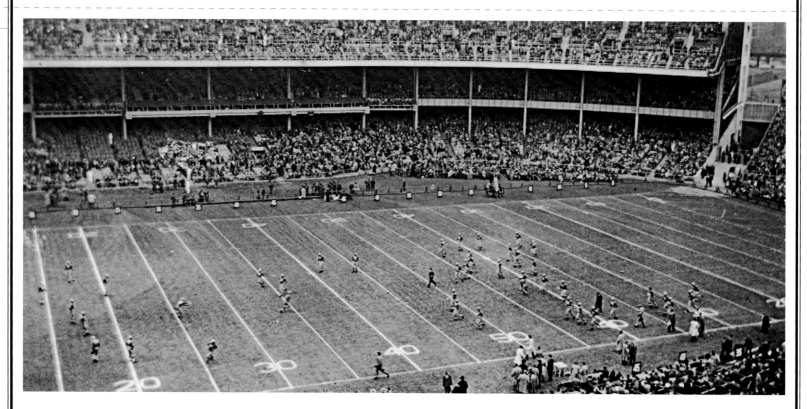

NOTRE DAME HAD A
15-6-3
RECORD AT YANKEE STADIUM.

It didn't take the Yankees long to realize that a new ballpark would be the object of desire of other teams, other sports, and other events. In its first season, barely a month after the Yankees had christened their home with a World Series championship, the Stadium opened its doors to college football, playing host to the 1923 Army-Navy game. That inaugurated a long and storied history of collegiate and professional football in the Bronx. It was within the Stadium's confines that one of the most famous motivational speeches in sports history was delivered: Knute Rockne's "Win One for the Gipper" oration that inspired Notre Dame's underdog squad to rise up against powerful Army.

The date was November 12, 1928, and Notre Dame and Army were locked in a scoreless tie after a half. Rockne's Fighting Irish had roared through the 1920s, but Army was considered to be the superior team in 1928.

Under Rockne, who had a 105-12-5 record in his thirteen seasons as the Irish's coach, Notre Dame was able to draw impressive crowds. When the Irish played at Army in 1921, attendance was twenty thousand, a West Point record. With Notre Dame's Cartier Field able to hold only three thousand, Rockne hunted for bigger stages such as Ebbets Field, the Polo Grounds, and Yankee Stadium.

Everyone had heard of George Gipp. In four seasons at Notre Dame, he rushed for 2,341 yards and passed for 1,769. But he was a tragic figure, dying of pneumonia in 1920 at age twenty-five.

Rockne borrowed on Gipp's legacy in that 1928 game against Army. There were nearly eighty-five thousand people at the Stadium, gripped by the thriving rivalry between the two squads and by Rockne himself. In perfect sync with the drama of the day, Rockne told his players at halftime of Gipp, on his deathbed, requesting that Notre Dame rally for a big win in his memory.

Historians say it's unlikely that Gipp uttered such a request—some say Rockne wasn't at the hospital when Gipp died—but the coach nevertheless told his players a heart-tugging story that late afternoon in a Yankee Stadium locker room. As he held his players spellbound, Rockne finished with a flourish. "The last thing he said to me was 'Rock, sometime when the team is up against it and the breaks are beating the boys, tell them to go out there with all they got and win just one for the Gipper.'"

Properly motivated, Notre Dame beat Army, 12-8, adding to Rockne's legacy as one of football's greatest coaches and motivators.

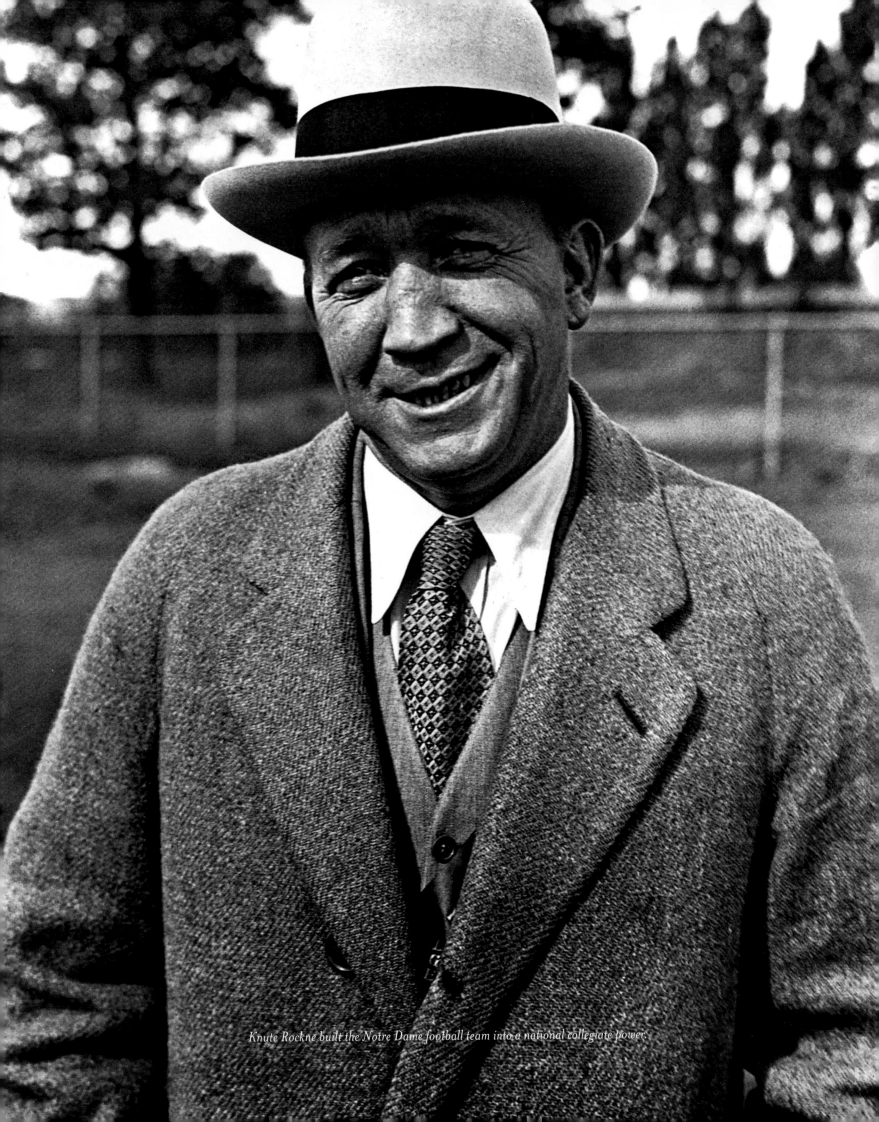

Knute Rockne built the Notre Dame football team into a national collegiate power.

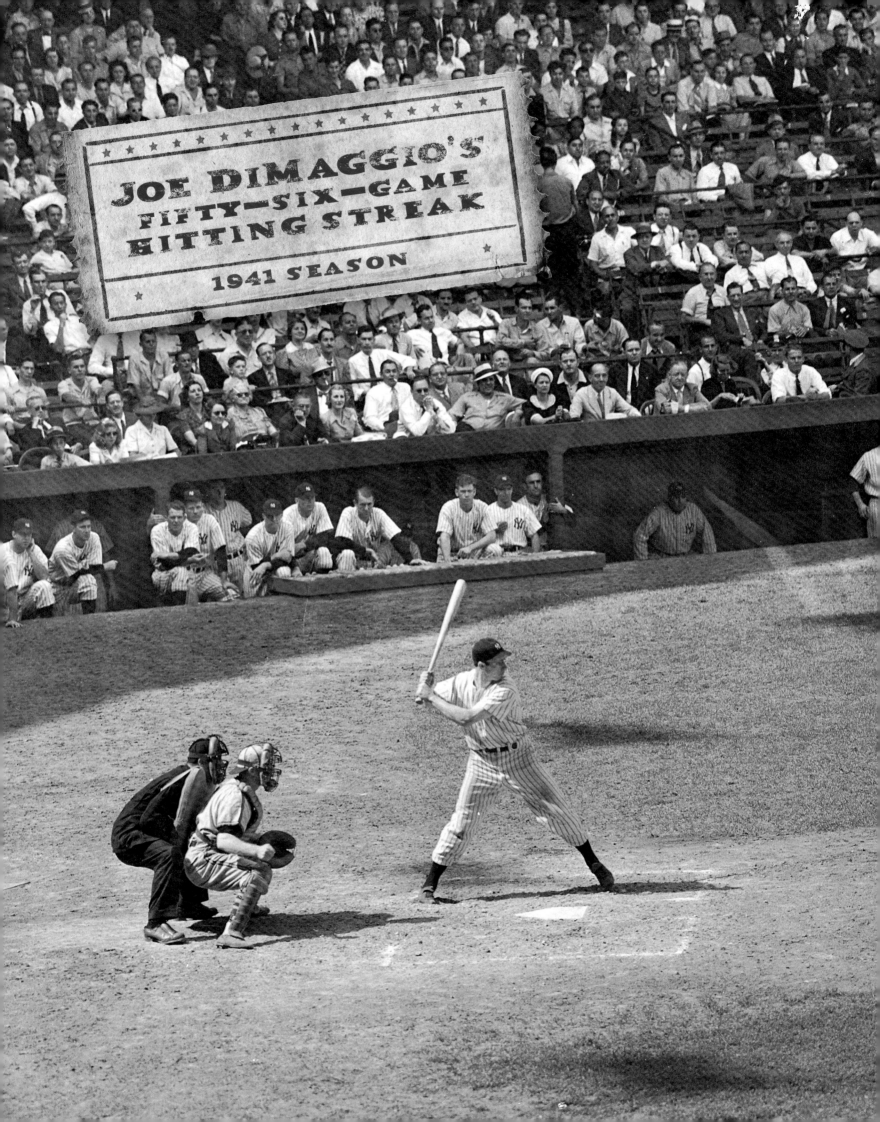

JOE DIMAGGIO'S
FIFTY-SIX-GAME
HITTING STREAK

1941 SEASON

45
CRACKS
RECORD

DIMAGGIO'S NUMBERS DURING HIS FIFTY-SIX-GAME HITTING STREAK

223
AT-BATS

91
TOTAL HITS

.408
BATTING AVERAGE

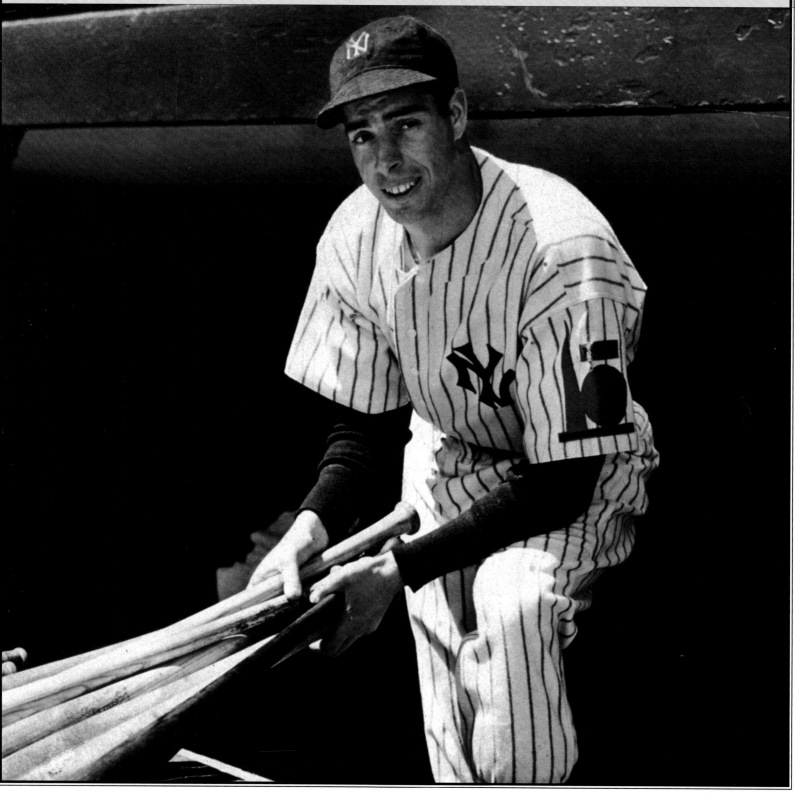

35
EXTRA-BASE HITS

15
HOME RUNS

55
RUNS BATTED IN

Any sports historian can recount the power and the glory of one of the greatest sports records of all time. We know that Joe DiMaggio's record hitting streak lasted fifty-six games, that it began on May 15, 1941, when he went one-for-four against the Chicago White Sox, and that it was completed on July 16, when he went three-for-four against the Cleveland Indians. But woven into the tapestry are a million individual fibers that captured DiMaggio's enormous will. Those at-bats boiled down to single pitches that breathed life into the streak.

It took a while for Yankees fans to awaken to DiMaggio's greatness that summer. As author Richard Ben Cramer documented in *Joe DiMaggio: The Hero's Life*, Americans were too worried about the worsening state of affairs in Europe to focus on the Bronx. As DiMaggio's streak neared twenty, Nazi leader Rudolf Hess made a mysterious flight to Scotland, and Italy's Africa corps of thirty-eight thousand surrendered to the British. The Germans conquered Crete, and the British Navy sunk the German battleship Bismarck.

DiMaggio's streak eventually became America's distraction from the impending march to war. As quietly as the streak began, it became impossible to ignore as DiMaggio's hits started piling up daily. Although there was no precise line of demarcation where DiMaggio became everyone's obsession, there was a moment when the streak became official Yankees' business, stitched into their in-game strategy.

It came during a weekend series in early June against the first-place Indians, with Bob Feller, who had an eight-game winning streak, on the mound for the visitors. The crowd at the Stadium was robust and numbered more than forty-four thousand, including Babe Ruth. Everyone wanted to see what DiMaggio could do against the American League's hardest thrower. They got their answer in the third inning, when Feller ran the count to three-and-0, and everyone in the ballpark knew he'd have to throw his fastball over the middle.

The question was, would manager Joe McCarthy let DiMaggio swing away? Under any other circumstance, the answer would be a resounding no, as the Yankees needed base runners. But McCarthy knew he was choreographing something special. The streak was now more important than the textbook, so McCarthy gave DiMaggio the green light. Sure enough, Feller challenged the great center fielder with a fastball that cut the plate in half. DiMaggio was ready, lashing a double to right-center field that turned the Stadium into an open-air asylum. Not only did the Yankees beat Feller and the Indians, but DiMaggio's streak was intact.

Of course, not every stop along the way was that perfectly scripted. DiMaggio had his precarious moments when it appeared the streak would die an inglorious death. There was some luck involved, generosity from the fates, and selflessness from his teammates. On June 26, DiMaggio's run was all but halted at thirty-seven games. Yankees pitcher Marius Russo had a no-hitter through six innings and was leading, 3-1, in the eighth. DiMaggio had flied out in the second inning, was safe on an error in the fourth, and grounded out in the sixth.

Russo was in complete control, making it unlikely that DiMaggio would get another at-bat. He was due to hit fourth in the bottom of the eighth, but with one out, Red Rolfe walked, bringing Tommy Henrich to the plate. That seemingly assured DiMaggio of another chance, but Henrich still feared the worst. Knowing that a sharply hit grounder would easily be turned into a double play, Henrich asked permission from McCarthy to lay down a sacrifice bunt.

Such a move defied conventional wisdom—Henrich was too good a hitter to give up an at-bat. But these were special times for DiMaggio, and the Yankees were ready to help in his pursuit of history. McCarthy told Henrich to bunt, which he did, bringing DiMaggio to the plate. The Stadium crowd, less than nine thousand, was keenly aware the Bombers had moved their chess pieces on DiMaggio's behalf. Everyone inched toward the edge of their seat as the slugger rose to the occasion. DiMaggio didn't work the count and didn't need time to measure his swing. Instead, he ambushed the very first pitch, sending a double into the left-field corner. The streak was alive and well.

DiMaggio broke Willie Keeler's old record of forty-four games on July 2 at Yankee Stadium. Joe's streak ended in Cleveland's Municipal Stadium on July 17, thanks to the acrobatic fielding of third baseman Ken Keltner. There was little joy in the ballpark that day, even though DiMaggio was an opposing player. Indians fans booed left-hander Al Smith when he walked DiMaggio in the third inning, and after Joe bounced into a double play in the eighth inning, his third at-bat, the crowd all but begged the Indians to tie the score and send the game into extra innings.

It didn't happen, but DiMaggio had achieved a feat that many believe will never be equaled.

DON LARSEN'S
PERFECT GAME

OCTOBER 8, 1956

NO
BETTING

ANYONE INTERFERING
WITH PLAY
SUBJECT TO ARREST

BROOKLYN
YANKEES

AMERICAN

UMPIRES — PLATE 4
BASES 1-5-236

STADIUM
FAVORITE BAL

EXIT EXIT EXIT

"I HAD NO TENSION ON THE MOUND, BUT THE DUGOUT
WAS A MORGUE. NO ONE WOULD TALK TO ME. I WAS
MORE COMFORTABLE ON THE MOUND." — DON LARSEN

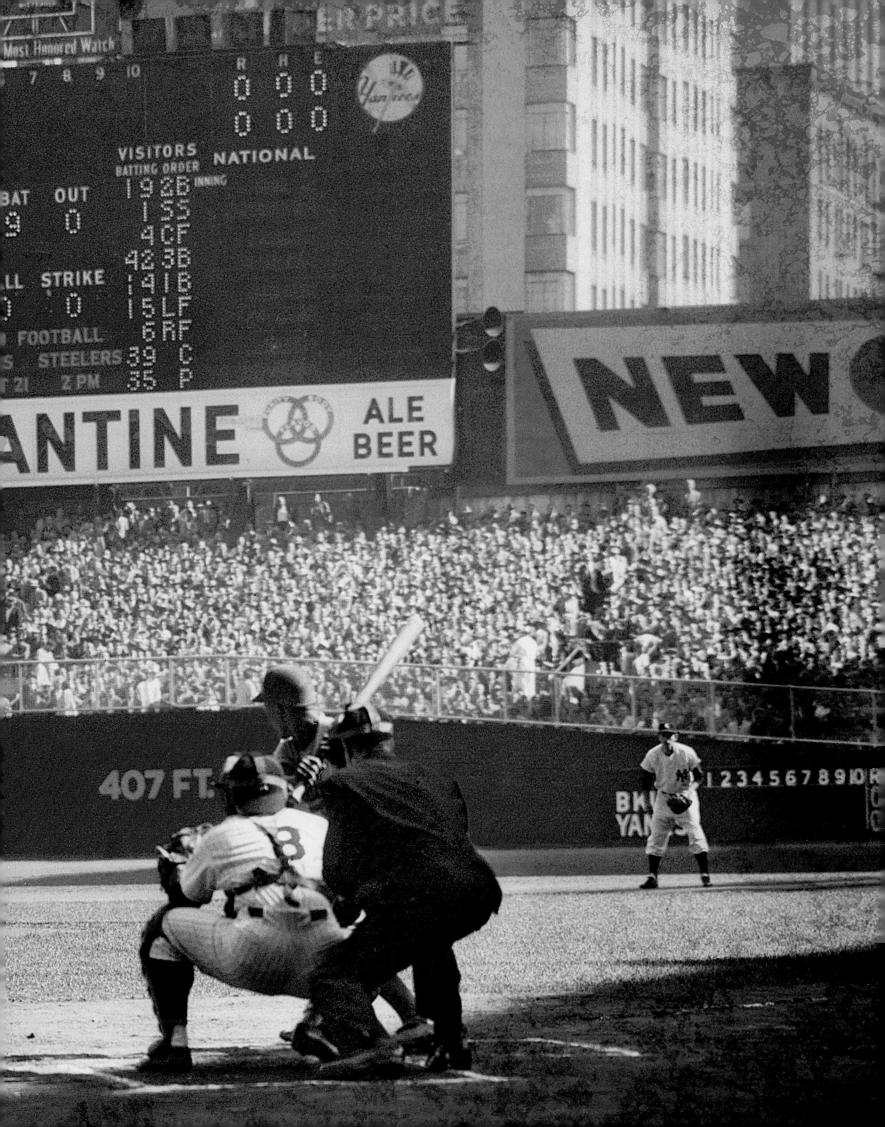

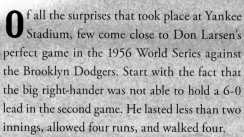

"THE IMPERFECT MAN PITCHED THE PERFECT GAME."

– DICK YOUNG, SPORTSWRITER

Of all the surprises that took place at Yankee Stadium, few come close to Don Larsen's perfect game in the 1956 World Series against the Brooklyn Dodgers. Start with the fact that the big right-hander was not able to hold a 6-0 lead in the second game. He lasted less than two innings, allowed four runs, and walked four.

The Yankees' uncertainty with Larsen ran deep. His reputation for enjoying the nightlife was solidified when he crashed his car into a light pole in spring training one year, long after the curfew set by manager Casey Stengel. "He must have went out to mail a letter," Stengel said.

The Yankees had lost the first two games of the 1956 World Series, and were in danger of losing the Series to the Dodgers for the second straight year. But when the Series shifted from Ebbets Field to Yankee Stadium, the Yankees steadied their course, winning the third and fourth games behind the steady pitching of

Whitey Ford and Tom Sturdivant. Question was, who would Stengel trust on the mound in Game 5 to oppose the formidable Sal Maglie?

Stengel put his faith in Larsen. It wasn't a crazy, random choice. Of all the Yankees pitchers that year, only Ford had a better earned-run average than Larsen. And unlike for Game 2, when Larsen claimed he had no idea he would be the starting pitcher until he arrived at the Stadium that morning, Larsen would be rested and prepared for Game 5.

It turned out that Larsen was more than ready. His control was impeccable, and being locked in a low-scoring game with Maglie was no distraction. The Yankees scored their first run on Mickey Mantle's home run in the fourth inning and added another run in the sixth. Larsen kept plowing through the Dodgers lineup as the tension grew in the Yankees dugout. The irreverent Larsen joked about his no-hitter with

Three days after his perfect game, Don Larsen poses with a football on the remnants of the pitching mound as members of the New York Giants football team crowd around him during a break in their practice session at Yankee Stadium.

teammates, who were afraid of jinxing their pitcher by acknowledging him. When Larsen asked Mantle if he thought a no-hitter was possible, the center fielder walked away, cursing under his breath.

Larsen would later say, "I had no tension on the mound, but the dugout was a morgue. No one would talk to me. I was more comfortable on the mound."

If Larsen wasn't sweating, everyone else was, including Stengel, who had Ford warming up in the eighth and ninth innings. But the bullpen went quiet after Larsen got Carl Furillo for the first out in the ninth. He had come this far,

dodging two bullets along the way. In the second inning, Jackie Robinson had hit a line drive off third baseman Andy Carey's glove, but the ball had caromed to shortstop Gil McDougald, who threw out Robinson by a step. Talk about timing and luck—that was Robinson's final season; who knows if he would have beaten out an infield hit had he been younger.

Larsen had gotten lucky in the fifth inning, too. Sandy Amoros had hit a line drive near the right-field foul pole that just missed being a home run.

With two outs in the ninth inning, Larsen prepared to throw his ninety-seventh pitch of the

game. Dale Mitchell was the batter and had two strikes against him. Catcher Yogi Berra signaled for a fastball and positioned his mitt on the outside corner of the plate as a target. The fastball tailed away from the left-handed-hitting Mitchell, who tried to check his swing but couldn't. That was the Dodgers' last breath. Berra sprinted toward the mound and leaped into Larsen's arms.

To this day, no one else has pitched a no-hitter in the World Series, much less a perfect game. Larsen's feat was aptly noted by the famous New York sportswriter Dick Young, who wrote, "The imperfect man pitched the perfect game."

PEOPLE ALWAYS ASK ME WHAT MY GREATEST THRILL WAS, AND I'VE HAD A LOT OF THEM. CATCHING DON LARSEN'S PERFECT GAME WAS PRETTY DARN GOOD. IT HAD NEVER HAPPENED IN WORLD SERIES HISTORY, AND IT HASN'T HAPPENED SINCE, AND MAYBE NEVER WILL.

That was an awfully good ballclub the Dodgers had. We knew what they could do. They had lots of good high-ball hitters, so we tried to keep the ball down and mix pitches up. If we didn't, guys like Duke Snider, Jackie Robinson, Gil Hodges, Roy Campanella, and Carl Furillo would have hurt us bad.

Larsen was a big guy with good stuff. When he was on, he made it look easy. He had trouble in Game 2, lasting only one-and-two-thirds innings because his fastball was too dead. On this day, he got ahead of everyone. His fastball was hopping, and he had a good slider and change-up, but I liked his fastball best. He only went behind on one batter, Pee Wee Reese, going to three-and-two in the first. After that, anything I put down, he got over. He never threw more than two balls to a hitter. His only bad pitch was when he hung a slider to Gil Hodges in the fifth. That's when Mickey Mantle made a heck of a catch on Gil's drive in deep left-center.

Don had just started that no-windup delivery, so it was like we were playing catch in the yard. That no-windup delivery also kept me on my toes because I had to be ready for him right away. Some people thought the Dodgers batters had trouble timing their swings because he was working faster. I'm not sure if that was true, but what I do know is that it didn't work so great in Game 2.

In Game 5, Don's control was the best I ever saw. Heck, he was perfect. He only shook me off a few times when I asked for fastballs. But I came back with the same sign, and he threw it. Don was calm, real nonchalant, until late in the game when he was feeling the pressure a bit. The guys were nervous, too. They wouldn't talk to him or sit near him in the dugout. They were afraid of jinxing him.

By the seventh, the drama was mounting and the crowd was buzzing. Don was trembling a little, but I didn't want him to worry about a no-hitter. We only had a 2-0 lead, and we needed to concentrate on every pitch.

I remembered how a no-hit game could change pretty bad. In the '47 World Series, my rookie year, Bill Bevens had a no-hitter against the Dodgers in the ninth, even though he was rather wild. In the last inning, they had a walk, a steal, and an intentional walk, and Cookie Lavagetto ruined the no-hitter with a two-out double—their only hit—to beat us.

Before the ninth, I just told Don, "Let's get the first out, that's the main thing." The excitement in the Stadium was hard to describe. Everyone was standing and roaring on every pitch. I was just worried about being able to call the right pitch. Furillo fouled off four pitches, but finally flied out on a slider. Next, Campy hit a long foul to left, then grounded to second on a slider. Dale Mitchell, a left-handed batter who we really didn't have a book on, was the pinch-hitter. I knew he was a good, smart hitter, and I knew we had to stick with fastballs and sliders. Joe Collins, our first baseman, told me later that he was praying that I wouldn't call for a curve. Joe said he could see Mitchell slapping a curve ball to the opposite-field for a hit.

Don got ahead of Mitchell one-and-two before he fouled off the next pitch. You could see Don's nervousness out there. He was fidgeting with his cap and the rosin bag, taking a little longer. On the next pitch, he shook off my sign, but that was done to keep Mitchell guessing. I gave him the original sign for a fastball, and Don threw a beauty that caught the corner. Babe Pinelli, the ump, yelled strike three, and it was over. Mitchell was fooled because he was going to swing, then he pulled back. No matter what anyone says, it was absolutely a strike. I ran out to Don and jumped in his arms. The celebration was pretty big, and the clubhouse was a madhouse. There must've been a hundred newspapermen and photographers around Don's locker. When a few came over to me, I looked up and said, "What's new?"

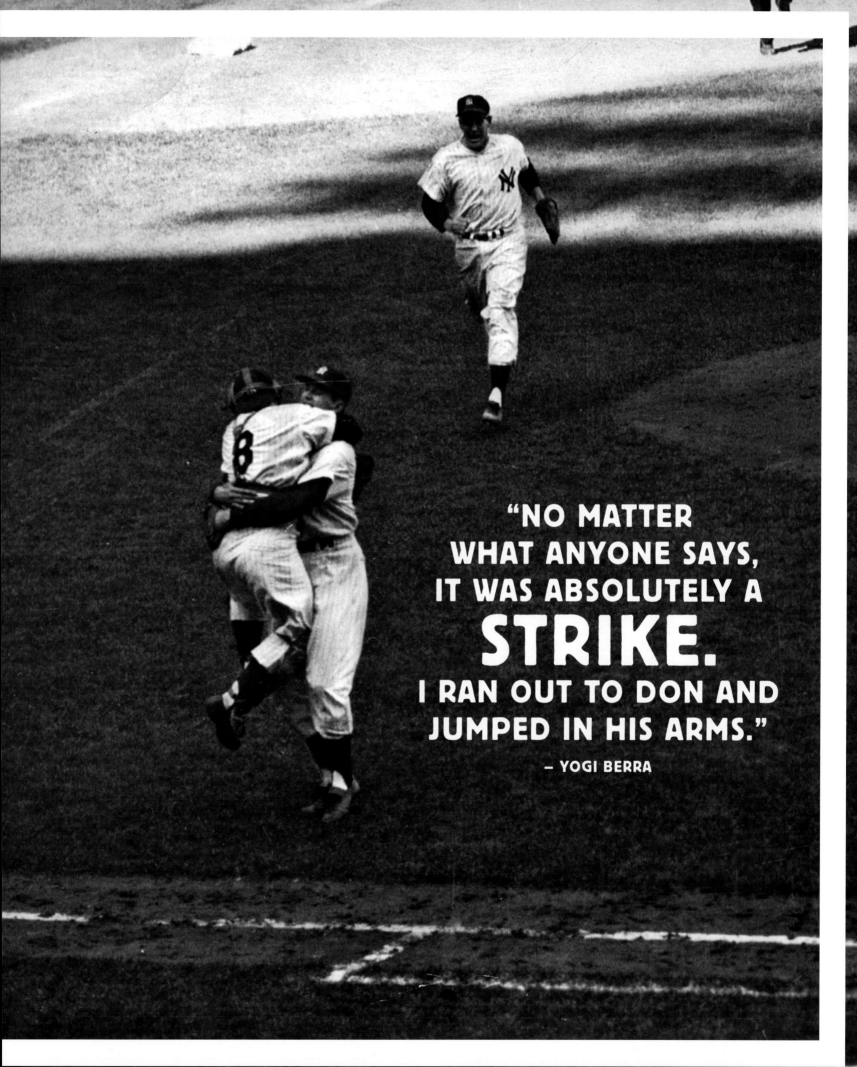

"NO MATTER
WHAT ANYONE SAYS,
IT WAS ABSOLUTELY A
STRIKE.
I RAN OUT TO DON AND
JUMPED IN HIS ARMS."

— YOGI BERRA

WHAT MORE CAN I SAY ABOUT THAT DAY— IT'S STILL LIKE A DREAM. I FEEL LIKE I HAVEN'T AWAKENED YET.

Pitching a perfect game in the World Series? It's been more than fifty years since it happened, and people ask if I ever get tired of answering questions about it. That's crazy. Why would I?

Truth is, I didn't know I would be pitching that day. We were tied with Brooklyn two games apiece in the 1956 World Series, so Game 5 at the Stadium was hugely important. In those days, I started as many games as I relieved. I had had a decent season, and my last four starts were pretty good, so Casey Stengel gave me the chance to start Game 2 at Ebbets Field. But I wasn't good at all. A pitcher should be able to hold a 6-0 lead, but I was wild and got pulled in the second inning. We wound up losing, 13-8. I was pretty mad—mad at myself and mad at Casey for the quick hook. I was boiling in the clubhouse because I probably blew my chance. I never thought I'd start again in the Series.

Whitey Ford and Tom Sturdivant won the next two games at the Stadium to tie it. I had no idea what Casey was thinking. For some reason, he chose not to tell anyone who was starting Game 5. Back then I lived in the Concourse Plaza Hotel, which was about a mile from the Stadium. I awoke that morning at eight o'clock, not by choice. I usually liked sleeping later, but Casey had told me to be in the clubhouse by ten. When I walked to my locker stall, I saw a baseball in my spikes. That was the Yankees' ritual of telling a pitcher he was starting. To say I was shocked would be putting it mildly.

It was a clear and sunny day with more than sixty-four thousand people filling the Stadium. Yet for some reason I didn't feel too nervous warming up. I felt confident because we were at home, and we always played the Dodgers well there. The reporters made a big deal of my new no-windup delivery, which was an unusual thing then. I only started using it the last two weeks of the season because I thought I was tipping off my pitches. But as I prepared for this game, I wasn't thinking much about my pitch selection. I wasn't doing much deep thinking at all. I just threw what Yogi called; he did the thinking. I only shook off a couple of signals, but he stuck with them so I threw what he asked for.

Retiring the Dodgers in order in the first inning was a confidence-builder. It definitely made me more relaxed on the mound. I struck out the first two batters—Junior Gilliam and Pee Wee Reese—on called strikes. Then Duke Snider hit a soft fly to right to Hank Bauer.

I could feel it was going to be a tense battle, though. The Dodgers had a pretty fearsome lineup, top to bottom. Plus, they were the defending champs. After Gilliam, Pee Wee, and Duke, they had Jackie Robinson, Gil Hodges, Sandy Amoros, Carl Furillo, and Roy Campanella. Campy, a Hall of Famer, was hitting eighth, so that tells you how good that lineup was.

Sal Maglie, the Dodgers starter, and I didn't allow a hit the first three innings. Thank God, we had Mickey Mantle. Mickey was coming off a Triple Crown year, and he got our first hit, a line-drive homer to right in the fourth inning. Then in the fifth, he made a fantastic running catch in deep left-center on a ball hit by Hodges.

I had good control that day. I pinpointed my fastball, and threw some sliders and a few curves. I had some pretty good luck, too. There was Mickey's great play, followed by Sandy Amoros' long drive that hooked foul into the seats by inches. In the second inning, Jackie hit a liner to third that caromed off Andy Carey's glove to Gil McDougald at short, and Gil's throw nipped Jackie at first.

People forget that Maglie pitched one heck of a ballgame that day. He gave up only five hits and two runs, and finished by striking out the side in the eighth. As the game progressed, my biggest worry wasn't losing the no-hitter; it was losing our 2-0 lead against a very powerful lineup.

By the sixth or seventh inning, I knew I was pitching a no-hitter. I didn't realize it was a perfect game until someone told me later on. In the late innings, I tried to talk to some of the guys on the bench, but they avoided me like the plague. It's an old superstition: don't talk to a pitcher who is working on a no-hitter. Still, I felt kind of alone and tried starting some conversation. In the seventh, Mickey was in the corner, getting a drink of water, and I went over to him and said, "Look at the scoreboard, Mick. Two innings to go. Wouldn't it be something if I made it?" And he got a little spooked and walked

away. The whole dugout was real quiet.

By the ninth inning, the tension was surreal. You could feel it in the crowd, almost like an eerie silence. Then there were loud roars after every pitch. There were late afternoon shadows, a smoky haze hanging over the field. I was three outs away, and more importantly I was three outs from giving the Yankees a three-games-to-two lead in the World Series. Now I was nervous. My legs were rubbery, and my fingers didn't feel like they belonged to me. I wasn't too religious or a praying man, but I said to myself, "Please help me get through this."

Furillo, always a dangerous hitter, was up first, and he fouled off several pitches. Finally, he flied out to Bauer. Next up was Campy, one of the best clutch hitters in the game. He belted a long shot to left, in the upper deck, but it was foul. I took a deep breath. Then Campy slapped a roller to Billy Martin at second. One out to go.

Bob Sheppard announced Dale Mitchell as a pinch-hitter for Maglie.

Immediately, I remembered him from his days in the American League. He was a lifetime .300 hitter, a good contact hitter who knew the strike zone well. My first pitch was a fastball for a ball. All day, I'd been getting ahead of the hitters, and now I was behind on the last batter. The next pitch was a called strike, and then a swinging strike. Then Mitchell fouled one off to the backstop. On a one-and-two count, Yogi called for another fastball. It came in letter-high on the outside corner, a called strike three. Mitchell kind of half-swung, then turned to argue, but the umpire, Babe Pinelli, was already gone.

I was stunned as I walked off the mound. Yogi rushed toward me and jumped into my arms. It was all too hard to believe. It was almost too preposterous.

Like I said to one of the reporters afterward, I expected an alarm clock to ring any minute and to hear someone say, "Okay, Larsen, it's time to get up."

FROM THOSE WHO WERE THERE

JOE TORRE | SPECTATOR IN THE LEFT-FIELD UPPER DECK

"I was sixteen years old and a junior at St. Francis Prep in Brooklyn. My brother, Frank, was playing for the Milwaukee Braves, and he secured two tickets for me to Game 5. I remember bringing the tickets to school the day before so that the Brothers would let me miss a day and attend the game. But I have absolutely no recollection of who accompanied me to the game. We sat in the upper deck in left field about midway between third base and the foul pole. When Mickey Mantle made that running catch in the fifth inning, it looked as though he was running toward us. I was rooting for the Dodgers that day, if only because they were the National League team. I had grown up a Giants fan, and with Frank playing for Milwaukee, I was now a Braves fan. But in about the fifth inning, with no hits for the Dodgers on the scoreboard, my rooting interest shifted to Don Larsen. Of course, I wanted to see him pitch a perfect game. I can still remember my view of Dale Mitchell's checked swing, and of Yogi's glove moving to catch the pitch, and then Yogi leaping onto Larsen. I've never forgotten that scene."

BOB TURLEY | YANKEES DUGOUT

"In those days, the way a pitcher knew that he was to start that day's World Series game was that [coach] Frank Crosetti would come by your locker before you arrived and place a brand new ball in your shoe. I lockered right next to Don, and I remember that when I saw that ball in his shoe, I said, 'Oh, my God!' Don was sore when Casey took him out in Game 2. He didn't know if he would ever pitch for Casey again, and I don't think he cared if he ever pitched for him again. He was disturbed. When he came in and saw the ball in his shoe, he just stared at it for a few seconds. Then he walked into the trainer's room and went to sleep. They woke him up about thirty to forty-five minutes before the game."

YOGI BERRA | LARSEN'S CATCHER

"I didn't catch him when he warmed up before the game, so I couldn't say how good his stuff was. But by the third inning, I said, 'Boy, he is on today.' I just put [the sign] down, and he'd throw it over. After the seventh inning, I'm saying, 'He's got a chance.' But, remember, I caught Bill Bevens in 1947. He had a no-hitter with two outs in the ninth, and we lost the game. You know, it really ain't over until it's over."

BOB WOLFF | TV BOOTH

"I was doing my first World Series on television for the Mutual Broadcasting System, [and it went] across the country and around the world on the Armed Forces Network. My partner was Bob Neal, the radio voice of the Cleveland Indians. At that time, each announcer did half the game, and for Game 5, I had the second half. When the mike was moved in front of me in the bottom of the fifth inning, I was very much aware of what was happening: Don Larsen had not allowed a base runner.

Red Barber was very much on my mind as the game went on. In 1947, Floyd Bevens of the Yankees had taken a no-hitter into the ninth inning of Game 4 against the Dodgers at Ebbets Field. Red felt it was his obligation to let the listeners know that Bevens was pitching a no-hitter, so he mentioned it repeatedly. Of course, Cookie Lavagetto broke up the no-hitter and won the game with two outs in the ninth inning. Well, Red got hundreds of letters from angry fans who claimed that he had jinxed Bevens. I, too, felt the listeners should know the situation, so I did the rest of the game using synonyms. I would say, 'Fifteen up and fifteen down,' or 'No Dodger has reached base,' or 'The Yankees have the game's only hits.' There are hundreds of ways to do it, and I used most of them. And I got no letters, not one. Everyone knew that Larsen was throwing a perfect game, although I never said it. When Babe Pinelli called strike three, I said, 'A no-hitter, a perfect game for Don Larsen.' It was the first time in the game that I had used those words.

Toward the end of the game, I gave myself a pep talk, 'Don't get caught up in the emotions of a fan. Just tell the audience what you see.' When it was over, it took three days for me to recover physically. I felt like I had pitched the last inning. My whole body was taut. It was a strange feeling."

HANK BAUER | RIGHT FIELD

"We knew exactly what was going on. If you looked into the dugout, there was Larsen, and a few yards away was everybody else. No one would dare talk to him. He went up to Mickey and said, 'Wouldn't this be something?' And I think Mickey looked at him and said, 'Shut up!' When I went out to right field for the ninth, I remember thinking to myself, 'If it's hit to you, do whatever it takes. Dive for it. Whatever you have to do.' You know, at the time, I really didn't know that a no-hitter or perfect game had never been thrown in the World Series. And I never thought that fifty years would go by and there still wouldn't be another one."

CHARLIE SILVERA |
YANKEES BULLPEN IN RIGHT FIELD

"I warmed Don up before the game, right there on the side of the infield. In those days, the starting pitcher didn't warm up in the bullpen; he didn't even use a mound. Don was very calm and casual when he was warming up, just like he always was, no difference. He warmed up fast, probably because he was used to pitching as a reliever, too. During the game, I took my spot out in the bullpen in right field. It was such a close game that I actually warmed up Whitey Ford in about the seventh or eighth inning, and all the time I'm thinking, 'I hope I don't have to catch anyone in the ninth because my back would have been to the field and I wanted to watch this thing.' How special was it? Well, I never used that glove again except one time, in the Giants' first Old-Timers Game in San Francisco. I asked Don to sign the glove, and he wrote, 'Let's do it again!'"

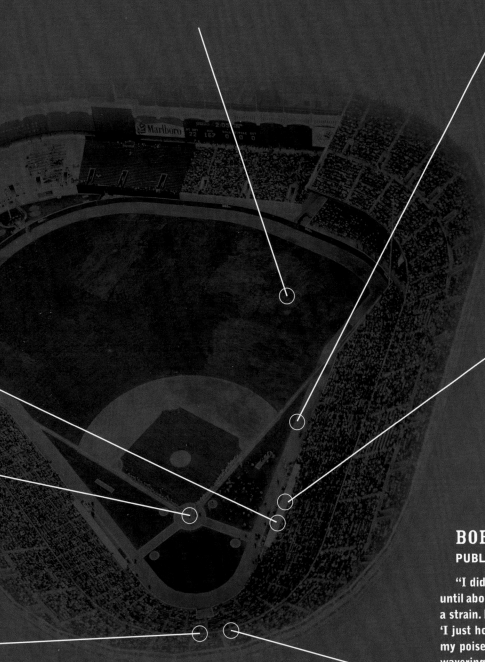

JERRY COLEMAN | YANKEES DUGOUT

"What a game. It really wasn't until about the seventh inning that we in the dugout realized that Larsen was not only throwing a no-hitter but also a perfect game. It just never occurred to us before that. And at about that time, everybody in the dugout started to offer their opinions on where to position the players in the field. 'Is he too deep?' 'Should he be more to the left?' Finally, Casey jumped up and yelled, 'Enough! I'm the manager, and I'll tell them where to play!' When Babe Pinelli called strike three on Dale Mitchell, I remember thinking, 'That may have been a strike, but it was the highest strike I've ever seen.'"

BOB SHEPPARD |
PUBLIC ADDRESS ANNOUNCER IN THE PRESS BOX

"I didn't pay much attention to the fact that no Dodger had reached base until about the fifth or sixth inning. Then around the seventh, the tingle became a strain. By the ninth, it was actually difficult to breathe. I remember thinking, 'I just hope I can do my job without revealing to the audience that I had lost my poise.' I needed to be as controlled as Larsen himself was controlled. Any wavering of my delivery, I thought, may actually affect him. As the pinch-hitter walked toward home plate, I said, 'Now batting for Maglie, number 8, Dale Mitchell, number 8.' And those, I believe, were the last words I spoke into the microphone that day. I closed my eyes and said a prayer, and then opened them to see Babe Pinelli signal strike three. I just sat there in a kind of shell-shocked state, as did many of the people who were in the stands. I may have said a prayer of thanks. That was special. Of all the great moments I have seen at Yankee Stadium, that is still number one."

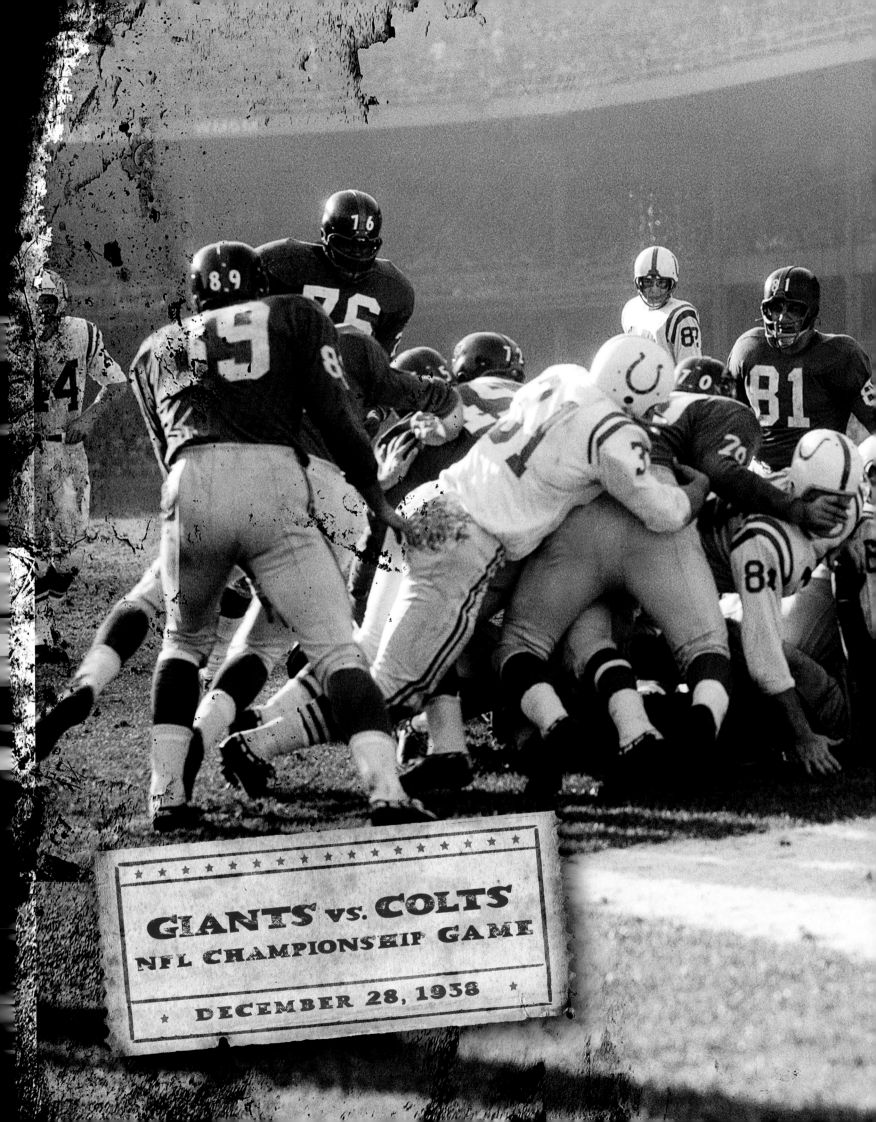

GIANTS vs. COLTS
NFL CHAMPIONSHIP GAME

DECEMBER 28, 1958

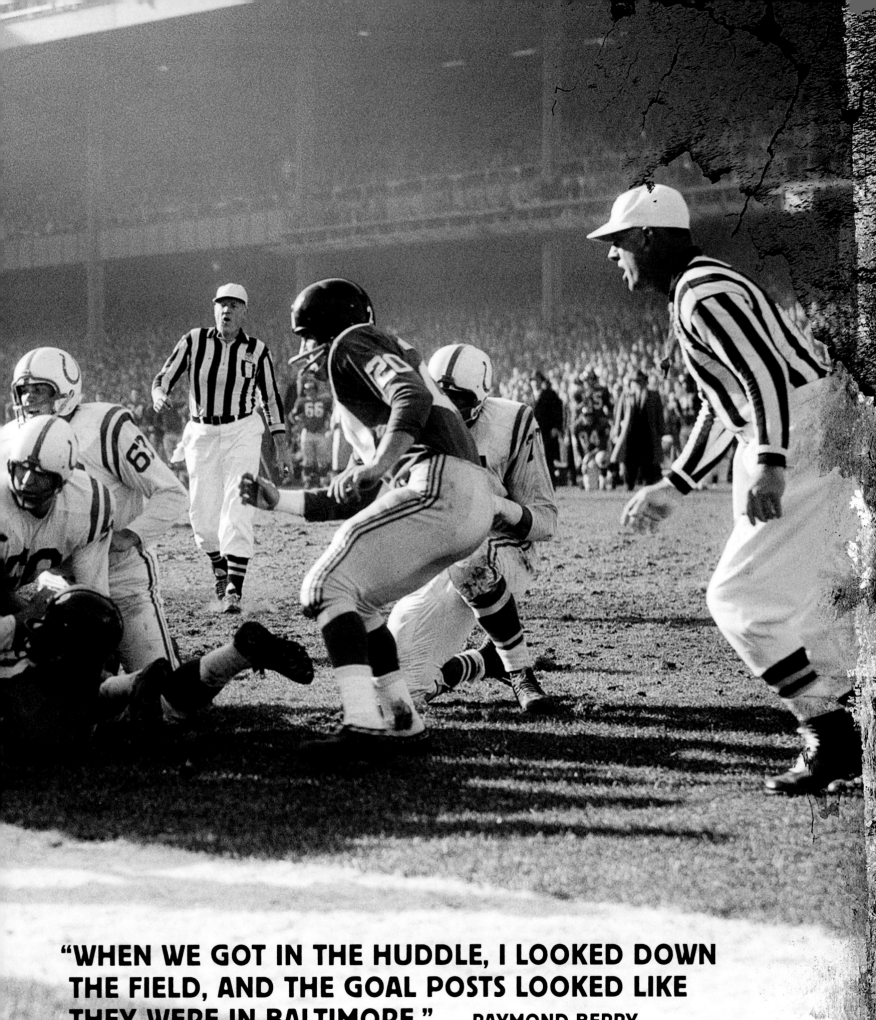

"WHEN WE GOT IN THE HUDDLE, I LOOKED DOWN
THE FIELD, AND THE GOAL POSTS LOOKED LIKE
THEY WERE IN BALTIMORE." — RAYMOND BERRY

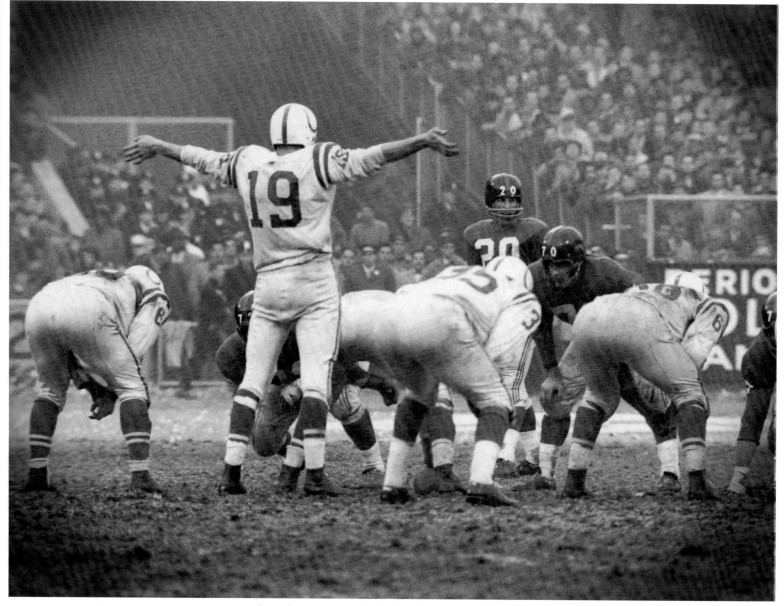

Colts quarterback Johnny Unitas (above) tries to quiet the Yankee Stadium crowd on Baltimore's game-winning drive in the 1958 NFL championship game. Giants defenders Dick Modzelewski (77) (right), Emlen Tunnell (45), and Sam Huff (70) stop running back Alan Ameche during the overtime. Ameche scored moments later to give Baltimore a 23–17 victory.

Many call it the "Greatest Game Ever Played," and there aren't many NFL experts who dispute that. Twelve future Hall of Famers graced the field that day, including the legendary quarterback Johnny Unitas. His play against the Giants in the 1958 NFL championship game solidified his reputation as one of the sport's greatest performers under pressure.

The Colts held a 14-3 lead after a half, and their march to the one-yard line in the third quarter had the Giants reeling.

But New York's defense stiffened, stopping running back Alan Ameche on fourth down. Giants quarterback Charlie Conerly led his team on a ninety-five-yard touchdown drive that included an eighty-six-yard gain on a fumbled pass completion. Conerly gave the Giants a 17-14 lead with a fifteen-yard scoring pass to Frank Gifford.

The Giants tried to hang onto their lead, but were foiled by a critical sequence. In a third-and-four situation at their forty-yard line, the ball was handed to Gifford, who burst forward before being stopped by Gino Marchetti and Big Daddy Lipscomb. Marchetti suffered a broken leg on the play, but his efforts were not in vain. The referee spotted the ball short of the first-down marker, much to the Giants' dismay.

Following a Giants punt, the Colts took possession at their fourteen-yard line with 1:56 remaining. As end Raymond Berry would say years later, "When we got in the huddle, I looked down the field, and the goal posts looked like they were in Baltimore." Unitas took the Colts sixty-two yards with four pass completions, setting up Steve Myhra's twenty-yard field goal with seven seconds remaining that sent the game into overtime.

The Giants got the ball first in the extra period, but quickly relinquished possession. Unitas hit Berry for twenty-one yards on third-and-fourteen, handed off to Ameche on a draw play that picked up twenty-three yards, and then passed to Jim Mutscheller to the one-yard line. Ameche scored, and the Colts had a 23-17 victory and the world championship.

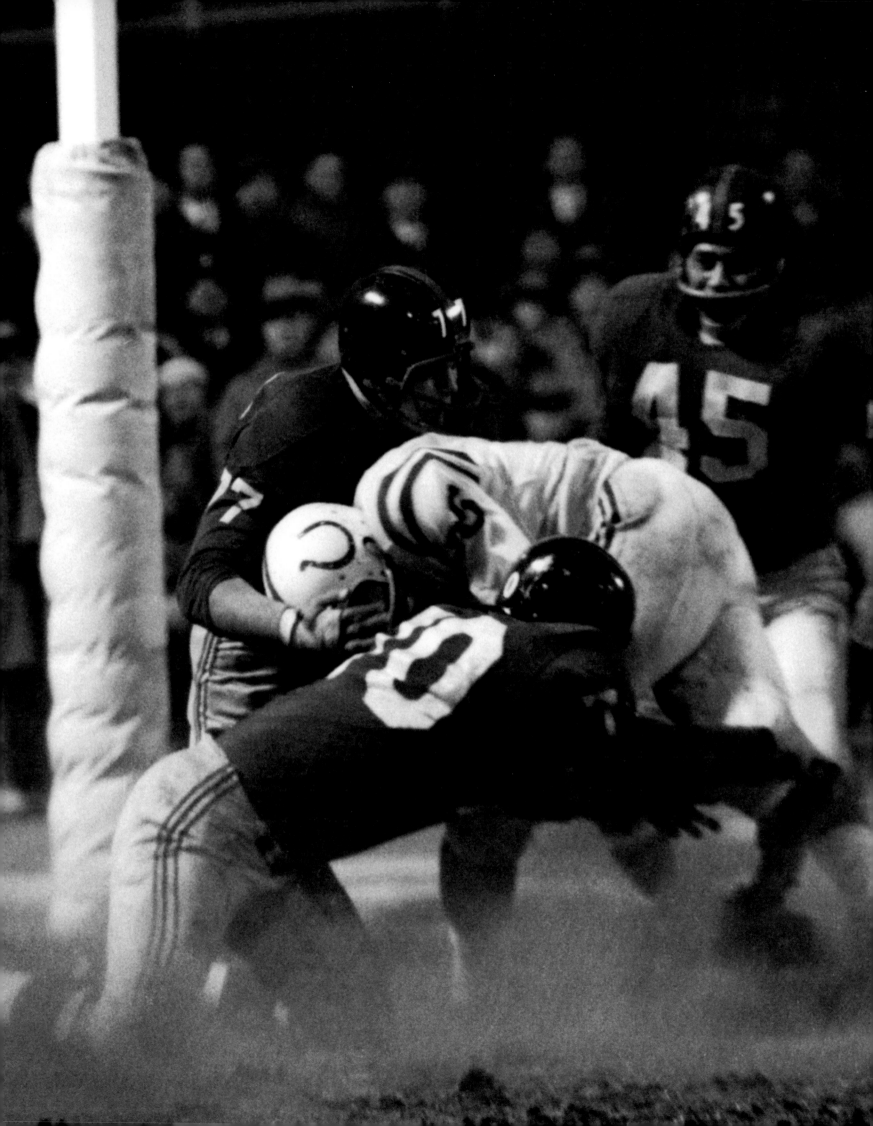

THE 1958 NFL CHAMPIONSHIP GAME AT YANKEE STADIUM WAS A GREAT DAY FOR FOOTBALL. IT WAS A COLD DAY, THE ATMOSPHERE WAS ELECTRIC, AND SO MANY PLAYERS PERFORMED AT THEIR HIGHEST LEVEL.

There were a lot of legends that played in that game: Johnny Unitas, Raymond Berry, Gino Marchetti, Big Daddy Lipscomb, Andy Robustelli, Charlie Conerly, Alex Webster, and quite a few other Hall of Famers all took the field that day. Unitas was one of the greatest players in NFL history, and he was the best player in that game. He wasn't what you would refer to as an attractive quarterback. He was pigeon-toed, and his shoulders were sloped. But we knew he could throw the ball well, and he developed into a great quarterback. His coach, Weeb Ewbank, recognized Johnny's talent early on and gave him great receivers.

Lenny Moore played running back, and on passing situations, he became a split end. He was a great football player. Raymond Berry caught a lot of passes in that game because we were so concerned with Lenny. Lenny was a real game-breaker. If we had double-covered Raymond, Johnny would have gone right to Lenny.

Every time a team came to Yankee Stadium to play us, the players would go over to the monuments during pregame warm-ups, and the Colts were no different that day. It was really easy to get caught up in all the history that was there. We used to call opposing players tourists. We were very respectful of the heritage of Yankee Stadium, and we had an edge because we were there for every home game.

There is no question that Yankee Stadium was already well-known at that time in our culture. There had been movies made about the Yankees. Babe Ruth and Joe DiMaggio had played there, and Mickey Mantle was the most popular player in baseball.

We felt pretty good at halftime, even though we were losing, 14-3. We had a couple of bad breaks in the first half, but we felt like we were in control of the game. If you play the game long enough, you know whether you are in trouble or whether you have things under control. We felt like we could come out in the second half and get right back into the game. All of us felt confident, even though we were losing.

We got back into the game in the fourth quarter, when Alex Webster picked up a fumble and ran it down to the fifteen-yard line. On the next play, I ran a simple slant pattern and scored an easy touchdown to put us ahead by three points. They punted on the next series, and that gave us a chance to run the clock out.

On that series, we quickly got into a third-down situation. We ran a Forty-Seven Power play that was designed to go right at Gino Marchetti. We found that it was better to go right at him rather than run away from him because he was so quick. It was a good call. We

had made a few first downs in the game using that same play, and in my estimation, we made that one.

Marchetti was in on the tackle, and he broke his leg on the play. He was screaming, and everyone was trying to get off the pile because he was on the bottom. The referee came in and started pulling players off Marchetti. With all of that going on, the referee had placed the ball in the wrong spot. When the play was over, I didn't even look over to the yard markers because I didn't think it was close.

It's very amusing now because if I had made that first down, we might not even be talking about that game. That gave the Colts an opportunity to tie the game and ultimately win it in overtime. A lot of people thought I got the first down, but if you were from Baltimore, you probably didn't.

After the game, the referee actually came up to me and said he was sorry, to which I said, "Thanks a lot."

Marchetti was a friend of mine. I had met him in the East-West Shrine Game a few years earlier. I was as distracted as the referee. I was worried about Gino because I didn't know what was wrong. That doesn't happen frequently in football.

Instead of going for it on fourth down—which we probably should have done since Marchetti was out of the game, and we could have ran the same play against his backup— we decided to punt. If we had gotten the first down, we could have just ran the clock out.

Vince Lombardi, who was our offensive coordinator, wanted to go for it—we all wanted to go for it. Our head coach, Jim Lee Howell, made the decision to punt, against all of our wishes. But if we had gone for it, it probably would not have gone down as a legendary game. It would have just been referred to as the game in which the Giants beat the Colts in 1958, and it would have taken Johnny Unitas a few more years to be recognized as the great talent he was.

After the Colts got the ball back, Johnny led them on a great drive in which Raymond Berry caught a bunch of passes, and they tied the game. Of course, they went on to win it in overtime. It has been interesting to see it develop into such a historic event.

At the time, I didn't know how the game was going to go down in history. All I knew is that at the end of the game, I was tired. It had been a long season. We had had a playoff game against the Cleveland Browns the week before, and Baltimore had been off. We were kind of beat-up.

It was a magical day for everyone.

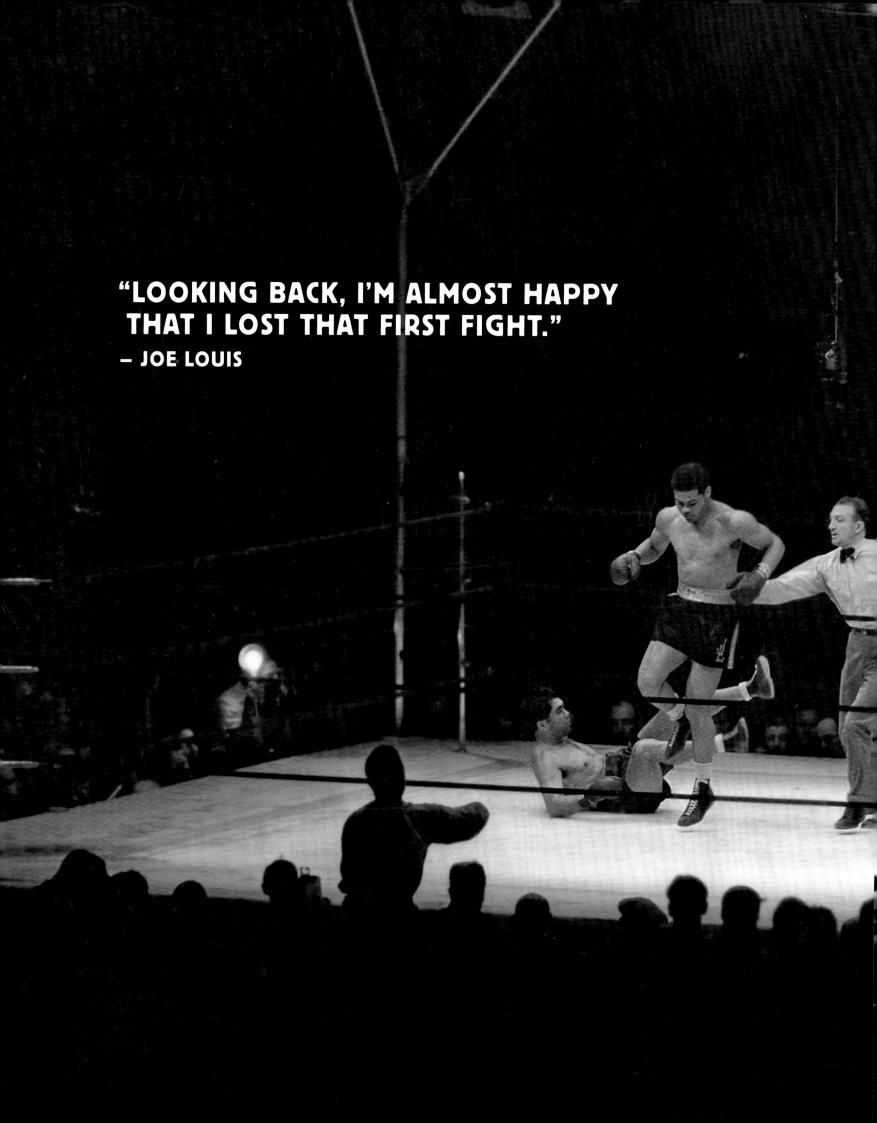

"LOOKING BACK, I'M ALMOST HAPPY
THAT I LOST THAT FIRST FIGHT."
– JOE LOUIS

JOE LOUIS VS.
MAX SCHMELING

JUNE 22, 1938

"JOE, WE'RE DEPENDING ON THOSE MUSCLES FOR AMERICA."

— PRESIDENT FRANKLIN D. ROOSEVELT

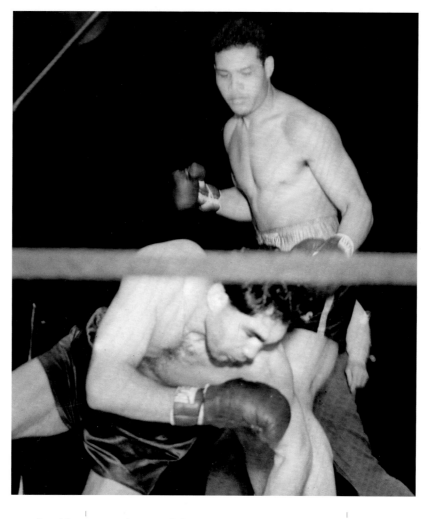

Talk about a full house. More than eighty thousand packed into Yankee Stadium to watch two great heavyweights in what was a microcosm of the coming World War II. Joe Louis, known as the "Brown Bomber," was trying to avenge a twelfth-round defeat two years earlier to the German powerhouse, Max Schmeling. Louis made good, knocking out Schmeling just two minutes and four seconds into the fight, which was scheduled for fifteen rounds.

It wasn't hard to understand why so many people flocked to the Bronx that evening. Hitler's Nazis were gobbling up Europe, and Americans, regardless of race or color, hated him. Schmeling was a symbol of Germany's growing power, just as Louis became a symbol of America, even to whites that harbored biases against blacks. Despite his billing as an Aryan superman, it was not certain that Schmeling was comfortable being Hitler's representative. Some historians say Schmeling saved two Jewish brothers during the Kristallnacht program in November 1938.

Schmeling was an undisputed force in boxing. He became the world champion after victories over Johnny Risko and Jack Sharkey in 1930, only to lose the title to Sharkey two years later. Stepping into the ring against the undefeated Louis in 1936, Schmeling was a ten-to-one underdog, but pulled off what many consider one of the greatest upsets in history.

The rematch two years later seemed to favor Schmeling, but he suffered a lightning-quick loss. Perhaps Louis was motivated by a conversation he had with President Franklin D. Roosevelt before the fight. FDR told Louis, "Joe, we're depending on those muscles for America."

Louis later said, "Let me tell you, that was a thrill. Now, even more, I knew I had to get Schmeling good."

Schmeling seemed philosophical in defeat, if not relieved. In a 1975 interview, he said, "Looking back, I'm almost happy that I lost that fight. Just imagine if I had come back to Germany with a victory. I had nothing to do with the Nazis, but they would have given me a medal. After the war, I might have been considered a war criminal."

The German press accused Louis of delivering an illegal, paralyzing kidney punch that rendered Schmeling helpless. True or not, payback was complete.

The day after the fight, sportswriter Heywood Broun wrote in the *New York World-Telegram*: "One hundred years from now some historian may theorize, in a footnote at least, that the decline of Nazi prestige began with a left hook delivered by a former unskilled automotive worker who had never studied the policies of Neville Chamberlain and had no opinion whatever in regard to the situation in Czechoslovakia.

"And possibly there could be a further footnote. It was known that Schmeling regarded himself as a Nazi symbol. It is not known whether Joe Louis consciously regards himself as a representative of his race and as one under dedication to advance its prestige. I can't remember that he has ever said anything about it. But that may have been in his heart when he exploded the Nordic myth with a bombing glove."

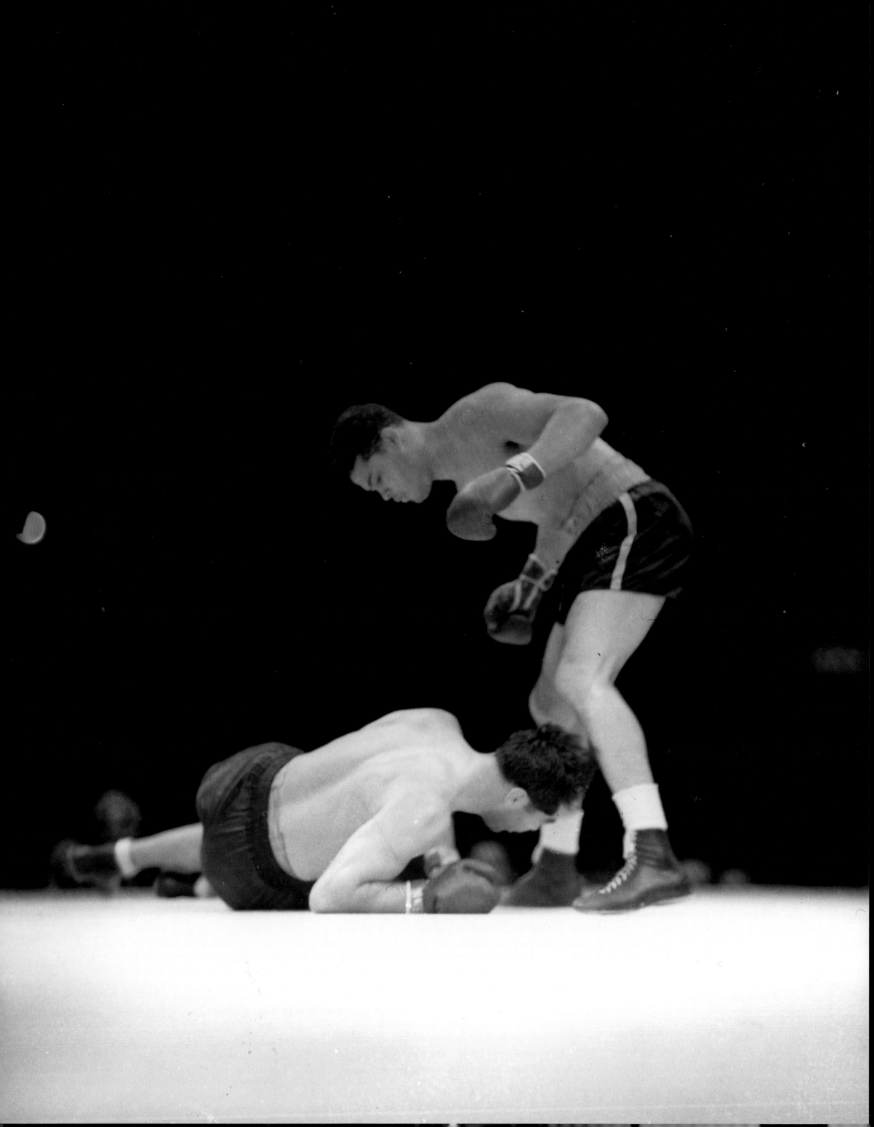

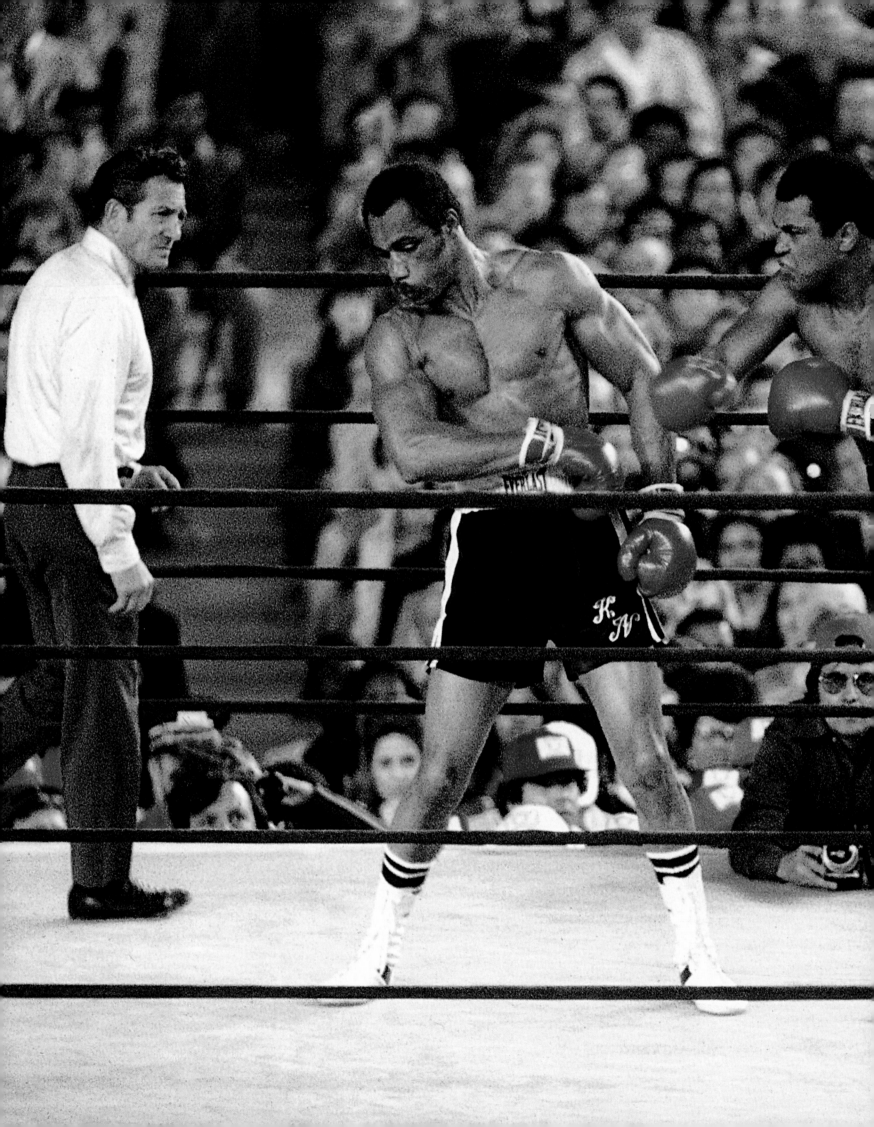

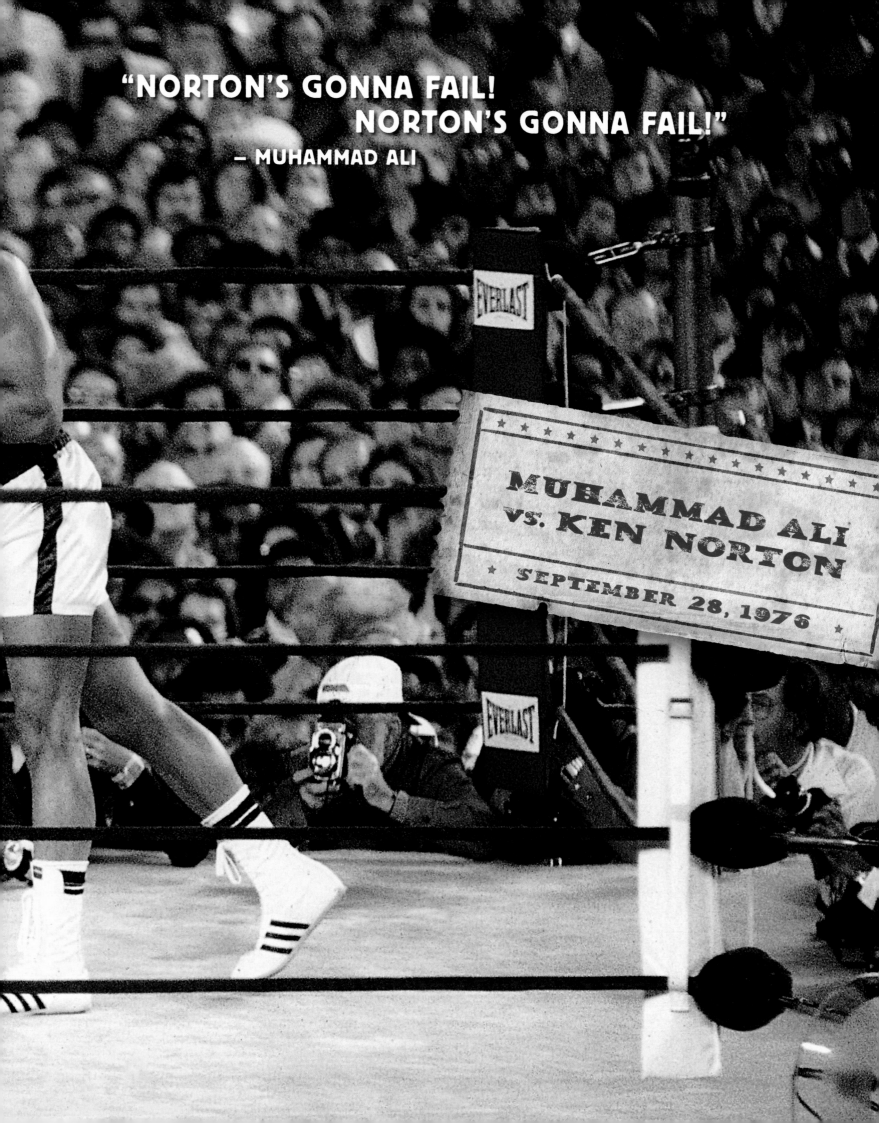

"NORTON'S GONNA FAIL!
NORTON'S GONNA FAIL!"
— MUHAMMAD ALI

MUHAMMAD ALI
VS. KEN NORTON
★ SEPTEMBER 28, 1976 ★

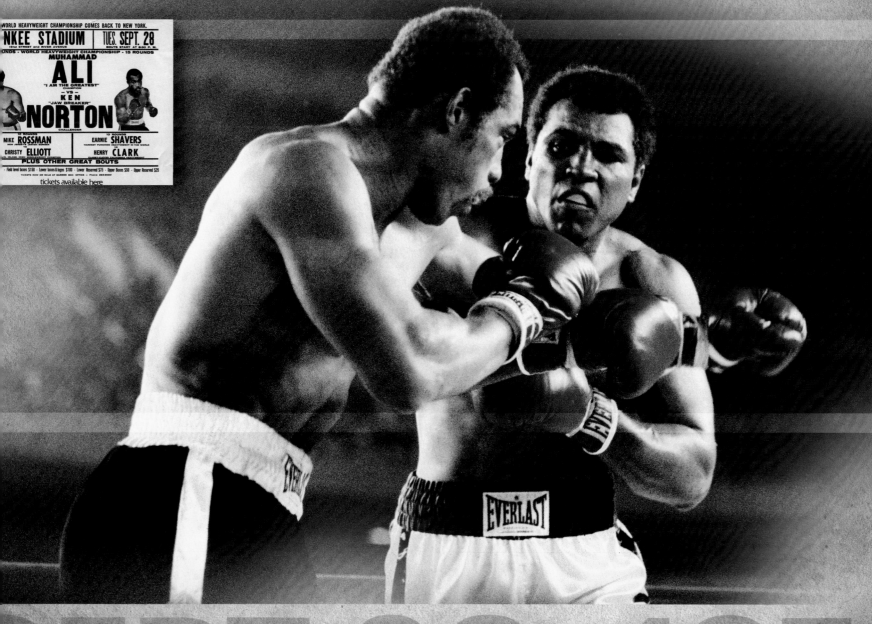

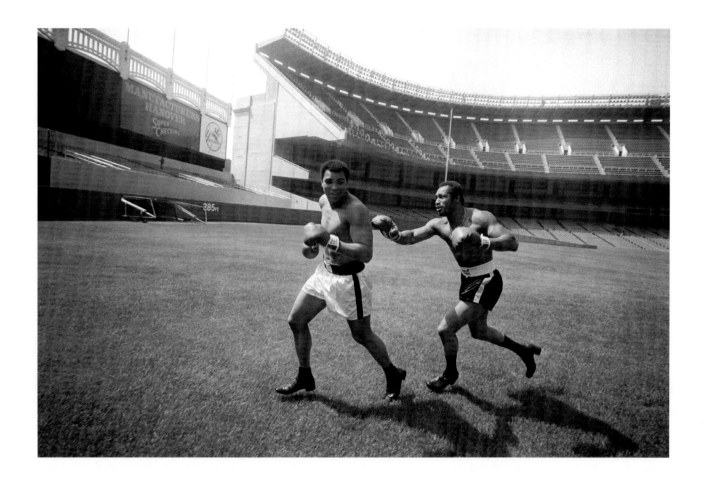

"I FOUGHT KEN NORTON AT YANKEE STADIUM, THE HOME OF THE NEW YORK YANKEES. WHAT COULD BE BIGGER THAN THAT?"

– MUHAMMAD ALI

Of all the controversies in Muhammad Ali's storied career, his third bout with Ken Norton is among the most hotly debated. Norton had beaten Ali in March 1973, and broken Ali's jaw in the process. Ali had won the rematch later that year.

Ali took the world heavyweight title from George Foreman in 1974, and two years later he was scheduled to meet Norton at Yankee Stadium. "Norton's gonna fail! Norton's gonna fail!" Ali proclaimed over and over in the days and weeks before the bout.

The crowd at the Stadium, announced at thirty thousand, was more than ready to see Ali make good on his promise. There was an unruly, dangerous vibe in the air that night. New York City's police officers were on strike, and thousands of fans were left to police themselves. As the fighters made their way to the ring, the crowd jostled them, an unsettling hint of how rowdy things would get.

Once the fight began, it became obvious this would be another in a long line of excruciatingly brutal Stadium bouts. Norton pushed Ali harder than any of his prior opponents with the exception of Joe Frazier.

Not even Foreman's thunderous punches had the same effect on Ali as Norton's did. Just as in their second fight, Ali and Norton were in a virtual draw until the fifteenth round. Ali was awarded a unanimous decision, but Norton believes to this day that he was robbed.

The decision inflamed the raucous crowd. While striking police officers picketed outside the Stadium, fights broke out in the stands, and objects were hurled from the upper deck. It made for an ugly scene. Ali had enjoyed the public's sympathy and support throughout the bout, and he seemed to have the judges' affection, too. It must have been on their minds that a world heavyweight champion had not lost by a decision in forty years.

THE FIRST TIME I SAW MUHAMMAD ALI FIGHT IN PERSON WAS AT YANKEE STADIUM ON SEPTEMBER 28, 1976, WHEN HE TOOK ON KEN NORTON. I WAS THERE WITH SOME OF THE OTHER GOLD MEDALISTS FROM THE 1976 OLYMPICS. MUHAMMAD ALI WAS MY IDOL, SO HAVING A CHANCE TO SEE HIM FIGHT WAS UNFORGETTABLE.

FIRST PERSON | SUGAR RAY LEONARD

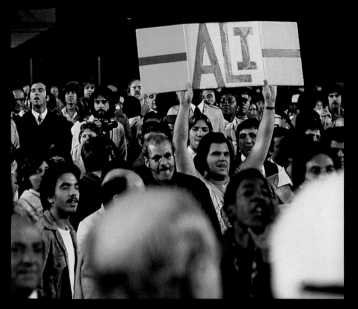

In addition to having a great seat, I got to meet Ali before the fight.

Ali's trainer, Angelo Dundee, approached me before the fight and asked me if I wanted to go meet the champ. I was blown away by that. I went to the dressing room, and Ali looked like a Greek god sitting on his table. He saw me and said, "Hey, I heard about you." Then he whispered in my ear, "If you ever decide to turn professional, make sure you get Angelo Dundee to train you."

I think that some things in life are predestined. I would have met Angelo Dundee eventually. I truly believe that certain things happen for a reason. Even as an amateur boxer, I emulated Ali, and I was on the verge of becoming a professional boxer, so that was a very opportune time for Angelo to come into my life. That relationship began at Yankee Stadium.

What a relationship it was. Angelo's philosophy and the way he guided me changed my career. He was the perfect guy to have in my corner. He always said the right things at the right time. His presence was special.

My moment with Ali left me in awe. That was my time. His presence was so huge. I couldn't believe I was talking to him.

I also knew Ken Norton. He was a friend of one of my trainers, Janks Morton. I had met Ken Norton before meeting Ali. Norton had the most perfect physique. He was amazing. He had the body everyone wanted.

We returned to our seats before the fight began. We sat a few rows back from the ring. For me, it might as well have been ringside. For a kid from Palmer Park, Maryland, sitting that close at a Muhammad Ali championship fight was incredible. It was amazing to see how artistic he was out there. He was beautiful to watch. To see a man that big who had the agility to slide and glide was unlike anything I could have imagined. And Yankee Stadium was a historic place to see him fight. That made for a spectacular event.

The lack of police presence that night made for a very tense atmosphere. I felt tense the entire night. I wasn't sure if it was because I was at such a big event, or because there were no police to protect the people in attendance. I recall that people looked happy, but they were also very nervous. You didn't know what was going to happen. A lot of fights broke out in the seats. It just started snowballing. I'm from the 'hood, so it was like home, but I will never forget that scene. It was eerie. I had a double dosage of emotion—I was excited to be there, but I was also uncomfortable.

The person I was sitting next to was petrified. She kept saying, "Oh, my God, look at all these people fighting around us." I was twenty years old at the time, so I was looking forward to protecting her if I had to.

It was a close fight. Norton not only lasted all fifteen rounds, but he nearly beat the champ. In the end, Ali got the decision. I am too biased to comment on who I thought won. But for what it's worth, I agreed with the judges' decision. Ali won the fight.

I came back to the Stadium in 2006 to throw out a ceremonial first pitch at a Yankees game. When I walked out to the mound on that summer afternoon, I fondly remembered that historic night in 1976. Yankee Stadium is an American institution. To be back there was special.

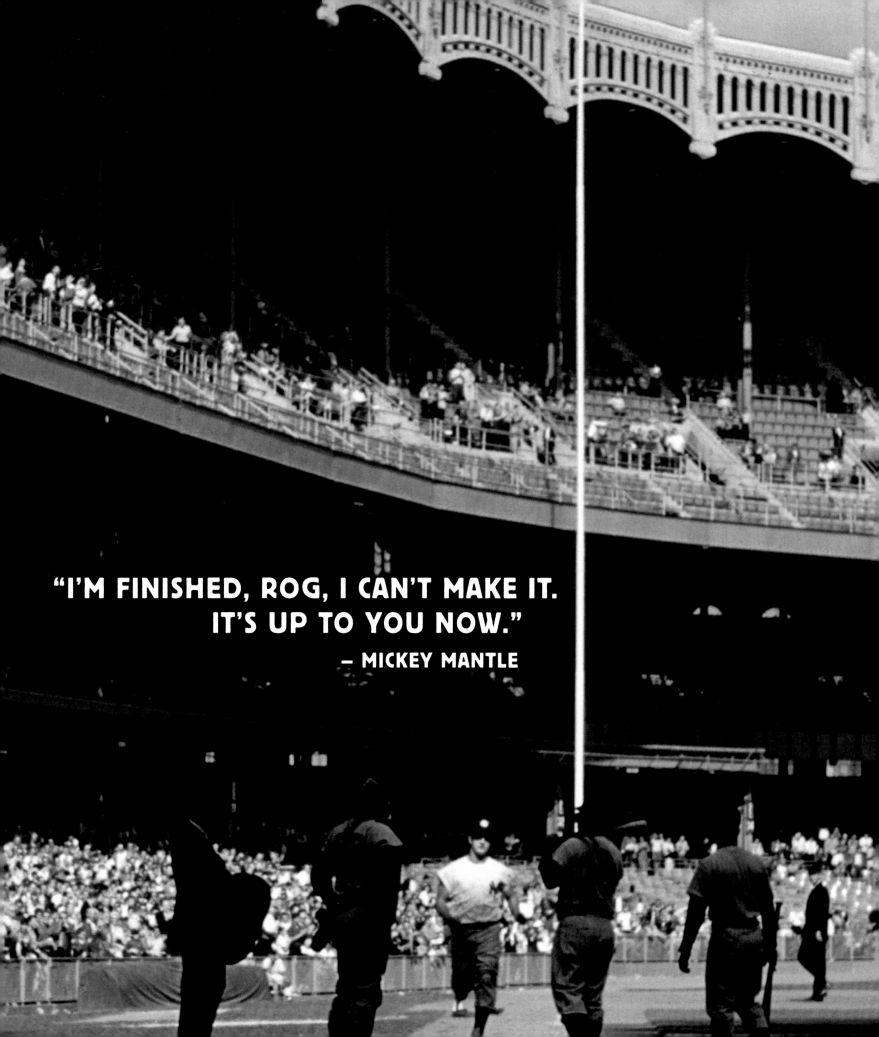

"I'M FINISHED, ROG, I CAN'T MAKE IT.
IT'S UP TO YOU NOW."

— MICKEY MANTLE

ROGER MARIS
SIXTY–FIRST
HOME RUN

OCTOBER 1, 1961

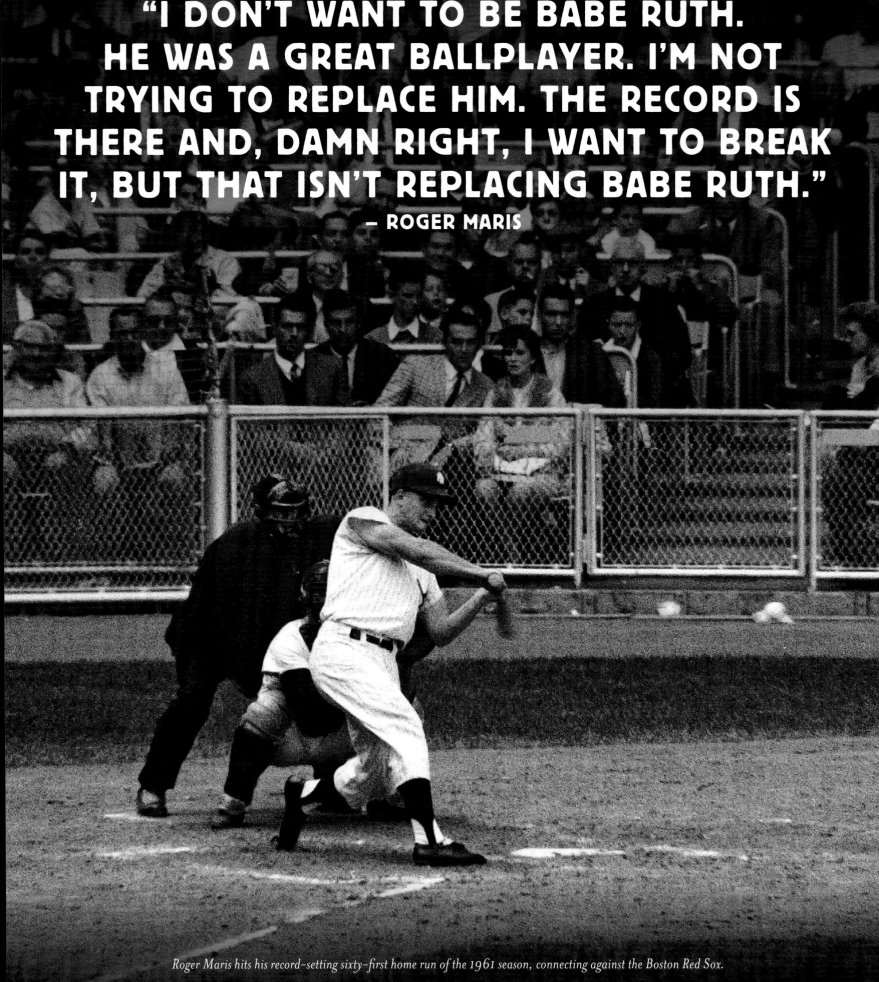

"I DON'T WANT TO BE BABE RUTH. HE WAS A GREAT BALLPLAYER. I'M NOT TRYING TO REPLACE HIM. THE RECORD IS THERE AND, DAMN RIGHT, I WANT TO BREAK IT, BUT THAT ISN'T REPLACING BABE RUTH."

— ROGER MARIS

Roger Maris hits his record-setting sixty-first home run of the 1961 season, connecting against the Boston Red Sox.

HEADING TO YANKEE STADIUM ON THE MORNING OF OCTOBER 1, 1961, I WAS FILLED WITH ANTICIPATION AND EXCITEMENT AT THE PROSPECT OF WITNESSING AND RECORDING BASEBALL HISTORY.

Since August, I had been covering the Yankees for the *New York World-Telegram & Sun*, documenting a two-man assault on the game's most cherished and prestigious record, Babe Ruth's sixty home runs in a season, a record that most believed never would be broken. A few had challenged the record, but each had fallen short, consumed by the pressure of the chase, the enormity of the task.

In 1961, the American League had expanded from eight teams to ten, the schedule lengthened from 154 games to 162, and golden-haired Roger Eugene Maris, of Fargo, North Dakota, was making his run at a record that had endured for thirty-four years.

There were no early signs that season to presage Maris as a threat to Ruth's record, and none in his brief major-league career. The previous season, his first with the Yankees, Maris hit thirty-nine home runs, eleven fewer than he had hit in his first three seasons combined and one fewer than his teammate, Mickey Mantle, the league leader. Maris' first home run in 1961 came in his eleventh game. In the same game, Mantle belted his sixth and seventh homers. Maris wouldn't catch up to Mantle until June 3 in Chicago when he hit his fourteenth homer.

Over the next two months, the major-league lead in home runs jockeyed back and forth between the Yankees' two sluggers, now identified in headlines as "M&M." By early August, the possibility that baseball would have a new single-season home-run king had raised the consciousness of the baseball establishment.

Some old-timers rued the thought that Maris, a career .257 hitter at the time, might break Ruth's record. Under duress, baseball commissioner Ford C. Frick decreed that if the record were broken after the Yankees had played 154 games, the feat would be denoted in the record books along with an explanatory line. Frick never uttered the word "asterisk," but the media nevertheless reported it as such.

I dropped into this storm of controversy in time to see Mantle hit his fortieth homer and pull even with Maris. Over the next few weeks, the lead changed hands three times until Maris blasted seven home runs in six games and pulled ahead of his friend, teammate, and roommate.

Mantle contracted a virus and was forced to sit out because of a hip abscess. He failed to hit a home run in eleven games, and knew his chance had passed.

"I'm finished, Rog," Mantle told Maris. "I can't make it. It's up to you now."

In the weeks that followed, I observed Maris tormented by the pressure of the chase, uncomfortable with the attention it brought him. As the schedule wound down, patches of Maris' hair fell out. A physician attributed it to stress.

In the final days of the season, I witnessed behavior by Maris that seemed bizarre. With a chance to surpass Ruth's record, he told manager Ralph Houk he needed a day off. In another game, he sacrificed an at-bat by bunting.

I came to understand that it was simply Maris being Maris. He wasn't about records or personal glory. His priorities were family, country, and team. Maris did not stand at home plate and admire the flight of his home runs, nor did he engage in high-fives, chest-bumping, and curtain calls once he had circled the bases.

Maris tied Ruth's record in his 159th game, in Baltimore, but he did not hit a homer in the next three games. It came down to the final day of the season, game 163—the Yankees had played in a tie game earlier—against the Boston Red Sox at Yankee Stadium. If I swelled with excitement on the morning of October 1, 1961, in anticipation of what might transpire at Yankee Stadium that afternoon, apparently I was in the minority—a crowd of only 23,124 turned out that day.

In the third inning, in his second at-bat, Maris connected against a Tracy Stallard fastball, and the ball soared into the right-field seats for his sixty-first home run.

Maris dropped his bat, lowered his head, trotted unobtrusively around the bases, and quickly disappeared into the Yankees dugout. The crowd, sparse but loud, was on its feet cheering wildly. Hector Lopez, Moose Skowron, and Joe DeMaestri pushed Maris out of the dugout, where he obliged the crowd with a reluctant and embarrassed curtain call.

It was the biggest story I had covered in my brief career. A half century later, after more than three thousand games, more than half of them in baseball's cathedral, Yankee Stadium, it remains the biggest story I have covered.

Phil Pepe is a New York sportswriter.

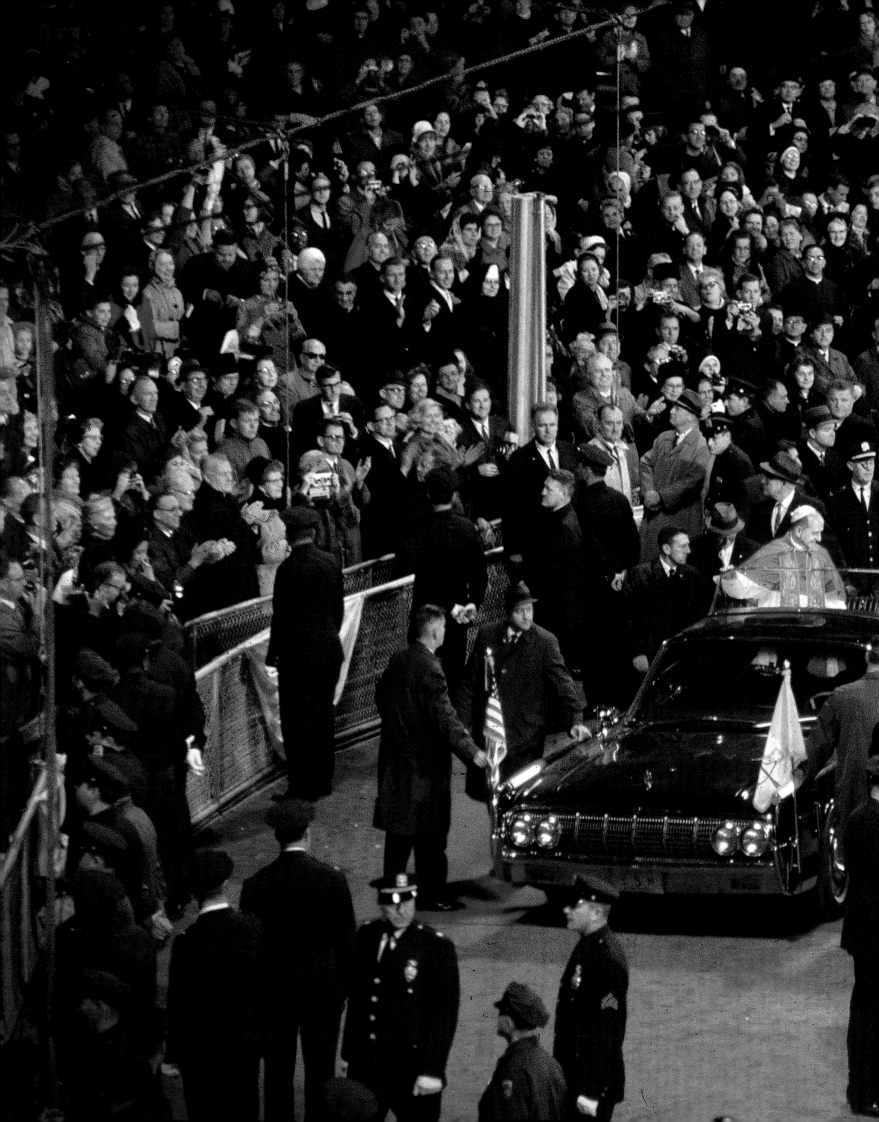

POPE PAUL VI

★ OCTOBER 4, 1965 ★

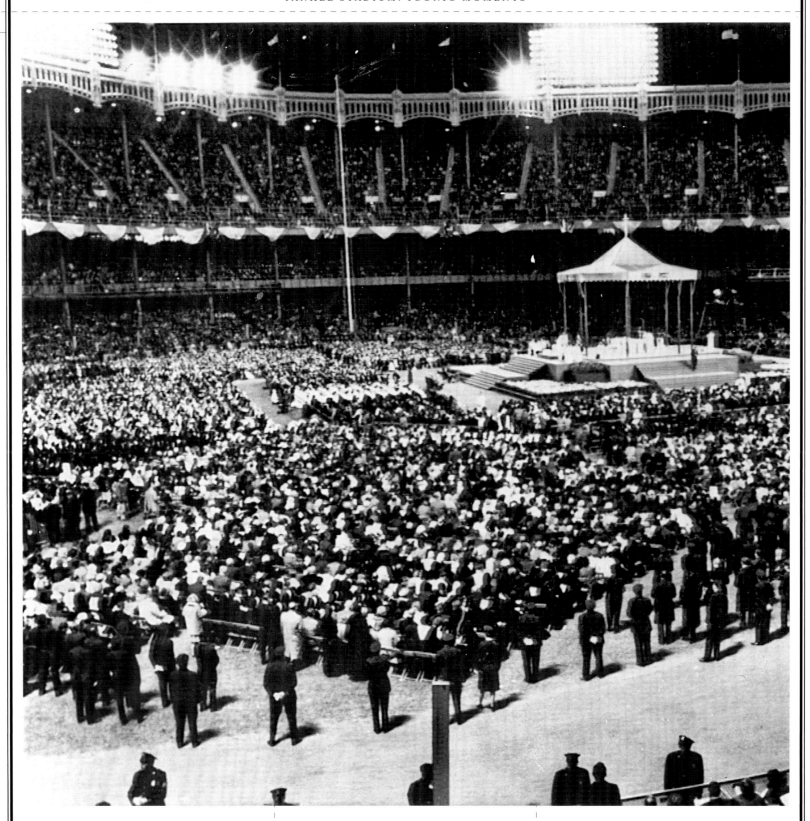

The Yankees failed to make the World Series in 1965 for the first time in six years. Yankee Stadium was uncharacteristically silent that October, but not for want of a huge crowd. Indeed, almost eighty thousand gathered on the fourth day of the month to participate in a historic ceremony. Pope Paul VI, the spiritual leader of Roman Catholicism, became the first pope to celebrate Mass in the Western Hemisphere.

Pope Paul's visit to New York City was deemed an unqualified success. He visited Saint Patrick's Cathedral in Manhattan and the Vatican Pavilion at the World's Fair site, and met with President Lyndon Johnson at the Waldorf-Astoria hotel. At the Stadium, the pope appealed for world peace, and ceremoniously accepted a pair of blue jeans as a sign of his commitment to youth.

The pope blessed a stone from Saint Peter's Basilica in Rome that was to be placed in the foundation of a seminary being built in the New York archdiocese.

The Yankees memorialized Pope Paul's visit to the Stadium by installing a plaque provided by the Knights of Columbus on the center-field fence, alongside the monuments and plaques that honored the team's storied baseball heroes.

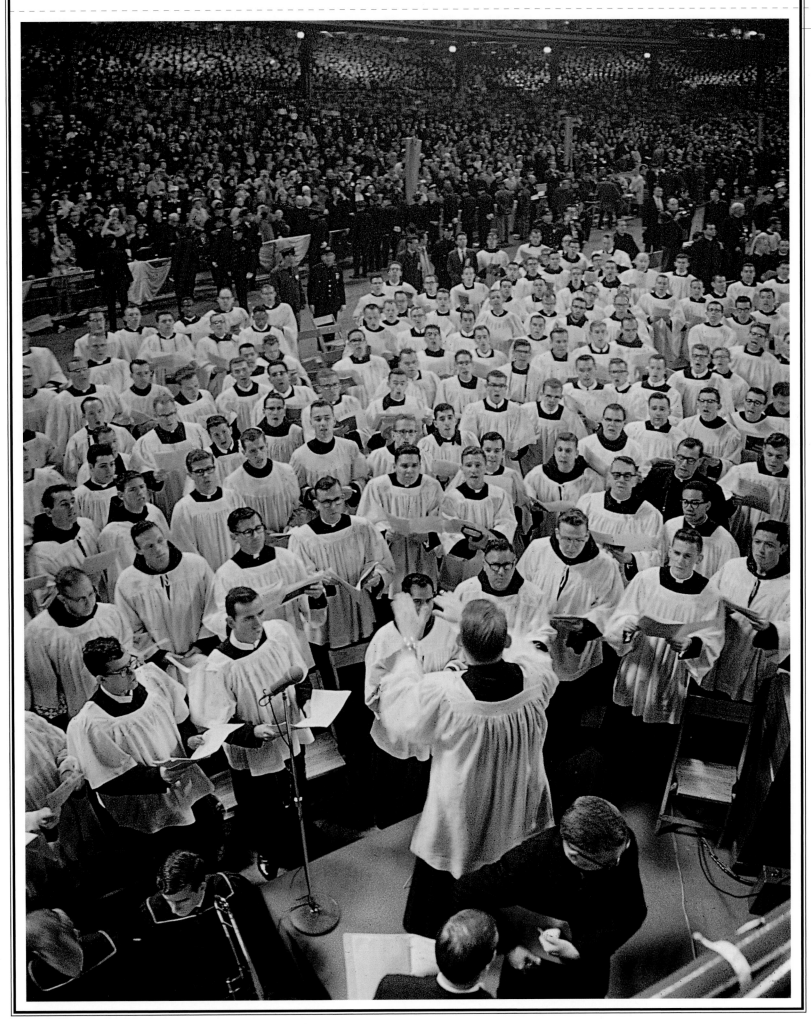

"I PLAYED SANDLOT FOOTBALL AT MACOMBS DAM PARK IN
A CATHOLIC YOUTH ORGANIZATION LEAGUE WHEN I WAS
A KID. DURING ONE OF OUR GAMES, I REMEMBER SEEING
THE ARMY CADETS MARCHING AROUND THE STADIUM AS
IT WAS FILLING UP. I WAS TOO YOUNG AT THE TIME TO
KNOW WHAT WAS GOING ON. BUT THAT WAS THE DAY
ARMY PLAYED NOTRE DAME IN 1946. THAT TURNED OUT
TO BE ONE OF THE KEY GAMES IN NOTRE DAME'S HISTORY,
AND WE WERE PLAYING OUR OWN LITTLE GAME RIGHT
IN THE SHADOW OF IT." — REGIS PHILBIN

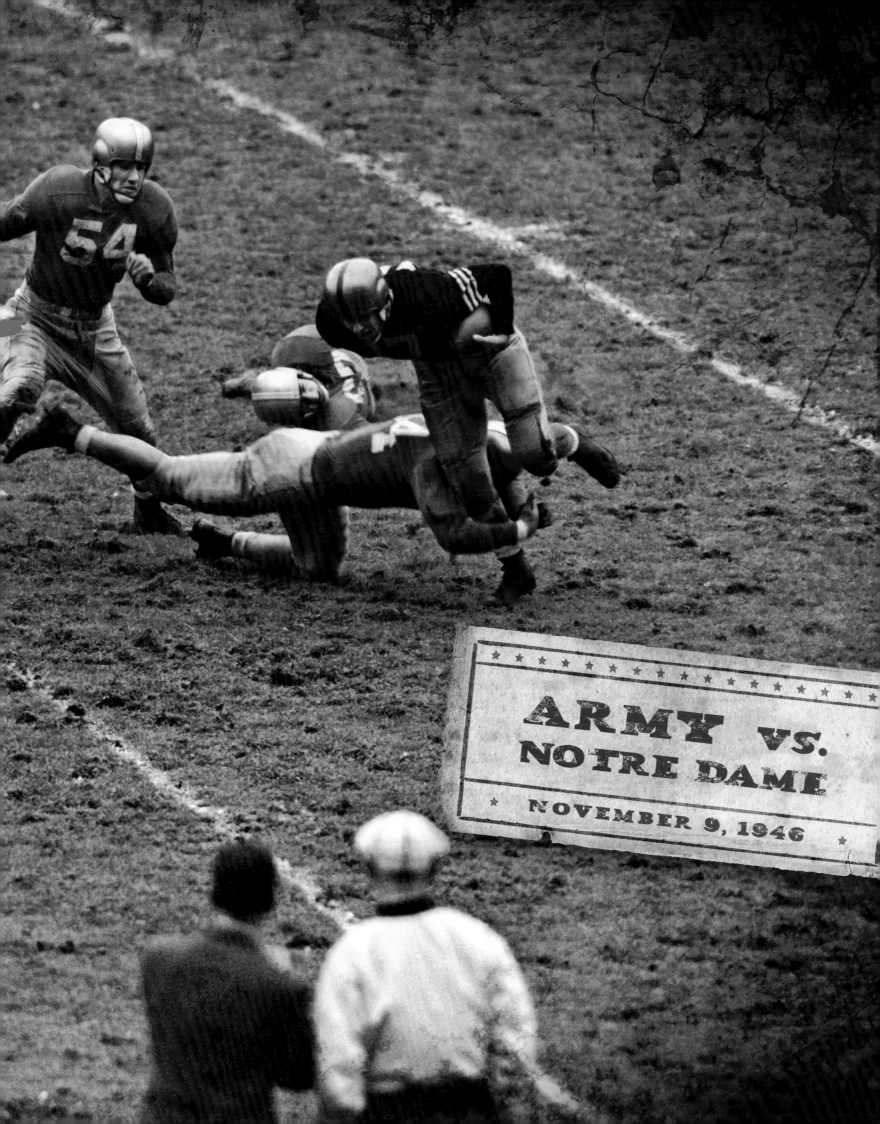

ARMY VS.
NOTRE DAME
NOVEMBER 9, 1946

"FIFTY-NINE AND FORTY-EIGHT, THIS IS THE YEAR WE RETALIATE."

Talk about a clash of titans: The Army-Notre Dame game in 1946 at Yankee Stadium is remembered as one of the greatest defensive standoffs in college football history. The 0-0 outcome was a stunning turnaround—considering Army had routed Notre Dame in their previous two games, 59-0 in 1944 and 48-0 in 1945, while winning two national championships.

Many of Notre Dame's star players had served in the military in 1944 and '45, and they were back on campus in 1946. Notre Dame's rallying cry on campus was:

Fifty-Nine and Forty-Eight,
This Is the Year We Retaliate.

Fighting Irish followers mailed postcards to Army coach Earl Blaik, signing them SPATNC (Society for the Prevention of Army's Third National Championship.)

The public was tuned in to the rivalry. The game was sold out by June, and when the highly anticipated day arrived, more than seventy-four thousand fans poured into the Stadium. Years later, they could say they saw four Heisman Trophy winners on the same field: Army's Doc

Blanchard (1945) and Glenn Davis (1946), and Notre Dame's Johnny Lujack (1947) and Leon Hart (1949).

It soon became obvious that both teams would have trouble moving the ball. Notre Dame approached Army's goal line once, only to be stopped on the four-yard line in the second quarter. Blanchard broke free of Notre Dame's defense on a second-half run and appeared headed for a touchdown, but Lujack caught him at the thirty-seven-yard line. The Cadets got to the twelve-yard line, but no closer.

WHEN WE PLAYED ARMY IN 1946, I WAS TWENTY-ONE YEARS OLD AND I HAD NEVER BEEN TO NEW YORK BEFORE.

To play at Yankee Stadium, "The House That Ruth Built," was one of the great highlights of my career.

I think that most of the hype in the week leading up to the game was with the fans. We prepared like it was any other game. We knew the importance of it, but we didn't feel the pressure.

On the Wednesday before the game, we were doing a pass-defense drill and I stepped into a hole and turned my ankle badly. I spent that night in the infirmary. We weren't sure if I was going to play in the game. Then on Friday, we went to Bear Mountain to practice, and my ankle still wasn't feeling good. The coaches had me punt a few times with my right foot, and it felt terrible. I thought I might play, but I didn't think I could play sixty minutes.

When we took the field, we could feel the excitement from the crowd, but we couldn't tell if they were rooting for Army or Notre Dame. We heard a lot of rumbling. We knew it was a big game because it was number one versus number two.

When you're playing against Doc Blanchard and Glenn Davis, you know that anytime they touch the ball, they might score a touchdown. Both teams were very conservative.

I was playing conservatively because I couldn't push off my right foot when I threw the ball. I threw three interceptions that day, and that's the only time I had three interceptions in my life.

A lot has been said of the tackle I made on Doc Blanchard in the second half. Maybe it was a game-saving tackle, but that is what I was back there for. I was supposed to make that play.

Doc took a handoff, faked to the right, and ran to the left in the backfield. It was the classic counter play. He ran through the hole between our defensive end and our defensive tackle and then broke to the sideline. I was the only guy in front of him, and I made a shoestring tackle. Doc says that if his ankle had been better, I wouldn't have gotten near him. I say that if my ankle had been better, I would have gotten to him earlier.

We were on Army's four-yard line after that, and we could have kicked a field goal. But that's not what teams did in those days. Maybe if we had kicked a field goal and gone ahead 3-0, it would have opened the game up. But I know that no one thought of kicking a field goal. As the quarterback, I couldn't call for a field goal because the kicker wasn't even on the field when I was. More often than not, when we were inside the five-yard line, we would score a touchdown.

Sometimes people say to me, "That game was supposed to end up in a 0-0 tie." I could never buy that, but now that I am getting older, when I hear people talking about that 0-0 tie, I think, maybe it was supposed to be that way.

I talked to Glenn Davis many times after the game. We were good friends for many years. He always said they should have won, and I always told him that we should have won.

We all played our hearts out that day. It was nice to be in New York. It was great to play at Yankee Stadium, and it was great to play against Army. It was something that we knew we would remember all of our lives.

It was one of the greatest games of the century.

Johnny Lujack led Notre Dame to three national championships, won the Heisman trophy in 1947, and later was a player for the Chicago Bears.

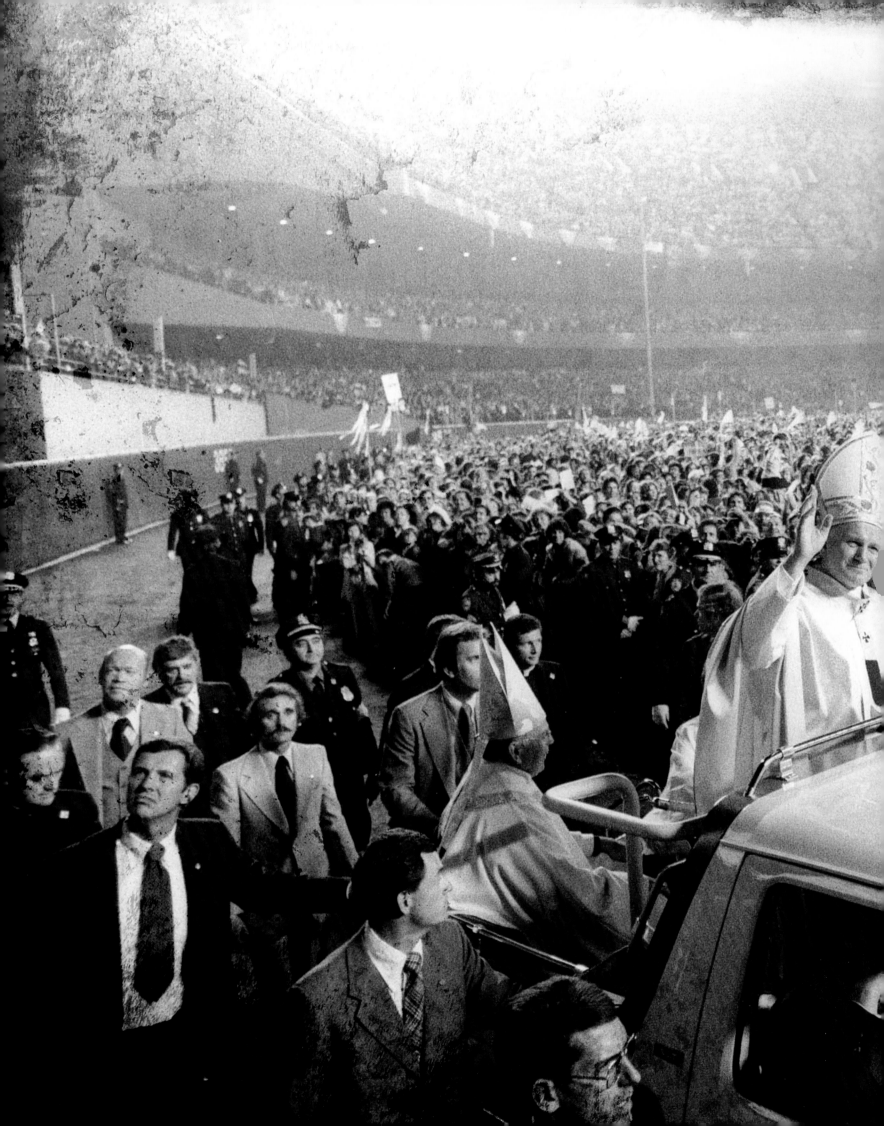

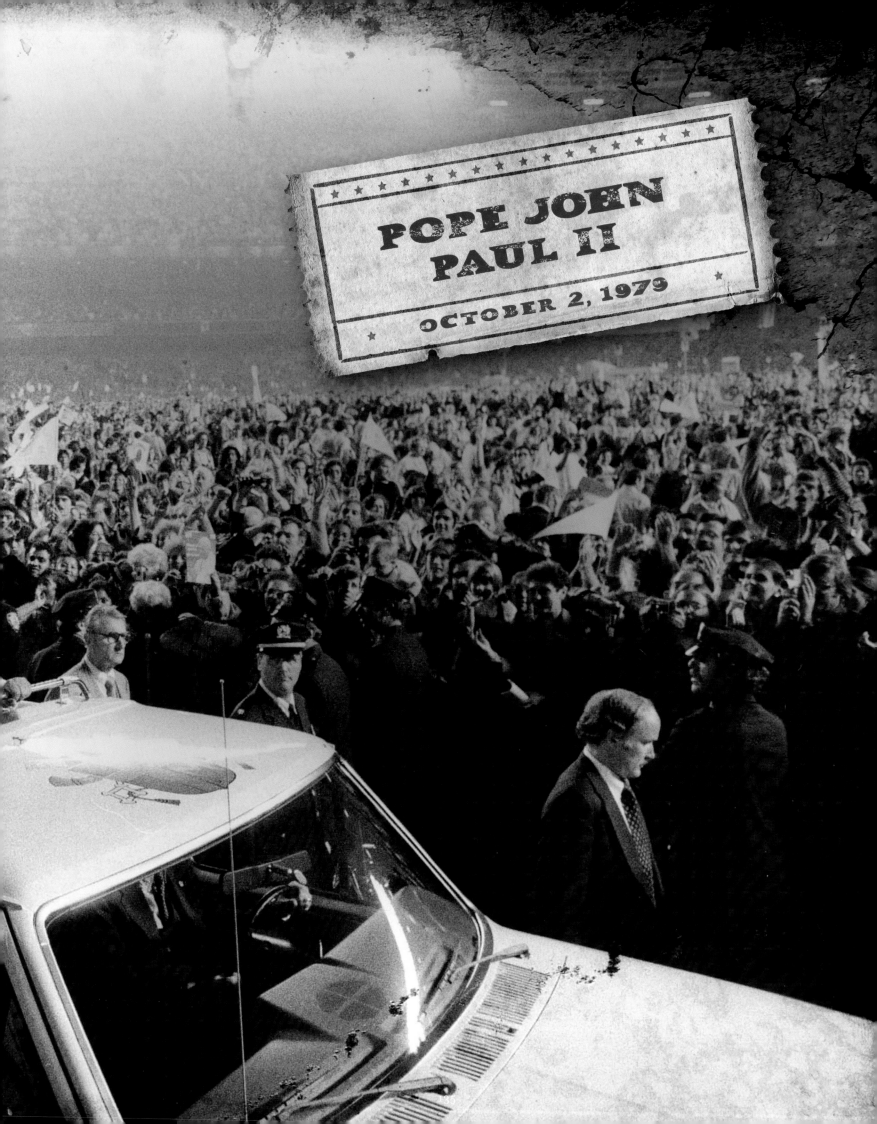

POPE JOHN
PAUL II

OCTOBER 2, 1979

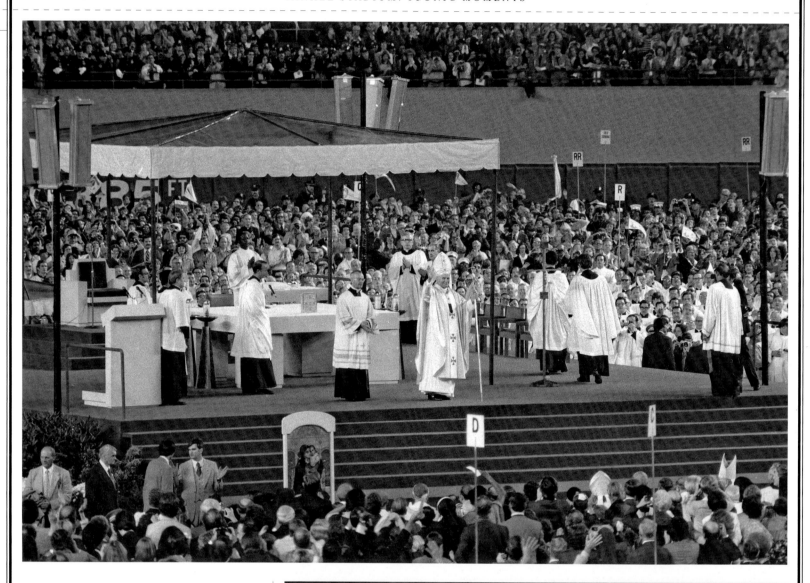

After three straight trips to the World Series, the Yankees fell to fourth place in the American League East in 1979. A difficult season for the Yankees turned tragic in August, when team captain Thurman Munson crashed his private airplane and was killed.

Even without baseball, Yankee Stadium was a focal point of New York City and far beyond for a day in October. More than eighty thousand turned out for the celebration of Mass by Pope John Paul II, the first non-Italian to lead the Catholic Church since the sixteenth century.

It was almost a repeat performance of fourteen years earlier, when Pope Paul VI said Mass at the Stadium. The excitement was overwhelming, especially for those fortunate enough to be in the several thousand temporary seats in the infield area, near an enormous altar erected for the occasion.

Speaking both to the crowd and the world that was watching on television, John Paul lashed out against Western consumerism, calling for

Christians to turn their backs on what he called, "a joyless and exhausting way of life." The crowd seemed captivated by John Paul, who was *Time*'s Man of the Year in 1994, feted for his energy "unmatched by anyone else on Earth," according to the magazine.

The Yankees marked the occasion by placing a plaque provided by the Knights of Columbus in Monument Park. The inscription read: "In commemoration of the Mass for World Justice and Peace Offered by His Holiness Pope John Paul II."

SEVERAL YEARS AGO, A FRIEND POSED A BASEBALL TRIVIA QUESTION TO ME THAT HAS STAYED WITH ME EVER SINCE.

"WHO ARE THREE FORMER CARDINALS WHO HAVE PLAQUES IN MONUMENT PARK?" HE ASKED.

As a hint, my friend declared that many would probably guess the name of one former Cardinal, Roger Maris, the unforgettable Yankees slugger who hit sixty-one home runs in 1961 to break Babe Ruth's record and concluded his brilliant career with the St. Louis Cardinals. The names of the other two former cardinals, my friend observed, are what makes this such a good question with which to stump someone. When I confessed that I did not know the answer, my friend told me, with a twinkle in his eye and a sly grin on his face, that the others are Pope Paul VI and Pope John Paul II, two former cardinals of the Catholic Church, each of whom visited Yankee Stadium, celebrated Mass there during pastoral visits to New York in 1965 and 1979, respectively, and have plaques in their honor in Monument Park.

The occasion for my friend to test my knowledge of Yankee Stadium was my first visit to "The House That Ruth Built" after I became the Archbishop of New York.

Our seats were excellent, and we had barely settled into them when I was informed that George Steinbrenner had invited me and my friends to sit in his personal box. As any baseball fan will attest, you do not say no to The Boss in his Stadium. But this was not our only surprise. Upon entering Mr. Steinbrenner's box—really a suite where one watches the game—I noticed a large photograph of Pope Paul VI celebrating Mass in Yankee Stadium. It was a breathtaking picture in which one could see the huge crowd that had gathered to participate in that monumental and historical event, the first-ever Mass celebrated by a pope in the United States. Seeing the photograph in Mr. Steinbrenner's box was for me a great New York moment.

All of which brings me to a trivia question of my own: What are the only three places in the United States to have the privilege of hosting a pope more than once? The answer is the United Nations, Saint Patrick's Cathedral, and Yankee Stadium. To me, this speaks volumes about the importance of these three venues. One can sense it, too, from a comment once made by the legendary Yankees broadcaster Mel Allen, who was a close friend of one of my predecessors, Francis Cardinal Spellman.

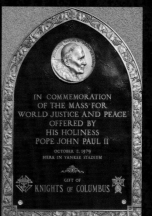

Allen once remarked, "Saint Patrick's Cathedral is the Yankee Stadium of churches." In light of that observation, it was truly fitting that Yankee Stadium hosted the first-ever papal Mass in the United States.

It was October 4, 1965, when Pope Paul VI celebrated that glorious Mass in front of a crowd of nearly eighty thousand. In his homily, the Holy Father greeted all New Yorkers and remarked, "We feel, too, that the entire American people is here present, with its noblest and most characteristic traits."

Imagine, the entire American people in our Yankee Stadium. In that homily, Pope Paul spoke about peace. He said that we must love peace, that we must be willing to serve the cause of peace, and that a lasting peace must have its roots in a religious understanding of life. At the end of the Mass, he blessed a stone that had been removed from Saint Peter's Basilica and brought from Rome by the Holy Father. It was later placed into the foundation of Saint Joseph's Seminary in Yonkers.

From Rome to Yankee Stadium to Saint Joseph's Seminary—what a remarkable journey.

History repeated itself on the night of October 2, 1979, when Pope John Paul II came out of the right-field bullpen of Yankee Stadium to celebrate Mass. Again, tens of thousands were present for this historic event in the Stadium. In his homily, the Holy Father's words rang out through the Stadium, and to the nation and the entire world. "Be not afraid," he pleaded, and those words became the hallmark of his papacy. And they were spoken right here in our city and in our beloved Yankee Stadium.

It is always an honor when a pope visits one's city and one's country. It is a special honor when popes visit two or more times. How great it is that we have had the joy and privilege of two papal visits in our magnificent Yankee Stadium, two glorious opportunities to celebrate the Eucharist with a successor of St. Peter and a vicar of Christ. Yankee Stadium will always hold the memory of those two marvelous days. For this reason, as well as for all the years of exciting baseball, Yankee Stadium will ever maintain a special place in my heart and the hearts of all New Yorkers.

Section Three

Yankee Stadium
BASEBALL
HISTORY

BILL MADDEN

Yankee Stadium was given its formal christening precisely the way its architects and financiers had envisioned—with a big blast from "The Big Bambino," Babe Ruth.

New York sportswriter Fred Lieb had dubbed Yankee Stadium "The House That Ruth Built" because the attendance boom generated by Ruth had helped provide Yankees owners Jacob Ruppert and Colonel Tillinghast L'Hommedieu Huston with the financial resources to build the grand, three-tiered edifice across the Harlem River from the Polo Grounds. When the White Construction Company was awarded a $2.5 million contract for the job on May 5, 1922, it was with specific instructions for a ballpark designed to play to the new game Ruth had single-handedly wrested from the Dead Ball era with his prodigious home runs—a game of power and offense, with shorter fences and an expansive outfield. The architects made certain to keep the park especially friendly for the left-handed-hitting Ruth, with a right-field fence 295 feet from home plate—some forty feet farther than in the Polo Grounds, where Ruth had made his mark as a Yankee in 1921, when he outhomered five of the other seven American League teams.

The magnificent new stadium opened its gates on April 18, 1923, and an announced crowd of 74,200 showed up for the Yankees' game against the Boston Red Sox to a backdrop of impresario John Philip Sousa's marching band. There was anticipation that day the crowd was waiting to see a Ruth home run.

He didn't disappoint. It came in the fourth inning when, with Joe Dugan on first and Whitey Witt on second, Ruth worked the count to two-and-two against right-hander Howard Ehmke and launched a shot into the right-field stands for the first Yankee Stadium home run. It was enough to provide the Yankees with a 4-1 victory, along with the pitching of Bob Shawkey. The home run would define Ruth and the Stadium that was built for him and because of him.

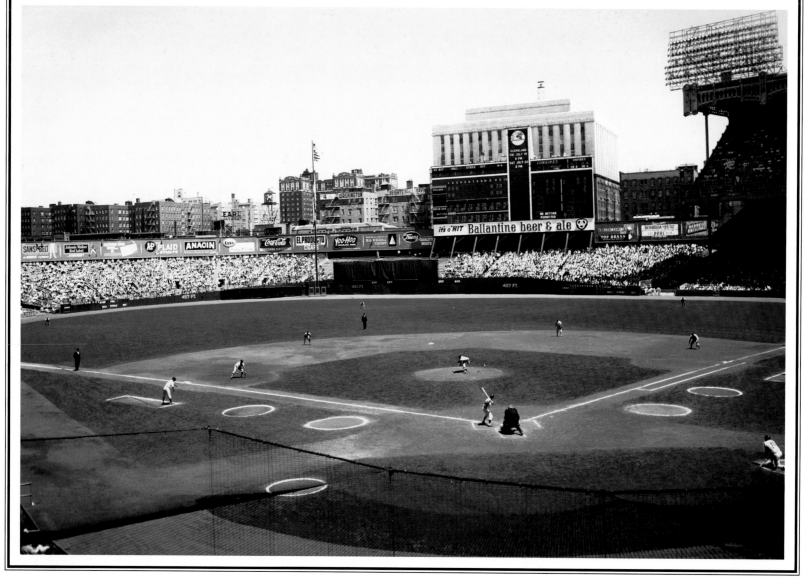

HOME RUNS

Over the years, Yankee Stadium was defined by the home run. After Ruth set and re-set the single-season home-run record, Roger Maris broke it in 1961. And because the Yankees appeared on baseball's center stage in so many World Series and postseasons, the Stadium was the venue for a significant number of the game's most important and dramatic home runs.

But because it was the final game of the season and the Yankees had long since clinched the pennant, a sparse crowd of about ten thousand was all that witnessed it.

It was a similarly empty setting when Maris broke Ruth's record thirty-four years later.

baseball writer who had been Ruth's ghostwriter and personal friend, ruled that for anyone to claim the home-run record, he would have to do it within the parameter of 154 games.

At 154 games, Maris stood at fifty-eight homers, and everyone assumed, because of Frick's edict, the record chase was over. Maris hit number sixty in game 159 on September 26, off Baltimore

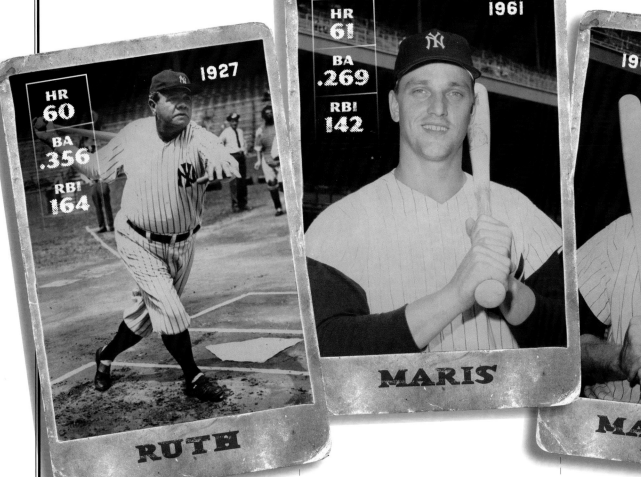

RUTH — HR 60 · BA .356 · RBI 164 · 1927

MARIS — HR 61 · BA .269 · RBI 142 · 1961

MANTLE — 1961 · HR 54 · BA .317 · RBI 128

Four years after opening the Stadium with that homer off Ehmke, Ruth embarked on an assault on his single-season record of 59, set in 1921. Taking full advantage of the made-for-him dimensions and structure, Ruth hit the final eleven of his record sixty homers in 1927 at Yankee Stadium. The sixtieth broke a 2-2, eighth-inning tie against the Washington Senators on September 30. It was a typical high-arching Ruthian blast into the right-field bleachers near the foul pole, hit off left-hander Tom Zachary.

Despite what had been a spirited two-man race for Ruth's record between Maris and teammate Mickey Mantle highlighting the 1961 season, baseball commissioner Ford Frick managed to turn the record-breaking final day of the season into a ho-hum, "playing it out" exercise.

The American League had expanded from eight to ten teams in 1961, and the schedule was lengthened from 154 games to 162. When Mantle was felled by a hip injury in mid-September, Maris kept going. On July 17, Frick, a former

Orioles right-hander Jack Fisher at the Stadium in front of a crowd of less than nineteen thousand. Then Maris took a day off before hitting the record-breaking sixty-first homer on the final day of the season, against the Boston Red Sox's Tracy Stallard.

Maris, too, had a left-handed, made-for-Yankee-Stadium swing—he just didn't hit his homers in quite the same soaring and majestic fashion as the Babe had done. Maris' record-breaker was a line-drive shot that landed some

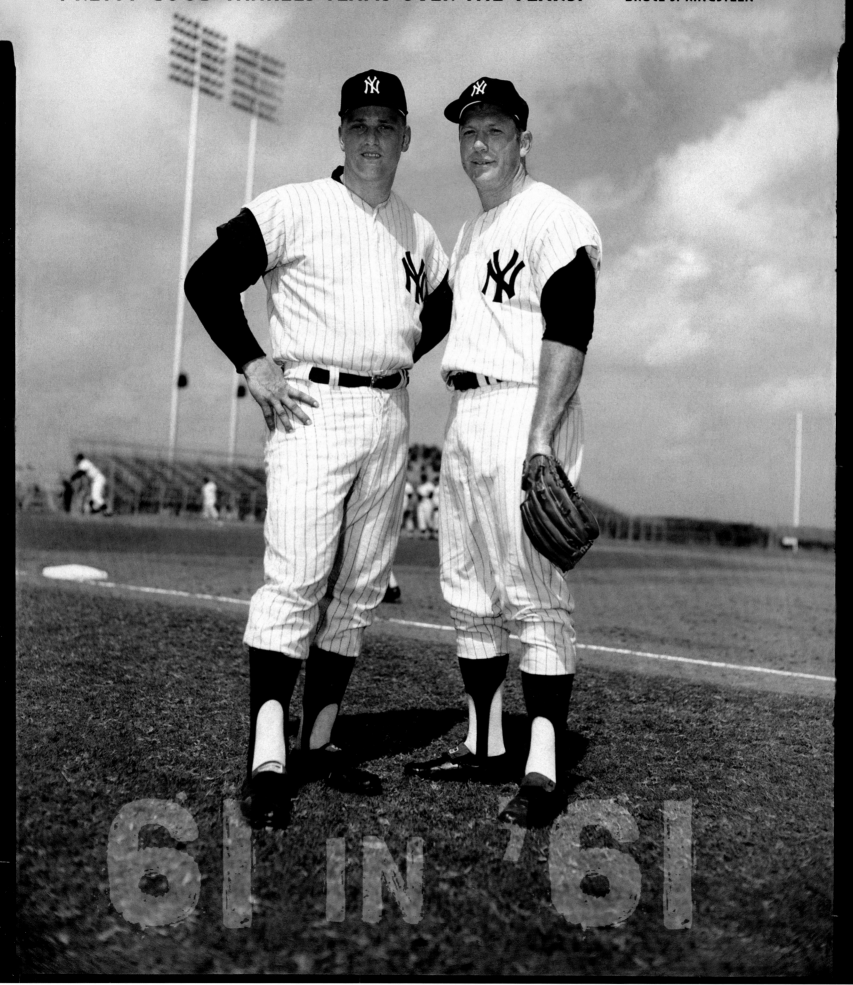

"I GREW UP IN THE '60S WITH MICKEY MANTLE AND ROGER MARIS, AND THE GLORY DAYS AT YANKEE STADIUM. I LIVED THROUGH SOME PRETTY GOOD YANKEES TEAMS OVER THE YEARS." — BRUCE SPRINGSTEEN

61 IN '61

six rows into the right-field bleachers. It would eventually be regarded as one of the signature home runs of all time, but because of Frick, it was considered inconsequential at the time, consigned to an asterisk in the record books and witnessed by only 23,124 fans.

The 1949 season, in which the Yankees won the first of ten pennants in twelve years under Casey Stengel, was one of the most inspired in their history if only because of the gritty nature of that injury-riddled team. A bone spur in his right heel kept Joe DiMaggio out of the lineup until June 28, and the Yankees' two other big bats, Tommy Henrich (back injury) and Johnny Mize (arm injury), were also sidelined for extensive periods. Nevertheless, the Yankees managed to hang tough with the Red Sox, and entering the

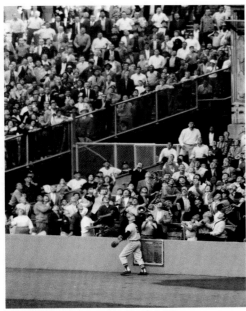

Roger Maris' historic sixty-first home run of the 1961 season soars into the right-field seats at Yankee Stadium.

final weekend of the season, the teams were in a tie for first place with showdown-for-the-pennant games on Saturday and Sunday, October 1 and 2, at Yankee Stadium.

In the Saturday game, the Yankees, buoyed by the sterling six-inning relief pitching of Joe Page, overcame a 4-0 deficit in front of a crowd of 69,551, but it was platoon left fielder Johnny Lindell's tie-breaking homer in the eighth inning that proved to be the signature moment of both the game and the season. With Lindell's homer having provided them a 5-4 win, the Yankees wrapped up the pennant the next day with a 5-3 victory.

Just as a homer had provided the impetus for

HOME RUN FACTOIDS

The Yankees have hit eight home runs in a game at Yankee Stadium on two occasions: June 28, 1939, against the Philadelphia Athletics, and July 31, 2007, against the Chicago White Sox.

•

The Yankees hit four home runs in one inning against the Tampa Bay Devil Rays on June 21, 2005. Jorge Posada homered with one out, and Gary Sheffield, Alex Rodriguez, and Hideki Matsui homered consecutively with two outs.

•

Three Yankees have hit home runs at Yankee Stadium in four consecutive at-bats, though none achieved the feat in one game: Johnny Blanchard, July 21-26, 1961; Mickey Mantle, July 4-6, 1962; and Bobby Murcer, June 24, 1972, in a doubleheader.

•

Many Yankees have hit three home runs in one game at Yankee Stadium, beginning with Tony Lazzeri on June 8, 1827. Only Reggie Jackson did it in a World Series game, on October 18, 1977. (Babe Ruth twice hit three homers in a World Series game, but both times on the road.)

•

Joe Pepitone hit two home runs in one inning at Yankee Stadium on May 2, 1962, against the Kansas City Athletics.

•

On May 17, 2002, Jason Giambi hit a fourteenth-inning, walk-off grand slam to lift the Yankees to a 13-12 win over the Minnesota Twins. Giambi joined Babe Ruth (September 24, 1925, against the Chicago White Sox in ten innings) as the only Yankees to hit a walk-off grand slam with New York down by three runs. Only twenty-two players have achieved it in major-league history—the Yankees were victims on June 21, 1988, when Alan Trammell of the Detroit Tigers connected against Cecilio Guante.

the Yankees winning the 1949 pennant, another homer did the same in their subsequent defeat of the Dodgers in the World Series. This time it was Henrich—he had returned to the lineup on September 23 after a month's absence—who provided the home-run heroics by breaking up a scoreless pitching duel between Allie Reynolds and the Dodgers' Don Newcombe in Game 1 with a leadoff blast into the lower right-field stands in the bottom of the ninth. They didn't call them walk-off homers in those days, but that's exactly what it was. Newcombe, who had struck out eleven, walked none, and limited the Yankees to just four hits to that point, was crushed. He walked off the mound with his head down, and in four subsequent losing starts against the Yankees in the World Series, he never came close

Nineteen-year-old Sal Durante, of Coney Island, New York, reaches high to catch the coveted baseball.

to pitching as fine a game. The Yankees went on to win the 1949 Series in five games.

The Henrich and Lindell homers, coming in the late innings, merely added to the "five o'clock lightning" lore sportswriters attributed to the Yankees, going back to Ruth and the 1927 team. Henrich, years later, used that as the title of his autobiography. In describing his homer off Newcombe, Henrich related that the most memorable part of it was, "Jackie Robinson following me all around the infield to make sure I touched every base."

The arrival of Mickey Mantle in 1951 brought new anticipation—not to mention dimension—for

(continued on page 146)

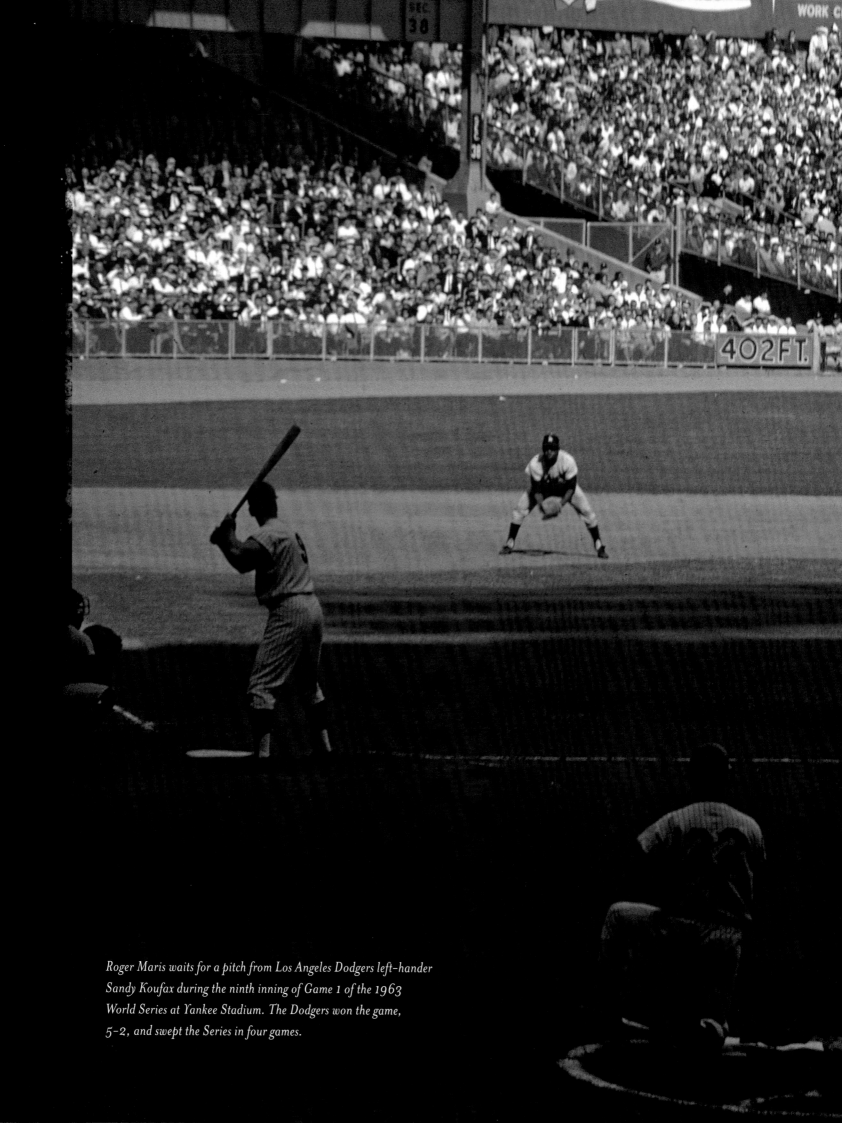

Roger Maris waits for a pitch from Los Angeles Dodgers left-hander
Sandy Koufax during the ninth inning of Game 1 of the 1963
World Series at Yankee Stadium. The Dodgers won the game,
5–2, and swept the Series in four games.

MOST CAREER HOME RUNS BY YANKEES PLAYERS AT YANKEE STADIUM

MICKEY MANTLE	266	JOE DiMAGGIO	148	GRAIG NETTLES	118
BABE RUTH	259	BERNIE WILLIAMS	143	*JORGE POSADA	115
LOU GEHRIG	251	BILL DICKEY	135	*DEREK JETER	103
YOGI BERRA	210	DON MATTINGLY	131	*ALEX RODRIGUEZ	89

*THROUGH THE 2007 SEASON

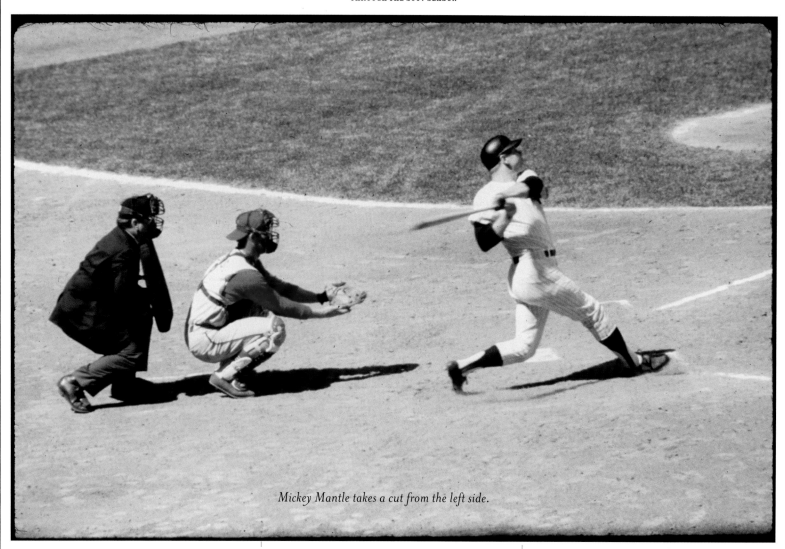

Mickey Mantle takes a cut from the left side.

home-run feats at Yankee Stadium. Scouts could not contain their excitement when discussing the switch-hitting, muscled lad from Oklahoma with the physical gifts of blinding speed afoot and raw power from both sides of the plate. New Yorkers got their first hint of Mantle's awesome power—albeit from afar—on April 17, 1953, when the twenty-two-year-old budding star hit the longest home run ever in Washington's Griffith Stadium, a 565-foot blast off left-hander Chuck Stobbs that cleared the back wall of the bleachers in left-center field and landed in a parking lot across the street. As the ball disappeared from sight, Yankees public relations chief Arthur Patterson reportedly ran out of the stadium with a tape measure to provide a precise recording of how far the ball had traveled.

On May 30, 1956, Mantle wowed the Yankee Stadium audience with his "tape measure" power, coming the closest of any batter ever to hit a fair ball out of the vast ballpark. Against Washington Senators right-hander Pedro Ramos, Mantle hit a ball that, in its descent, struck the upper-deck façade in right field, barely two feet from the roof. Not Ruth, Lou Gehrig, or any of the American League's most imposing and prolific power hitters had ever come close to hitting a ball that far and high in Yankee Stadium.

A couple of weeks later, Detroit Tigers All-Star shortstop Harvey Kuenn was standing at the batting cage at Yankee Stadium, listening incredulously to broadcaster Howard Cosell, who had been at the Memorial Day game, reciting where the ball had been hit. "Mickey's strength isn't human," Kuenn said. "How can any man hit a ball that hard?"

Call it super-human, if you will, but Mantle actually hit a second home run off the Stadium's right field façade, which would have traveled out of any other ballpark. He accomplished the awe-inspiring feat for the second time on May 22, 1963, against Kansas City Athletics right-hander

I PLAYED IN THE WORLD SERIES AT YANKEE STADIUM IN 1957 WITH THE MILWAUKEE BRAVES. EVERYBODY TALKED ABOUT YANKEE STADIUM. THEY TALKED ABOUT THE SHADOWS, AND THIS AND THAT. AS A YOUNG TEAM, MOST OF US WERE SCARED TO DEATH OF PLAYING THERE. WE WERE SCARED WHEN WE WALKED IN BECAUSE WE KNEW THERE WAS GREAT TRADITION IN THAT BALLPARK.

There were some great ballplayers that played there, the likes of Ruth, Gehrig, and DiMaggio. When you walked into that stadium, and you walked into the batter's box, you said "Ah." It's kind of like when you're standing up on the podium at Cooperstown. "I finally made it," you think to yourself.

It was a pleasure to play in Yankee Stadium. We beat the Yankees in seven games, and then they came back and beat us in 1958. It is a tremendous experience for any young player to take the field there, and to know that many greats had played there before. It's kind of like going to Harvard University and seeing all of those old buildings— it's so intimidating. The same goes for playing at Yankee Stadium. It's intimidating just to be there.

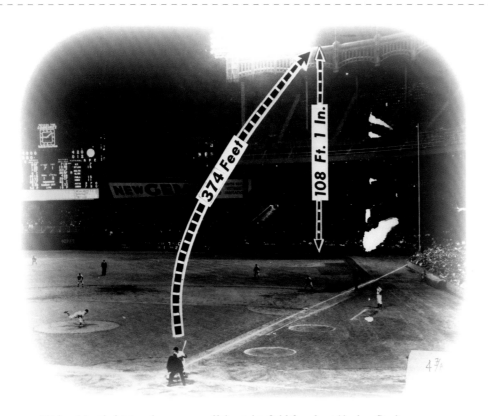

Mickey Mantle hit two home runs off the right–field façade at Yankee Stadium.

Bill Fischer.

What separates the blast off Fischer from the first one is that, as it struck the façade in nearly the same spot as the one off Ramos, the ball was still on the rise.

It is important to note that Mantle's tape-measure homers in Yankee Stadium were not limited to the upper-deck façade in right. Batting left-handed against White Sox right-hander Ray Herbert on August 12, 1964, he hit what is credited as being the longest home run actually measured in the Stadium, a tremendous drive over the old 461-foot sign in center field that landed 502 feet from home plate.

Although not quite the tape-measure shot as some of those others, Mantle's towering upper-deck homer off St. Louis Cardinals' knuckle-baller Barney Schultz in the ninth inning of Game 3 of the 1964 World Series also goes down in the annals as one of the most memorable hit at Yankee Stadium. For one thing, it won the game, 2-1, for the Yankees, and, for another, it

"I WAS AN EIGHTEEN-YEAR-OLD KID WHEN MICKEY MANTLE HIT THAT HOME RUN IN 1963 THAT A LOT OF US STILL THINK IS THE LONGEST ONE HE EVER HIT. IT WAS ASCENDING WHEN IT HIT THE FAÇADE. I STILL RECOLLECT THAT SHOT. I REMEMBER MANAGING IN YANKEE STADIUM IN THE FIRST TWO GAMES OF THE 1982 SEASON, WITH THE CHICAGO WHITE SOX. WE WERE SNOWED

AL KALINE

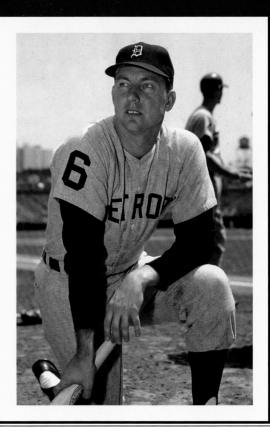

The first time I saw Yankee Stadium was amazing. I took the train to the ballpark with one of the Detroit Tigers trainers. I was just a kid. I took a walk on the field, and I was totally amazed at how big the dimensions were. It had a big outfield at that time with the monuments in center field.

Playing there against all those great Yankees teams was always fun. I always enjoyed playing against the Yankees. They had so many great hitters, so I knew that I was going to get a lot of action out in right field.

I was there for Mickey Mantle Day, and I thought that was outstanding. I was a big fan of Mantle.

There is one game that really stands out. We were leading by one run, and they had a man on base in the bottom of the ninth. Mantle hit a long ball out to right field, and I jumped up and caught the ball. Mel Allen had called it a home run. Our clubhouse manager had turned the radio off right away—he figured everybody was going to be coming in mad. Well, everyone was happy, and he said, "What's wrong?" And they said, "Kaline caught the ball."

gave Mantle the most homers in World Series history (16), breaking a tie with Ruth.

Coming in the World Series, Mantle's homer off Schultz was both historic in scope as well as dramatic. With the Yankees having appeared in thirty-seven World Series at Yankee Stadium, and an additional seven postseasons since the advent of league and divisional championship play, the Stadium has played host to the lion's share of the most significant home runs in history.

In what became the Yankees' equivalent of Bobby Thomson's 1951 "Shot Heard 'Round the World" that won the National League pennant for the Giants over the Dodgers, Chris Chambliss ended the team's twelve-year World Series drought at the Stadium. On October 14, 1976, Chambliss belted a leadoff homer in the bottom of the ninth inning of the final game of the American League Championship Series to give the Yankees a 7-6 victory over the Kansas City Royals. It had been a classic series, with the two teams splitting the

(continued on page 151)

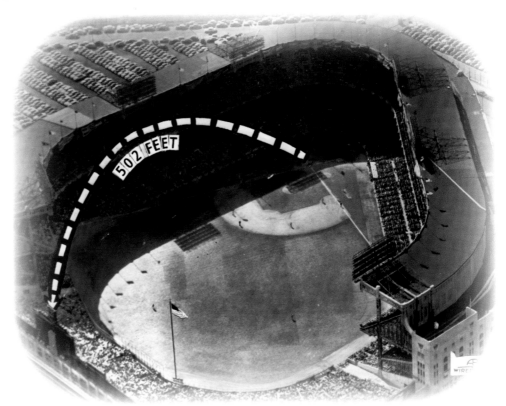

Mantle's homer to center field in 1964 is considered the longest ever hit at Yankee Stadium.

OUT IN CHICAGO, SO WE OPENED ON THE ROAD IN NEW YORK WITH A SUNDAY DOUBLEHEADER. IT WAS JIM LEYLAND'S FIRST DAY IN THE MAJOR LEAGUES—HE WAS ONE OF MY COACHES. WE WON THE FIRST ONE IN TWELVE INNINGS, AND WE WON THE SECOND GAME AS WELL. I HAVE A TON OF MEMORIES FROM YANKEE STADIUM." – TONY LA RUSSA

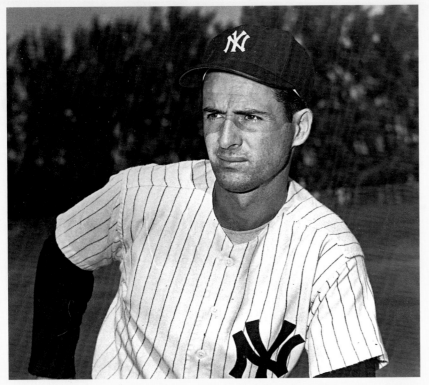

★★ | FIRST PERSON | JERRY COLEMAN | ★★★

Yankee Stadium is where it all began for me. In 1949, which was my first full year in the majors, we won the pennant on the last day of the season against the Red Sox.

I was scared to death that day. We were tied with the Red Sox with one game left to play. The last game of the season was for all the marbles. It was a cool Sunday in October, and we won, 5-3.

In the game, Joe DiMaggio took himself out in the seventh inning. He couldn't get to a fly ball that he knew he should have caught. He retrieved the ball, brought it in, and left the field. No one asked him to leave; he left on his own, because he knew he wasn't well. I will never forget that moment.

When you put on the pinstripes and walk onto that field, you can't help but think back to all the great players who played there and all the championships that were won there. It makes you feel special. For me, the most special thing is when I go to Yankee Stadium and look at all of the championship teams that played there. I played on the 1977 and '78 teams—that's part of Yankees history. It really makes me feel great.

My favorite memories are of the Old-Timers' Day games. The parade of Hall of Famers and great players—from Joe DiMaggio and Phil Rizzuto, to Mickey Mantle, Whitey Ford, and Yogi Berra—is incredible. That's a special, special day at Yankee Stadium.

And when there is a packed house for a Boston Red Sox series, that's pretty special, too.

first four games. The Royals had tied the deciding Game 5, 6-6, on George Brett's three-run homer in the eighth.

For the ninth inning, Royals manager Whitey Herzog brought in Mark Littell, who had led the club with sixteen saves that year, and on the right-hander's first pitch, a high fastball, Chambliss connected and sent a drive over the right-field fence. As soon as the ball cleared the fence, bedlam erupted. Fans poured onto the field, engulfing Chambliss as he frantically

attempted to round the bases and touch home plate. "I ran one guy over," Chambliss said. "All I could see were the fans trying to steal everything they could. They got a lot of the equipment and they tried to get my helmet.

"I know I'll always be remembered for that homer, but I hit another one I was pretty proud of too—off the Dodgers' Burt Hooton in the sixth game of the 1977 World Series. Everybody's forgotten that one, though. It was the same game Reggie hit his three."

Ah, yes. Was there ever a night of such home-run heroics at Yankee Stadium as that one, when Reggie Jackson culminated a season of personal turmoil and torment by tying Ruth's record of three home runs in a World Series game?

Jackson had been at odds with Yankees manager Billy Martin, as well as his teammates, throughout most of his first season with the Yankees after reportedly boasting, "I'm the straw that stirs the drink," to a magazine reporter in spring training. But in the end, Jackson lived

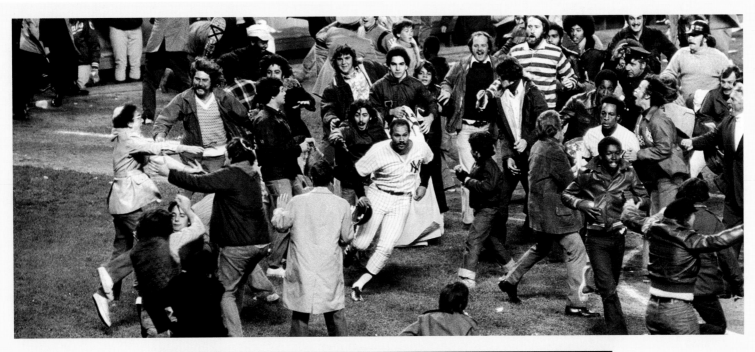

★★★ | FIRST PERSON | CHRIS CHAMBLISS ★★★

When I stepped to the plate in the ninth inning of Game 5 of the 1976 playoffs, the atmosphere was tense. We had a big rivalry with Kansas City. They were a fine ballclub, and we both won a lot of games against each other that year. That particular playoff was the same way. Either team could have won it. And it got down to the last of the ninth inning with a tie score. What a tense situation to be in.

Before I could come to the plate, there was a delay. There were a lot of people sensing the moment, and they threw a lot of junk onto the field, and it took time for the grounds crew to pick everything up. I got very cold while I was waiting. I was just trying to stay loose and stay warm. I left the on-deck circle and went back into the dugout. Finally, we got to the first pitch, and I took a hard swing at it.

I was able to hit that pitch over the fence, and it felt great.

I hit it real high, and their right fielder went back, and it

looked like he could catch it, but it went over the fence. From the second the ball went out, it was magical. That's when all hell broke loose.

I was surprised to see the fans storm the field. They were running across the field. It was pandemonium.

When I got to second base, there was a mob of people around me. They weren't jumping on me; they were just jumping around and trying to get souvenirs. I was afraid that I might fall and have them on top of me. I really didn't want that to happen.

Around the time I got to third base, two New York City police officers helped me get through the crowd and toward home plate. I touched that area, but the fans had stolen the plate already.

When I finally got to the clubhouse, we celebrated just like the fans were celebrating on the field. We went crazy.

I'm proud of what I did that night. I'm proud of my time with the Yankees, and that was the highlight of my career.

up to those words in his own inimitable fashion. He lined the first pitch he saw from Hooton into the right-field stands for a two-run homer that put the Yankees ahead, 4-3, in the fourth inning of the Series' sixth and final game. He hit the first pitch he saw from Elias Sosa for another two-run homer in the fifth, making it 7-3, and climaxed his record-tying night by putting a charge into the first pitch he saw from knuckle-baller Charlie Hough in the eighth and sending it on a high, majestic arc into the center-field black area to complete the Yankees' 8-4 win.

Three pitches, three home runs. The Yankees had dominated the 1977 World Series, and there was no denying the grand finale was all about Jackson, who earned the moniker "Mr. October" that night.

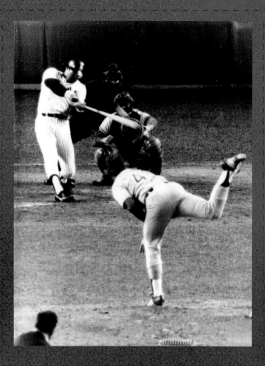

"I felt vindicated," Jackson said. "All that stuff I'd been through with Billy, none of it mattered anymore at that moment. I can't imagine ever feeling as good as I felt, taking that turn around the bases the third time."

Perhaps almost as satisfying, however, was when he made his triumphant return to Yankee Stadium in 1982 after having been allowed to leave as a free agent without an offer from the Yankees. On April 27, 1982, Jackson and his new team, the California Angels, arrived at Yankee Stadium as the first opponents for Gene Michael, who had just replaced Bob Lemon as the Yankees manager. Coming into the game, Jackson was in the throes of a slump.

But in the seventh inning, Jackson connected against a fastball from Ron Guidry, hitting an

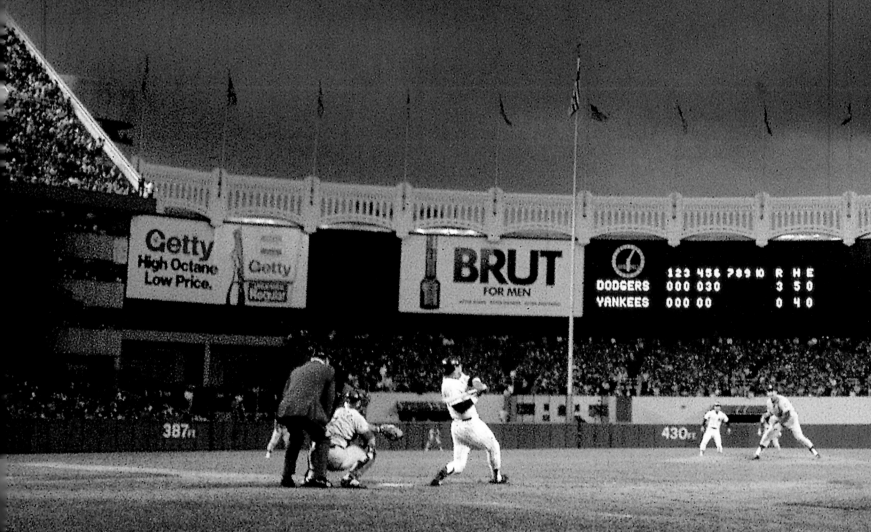

electrifying homer off the right-field façade.

It was a scene reminiscent to the one on Opening Day 1978 at the Stadium, when, following a first-inning home run by Jackson (again on the first pitch, in his first at-bat since the 1977 World Series, giving him four straight homers on four straight pitches), the capacity crowd tossed "Reggie" candy bars onto the field. The candy bars had been given to the fans as part of a promotion by the Standard Brands Company, which had followed up on Reggie's boast a few years earlier in which he said, "If I ever played in New York, they'd name a candy bar after me."

Certainly Jackson had a way when it came to hitting dramatic home runs at Yankee Stadium. But if Jackson fulfilled his destiny as the player most likely to hit prime-time home runs at Yankee

Stadium, then Jim Leyritz would fulfill his as the one least likely.

Leyritz, who played just about any position the Yankees asked him to, was essentially the twenty-fifth man on the team from 1990 through 1996. And while he drove managers batty with his constant pleas for more playing time, he did have a flair for the dramatic.

The first example of that was in the second game of the 1995 American League Division Series between the Yankees and Seattle Mariners, which was as one of the most thrilling postseason games played at the Stadium. Although the Mariners out-hit the Yankees, 16-11, and had four separate leads in the game, it was the Yankees who prevailed on Leyritz's one-out, two-run homer

(continued on page 156)

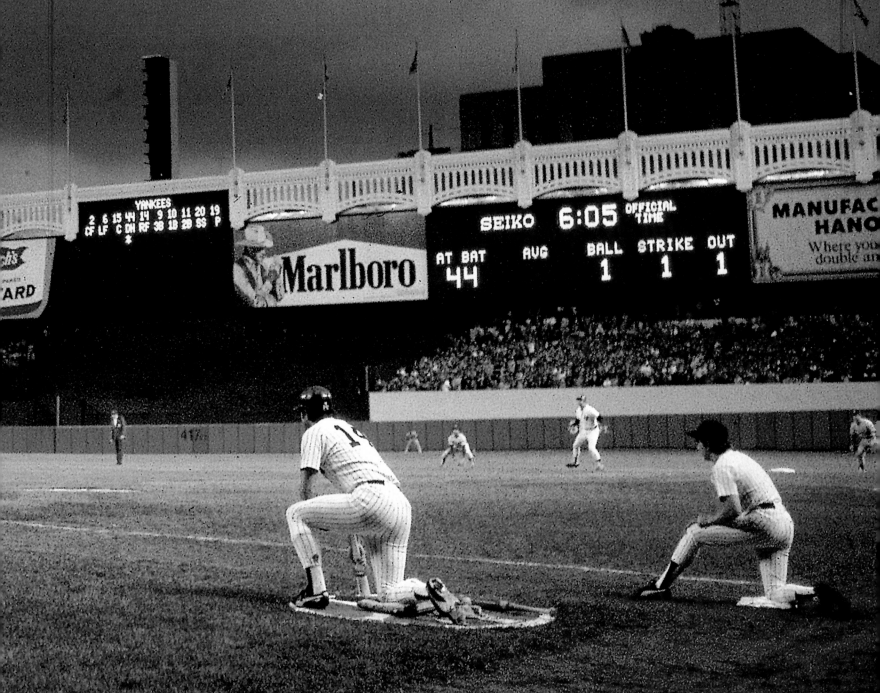

WHAT I REMEMBER ABOUT GAME 6 OF THE 1977 WORLD SERIES IS THAT I HAD AN UNBELIEVABLE BATTING PRACTICE. IF I HAD FIFTY SWINGS, I HIT FORTY BASEBALLS INTO THE STANDS.

Dick Howser threw my batting practice that day. I got a standing ovation as it concluded. I had a few friends sitting in the loge level, and I was very relaxed, so I threw them a baseball. I was certainly amped for the game. We knew it was a game where we could clinch the whole thing, and we didn't want a Game 7, so the intensity was high in the clubhouse before it got started.

It was the second time the Yankees were in the World Series in two years, but it felt like the first time we really had a chance to win it. It was my first World Series with the Yankees, so I certainly understood the importance of ending the Series that night.

The first pitch I saw in my second at-bat was a fastball on the inside part of the plate, and I hit it out. The first pitch in my third at-bat was also a fastball on the inside of the plate, and the result was the same.

I didn't always swing at the first pitch, but in both of those situations the pitcher threw me a strike that I knew I could drive. Throughout my career, I just tried to get a pitch I could hit. Today, the game is more about taking pitches, which we didn't do. I swung and missed too much. I had to take advantage of pitches that I knew I could hit.

After I hit the second home run, I started to think about guys who hit two or three home runs in a World Series game. I knew that I had a chance to do something very special.

I really couldn't believe that they were going to let Charlie Hough face me in the eighth inning. He was a knuckle-baller, and I had had a lot of success against knuckle-ballers in my career.

Again, the first pitch I saw was one that I knew I could do something with—and I did. When I was rounding the bases after my third home run, I felt like I was running on a cloud, like I was six feet off the ground. The next day, I saw pictures of myself rounding second base,

and both of my feet were off the ground. That is exactly how I felt.

When I was rounding the bases after each home run, I signaled to The Boss, George Steinbrenner, who was watching the game from his office. I tipped my cap to him because he had brought me to New York, and we had a special bond. That was the first success we had together.

When I think about that night now, it was certainly a great event in sports, but at the time I was just having a great day in my career. I felt like I was just honoring the contract I signed.

I never thought or worried about failing—not even in that game. I felt like if I failed, I was just like everyone else. I looked at those big at-bats a lot like Derek Jeter does now. I looked at them as opportunities to succeed. I only thought about what I needed to do in order to succeed. I never thought about being booed, or what someone might say or anything like that. It was hard enough to put the bat on the ball; I didn't need to think about anything else.

I was intense, and intent on succeeding. I wasn't nervous. I knew that if I got the barrel of the bat on the ball, I had a chance to make history.

I was in what athletes call "the zone" that night. The game did slow down for me. I could see everything that mattered. I couldn't see who was in the stands or hear what anyone was saying. It was me, the pitcher, and the ball that night. That's all I could see. When he let it go, I was ready to do something with it.

I started out as a young man just trying to be successful. The cards fell into place for me. God touched me on the shoulder a few times, which made me a part of the history of the Yankees. It is one of the greatest things that has happened to me in my life. I am honored to be part of a franchise that is as significant as the Yankees are in America. To have been part of it, to be mentioned as one of the special players who accomplished something that everyone knows about, and that is a part of the Stadium's history, I will always be grateful.

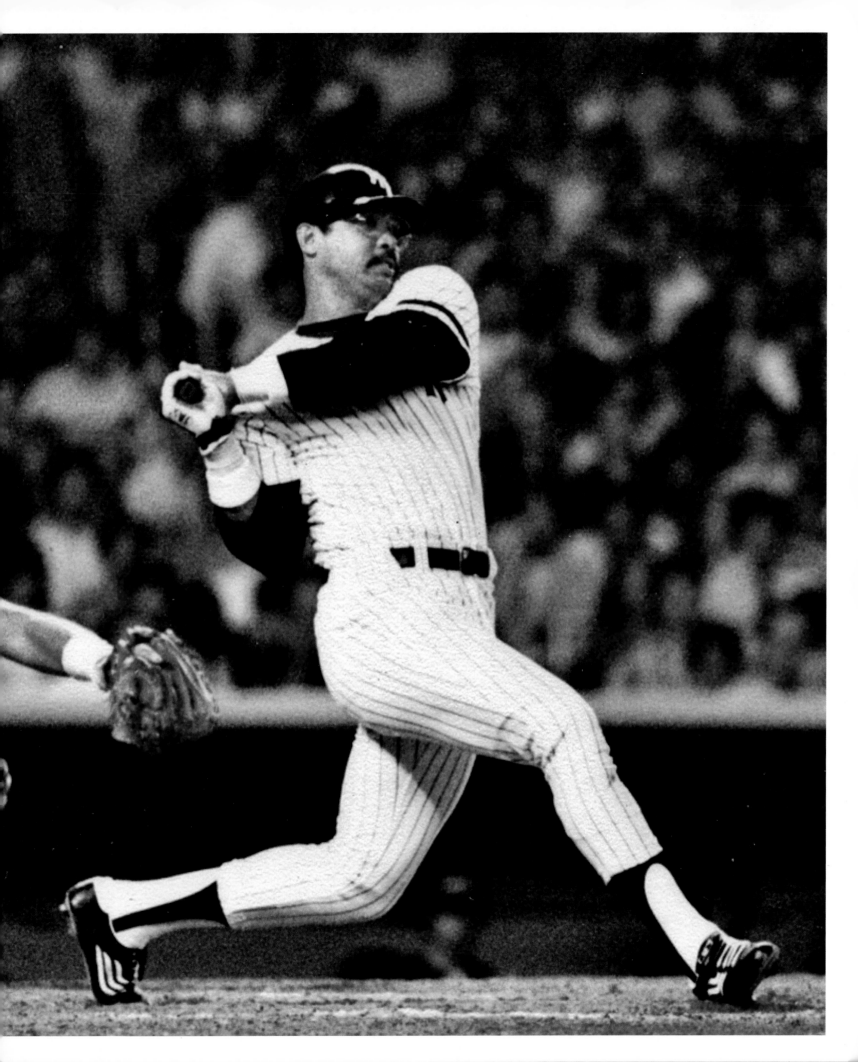

DAVID CONE

There's a mystique about Yankee Stadium. Opposing teams saw that when they came in. We had a great home-field advantage. Yankee Stadium, going back to Babe Ruth and all the history through Joe DiMaggio and Mickey Mantle, and through the Yankees of the 1970s, links generations. Grandfathers can talk to their grandchildren about their favorite players. That sort of history is unmatched anywhere else.

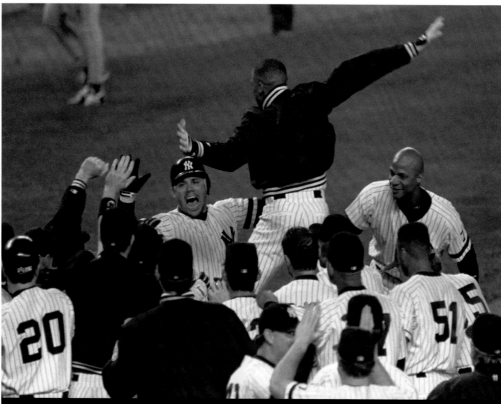

The Yankees celebrate Jim Leyritz's one-out, two-run homer off Seattle's Tim Belcher that won Game 2 of the 1995 American League Division Series at the Stadium.

LONGEST GAME IN POSTSEASON HISTORY
YANKEES BEAT SEATTLE
GAME 2 OF THE 1995 AMERICAN LEAGUE DIVISION SERIES

1:22 AM
15 INNINGS
5 HOURS 13 MINUTES

off Tim Belcher at 1:22 AM in the bottom of the fifteenth inning. The game took five hours and thirteen minutes, longest in postseason history, and moments after Leyritz had circled the bases, the skies opened up over the Stadium, yet most of the 57,126 delirious fans remained in the ballpark, cheering and singing in the pouring rain. What they didn't know was that it would be the final game of the season for them as the Yankees were swept away in the next three games in Seattle.

They would be back again in the postseason the following year under new manager Joe Torre, and so, too, was Leyritz, who, in the eighth inning of Game 4 of the 1996 World Series in Atlanta, hit what can arguably be considered the most important home run of the Torre championship era—a three-run shot off the Braves' Mark Wohlers that brought the Yankees all the way back from a 6-0 deficit and spurred them on to winning the Series in six games.

"I didn't think I could ever top the home run against Seattle," Leyritz said. "That one, coming when it did and where it did, winning the game and making all those New York fans so happy, may have been bigger from a personal standpoint."

As much as Leyritz will likely always have a place of endearment with Yankees fans, he was supplanted at the top of their list of all-time unlikely home run heroes at Yankee Stadium by Aaron Boone in October 2003—if only because of the circumstances under which Boone hit his homer.

A slick-fielding third baseman not particularly noted for his bat, Boone was acquired by the Yankees in a deal with the Cincinnati Reds in July 2003. It was a deal that was greeted with mixed reaction from fans and media, primarily because the Yankees sent their best pitching prospect, Brandon Claussen, to the Reds. When Boone hit only .254 for the Yankees in the last two months of the season, Torre began platooning him occasionally at third base with Enrique Wilson. Wilson started at third base in Game 7 of the 2003 American League Championship Series, as Boone was mired in a five-for-thirty-one postseason slump with nine strikeouts. But after entering the game as a pinch-runner in the eighth inning, Boone was able to erase all of that futility with just one swing of the bat when he came to the plate to lead off the eleventh inning.

(continued on page 162)

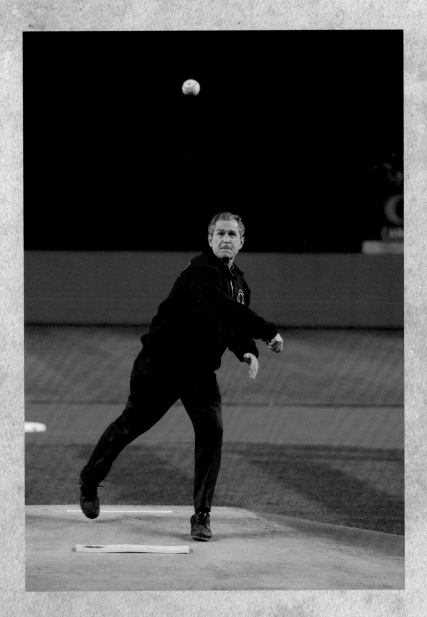

YANKEE STADIUM DESERVEDLY RANKS AMONG THE GREAT LANDMARKS IN AMERICA; CERTAINLY AMONG THE SPORTING LANDMARKS.

The major event at Yankee Stadium that stands out in my memory is, of course, when my son, the forty-third U.S. president, opened Game 3 of the 2001 World Series with that "strike" pitch. The fact that the President went to Yankee Stadium, and in so doing showed leadership, was a great day in American history.

As a young boy, I went to Yankee Stadium with my father quite often. I will never forget the majesty of the Stadium, and the excitement that the baseball played there gave to the entire country. I regret to report that I have not been to Yankee Stadium in a long, long time.

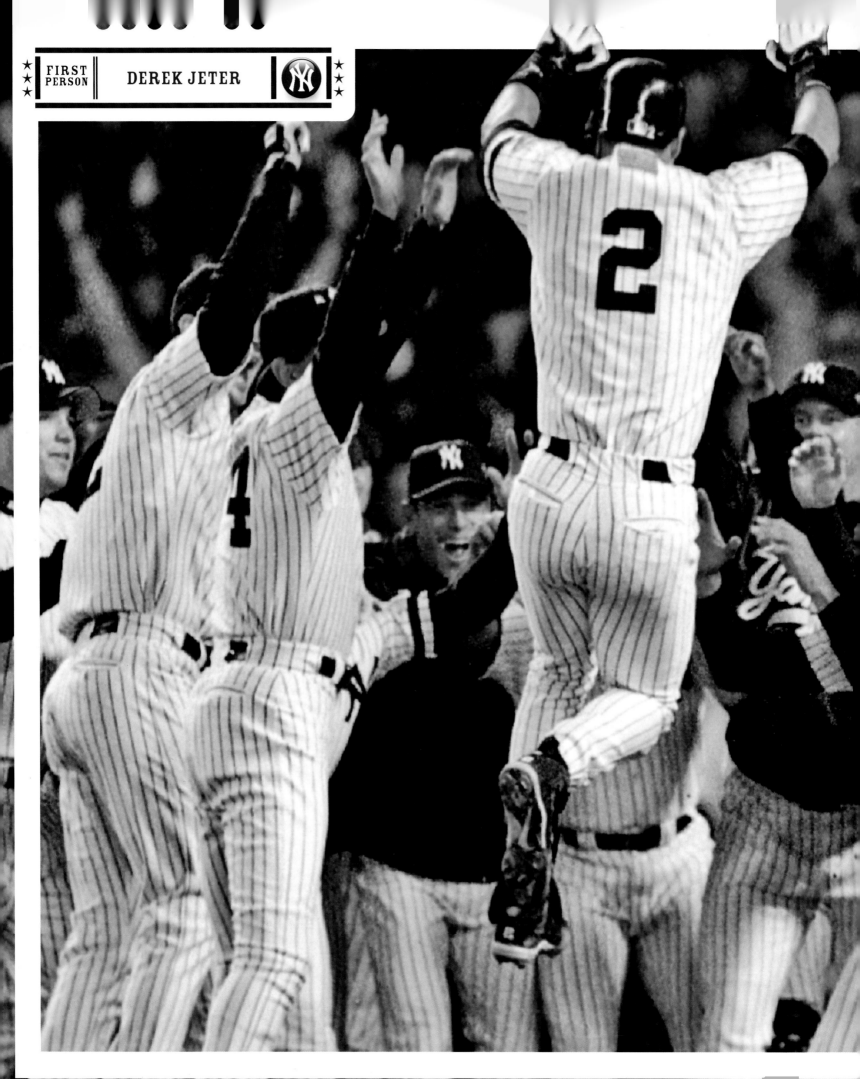

WE WERE DOWN, TWO GAMES TO ONE, GOING INTO GAME 4 OF THE 2001 WORLD SERIES AGAINST ARIZONA. WE WERE DOWN IN THE NINTH INNING BY TWO, AND THERE WERE TWO OUTS WHEN TINO MARTINEZ HIT A HOME RUN TO TIE THE GAME.

I always give my bat to Mr. T, Joe Torre, and his contract was up at the end of October, and it was October 31. I gave him my bat and said, "Well, you got one more hit left in it because after this you don't have a contract." And then when I was hitting in the bottom of the tenth, it turned midnight. That was the last hit he put into that bat under his previous contract.

I was just trying to get on base. It was a tie game, and my job is just to try to get on base. It was a full count, three-and-two. Byung-Hyun Kim throws at a funny arm angle, so I was just trying to get a good pitch to hit and put in play. Fortunately, it went out. It didn't go out by much, and I didn't know right away it went out. I was looking up at it, and then when it went out, it was a good feeling. It was almost like I was in slow motion running around the bases, watching the whole Stadium going crazy. That—and 1996, my first World Series—was probably the loudest I've heard Yankee Stadium. That was after September 11, so there was a lot of emotion in the Stadium. I jumped to touch home plate, and I hurt my heel in the process, but I didn't feel it until the next day.

I had never hit a walk-off home run up until that point. It was a dream come true. Everyone has dreams, whether it is to play baseball or do anything else, and seeing that dream become a reality is the ultimate feeling. I think every kid imagines he's hitting a home run to win a World Series game when he's playing Wiffle ball or T-ball in the backyard. I was fortunate enough to do it.

DURING MY LAST SEASON, I TRIED TO AVOID TALKING ABOUT MY RETIREMENT. WHEN YOU ARE GOING THROUGH THE SEASON, YOU DON'T WANT TO TALK ABOUT WHAT IS GOING TO HAPPEN AFTER THE SEASON BECAUSE IT REALLY DOESN'T HAVE ANYTHING TO DO WITH WHAT IS TAKING PLACE ON THE FIELD.

I think before that last game at Yankee Stadium, I actually told some reporters, "Yeah, this is it," and I think that is why the story broke.

Every once in awhile, it came to my mind during the game, but we were in the World Series, so I didn't allow my mind to get distracted too much until that one inning when they started chanting my name. Then it was kind of hard to think that it was all coming to a close. It was a very memorable thing for me, obviously.

You always remember the World Series atmosphere in Yankee Stadium. We played in other cities, and I played on another team in the World Series, and none of it compares to playing playoff baseball—World Series baseball—at Yankee Stadium. It's because of the passion of the people here. They live and die with the team. Nowhere else do people talk about the game last night every single day of their life. What the Yankees do is just so important to them. In other cities, they can give you a pat on the back and say, "Good year. You didn't win, but good year." In New York, you have to win the World Series. That's the difference.

The atmosphere at Yankee Stadium motivates players. You don't ever take the field with the attitude of, "You know, I don't really feel like doing it tonight." You don't ever have that feeling in Yankee Stadium because of what the people expect, and because of the excitement there. The tradition and the history, it's here. You can feel it when you take the field.

It took me a while to figure out what they were saying, and then I realized it was something in unison and then I realized, "My goodness, it's my name." It was kind of overwhelming. I didn't know what to do because I was stuck. It is not like I could have tipped my hat and ran off the field. I was stuck in right field in the middle of a World Series game that we were losing. It ended up being an unbelievable night because twenty minutes later we tied the game and then won. It was just an unbelievable memory, and the more I talk to people who say they were there, they remember it, too.

When I tipped my hat, I was saying thank you. The fans here have always been great to me. There wasn't really a time where there was a break-in period where I had to win fans over. They were always good to me. I came here at the perfect time, when the team started to turn around. They associated a group of the people on that team as being guys that helped this team win, and that was fun to be a part of. I think we took it for granted a little bit, but looking back now, it was a fun and special time to be playing in New York. When you are playing, you take it for granted, but to win four out of five World Series in a short period of time, teams just don't do that.

I remember going home that night. The emotions you feel when you come back and win a game like that are unbelievable because you are thinking, "We are going to win another World Series." Then I got home that night—my whole family had been at the game, and they were talking about it, and it kind of blew up to where I realized what had just happened. It was just a neat, neat thing that I'll never forget.

Everything was so magnified because of what was going on in this country with 9/11. There were just so many emotions and feelings from everybody, and I think that brought about special things. I saw a big change in New York at that time, the way people looked at each other. It was a period when I was proud to be here in New York, sharing this with a lot of people.

Connecting on the first pitch from Red Sox knuckle-baller Tim Wakefield, Boone hit a high drive into the left-field seats to send the Yankees into the World Series with another dramatic victory over their bitter rivals. Afterward, Boone recounted how Derek Jeter had told him about "ghosts" in the Stadium late in the season.

"He tells me about them all the time," Boone said. "They occasionally make appearances in September and October."

Still, in terms of ghosts and the unleashing of unbridled joy at Yankee Stadium, no home runs were bigger or more significant to the city's consciousness than the ones struck by Tino Martinez, Jeter, and Scott Brosius against the Arizona Diamondbacks in the 2001 World Series. It was barely a month and a half after the terrorist attacks on the World Trade Center, and New York City was still in mourning; numbed from the thousands of lives lost, and in desperate need of a diversion from the tragedy that lingered. The

Yankees had done their best to be that diversion, coming back from an two-games-to-none deficit to beat Oakland in the best-of-five American League Division Series and then dispatching the Seattle Mariners in five games in the ALCS to advance to their fourth straight World Series.

After losing the first two games in Arizona, it appeared as if maybe the Yankees, too, had their emotions spent. Then Roger Clemens and Mariano Rivera combined on a three-hitter for a 2-1 victory in Game 3 at the Stadium, and it was as

if the city was instantly rejuvenated. A boisterous crowd of 55,863 showed up on Halloween night for Game 4 and settled into a tense trance as Arizona's Curt Schilling and Orlando Hernandez dueled into the seventh inning with the score tied, 1-1. After the Diamondbacks scored two runs off the Yankees bullpen in the eighth, Arizona manager Bob Brenly entrusted Byung-Hyun Kim to close the deal. It looked like Kim was up to the task, as he struck out the side in the eighth and retired two of the first three Yankees in the

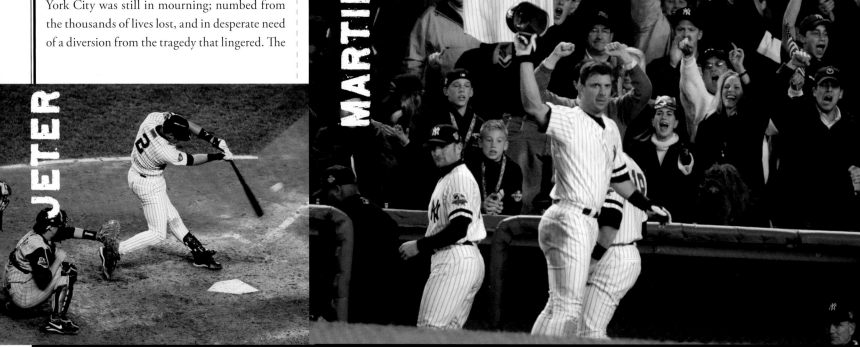

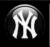

★★★ **FIRST PERSON** ★★★ **TINO MARTINEZ**

When I was in the on-deck circle in the ninth inning of Game 4 of the 2001 World Series, I kept telling myself, "Just have a good at-bat." I wasn't worried about winning or losing a World Series game. I was just looking to get a good pitch to hit and drive it somewhere.

There were two outs, and we were down by two. Paul O'Neill walked, and I just wanted to extend the inning. I wanted to get a line drive and get on base. I wanted to give the next guy a chance to win the game. I was looking for a first-pitch fastball, and that's what Byung-Hyun Kim threw. I hit it perfectly. It was a low line drive that I thought was going

to hit the wall. But it just kept going. I was surprised that it went over the wall. The reaction from the fans as I was rounding first base was incredible.

Yankee Stadium is above and beyond any other venue in sports. To be able to wear that pinstriped uniform and play in the Stadium day in and day out is something most players can only dream of. I wish every player had the chance to experience it, because I can't really explain how humbling it is.

ninth. One out away from victory after fanning Bernie Williams, Kim was rocked by a game-tying, two-run homer over the center-field fence by the previously hitless Martinez.

The following inning, with Kim still pitching, Jeter, who was only one-for-fifteen to that point in the Series, won the game moments after the stroke of midnight by homering down the right-field line after fouling off three two-strike pitches. Amid the crowd's pandemonium and the sound of Frank Sinatra's "New York! New York!" bellowing out of the public-address system, the center-field scoreboard flashed "Mr. November!" as Jeter triumphantly circled the bases.

"When I first hit it, I had no idea it was going out," said Jeter, "but once it went out, it was pretty special. I've never hit a walk-off homer."

The momentum of the Martinez and Jeter homers carried into the next night. In almost surreal identical circumstances, Kim was again on the mound in the ninth inning, this time attempting to preserve a 2-0 lead. After yielding a leadoff double to Jorge Posada, Kim retired the next two Yankees, bringing Arizona to the brink of a three-games-to-two Series lead, only to again be victimized by the long ball as Brosius tied the game with a homer over the left-field fence.

Three innings later, the Yankees won it, which proved to be their last hurrah of the season. The Diamondbacks took Games 6 and 7 in Arizona, but for a wounded and devastated city, the Martinez, Jeter, and Brosius home runs had done more to lift spirits than anyone could have imagined.

BROSIUS

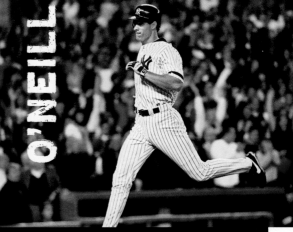

O'NEILL

SCOTT BROSIUS

FIRST PERSON

The 2001 playoff run was especially memorable. We dropped the first two games of the Division Series against the Oakland A's at home, picked up the next two in Oakland, where I had started my career, and came back to the Stadium for Game 5. One of the things that I remember specifically about Game 5 is ending up on second base in the second inning after Alfonso Soriano drove in two runs to tie the game, 2-2.

As I stood at second base, the energy and the noise in the Stadium was so loud and intense that the ground was shaking. I had experienced that before in a dome, but I'd never experienced that in an outdoor stadium, and I thought to myself, "This is just so amazing." Given everything that had gone on with September 11, it was just an awesome moment.

On a more personal level, I will never forget my first Saturday afternoon game at Yankee Stadium. I was a visiting player with the A's. It brought back everything about my childhood and the dream of playing in the big leagues. When I was a kid, the Saturday Game of the Week on TV was all we had, and it usually featured whatever team happened to be winning. Many times, it was the Yankees, and so those games meant Yankee Stadium and the monuments.

I remember getting to the Stadium early and walking through Monument Park. There were still people out on the field, the sun was shining, and it hit me: "This is the big leagues. This is Yankee Stadium."

With the history and the people that have played there, Yankee Stadium is more special than any other ballpark, even for visiting players. It continues to be a place where people expect special things to happen, and you're never let down.

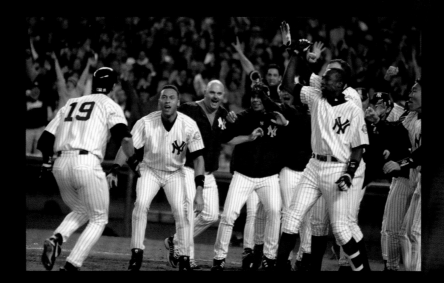

AARON BOONE'S HOME RUN AGAINST THE RED SOX IN GAME 7 OF THE 2003 ALCS IS MY FAVORITE MEMORY OF YANKEE STADIUM. THAT HOME RUN WAS SO IMPORTANT BECAUSE IT MEANT ONE TEAM WAS GOING TO THE WORLD SERIES AND ONE TEAM WAS GOING HOME IN THE MOST INTENSE RIVALRY IN THE HISTORY OF SPORTS.

That was an incredible night, more so than when we won the World Series in 1996, because we still had another game if we had lost. The Stadium was rockin' when we had those late comebacks against Arizona in the World Series, but that was in the middle of the Series. With the Aaron Boone home run, there was so much on the line. There were no games left in that series—it was Game 7.

I was excited that we had an opportunity to win that game after we scored three runs in the eighth inning to tie it. But the job wasn't finished yet. You can fight back all you want, but if you lose the game, it's meaningless. It was an exciting inning because we got back into the game, but it didn't compare to the eleventh inning. To see Aaron Boone, who hadn't been hitting at all, come to the plate against Tim Wakefield, who had dominated the Yankees for so long—it was a very unexpected home run. I wasn't thinking, "Something great could happen here." It was very unexpected, and that made the moment so special.

It's a great honor to be able to walk into this building and have the opportunity to work for a franchise that is so special. There have been so many great moments at Yankee Stadium. When I walk down the hallway and see some of the black-and-white pictures of the great Yankees that played here, I can't help but feel they are somehow involved in this place today. They are the caretakers of Yankee Stadium.

I have no doubt that our players think about the people who once sat in their lockers, or who pitched off the same mound as they do, or who wore their numbers. I know that Joe Torre is aware that he is tied to the great managers of the past, like Miller Huggins, Casey Stengel, Joe McCarthy, and Billy Martin. It is all connected. You may not know the people that came before you, but regardless of the job you are doing, you are playing a part in continuing the tradition of Yankee Stadium.

Brian Cashman is the Yankees general manager.

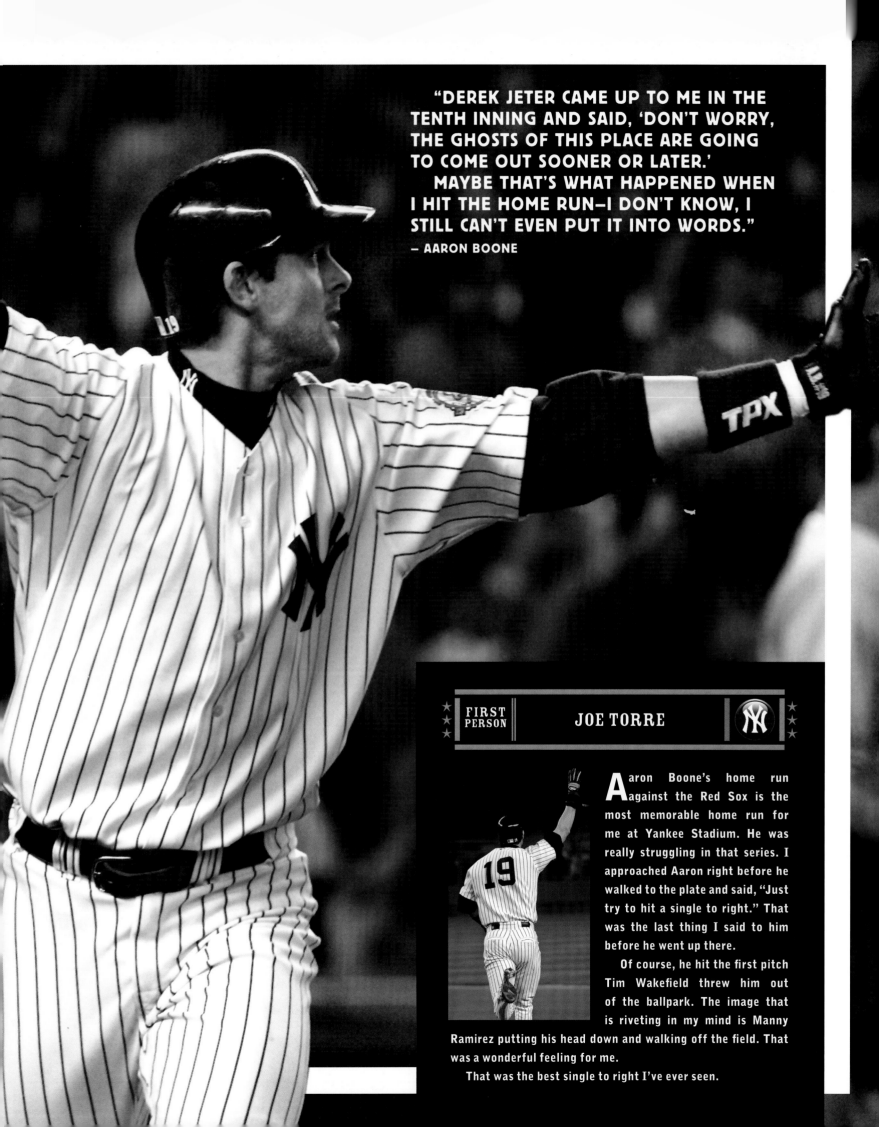

"DEREK JETER CAME UP TO ME IN THE TENTH INNING AND SAID, 'DON'T WORRY, THE GHOSTS OF THIS PLACE ARE GOING TO COME OUT SOONER OR LATER.' MAYBE THAT'S WHAT HAPPENED WHEN I HIT THE HOME RUN—I DON'T KNOW, I STILL CAN'T EVEN PUT IT INTO WORDS."
– AARON BOONE

★ FIRST PERSON ★ JOE TORRE

Aaron Boone's home run against the Red Sox is the most memorable home run for me at Yankee Stadium. He was really struggling in that series. I approached Aaron right before he walked to the plate and said, "Just try to hit a single to right." That was the last thing I said to him before he went up there.

Of course, he hit the first pitch Tim Wakefield threw him out of the ballpark. The image that is riveting in my mind is Manny Ramirez putting his head down and walking off the field. That was a wonderful feeling for me.

That was the best single to right I've ever seen.

TURMOIL AND TRAGEDY

According to the Elias Sports Bureau, 10,922 homers were hit in Yankee Stadium from its inception in 1923 through 2006. While a hundred or so of them were what you could call defining or historic, not all were hit by Yankees or struck by renowned sluggers in critical games. Probably the most notable Yankee Stadium homer to be struck by an opponent was the one by the Kansas City Royals' George Brett on July 24, 1983, if only because it touched off one of the biggest controversies in baseball history.

It had been a season of seemingly non-stop conflict between the Yankees, umpires, and baseball officials, primarily due to the

the little-known and seldom-applied rule 1.10 b in the official rule book. Sure enough, as Brett crossed the plate, Martin came running out of the Yankees dugout and team captain Graig Nettles came running in from third, hollering to home plate umpire Tim McClelland and pointing to Brett's bat. Upon hearing Martin's protest, and examining the bat and laying it across the plate to measure it, McClelland conferred with the other umpires and determined that the pine tar did exceed the legal eighteen inches, and he nullified the homer. The scene of Brett charging out of the dugout like a raging bull at McClelland is part of classic baseball highlight film lore, but the "Pine

said when the rule was drawn up, there was no thought of the batter being declared out but rather that the bat had to go," MacPhail explained.

In the interim twenty-five days, the "Pine Tar Game" dispute raged through the courtrooms of the Bronx and Manhattan, as well as the baseball offices at 350 Park Avenue. Steinbrenner brought in the flamboyant trial lawyer Roy Cohn to pursue justice for the Yankees against MacPhail. In the end, all the lawsuits were dismissed, and when the game resumed, only 1,245 fans showed up at the Stadium to watch what amounted to a twelve-minute, four-out mockery in which Martin, in continuing protest, had Ron Guidry in center

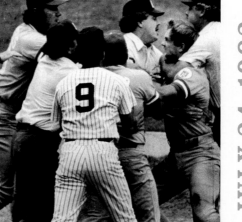

JULY 24, 1983

The Yankees and the Kansas City Royals played the infamous "Pine Tar Game" at Yankee Stadium. New York took a 4-3 lead into the top of the ninth. After the first two batters were retired, U.L. Washington reached base on a single, and George Brett hit a home run off Goose Gossage for an apparent 5-4 lead. But at the request of the Yankees, umpire Tim McClelland measured Brett's bat and ruled that it had pine tar too far up the handle, beyond the eighteen-inch limit. McClelland nullified the homer, and declared Brett out. The incensed Brett sprinted out of the dugout to confront McClelland, and soon was joined by players on both teams. But the game was over, with the Yankees a 4-3 winner—or so it seemed. The Royals protested to the American League, which reversed the umpire's decision, upheld Brett's home run, and ordered that the game be completed. On August 18, the game was resumed from the point of the home run in front of a crowd of 1,245 at the Stadium. Kansas City's Hal McRae struck out to end the top of the ninth, and Dan Quisenberry retired the Yankees in order in the ninth. It took twelve minutes, and the Yankees came up short, 5-4.

ever-combative nature of Yankees manager Billy Martin and the outspoken Yankees owner George Steinbrenner. On this day, the Yankees were leading the Royals, 4-3, going into the ninth inning, when Kansas City went ahead on Brett's two-run homer off Goose Gossage.

What Brett, the Royals, and even the umpires didn't know was that the Yankees had been observing the excessive pine tar on Brett's bat for a couple of weeks and had privately determined that it probably exceeded the allowed eighteen inches from the end of the bat, as detailed in

Tar Game" controversy had only just begun.

Four days later, American League president Lee MacPhail upheld the Royals' protest of the umpires' decision, declaring that the "spirit of the rule" had not been applied by the umpires. It was MacPhail's determination that Brett's bat had not been intentionally doctored to "improve distance on the ball." Thus, he said, the home run counted and the game should be picked up from that point on August 18, an open date for both clubs.

"I talked to the rules committee, and they

field in place of Jerry Mumphrey, who had since been traded to Houston, and the left-handed Don Mattingly playing second base.

"I have to admit," said MacPhail, "after all that had happened, I didn't have the guts to sit in the American League box. I sat upstairs, where nobody could see me."

While Brett's mad charge at McClelland will surely rank as one of the scariest incidents of unleashed rage in Yankee Stadium, the big ballpark has had its share of celebrated brawls. Among the most memorable: Joe Pepitone's

beanball rumble with Cleveland Indians right-hander Gary Bell in the second game of a doubleheader on August 22, 1963; Graig Nettles' kayo of Boston left-hander Bill Lee, May 20, 1978, in the most vicious of all Yankees-Red Sox brawls; Reggie Jackson's homer and the ensuing melee after the Yankees slugger was decked by a pitch from temperamental Indians right-hander John Denny, September 23, 1981; and the terrifying mayhem that broke out on May 19, 1998, after Tino Martinez was plunked in the back by a hundred-mile-per-hour fastball from Baltimore Orioles closer Armando Benitez.

According to Pepitone, Indians manager Birdie Tebbetts had targeted him for harm after he'd been on base ten times in thirteen plate appearances in the series against the Indians, including three-for-four in the first game of the doubleheader.

"I heard Tebbetts had told his pitchers that for every time they missed me, it would cost fifty dollars," Pepitone said. "So after Barry Latman hit me on the wrist in the third inning, and Bell hit me in the [butt] my next time up, I cussed him out going to first base and then all hell broke out. After I threw down [Indians first baseman] Fred Whitfield, I saw the whole Cleveland ballclub coming at me."

The Nettles-Lee dust-up, probably the definitive fight in the long Yankees-Red Sox rivalry in terms of punches landed and physical harm inflicted, was precipitated by a hard collision at home plate between a sliding Lou Piniella and Red Sox catcher Carlton Fisk. Fisk took umbrage to the manner in which Piniella had plowed into him and immediately came up swinging, prompting both dugouts and bullpens to empty. In the ensuing fights that broke out all over the infield, Nettles squared off with Lee and flipped the pitcher onto the ground, breaking his collarbone.

Another lively and memorable Yankees-Red Sox brawl at the Stadium occurred on May 30, 1938, in the first game of a doubleheader, witnessed by 81,841, the largest crowd for a baseball game in Stadium history. After Yankees outfielder Jake Powell was hit by a pitch from Red Sox left-hander Happy McKain, he charged the mound only to be intercepted by Red Sox

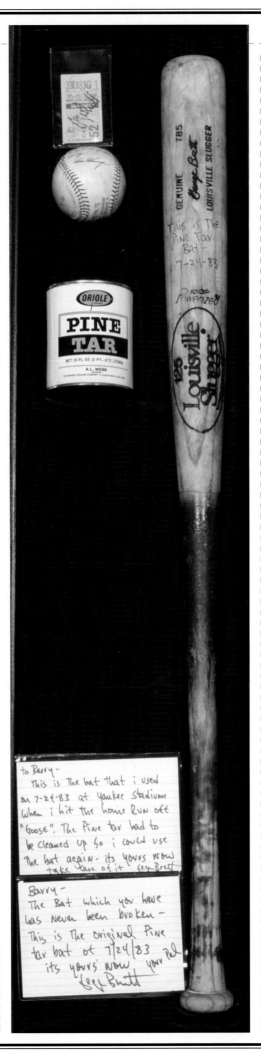

shortstop and player-manager Joe Cronin. Both Cronin and Powell were ejected for fighting, but they weren't done. They resumed their fisticuffs under the stands and had to be separated again, this time with Cronin sporting scratches all over his face. It was thus a winning day over all for the Yankees, who swept both ends of the doubleheader.

In contrast to that largest baseball crowd in Stadium history, the smallest crowd was 413 for a makeup game with the Chicago White Sox on September 22, 1966, a day that resulted in further Yankees' infamy when legendary announcer Red Barber was fired by team owner CBS for ordering the television cameras to pan the empty stands.

Jackson's face-off with Denny, while not nearly as sustained or violent as some other fights at Yankee Stadium, was nevertheless memorable if only because of Jackson's uncanny flair for the dramatic. Denny, who was seeking his seventh straight win, had a 2-0 lead in the second inning when, with two runners on base, he knocked Jackson back with a fastball under his chin and then struck him out two pitches later. Both embarrassed and enraged at striking out, Jackson charged the mound, and both dugouts cleared. No punches were thrown, however, as Jackson was restrained by teammates.

"The playoffs are coming up, and I'm a free agent," Jackson declared. "I didn't want to break a hand and hurt myself, or the ballclub. But you keep getting knocked down and knocked down, and then somebody throws a ball close to you, and you react."

In his next at-bat, in the fourth inning, Jackson hit a two-and-two pitch from Denny into the right-field seats with Dave Winfield on base to put the Yankees ahead. Before circling the bases with a grin of satisfaction on his face, he paused at the plate long enough to pump his fists and tip his hat to the crowd. As Jackson touched home plate, Denny, who had been glaring at him the whole time, moved toward him, prompting Reggie to again charge the mound. Once more, he was restrained by teammates, and after going back to the dugout, he re-emerged onto the field with his uniform shirt off as if to challenge Denny to a third round with the Stadium crowd urging

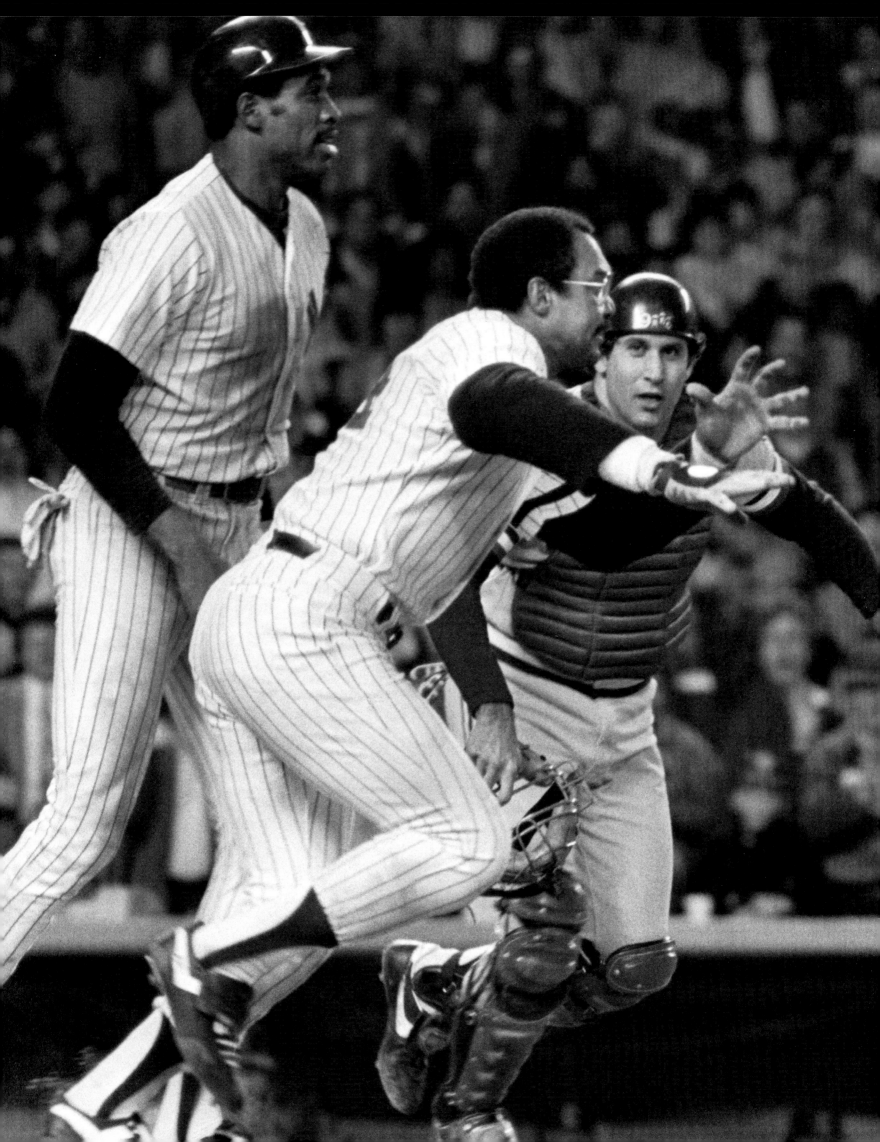

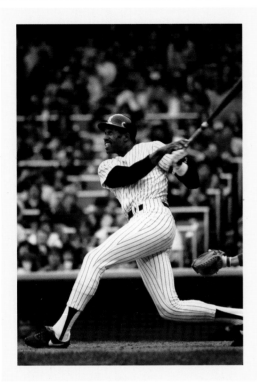

DAVE WINFIELD

I grew up a baseball fan near Minneapolis, which is an American League city, so I knew that Yankee Stadium was a storied place. My first experience at Yankee Stadium was when I played in the 1977 All-Star Game. That was my first All-Star Game. What a thrill it was to play in your first All-Star Game at Yankee Stadium. There couldn't be any bigger stage—I knew that going into that game.

When I signed with the Yankees, I was ready for Yankee Stadium and New York. But you had to be ready every day there. There were no off days, or days that you could just mail it in. There wasn't an inning where I wasn't focused or prepared to play there. I had some bad games, but I always had a heightened sense of awareness at Yankee Stadium.

The fans were always on their feet in the ninth inning, whether we were winning or losing. They were either pushing us to win or holding the other team down. That doesn't happen anywhere else.

him on, chanting "Reggie! Reggie! Reggie!"

One of the scariest fights ever at Yankee Stadium took place May 19, 1998, between the Yankees and Orioles, and it got its impetus from a home run. Bernie Williams' three-run, eighth-inning homer off Armando Benitez had climaxed a big Yankees' comeback. In obvious frustration, Benitez drilled Tino Martinez in the upper back with his next pitch. As the incensed Martinez writhed in pain, home plate umpire Drew Coble ejected Benitez. At the same time, Darryl Strawberry was leading the charge out of the Yankees dugout toward Benitez. Players from both sides swarmed all around the mound, and the combatants shoved their way across the field and into the Orioles dugout. With security personnel frantically trying to break up the fighting, players tumbled down the dugout steps. Strawberry was seen throwing a wild haymaker over the crowd of players, targeting Benitez's head.

"When it spilled into the dugout, and guys were rolling down the steps, that's when it got really ugly," said Orioles catcher Lenny Webster.

Observed Orioles coach Elrod Hendricks: "That was some brawl. I don't think there was a guy on the field who didn't throw at least one punch."

In direct contrast to those wild and rambunctious days and nights at the Stadium were the just-as-memorable solemn occasions in which the grand ballpark was transformed into the shrine it often has been called. Through the years, baseball has borne witness to emotional ceremonial events, none of which is more etched in the game's lore than Lou Gehrig Appreciation Day, July 4, 1939, in which the doomed Yankees captain stood at the microphones and told the hushed crowd of 61,808 that, despite being afflicted with the rare and fatal disease, amyotrophic lateral sclerosis, he considered himself "the luckiest man on the face of the earth."

Eight years later, on April 27, 1947, the Yankees held a similar occasion for a dying Babe Ruth. His voice hoarse, the Babe stood at the microphones near home plate, just as Gehrig had done in his farewell address, and thanked the fans for their support and admiration. He would make his final appearance at the Stadium on June 13, 1948, two months before throat cancer would claim him at age fifty-three. On this occasion, Ruth merely leaned on a bat at home plate while others celebrated his career.

Certainly no one who was there will forget the emotional scene on Friday night, August 3, 1979, when the Yankees, grief-stricken over the death of team captain Thurman Munson in a plane crash in Canton, Ohio, the previous day, took the field against the Baltimore Orioles. Sobbing as they stood at their positions—the catcher's box was left vacant—they observed a moment of silence. The emotional scene lasted nearly ten minutes. After the playing of the

(continued on page 172)

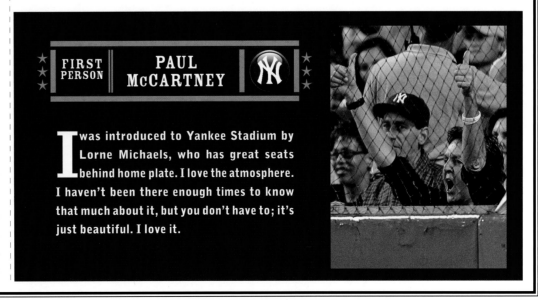

PAUL McCARTNEY

I was introduced to Yankee Stadium by Lorne Michaels, who has great seats behind home plate. I love the atmosphere. I haven't been there enough times to know that much about it, but you don't have to; it's just beautiful. I love it.

I DOUBT VERY MUCH THAT ANYTHING CAN TOP THE FIRST GAME I PITCHED IN A YANKEES UNIFORM AT YANKEE STADIUM ON AUGUST 12, 1964. IT WAS THE FIRST TIME I WAS EVER IN THE STADIUM.

I had been called up the day before and had seen the clubhouse, but the first day that I was on the field, I was pitching in a game against the Chicago White Sox. I think that probably tops all the other things that happened during my stay at Yankee Stadium. I was just amazed at the size of the Stadium. It was massive. I remember how unusual it looked to see the monuments in center field; they were actually on the playing field. The ballpark was pretty well filled. I don't know if they had a sellout crowd that day, but they had a pretty good crowd. I was just amazed at the absolute size of it, and all the dimensions. Center field was just so far back, 461 feet to the fence.

I felt somewhat overwhelmed, but I was so excited about getting ready to pitch my first game. The other thing that I thought was strange was that the pitcher warmed up right in front of the fans near home plate instead of in the bullpen. They had a pitching rubber on both sides of home plate, where the pitchers would warm up right in front of all the fans. It made me a little nervous because I was aware of all the fans that were in the Stadium. Once the game started, I was able to block everything else out, except for what was happening during the ballgame. Fortunately, that was one of the strong traits that I had—my concentration level was pretty good.

The reception I received when I stepped onto the field was kind of quiet. Nobody knew too much about me, but it seemed as if I was welcomed. At that time, the Yankees were in a very hot pennant race, and they were, I think, looking for someone like myself to kind of set them in the right direction. They were three and a half games out of first place, and they were really looking for somebody to start the fire, so my reception was pretty good.

The stories I had heard about the Stadium were about how massive it was, and, of course, everybody knew the history and the pride that Yankee Stadium had about it. At that time, Mickey Mantle was playing. I was coming from the small town of Mabton, Washington, which had a population of one thousand. You can hide that in one little corner of Yankee Stadium, so you can imagine how big I thought it was.

I had been a lifelong Yankees fan growing up, even though I was in the Pacific Northwest. It seemed like they were on television every week. The Game of the Week would always have the Yankees and someone else. I can't tell you how many times I watched Yogi Berra hit an 0-and-two pitch that was almost over his head and line it down the left-field line or hook it down the right-field corner for a double or a home run. To witness the massive home runs that Mantle hit—watching them on television and then being able to see that in person—was really something.

I don't think any thrill could match walking into that huge Stadium and pitching there my first time. I don't think any of the other things I experienced—and I experienced a lot of great days at Yankee Stadium as a player—could top it.

My greatest moment as a coach with the Yankees occurred in 2001, after I had returned from my bout with melanoma. I had the opportunity to throw out the first pitch on Opening Day. I don't think any other thrill I had as a coach could match the feeling I had that day. For one moment, I felt like the entire crowd was patting me on the back for returning as the pitching coach after battling cancer. It was a monstrous moment for me and my family.

Mickey Mantle congratulates Mel Stottlemyre on July 20, 1965 after Stottlemyre hit an inside-the-park grand slam off Bill Monbouquette in a 6-3 victory over the Boston Red Sox at Yankee Stadium.

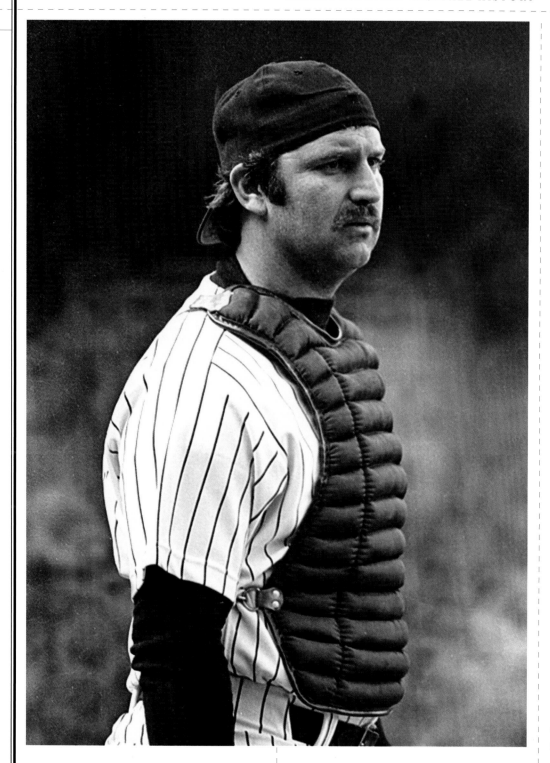

The Yankees observe a moment of silence in honor of Thurman Munson after he was killed in a plane crash in August 1979.

national anthem, the crowd remained standing, applauding softly as Munson's visage remained frozen on the center-field scoreboard.

Three nights later, the scene was repeated, when the Yankees, having attended Munson's funeral in Canton that afternoon, arrived at the Stadium to resume the series against the Orioles, emotionally drained. In that game, Bobby Murcer, who was Munson's best friend and had delivered the eulogy only a few hours before, drove in all five runs in the Yankees' 5-4 win with a three-run homer and a two-run single.

"I had thought about not playing," Murcer said. "But I know Thurman would have said, 'What, are you crazy?' so I had to play. I never used that bat again. I gave it to [Munson's widow] Diana."

Murcer, one of the most popular Yankees ever, received a resounding and moving standing ovation of his own on the occasion of his return to the Yankees broadcast booth on Opening Day 2007, after having spent the previous winter battling a malignant brain tumor.

For his part, Murcer always said one of the most moving and special days at Yankee Stadium was June 8, 1969, when the Yankees honored his boyhood idol and fellow Oklahoman, Mickey Mantle, whom he succeeded in center field. Mickey Mantle Day, during which the team retired the number 7 worn by Mantle for nearly his entire eighteen-year Yankees career (1951-68), was indeed a spectacular event, culminated by Mantle touring the Stadium in a golf cart as the capacity crowd showered him with enthusiastic applause.

I WAS NERVOUS AS HELL AND VERY SCARED THE FIRST TIME I PLAYED IN YANKEE STADIUM.

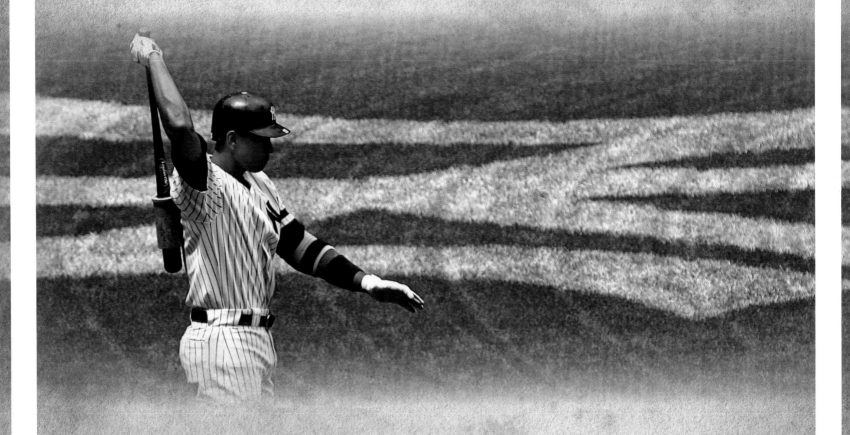

I came to Fenway Park and Yankee Stadium on the same road trip, and it was awesome. I was very excited. I was just in awe of the Stadium. I felt like it was a museum, a place we all as kids grow up admiring and watching from afar.

Yankee Stadium is the greatest place to play on Earth. It is the biggest stage in the world from a sports point of view. It has the best crowd and the best energy. The crowd is always very loud, very into it, and very knowledgeable. It is good that they are knowledgeable—it inspires you.

One of the cool moments for me at the Stadium was in 2007—the walk-off grand slam against Baltimore. That was pretty exciting just because it was unique—a grand slam, down by one. You dream of situations like that. To be able to come through and have the Stadium go crazy was pretty special. Bottom of the ninth, two strikes, bases loaded—that's as good as it gets.

I was prepared going up to the plate. I was actually very calm, and I was surprised. The last thing I was trying to do was hit a home run. I was just trying to hit the ball hard and help us win the game. And, sure enough, I put a nice swing on it, and the ball just took off. I was the happiest guy in the Stadium. Sixty thousand people, and I was the happiest one. Right when I hit it, I knew it was a home run. It's a feeling you get.

POMP AND GLORY

In the history of Yankee Stadium, there have been eight no-hitters pitched by Yankees, including three perfect games, all of them bearing their own unique circumstances. Monte Pearson's no-hitter against the Cleveland Indians in the second game of a doubleheader, August 27, 1938, was the first by a Yankee at the Stadium. Pitching on two days' rest, Pearson struck out seven and walked two, concluding an eventful day for 40,959 fans, who also saw Joe DiMaggio tie a major-league record with three triples in the victorious first game for the Yankees.

It would be another thirteen years before the Stadium would be the scene of its second no-hitter by a Yankee, this one on September 28, 1951, by Allie Reynolds, who was the ace of the staff from 1947 through 1954. What made Reynolds' no-hitter unique was that it was his second of the season. On July 12, he no-hit the Indians in Cleveland. This one, against the Red Sox, was completed with more drama than Reynolds probably would have liked. The final Red Sox hitter was Ted Williams, who, down 0-and-one in the count, hit a high pop behind

the plate. Catcher Yogi Berra circled under the ball, only to drop it and fall on his face. As the crowd of 39,038 let out a collective sigh, Reynolds gathered himself and threw Williams another fastball. Again, Williams hit a high pop foul, this one near the Yankees dugout. Given a reprieve, Berra did not drop it.

On October 8, 1956, Don Larsen, an unheralded, free-spirited right-hander, pitched the greatest game in World Series history, a perfect game against the Brooklyn Dodgers. No one before or since has pitched even a no-hitter

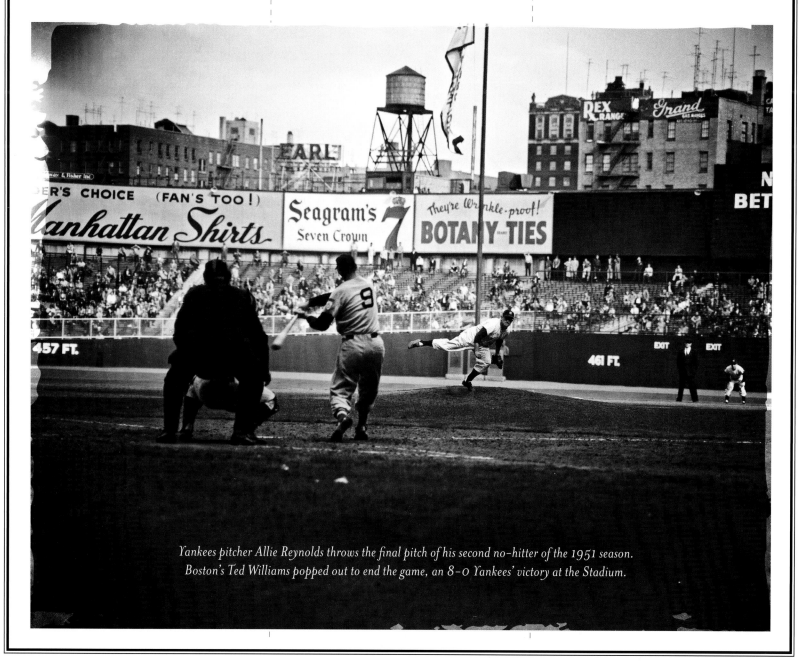

Yankees pitcher Allie Reynolds throws the final pitch of his second no-hitter of the 1951 season. Boston's Ted Williams popped out to end the game, an 8–0 Yankees' victory at the Stadium.

★ FIRST PERSON ★ — WHITEY FORD

The thing I was the proudest of is that in the sixteen-year stretch from 1949 through 1964 we made it to the World Series fourteen times. Just to be associated with Joe DiMaggio, Mickey Mantle, Roger Maris, and everyone else that took the field at Yankee Stadium in those days was the biggest thrill for me.

If I didn't play in New York, and specifically at Yankee Stadium, my life would have turned out a lot differently.

in the World Series, and Larsen was probably about the most unlikely person to perform such a feat. A notorious night owl, he'd been so wild in his first start of the 1956 Series, in Game 2, that Yankees manager Casey Stengel removed him in the second inning. Larsen didn't figure to get another start, especially after he blasted Stengel in the newspapers. But when he arrived at Yankee Stadium for Game 5, Larsen found a baseball in his shoe, the manager's way of letting him know he was starting that day. This time, Larsen's control was pinpoint as he retired all twenty-seven batters, using just ninety-seven pitches and going to a three-ball count on only one hitter.

Those who would maintain that history never repeats itself should have been at Yankee Stadium on May 17, 1998, when burly left-hander David Wells, another notorious free spirit who had attended to the same San Diego high school as Larsen, pitched the second perfect game in Yankees history, a 4-0 victory against

the Minnesota Twins. So surreal were all the coincidences involving Wells and Larsen that, after the game, the normally unflappable Wells was dumbstruck upon being introduced to Larsen on the phone.

"I'm honored to share this with you, Don," said Wells. "I mean, two guys from the same high school doing this at Yankee Stadium? What were the odds? Who would ever believe it?"

Who would believe that, after forty-two years between perfect games at Yankee Stadium, there would be another one a year later—and that both Larsen and Berra would be in the ballpark to witness it? On July 18, 1999, the Yankees were scheduled to play an inter-league game against the Montreal Expos, and it was also Yogi Berra Day, a celebration of the Hall-of-Fame great having ended his fourteen-year estrangement from the team that had been the result of his firing as Yankees manager by George Steinbrenner sixteen games into the 1985 season.

Among the many on hand to pay tribute to Berra was Larsen, who recreated the final out of his perfect game with Berra in the pregame ceremonies. The Yankees starter was David Cone, who was thirty-six, had undergone two serious shoulder operations in his career, and had been an inspiration to the team that season in winning nine of his first thirteen decisions. In this game, he needed only eighty-eight pitches, struck out ten, and never went to a three-ball count. Cone accomplished his feat despite a thirty-three-minute rain delay after he had struck out the side in the third inning.

"It was incredible," said Cone who was carried off the field by teammates as he repeatedly doffed his cap to the 41,930 fans. "Every time I walked out, I got a standing ovation. You can't help but feel the emotion of the crowd. I could feel my heart pumping through my uniform. I didn't want to upstage anybody. I felt I had a *(continued on page 178)*

(continued on page 178)

NO-HITTERS AT YANKEE STADIUM

YANKEES

MONTE PEARSON
8/27/1938, VS. CLEVELAND, 13-0

ALLIE REYNOLDS
9/28/1951, VS. BOSTON, 8-0

DON LARSEN
10/8/1956, VS. BROOKLYN, 2-0
(WORLD SERIES, PERFECT GAME)

DAVE RIGHETTI
7/4/1983, VS. BOSTON, 4-0

JIM ABBOTT
9/4/1993, VS. CLEVELAND, 4-0

DWIGHT GOODEN
5/14/1996, VS SEATTLE, 2-0

DAVID WELLS
5/17/1998, VS. MINNESOTA, 2-0
(PERFECT GAME)

DAVID CONE
7/18/1999 VS. MONTREAL, 6-0
(PERFECT GAME)

VISITOR

CY YOUNG
BOSTON, 6/30/1908, 8-0

RAY CALDWELL
CLEVELAND, 9/10/1919, 3-0

BOB FELLER
CLEVELAND, 4/30/1946, 1-0

VIRGIL TRUCKS
DETROIT, 8/25/1952, 1-0

SIX HOUSTON PITCHERS
6/11/2003, 8-0 (OSWALT, MUNRO, SAARLOOS, LIDGE, DOTEL, WAGNER)

In the history of Yankee Stadium, three pitchers have thrown a perfect game, the most famous of which is Don Larsen's in the 1956 World Series. And it's likely that only three people—Joe Torre, Don Zimmer, and public-address announcer Bob Sheppard—saw all three in person. The second one came forty-two years after the first, when David Wells was perfect against the Minnesota Twins in 1998. A year later, against the Montreal Expos, David Cone retired twenty-seven straight. Torre saw them all, first as a young fan in the stands for Larsen's gem, then as manager from the Yankees dugout. Zimmer played for the Brooklyn Dodgers when Larsen threw his gem, and later was a Yankees coach on Torre's staff.

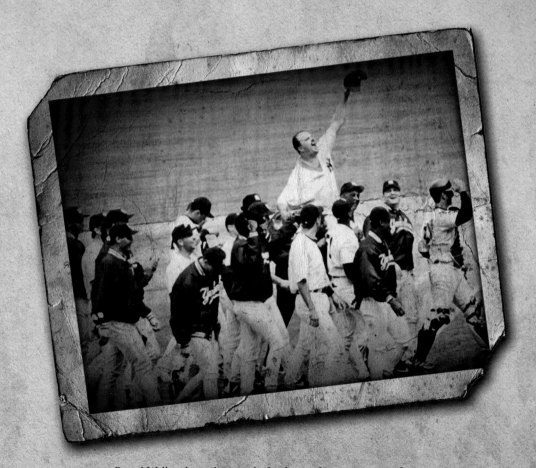

David Wells salutes the crowd after his perfect game in 1998.

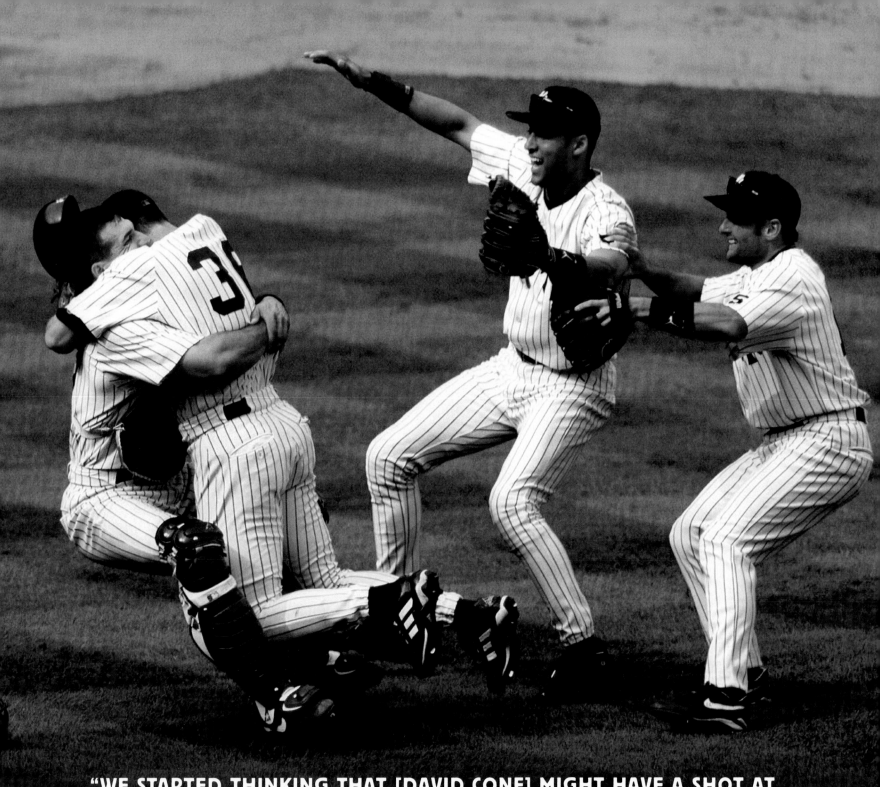

"WE STARTED THINKING THAT [DAVID CONE] MIGHT HAVE A SHOT AT PITCHING A PERFECT GAME IN THE SIXTH OR SEVENTH INNING. THE AMAZING THING FOR ME WAS HOW MUCH BETTER HIS STUFF GOT AFTER THE RAIN DELAY. AFTER THE DELAY, HIS STUFF WAS ELECTRICTHE OTHER THING THAT WAS SO GREAT ABOUT HIM PITCHING A PERFECT GAME IN 1999 WAS THAT HE HAD A CHANCE TO THROW A NO-HITTER WHEN HE CAME BACK FROM HIS ANEURISM IN 1996. HE UNDERSTOOD THE IMPORTANCE OF THE PLAYOFFS AND DIDN'T TRY TO PUSH IT. HE TOLD JOE, 'IF I'M DONE, I'M DONE.' HE CAME OUT OF THE GAME IN THE SEVENTH, AND WE WENT ON TO WIN THE WORLD SERIES." — JOE GIRARDI

DWIGHT GOODEN

DAVE RIGHETTI

JIM ABBOTT

better chance of winning the lottery than this happening today on Yogi's day."

The other three no-hitters by Yankees at Yankee Stadium were unique because of the pitchers that threw them.

Dave Righetti was a budding star for the Yankees, coming into his own, when he pitched his 4-0 gem against the Red Sox on July, 4, 1983, in front of a crowd of 41,077 that included former President Richard Nixon. It was one of the last games broadcast by the legendary Mel Allen, who was in the booth for the fledgling SportsChannel cable network.

Ten years later, on September 4, 1993, Jim Abbott, a symbol of inspiration for having forged a fine major-league career despite having been born without a right hand, no-hit the Cleveland Indians, 4-0, at the Stadium in a game played under threatening skies and intermittent showers in front of a crowd of 27,225. It would prove to be the highlight of Abbott's brief and inconsistent Yankees career.

In 1996, Dwight Gooden, the erstwhile *wunderkind* for the cross-town Mets, was attempting to resurrect his career with the Yankees after his battles with drugs had led to his suspension for the 1995 season. He was thirty-one, eleven seasons removed from his electrifying 1985 Cy Young Award season in which he'd led the National League in wins (24), earned-run average (1.53) and strikeouts (268). After earning a spot in the Yankees rotation in spring training, Gooden was only 1-3 entering his May 14 start against the Seattle Mariners. As Gooden would reveal later, his mind that night was as much on his ailing father, who was waiting to undergo open-heart surgery in Tampa, Florida, as it was on the Mariners.

"I don't know if he was able to watch it on TV," Gooden said after completing the no-hitter, a 2-0 victory. "But even before I went out there, I had dedicated this game to him. I never dreamed it would be as great as this."

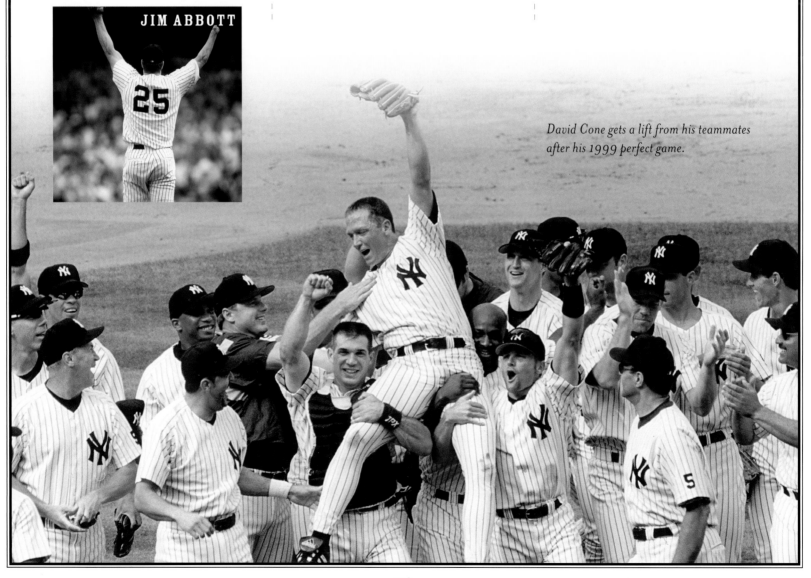

David Cone gets a lift from his teammates after his 1999 perfect game.

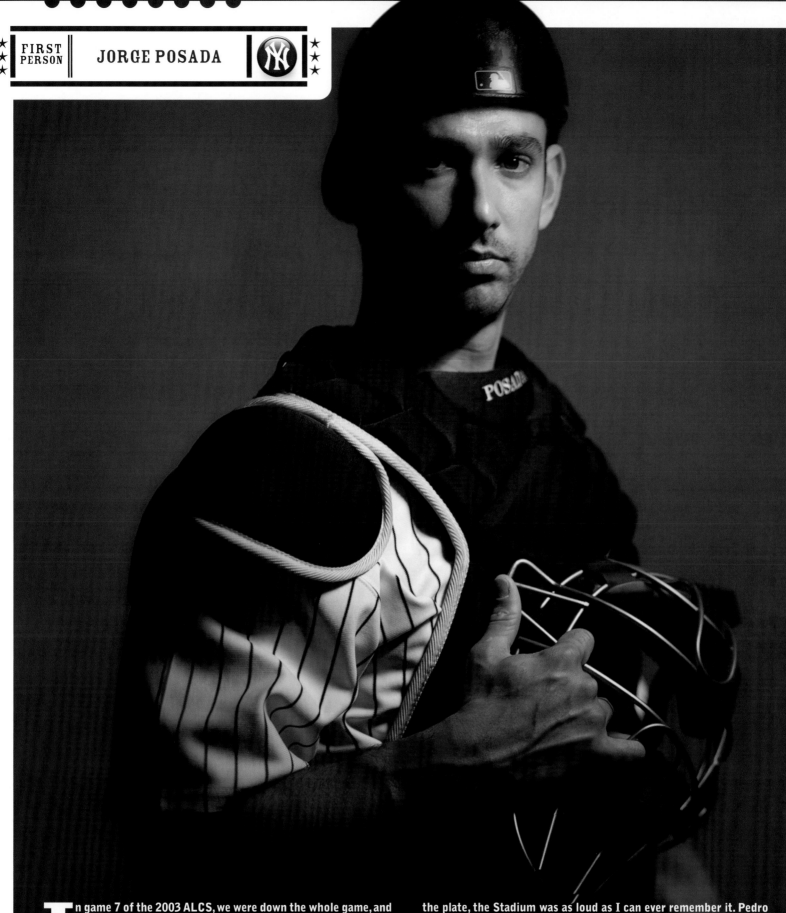

In game 7 of the 2003 ALCS, we were down the whole game, and we finally had a chance to tie it in the eighth inning. Obviously if we hadn't tied it, we wouldn't have had the chance to win it. We were playing the Red Sox, which obviously made the atmosphere crazy. After I got the hit that brought the tying runs to the plate, the Stadium was as loud as I can ever remember it. Pedro Martinez had good numbers against me, and he still had plenty of juice. Grady Little wanted to go with Pedro to get out of that inning, but that didn't work out. If we didn't win that game, we wouldn't have gone to the World Series. That's as big as it gets.

RICK CERONE

PHIL RIZZUTO AND JOE TORRE

WADE BOGGS

The arrival of George Steinbrenner as Yankees owner in 1973 brought a whole different temperament to Yankee Stadium. Unlike previous Yankees owners who preferred staying in the background and letting the baseball operations people run the team, Steinbrenner was hands-on in every way from the beginning.

Under Steinbrenner's stewardship, it seemed as if the Yankees had a uniform-retiring "day" for a former Yankees favorite every year. One of those particularly etched in Yankees fans' memories was Phil Rizzuto Day, August 4, 1985, which turned out to be a double celebration. Following the Rizzuto festivities, Tom Seaver, the one-time Mets star who was now pitching for the Chicago White Sox, beat the Yankees, 4-1, to become the seventeenth pitcher to win 300 games.

It was hard to believe that a pitcher winning his 300th game—especially a New York favorite like Seaver—would be an anti-climactic event, but it was. Ask anyone who was there that day what they remembered most, and they'll more than likely say that it was watching the irrepressible Rizzuto being tripped up by a cow and tumbling onto the ground in somersault fashion during the pregame ceremonies.

Even Steinbrenner couldn't have orchestrated that, although The Boss had proved time and again to be a master of the surprise, the most notable being his 1978 Old-Timers' Day announcement that Billy Martin, who had resigned as Yankees

2006 OLD-TIMERS' DAY

WHITEY FORD, YOGI BERRA, AND REGGIE JACKSON

DON MATTINGLY

YOGI BERRA

MEL STOTTLEMYRE AND MARIANO RIVERA

BOB SHEPPARD AND BOB WOLFF

manager five days earlier, would be returning as manager in 1980.

It was a bit of a Steinbrenner-Martin déjà vu, in that it was also an Old-Timers' Day—in 1975—when Steinbrenner hired Martin as his manager for the first time. The '78 Old-Timers' Day theatrics caught everyone by surprise, not the least of whom was Bob Lemon, who had just replaced Martin as Yankees manager.

Twenty-nine years later, Steinbrenner, along with Yankees president Randy Levine, chief operating officer Lonn Trost, and general manager Brian Cashman, pulled off a similar surprise in front of another capacity Stadium crowd, when he had Roger Clemens appear in the owner's box at the conclusion of the seventh-inning stretch in a May 6, 2007 game against the Seattle Mariners. Holding a microphone, Clemens was not there to sing "Take Me Out to the Ballgame," but to announce to the stunned and delighted crowd that he was coming back to pitch for the Yankees.

For eighty-five years, Yankee Stadium has stood tall, grand, and proud on the banks of the Harlem River, a playground palace for so many of baseball's most defining games and indelible moments, as well as a shrine for its most poignant and moving ceremonies.

From the Babe to The Boss, it's been some ride for the old place.

2007 OLD-TIMERS' DAY

DARRYL STRAWBERRY AND DAVID CONE

PAUL O'NEILL

GAME 7 OF THE 2003 ALCS BOILED DOWN TO ONE THING: THE LOSERS WERE GOING HOME, AND THE WINNERS WERE GOING ON TO THE WORLD SERIES.

We were losing the game going into the sixth and seventh innings. It was tough. I was praying that we would get something going, and then all of a sudden everything started changing. We scored a few runs. Jorge Posada hit a little blooper over second base. Before we knew it, we had tied the game. We didn't get any big hits. There were no line drives or anything like that. It was little things that made the difference. The tie forced the game into extra innings.

I came in in the ninth and held it into the eleventh. It was in the eleventh that Aaron Boone hit that big home run. That was huge.

It was such a great feeling, because the whole series was tough. The whole series and the whole season had been tough.

Overcoming the adversity and winning it in the Stadium gave us great satisfaction.

There were a lot of emotions. The whole thing—the rush, the energy, and the adrenaline at the Stadium—was unbelievable. It is something I will take with me to the grave. As a Christian, I felt close to the Lord. The mound is where my job takes place. I headed out there because I had been praying the whole day—my family and my friends had also been praying—and those prayers were answered. I went to the mound to give thanks. It was a special moment. It was a special moment just to be by myself. I know all the guys were celebrating at home plate, but it didn't matter who was watching. I didn't care how many people were watching.

THERE'S NO PLACE LIKE HOME

❧ JOHN THORN ❧

When Pete Palmer and I collaborated on *The Hidden Game of Baseball*
twenty-five years ago, we included a chapter titled, "There's No Place Like Home."
But in those days, before retrosheet.org and baseball-reference.com, we had only scant,
fragmented information available to us. Now, for this book on Yankee Stadium,
we can identify the top individual and club performances on this hallowed
ground by both the Yankees and their guests.

Among the findings we shared with the baseball community in 1984 was that home teams won 54 percent of the time on average, and that both batters and pitchers tended to perform about 10 percent better at home. These figures held up for all major-league clubs since the dawn of the twentieth century; thus, in a 162-game season, an average home record would be 45-36, or 10 percent better than 41-40. (The corollary is that an average road record would be 36-45, so the two average records would combine to 81-81, by definition, the league-average mark.)

"Why would a team, strong or weak, perform better in its own park than on the road?" we asked. Our answer, "The players benefit from homestands of reasonable duration—say, eight to thirteen games—when they live in their own residences, sleep at more regular times, play before appreciative fans, and benefit from the physical park conditions, which to some degree may have made their organizations acquire them in the first place."

Of course, there are parks that favor hitters, like Fenway Park and Wrigley Field, and more recently Coors Field. Others forgave pitchers' mistakes, like the Astrodome and old Comiskey Park. But the historic formula for winning was the same everywhere: play at least average ball on the road, and fatten your record at home.

How did the Yankees do? Well, twenty-six world championships, thirty-nine pennants, and forty-six playoff appearances provide something of an answer. Drilling down a bit, we see that the club's home record in Yankee Stadium, in the years 1923-73, was 2,553 wins and 1,410 losses, for an astounding winning percentage of .644. That rate was unmatched in the Yankees' prior homes: Hilltop Park (1903-12) and the Polo Grounds (1913-22); their interim home of Shea Stadium (1974-75), and the renovated Yankee Stadium (1976-2007). Then again, it was

TOP FIVE HOME RECORDS

1932 YANKEES
62-15
.805

1961 YANKEES
65-16
.802

TWENTY-SIX
WORLD CHAMPIONSHIPS

THIRTY-NINE
PENNANTS

FORTY-SIX
PLAYOFF APPEARANCES

unequaled in the whole of baseball history.

Give credit to Ed Barrow and George Weiss in the front office for tailoring their rosters to succeed in a home park with a cavernous center field (461 feet) and short distances down the lines in left and right (301 and 296 feet, respectively). Bravo as well to managers Miller Huggins, Joe McCarthy, Casey Stengel, and Ralph Houk for executing the plan, which was to deploy pull-hitting sluggers, an incomparable center fielder, and pitchers who could throw the ball low and away. By contrast, in the renovated Yankee Stadium, with its more conventional outfield dimensions, Billy Martin's champions only once posted the league's best home record. While Joe Torre presided over a 62-19 home record in the 114-victory season of 1998, his remarkable run of eleven straight playoff appearances has otherwise presented a fairly balanced home-road profile.

Of the top five home records in baseball since 1900, Yankees teams—from different eras—occupy the top two spots. Note that the only team listed below that did not win the pennant was the 1949 Red Sox, who lost to the Yankees on the final day of the season—the first of five straight World Series for the Yankees under Stengel.

Until recently, individual home—or road—records were visible only through

dogged research into the day-by-day logs of selected players. Thanks to Palmer's research for *The Hidden Game*, we were able to state that Babe Ruth slugged .985 at home in 1920 (201 total bases in 204 at-bats) and .929 in 1921. That was at the Polo Grounds, where the Yankees were tenants of the Giants until they moved into their own stadium in 1923. Ruth's performance in his first year at Yankee Stadium was only slightly less awesome, .805, with a batting average of .411 and an on-base percentage of .572. (Mickey Mantle's home on-base percentage of .512 in 1957 remains the top Yankees mark since Ruth's .516 in 1926.) The Babe was a better hitter at home than he was on the road, though not by much. In 1927, the year of his record-setting sixty home runs, thirty-two came in road games. Like Lou Gehrig, his principal partner in crime along Murderers Row, Ruth was not a pure pull hitter, so Yankee Stadium may have cost him as many home runs as it afforded him.

Gehrig, on the other hand, would have piled up greater records playing almost anywhere else. He slugged .805 on the road in 1927, and .794 in 1930, the top two performances in baseball history until Barry Bonds surpassed them with an .815 road slugging percentage in 2001. In seventy-six road games in 1930, Gehrig had 117 RBIs, 27 homers, and a .405 batting average. Lifetime,

his road batting average was .351; at home it was .329. In 1934, with Ruth in decline, Gehrig seemed to adjust his swing to pull the ball more often at Yankee Stadium, hitting .414 at home with 30 homers and 98 RBIs. If Ruth and Gehrig were the two greatest Yankees, they were also the two greatest at Yankee Stadium.

Yankee Stadium hurt the two nonpareil center fielders, Joe DiMaggio and Mickey Mantle. DiMaggio hit .413 on the road and .350 at home in 1939—the year the Yankees demolished the opposition, despite losing Gehrig in May. Do you recall the classic footage of Al Gionfriddo robbing DiMaggio of a home run in deep left-center field at Yankee Stadium in the 1947 World Series, with DiMaggio kicking the dust at second base? He must have lost fifty home runs in that fashion over the course of his career.

Mantle hit for a higher average at home than on the road, but exhibited more power on the road. In 1961, the year of his home-run race with Roger Maris, Mantle hit thirty of his fifty-four homers in road games. Maris also hit thirty away, and thirty-one at home, the Yankee Stadium record. (Ruth hit thirty-two home runs in home games in 1921, when home for the Yankees was the Polo Grounds.)

1931 ATHLETICS
60-15
.800

1949 RED SOX
61-16
.792

1946 RED SOX
61-16
.792

Section Four

America's
AMPHITHEATER

☙ IRA BERKOW ☙

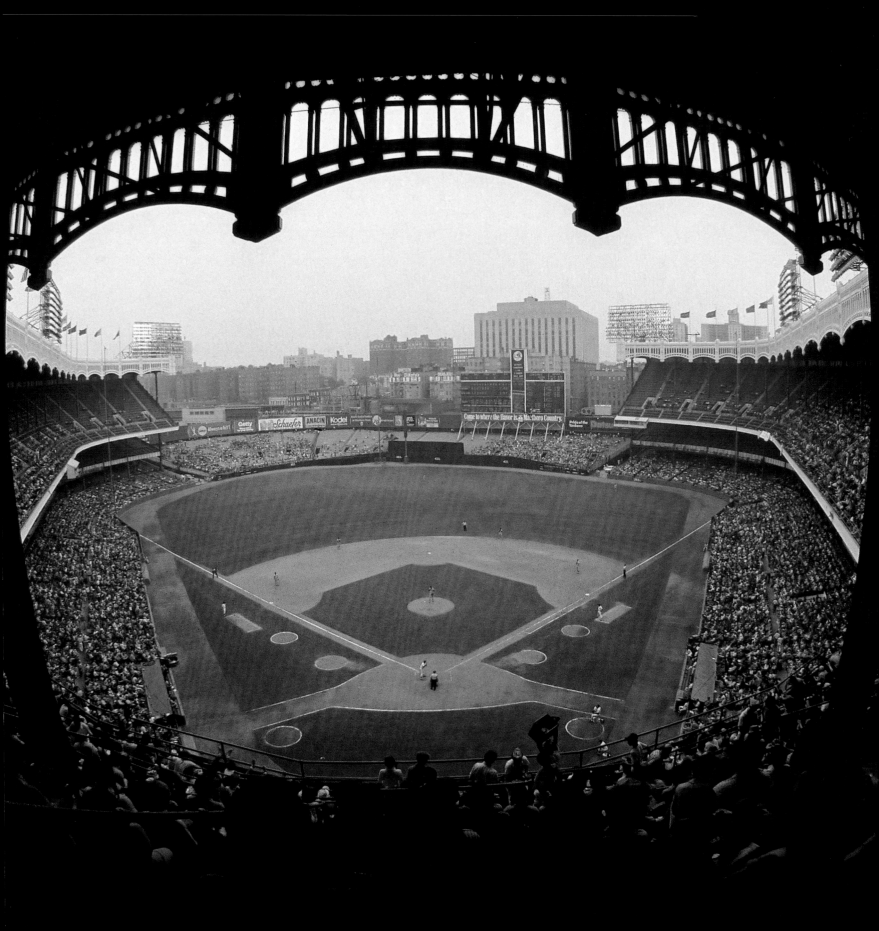

Yankee Stadium, June 1973, against the Detroit Tigers.

IN JUNE 1999, *SPORTS ILLUSTRATED* PUBLISHED ITS LIST OF THE TOP TWENTY VENUES OF THE TWENTIETH CENTURY. NUMBER ONE:
YANKEE STADIUM.

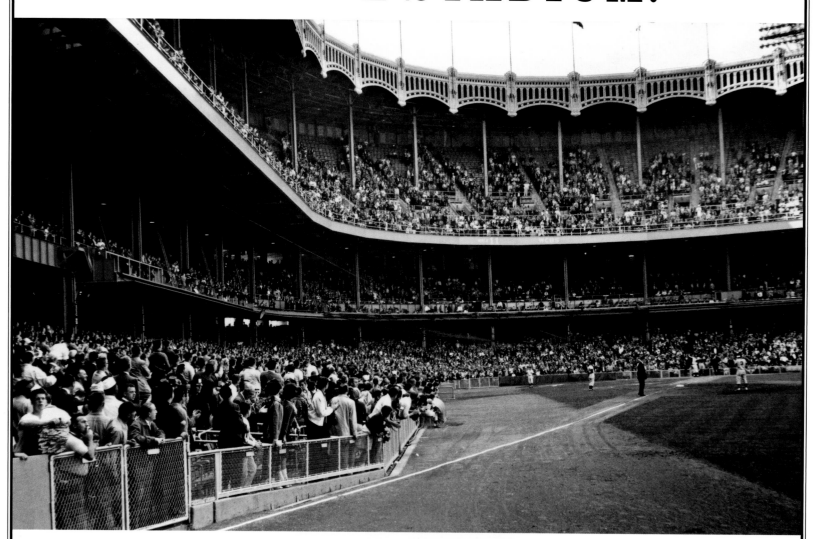

"**N**o sports arena in history, with the possible exception of the Roman Coloseum, has played host to a wider variety of memorable events," *Sports Illustrated* noted about Yankee Stadium. "Two popes prayed here. Johnny Unitas threw here. Jim Brown ran here. Joe Louis fought here, and Babe Ruth, Lou Gehrig and Joe DiMaggio played here. Ground can't be more hallowed than that."

From Red Smith, one of the premier sportswriters of all time, "I know that games are a part of every culture we know anything about. And often taken seriously. It's no accident that of all the monuments left of the Greco-Roman culture the biggest is the ballpark, the Coloseum, the Yankee Stadium of ancient times."

Surely for the sake of space, *Sports Illustrated*

"MY FAVORITE MEMORY IS THE FIRST TIME I WALKED INTO THE STADIUM. I NEVER THOUGHT I WOULD DO THAT WHEN I WAS A YOUNGSTER. I USED TO WATCH THE YANKEES AND NEVER HAD A DREAM THAT I WOULD PLAY IN YANKEE STADIUM. IT HAS AN AURA ABOUT IT. THE YANKEES HAVE WON SO MANY CHAMPIONSHIPS HERE. IF THE YANKEES HADN'T WON AS MUCH AS THEY HAVE, IT WOULDN'T BE YANKEE STADIUM."

— GENE MICHAEL

didn't mention other memorable events at Yankee Stadium, such as the Billy Graham crusades, concerts by rock icons Pink Floyd and U2, and a Muhammad Ali bout.

And let's not forget the esteemed and dignified Henry Kissinger rounding the bases and sliding head-first into home plate at Yankee Stadium.

For many, Yankee Stadium loomed like a pyramid, a Parthenon—and, yes, a colossus—when it came into view as the number 4-train rattled up from the subway tunnel and onto the elevated tracks toward the 161st Street station. It was that way for me, a transplanted Chicagoan who had spent much of his youth in the bleachers, grandstands, and box seats (until shooed away by the ushers) of Wrigley Field and Comiskey Park. I saw Yankee Stadium in person for the first time

FIRST PERSON | BOBBY MURCER

MY WIFE AND I DECIDED ONLY A FEW DAYS BEFORE THE SEASON STARTED THAT WE WANTED TO BE AT THE STADIUM FOR OPENING DAY IN 2007.

After the health problems I had encountered, there was some concern as to whether I would be up to it. But I felt good and I wanted to be there. I haven't missed an Opening Day in many years. Opening Day at Yankee Stadium is special every season. I wanted to be there to show the people that I was healthy. I wanted to thank everyone for their prayers. I wanted Yankees fans to know that I love them.

When they showed me on the scoreboard, the fans gave me a standing ovation. I looked down toward the Yankees dugout and noticed all of the players and coaches waving to me. That brought tears to my eyes. It was totally unexpected. It was such a special moment in my life.

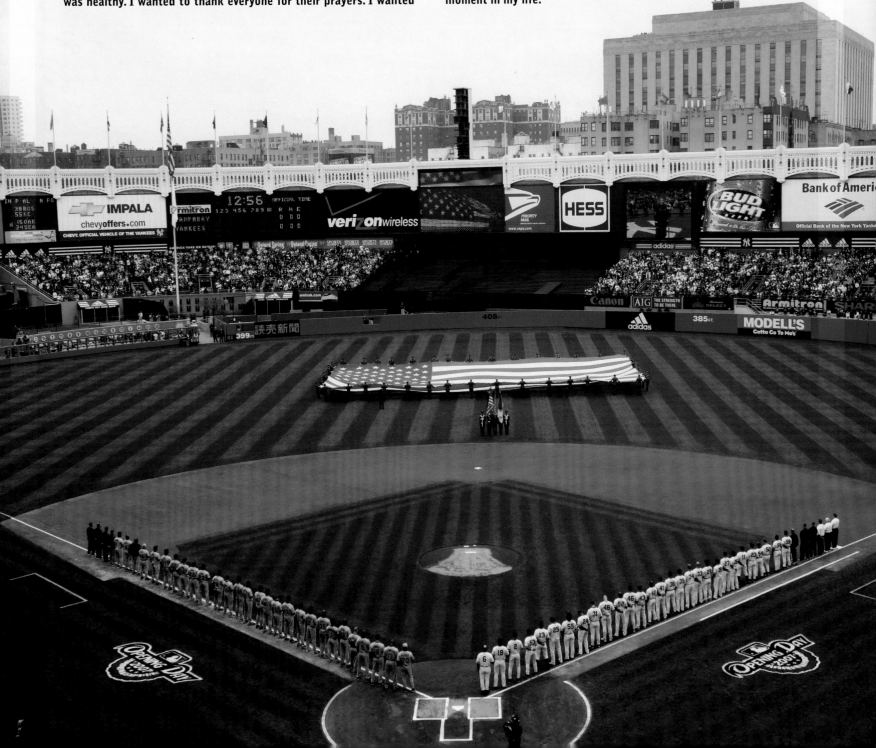

"YANKEE STADIUM IS SYNONYMOUS WITH BASEBALL, AND IT'S THE MOST FAMOUS SPORTS VENUE IN THE UNITED STATES. SOME OF MY FAVORITE MEMORIES OF THE STADIUM ARE THROWING THE OPENING DAY FIRST PITCH, AND SITTING WITH GEORGE STEINBRENNER IN HIS BOX, WHICH I DO REGULARLY. IT MAKES THE GAME EVEN MORE EXCITING. THERE'S NO ONE LIKE GEORGE, AND THE DRAMA OF BASEBALL IS ENHANCED CONSIDERABLY BY HIS ENERGY. YANKEE STADIUM IS A FANTASTIC SITE, AND EVERY GAME THERE IS WORTH GOING TO FOR THAT EXPERIENCE ALONE." — DONALD J. TRUMP

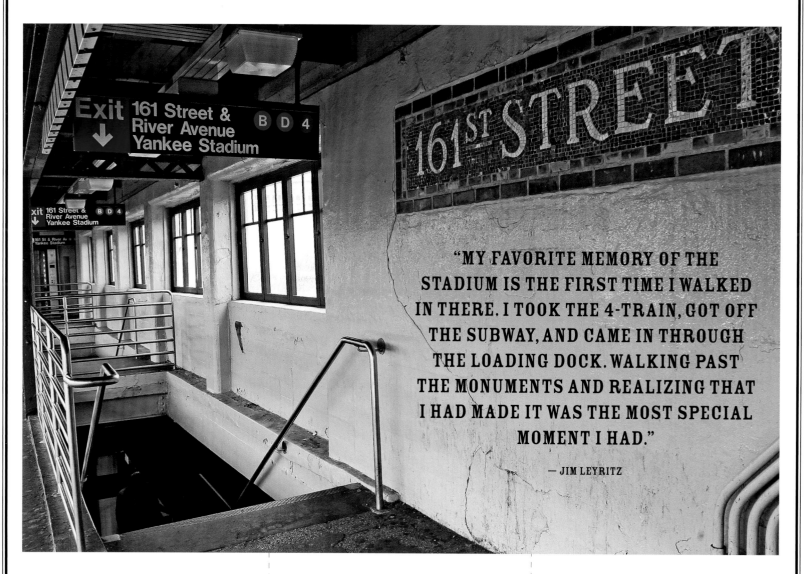

"MY FAVORITE MEMORY OF THE STADIUM IS THE FIRST TIME I WALKED IN THERE. I TOOK THE 4-TRAIN, GOT OFF THE SUBWAY, AND CAME IN THROUGH THE LOADING DOCK. WALKING PAST THE MONUMENTS AND REALIZING THAT I HAD MADE IT WAS THE MOST SPECIAL MOMENT I HAD."

— JIM LEYRITZ

in 1967. While Wrigley Field was beautiful—all symmetry, outfield-wall-vined, and Lake Michigan in the distance—and Comiskey Park was a giant bandshell of a ballpark, they paled to the mystique of Yankee Stadium. The white façade hanging from the roof, the center-field monuments, Bob Sheppard's lordly voice on the public-address system—the place wasn't so much a ballpark as it was a shrine.

Coming out of the subway station on the east side of River Avenue, one's first sight was not of Yankee Stadium, but of the souvenir shops that lined an entire block from 161st Street to 160th. On game days, it was a Coney Island-like atmosphere. As the train roared along the tracks overhead, fans hunted for jerseys, caps, pins, and assorted other items at Stan's Sportsworld and at Baseball Land. Another popular stop was Billy's

Sports Bar and Restaurant, with a mural of the late Billy Martin, a frequently hired and fired Yankees manager in the 1970s and 1980s. For these fans, the first glimpse of Yankee Stadium was the outfield side of the park, painted a bright white. At the entrance was a sign that read, "Bleachers Entry"—an understated beckoning into one of the world's greatest venues.

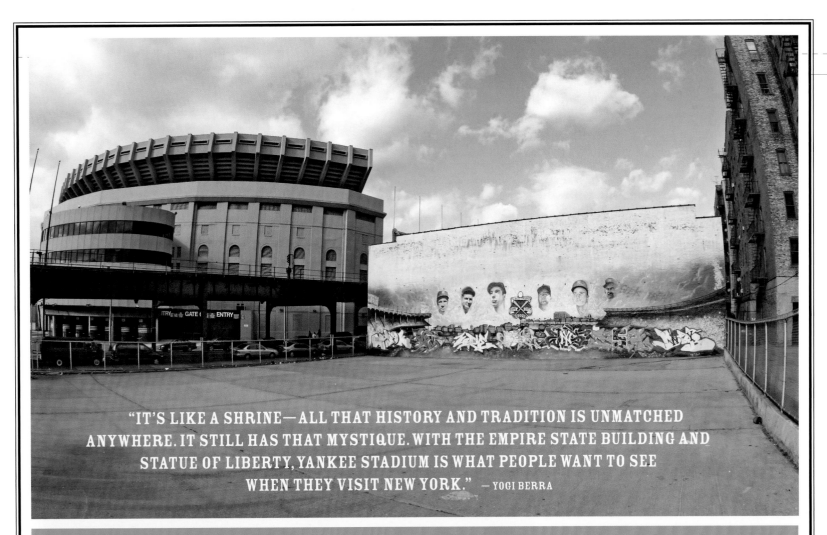

"IT'S LIKE A SHRINE—ALL THAT HISTORY AND TRADITION IS UNMATCHED ANYWHERE. IT STILL HAS THAT MYSTIQUE. WITH THE EMPIRE STATE BUILDING AND STATUE OF LIBERTY, YANKEE STADIUM IS WHAT PEOPLE WANT TO SEE WHEN THEY VISIT NEW YORK." —YOGI BERRA

The first time I saw Yankee Stadium, I was a member of the Chicago White Sox. My legs were shaking so much that I could barely carry myself to the mound. I didn't even think I could walk to the mound, that's how nervous I was. The Stadium lived up to all of my expectations, no question about it. It was everything, and then some. It was special, that's all there is to it. I played for eight other teams and loved every minute of every team, but there was nothing like putting on the pinstripes. The minute I put them on was an unbelievable experience. I grew up a Yankees fan out in Colorado, so getting to play there the six years I did was unbelievable. There were so many great games, so many big games. The playoffs and the World Series, it just doesn't get any better than that, period.

The best part about playing at the Stadium was everything that went along with it: the tradition, the great players that played there before, the atmosphere, the excitement. The fans add a lot to the adrenaline that goes through you. Pitching with that kind of energy behind me was off the charts. You have to really learn how to control your emotions on the mound and keep them in check. It's a different thing, playing there. There is nothing like playing at Yankee Stadium. Yankees fans are the best in the world, and I don't mean to take anything away from all the other great fans. There are great fans everywhere, but Yankees fans are demanding. Yankee Stadium is a very difficult place to play, but it's a great place to play. It's the only place to play.

omantic notions are one thing, but Yankee Stadium was for many a place of employment. In my first year in New York, I was assigned a story on Mickey Mantle. The blond god, the all-American everything, the hick kid from Commerce, Oklahoma, who charmed Gotham and the rest of the nation. Mickey Mantle, who once nearly hit a ball out of the Stadium with a monstrous blow that struck the famed overhang—a sort of upside-down picket fence—on the right-field roof. Mickey Mantle, who could run like a Saluki, and had Paul Bunyan-like strength from both sides of the plate.

Mantle, in his eighteenth—and final—major-league season was struggling. On this day, however, he went five-for-five with two home runs. Along with several other writers, I went to the clubhouse to see Mantle.

One of the writers politely asked a question. "What are you comin' over to me for?" Mantle said, in what appeared a surly response. "Why don't you talk to some of the guys that made a difference in the game?"

I hadn't been prepared for the sharp retort, or for Mantle functioning as an editor and determining what the news was.

When he finally did assent to answer questions, some reporters turned their backs, literally, in a kind of protest.

To give Mantle the benefit of the doubt, he was playing in pain, and playing without the great success he had been accustomed to for nearly two decades.

No one worshipped Mantle more than the entertainer Billy Crystal. Eleven days after Mantle died of liver cancer at age sixty-three, a ceremony celebrating his life was held at Yankee Stadium, and Crystal was the host, representing legions of Mantle fans. I spoke with Crystal before the game, and he recalled his father taking him to his first major-league game on May 30, 1956. The Crystals, who lived on Long Island, made the ninety-minute drive from their home to the Bronx. After parking the car, Billy and his father walked down Jerome Avenue. Billy looked up, and there it was, rising above them, in all its majesty: Yankee Stadium.

"There's this, my God, this thing that just ate up the Bronx," he said.

BILLY GRAHAM

One of the most unforgettable events of my entire ministry is the meeting we held in Yankee Stadium on July 20, 1957. For more than nine weeks, I had been speaking at Madison Square Garden, and the local committee that had invited us to New York City agreed this would be our final event.

It turned out to be one of the hottest days of the year—93 degrees outside and 105 degrees on the platform—and yet the Stadium was jammed with one-hundred thousand people, and there were an additional ten thousand who couldn't get in. Stadium officials told us later that it was the largest gathering in the history of Yankee Stadium at that time. When I walked across the diamond and looked out over the crowd from the platform that had been erected over second base, I could hardly believe my eyes. Tears welled up in my eyes, and I bowed my head and silently thanked God for bringing that great crowd of New Yorkers together.

Because of the response that day, the local committee asked us to extend our meetings in Madison Square Garden, which we did—sixteen weeks in all. It was the longest crusade we ever held.

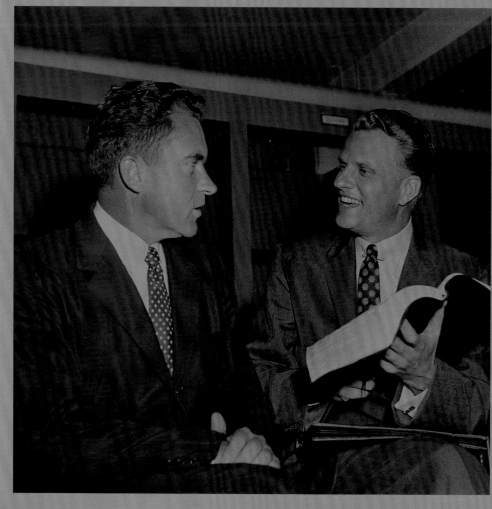

Then—Vice President Richard Nixon chats with crusading evangelist Billy Graham prior to a Yankee Stadium rally.

YANKEE STADIUM WAS ALWAYS THE PLACE FOR THE MOST DRAMATIC MOMENTS.

All the perfect games seemed to happen in Yankee Stadium: Don Larsen in the 1956 World Series, David Wells in 1998, and David Cone in 1999. And it's always had historical implications beyond the place that Babe and Lou and Joe and Mickey played. The sudden-death game between the Giants and the Colts was played there, and it was the site of the Joe Louis-Max Schmeling fight, an incredibly important fight, the good guy versus the Nazi fighter.

The Stadium was built in such a way—the aura, the size of it—that it literally swallowed up the Bronx. Its design was more like a coliseum than a stadium. The filigree was so beautiful: a copper roof originally, with pillars and posts. The challenge of hitting it over the center-field fence, which was originally 490 feet away, made it an epic place to perform in. It was the ultimate stage.

My first game at the Stadium is indelible in my mind. It was May 30, 1956. It turned out to be the day that Mickey Mantle hit the ball off the façade of the original roof. No one had ever hit one out, and he missed by less than two feet. My dad was in the music business, and we had Louis Armstrong's seats. He had arranged for us to go down to the Yankees clubhouse, and we got autographs. Mickey signed my program that day, and then he hit that gigantic home run. As an eight-year-old, I thought it happened every day. "Boy, I love baseball! Mickey hits a home run like that, and he signs your program." I'll never forget that first game, learning how to keep score, sitting there with my brothers and my dad in Yankee Stadium, and seeing the great Mantle at the height of his career during his Triple Crown season.

Since then, I've witnessed even more of baseball's greatest moments. I was at David Wells' perfect game. I was there the night Tino Martinez hit the grand slam that gave the Yankees the lead in Game 1 of the 1998 Series against San Diego. I saw Scott Brosius hit the ball into the left-field seats during Game 5 of the 2001 World Series against the Diamondbacks. His home run came a night after Tino's magical ninth-inning home run tied Game 4. I've had moments in that ballpark that were excruciatingly tense and joyful, and the greatest of them all is that home run Tino hit. The whole country wanted the Yankees to win that post-9/11 Series. The Yankees were the sentimental favorite.

The single greatest game was Game 7 of the 2003 AL Championship Series. Aaron Boone ended it with a home run off Boston's Tim Wakefield in the bottom of the eleventh inning. The crowd stood up for the final three innings of that game. We didn't sit down as Mariano Rivera single-handedly willed the Yankees to victory, refusing to let the Red Sox beat him. Those three innings make up the greatest pitching performance I have ever seen. There was no margin for error. If they lost, they went home, and Rivera would not let them lose. It was an astounding feeling to be part of a crowd of five-six thousand people who all wanted the same thing.

There is an elegance about Yankee Stadium that I will truly miss because so much of my childhood was there.

Even though the Stadium was renovated in 1974 and 1975, it still had the magic of the original Stadium. When I made the movie *61**, we re-created Yankee Stadium in the old Tiger Stadium in Detroit. The set designer was amazed that I could tell him where things were or what was missing without photographs. For the eleven days that we shot the movie there, I was able to be back in the old ballpark. You know that line from the movie *Field of Dreams*: "Is this heaven? No, it's Iowa." I was thinking, "Is this heaven? No, it's Yankee Stadium."

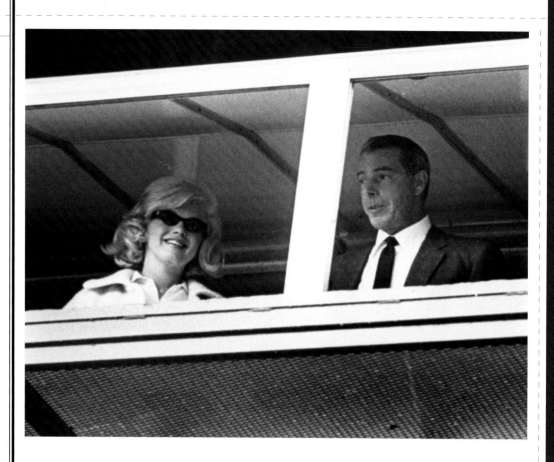

Marilyn Monroe and Joe DiMaggio watch from a club-level box at Yankee Stadium in 1961.

Like the players, sportswriters navigated the subterranean corridors of the underbelly of Yankee Stadium, and once I did so with Joe DiMaggio. I had come to know DiMaggio when he was a coach with the Oakland A's in the late 1960s. On an Old-Timers' Day at Yankee Stadium in the 1970s, I walked with the Yankee Clipper, now a gray-haired eminence, from the media dining room on the basement level to the Yankees clubhouse, where he put on his famous number 5 Yankees uniform. By an odd set of circumstances, I felt I had an opportunity to ask DiMaggio something about Marilyn Monroe, to whom, as the world knows, he was once married.

Reporters knew that if you mentioned Marilyn to Joe, he'd walk away, ending your relationship. A magistrate in Maryland who, as a sergeant in the U.S. Army had been assigned in 1954 to take photos of DiMaggio and Monroe as they deplaned on their honeymoon in Tokyo, sent me the photos he had taken. He had read a column of mine about DiMaggio and thought I might be able to get the photographs to Joe. He asked nothing in return, not even a DiMaggio autograph. He simply had had the pictures for a long time, and he wanted DiMaggio to have them.

"These are terrific shots," DiMaggio said. "I can't believe the guy was an amateur." We were now walking down the corridor.

"She looked great in the pictures," I ventured.

"She was a beautiful woman," DiMaggio said, as if breaking news.

We walked a little farther in silence.

"Joe," I said, after a moment, "there's a question I've always wanted to ask you, but didn't quite know how to say it."

"Oh," he said, eyeing me suspiciously, "what's that?"

"Well," I said, "there's one of the great sports anecdotes relating to you and Marilyn."

"And?" he said cautiously.

"It was when you two were on your honeymoon, and Marilyn was asked by the Army brass if she'd go over to Korea and entertain the troops. And she did, and you stayed behind in Tokyo. And when she returned and came through the door of your hotel room, she seemed excited. You supposedly asked her how it went, and she said, 'Joe, you never heard such cheering.'

"And you said, 'Yes I have.' Did that really happen, Joe?"

"Yes," he said, "it did."

Terse, but satisfyingly definitive.

(continued on page 197)

"I KNOW THERE WILL BE MANY THINGS THAT I'LL MISS ABOUT BASEBALL, BUT COMING TO NEW YORK AND PLAYING IN YANKEE STADIUM WILL ALWAYS BE AT THE TOP OF THAT LIST. AS A FAN OF BASEBALL, YOU REALIZE THAT THE HISTORY OF BASEBALL IS VERY RICH, AND YANKEES HISTORY IS A VERY BIG PART OF IT. JUST BEING ABLE TO WALK ONTO THE FIELD AT YANKEE STADIUM GIVES YOU A CERTAIN FEELING. BY PLAYING THERE FOR TWENTY-ONE YEARS, YOU REALIZE WHY IT IS SO SPECIAL. THE ATMOSPHERE MAKES IT SPECIAL."

— CAL RIPKEN JR.

MY FAVORITE MEMORY FROM MY FIRST GAME AT YANKEE STADIUM IS WHEN I WALKED DOWN THE TUNNEL INTO THE DUGOUT FOR THE FIRST TIME.

That is the first time I saw the field and all the seats. I had only played in minor-league ballparks, where there was only one tier. I couldn't get over the size of the upper deck at the Stadium. It seemed huge.

I was excited about being at Yankee Stadium. That day was the realization of a dream—I had finally made it to the big leagues. To reach that goal was incredible.

Another time I won't ever forget is when I came out of the dugout for batting practice before Game 1 of the 1995 American League Division Series. I got a huge ovation from the crowd. The place was juiced; it was an electric atmosphere. We had been trying to get to the playoffs for a long time. We had one of the best records in baseball in 1994 before the strike ended the season. We got denied that year, and then we weren't playing well early in 1995, but we put together a great stretch late in the year to get into the playoffs. I had never been in the playoffs, so it was a relief to finally get there.

The home run I hit in the second game of that series was big for me. It was weird to face Andy Benes the first time I ever got into the playoffs because he is from my hometown of Evansville, Indiana. I got a base hit early in the game, and I had a good idea of what Andy was going to try to get me out with in my second at-bat. He hung a change-up over the plate, and I was able to hit it into the seats.

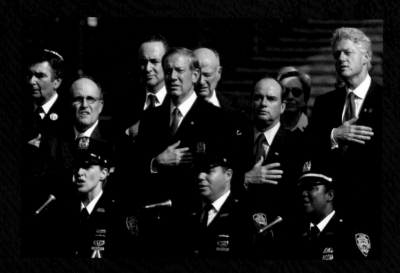

JUST TWELVE DAYS AFTER THE HORRIFIC ATTACKS OF SEPTEMBER 11, TENS OF THOUSANDS OF PEOPLE GATHERED IN YANKEE STADIUM FOR THE PRAYER FOR AMERICA, ONE OF THE FIRST CHANCES FOR NEW YORKERS AND AMERICANS TO COME TOGETHER AND BEGIN THE LONG PROCESS OF HEALING.

We gathered to mourn the victims of the September 11 terrorist attacks, support their families, and celebrate our country's resiliency, diversity, and strength. As we stood united, we were reminded that none of us were alone, that we were all in this together, and that by relying on each other, we could emerge from this tragedy stronger than before.

The Prayer for America brought together religious leaders from the Christian, Muslim, Jewish, Sikh, and Hindu faiths. They prayed with the crowd for the missing and the dead, and for the city's and our nation's recovery. Despite their doctrinal differences, they were of one mind when they spoke of the need for tolerance and understanding in the difficult days ahead.

Even so soon after that terrible day, gathered in one of baseball's great cathedrals and listening to many of our nation's most eminent religious dignitaries, entertainers, and political leaders, we were able to find some comfort in our shared understanding and resolve.

In the weeks after September 11, as the nation's ballparks reopened and play resumed, baseball was one of the pastimes we looked to for a sense of normalcy. That year's postseason was one of the most exciting in recent memory. The Yankees embodied their city's resiliency and tenacity as they fought their way to the seventh game of the World Series, coming back time and time again from the brink of elimination. For a while, they were able to distract New Yorkers from their recent sorrow and allow them to once again feel hope and pride.

Baseball has always helped us come together as a country. It is part of our common heritage and reflects many of our basic values: teamwork, perseverance, fair competition, optimism, and the importance of playing by the rules.

Jackie Robinson's courageous integration of baseball in 1947 foreshadowed the remarkable progress our country would make on civil rights in the ensuing decades. As Jackie proved, when you're at the plate with a bat in your hands, it doesn't matter what color your skin is, what language you speak, or where you come from.

For countless recent immigrants, baseball has provided an accessible entry point into American culture. New Yorkers of every background imaginable could share in the pride they felt when watching the Yankees compete and excel.

Yankee Stadium has been host to many memorable events in America's history: Masses held by Pope Paul VI and Pope John Paul II, a historic boxing match between Joe Louis and Max Schmeling, and a rally addressed by one of the greatest leaders of our era, President Nelson Mandela, shortly after his release from prison. Since its gates first opened in 1923, New Yorkers and Americans from across the country have visited Yankee Stadium to share a common experience, celebrate athletic greatness, and root for their favorite teams.

As one of the most visible landmarks of one of America's great social and cultural unifiers, Yankee Stadium has given immigrants, people of modest means, and other marginalized groups a shared sense of identity, and it has allowed them to participate more fully in American society.

Two months after the September 11, 2001, terrorist attacks, a televised public service advertisement touted New York City tourism with the theme, "Everyone has a New York Dream." In the TV spot, a man in a business suit stood at home plate in Yankee Stadium, hit an imaginary baseball, and rounded the bases. As the man slid into home, his face came into view. It was Henry Kissinger, who supposedly had just fulfilled his New York dream. "Derek who?" he asked smugly from the dirt, referring to the Yankees' great shortstop, Derek Jeter.

Kissinger is a Nobel Peace Prize winner, was the Secretary of State under Presidents Nixon and Ford, and is a distinguished diplomat—but baseball, the Yankees, and Yankee Stadium helped ease his transition from Europe to America.

"I had just turned sixteen, and had been in this country for less than a year when I first fell under the spell of Joe DiMaggio," Kissinger wrote in the foreword to the book, *DiMaggio: Setting the Record Straight*. "I had arrived in New York in 1938 with my parents and younger brother, escaping the increasingly dangerous environment in Nazi Germany. We settled in Washington Heights in upper Manhattan, a haven for many other German Jewish refugees, and I enrolled in a local high school."

Kissinger said he worked by day to help support his family and went to school at night. Knowing nothing about baseball, he was left out of conversations about the game with his co-workers at a shaving-brush factory. One Sunday, his friends invited him to a game at Yankee Stadium. They sat in the fifty-five-cent bleacher seats, "where we couldn't see much of what was going on at home plate, but had a good view of the great DiMaggio," Kissinger said.

DiMaggio's smooth and stylish manner playing baseball hooked Kissinger on the game. "Every Sunday when the Yankees were playing a home game, I would walk forty-five minutes to the Stadium to watch my hero work his magic," he said. "I had become an American in my heart, if not yet in the eyes of the Bureau of Naturalization."

Yankee Stadium often played a role in promoting nationalism. Following the September 11 attacks, the Yankees won the American League pennant and met the Arizona Diamondbacks in the World Series. The first two games were played in Phoenix before the Series shifted to New York. In front of an emotionally charged crowd at Yankee Stadium, President George W. Bush threw out the ceremonial first pitch for Game 3. In Games 4 and 5, the Yankees mounted improbable comebacks for stirring victories that were seen as sterling examples of the resolve and

AT A RALLY AT YANKEE STADIUM ON JUNE 21, 1990, SOUTH AFRICAN NATIONAL CONGRESS PRESIDENT NELSON MANDELA SAID:

"NOW YOU KNOW WHO I AM. I AM A YANKEE."

resiliency of all New Yorkers.

"To me, there is no doubt about it: We helped heal our city," said Brooklyn native Willie Randolph, a Yankees coach in 2001. "I was there. I lived it. We were more than just a diversion and escape for our devastated city. We fought back like true New Yorkers do, and I think it gave us hope. It was a very emotional time."

Said Rudolph Giuliani, New York City mayor at the time, "There was something about baseball. It had a wonderful impact on the city. It was exactly what we needed to get [our] eyes off the ground, [and] looking into the future."

"It was like there was more of a weight on our shoulders to try to bring some happiness to the people of New York," Randolph observed. "The city was abuzz, of course, as it always is when the Yankees are in the postseason. So you did kind of feel that you almost had a responsibility to get this done. That's why it hurt so much when we lost." The Yankees were defeated by the Diamondbacks in seven games.

On September 23, 2001, the Stadium served as a venue for an interfaith prayer service for the nearly three thousand people dead and missing in the destruction of the World Trade Center. When Mayor Giuliani announced plans for the service—called Prayer for America—he said it would "give the families of victims and those affected by the tragedy an opportunity to come together, worship together, and gain strength." An estimated twenty thousand people showed up at Yankee Stadium, a venue "that has symbolized victory for the last four years, and indeed for generations," read a statement from the mayor's office. The speakers included Christian, Muslim, and Jewish leaders, as well as Giuliani and New York Governor George Pataki.

The Yankee Stadium baseball diamond was dressed for a prayer service. A bed of flowers lay on home plate, and the pitcher's mound was planted with flowers in a formation of stars and stripes. Cries of "Beer, ice cold beer, here!" were replaced by "USA! USA!" The ceremony was shown live on scoreboard screens at minor-league stadiums in Brooklyn, Staten Island, and Newark, New Jersey.

Yankee Stadium was the site of historic religious services, none more reverential than the Mass celebrated by Pope John Paul II on October 2, 1979. The pope, the world leader of Roman Catholicism, stood on a platform in the infield, surrounded by an estimated eighty thousand people, "a predominately middle-class crowd," according to the *New York Times*. In an appeal to aid the impoverished, the pope said, "The poor of the United States and of the world

(continued on page 200)

SPENDING MORE THAN TWO YEARS WITH THE PEACE CORPS IN THE DOMINICAN REPUBLIC WAS A CHALLENGING ASSIGNMENT. AS A LIFELONG BOSTON RED SOX FAN, STANDING IN THE INFIELD OF YANKEE STADIUM TO TALK ABOUT IT WAS ALMOST AS DIFFICULT.

The last time I'd been to the Stadium was for the seventh game of the 2003 American League Championship Series. I sat in the stands and watched Aaron Boone's home run off Tim Wakefield land in the lower deck, ending the hopes, once again, of a Red Sox pennant and the chance to put the "Curse of the Bambino" to rest.

Three years later, when I was invited to celebrate the forty-fifth anniversary of the Peace Corps at Yankee Stadium, I saw the storied field from a different perspective, not as a partisan fan, but as a participant in another chapter of Yankees lore.

As much as I love Fenway Park, I couldn't help but feel the sweep of history as I stood on the grass in Yankee Stadium, the inner sanctum of America's game. In 1961, the year President John F. Kennedy launched the Peace Corps, Roger Maris hit sixty-one homers, eclipsing Babe Ruth's record and leading the Yankees to the World Series title. Yankee Stadium led baseball in attendance that year, and, like the Peace Corps, it is still attracting new fans.

Through decades of war and depression, civil strife, the cycles of boom and bust, and the everyday struggles of average working people, America has turned its eyes to the Bronx for relief, so often capping off the baseball rites of summer with the autumn rituals of the playoffs and the World Series.

In many ways, Yankee Stadium is not only America's ballpark, but also the cornerstone of the baseball world, a lure to those who come together to play and watch on common ground. Ruth and Gehrig and Combs gave way to DiMaggio and Berra and Jackson, and now Jeter and Mussina and Rivera take to the diamond. The pull is universal, and, in my case, familial as well.

I grew up in Boston, and one of the pictures I saw every day in our family dining room was a black-and-white photo of my grandfather, Sen. Robert F. Kennedy, shaking hands with Mickey Mantle during an appreciation day for the Yankees outfielder in 1965. My father, Joseph P. Kennedy II, treasures that photo—at age thirteen, he skipped school to attend the ceremony with his dad. The same image hung on his office wall in the U.S. Congress and now looks over his desk at Citizens Energy Corporation.

The photograph shows Sen. Kennedy, elected just a year earlier from the state where he was born, and Mickey, near the end of his career, leaning in toward one another, shaking hands, and sharing a private joke. Mickey's cap is tucked under his massive left forearm. In the background, fans along the first-base line stand in tribute in the September sun.

The cycle of seasons means everything comes to an end. Yankee Stadium, like Ebbets Field, the Polo Grounds, and Hilltop Park before it, will yield to a new ballpark and new memories, many of them in the accents of players and fans from the world over as they, like generations of fans before them, come to cheer America's game.

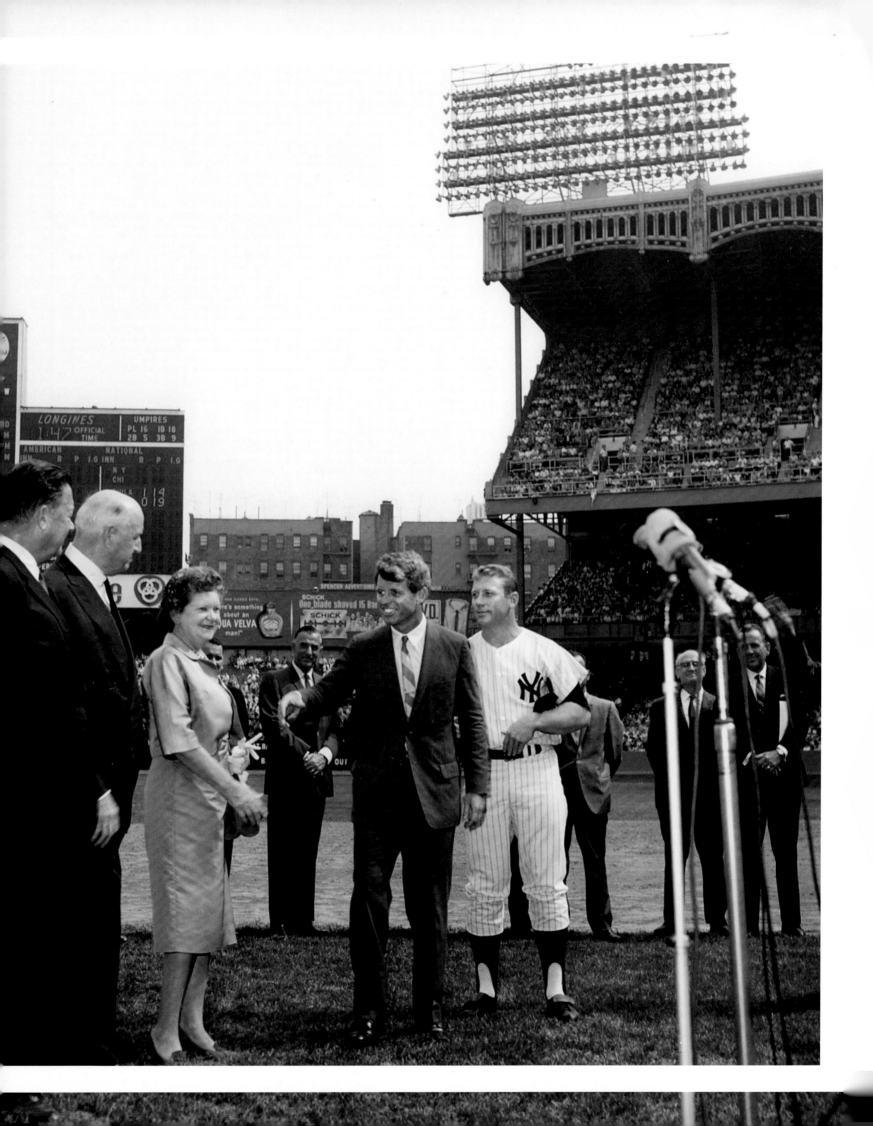

are your brothers and sisters in Christ. You must never be content to leave them just the crumbs of the feast."

On his visit to New York, the pope also toured a housing rehabilitation project a short distance from Yankee Stadium in the south Bronx, and delivered an address at Harlem's St. Charles Borromeo Roman Catholic Church.

The Stadium also proved to be a worthy venue for rock 'n' roll. In 1990, Billy Joel performed the first rock concert at the Stadium, and later released a video titled, *Billy Joel: Live at Yankee Stadium*. U2 and Pink Floyd held concerts in 1992 and 1994, respectively. U2 performed twice at the Stadium in August 1992, entertaining huge crowds with both its music and use of hyper technology.

Among those who flocked to see U2 was tennis star Steffi Graf. A few days later, she lost her U.S. Open quarterfinals match to Arantxa Sanchez Vicario. Asked about her visit to New York, Graf didn't mention the U.S. Open, but talked excitedly about the U2 concert at Yankee Stadium.

Boxing also created memories at Yankee Stadium, the site of thirty championship prizefight, from 1923 to 1976. The most famous was the 1938 world heavyweight title bout between Joe Louis and Max Schmeling, indeed perhaps the most significant prizefight of all time. It was portrayed as black versus white, America versus Nazi Germany. Louis, who had lost earlier to Schmeling, this time knocked out his formidable opponent 124 seconds into the first round.

The Stadium was electric, too, on the night of September 28, 1976, for the world heavyweight title bout between the challenger Ken Norton and the champion Muhammad Ali. I have attended championship fights at Shea Stadium and Madison Square Garden, and neither venue could match the ambience of the grand, historic Yankee Stadium, with the cynosure of the ring and the fighters illuminated in the night, all in all an extraordinary experience for those fortunate enough to be there.

Ali retained the title in a controversial fifteen-round decision. It was always difficult to take your eyes off Ali, in or out of the ring, and he didn't disappoint that night. Ever the gallant fighter and irresistible showman, he mesmerized the huge throng in what would be the final championship fight held at Yankee Stadium.

Yankee Stadium concert performers: Billy Joel (above); Bono (opposite) of U2.

While the Yankees' fortunes improved under the ownership of George Steinbrenner and they again became World Series contenders in the mid-1970s, their surroundings did not follow suit. "The neighborhood around the stadium was enduring some of its worst horrors," wrote Neil J. Sullivan in his authoritative history, *The Diamond in the Bronx: Yankee Stadium and the Politics of New York*. The area was in social and economic decline into the 1980s and '90s, and gained a reputation for random violence.

Steinbrenner lobbied the city in the early 1990s to build a new stadium for the Yankees, perhaps on the West Side of Manhattan, and he had previously made overtures about moving the team to New Jersey. Steinbrenner complained that relatively low attendance at Yankee Stadium was due to a perception that the neighborhood was dangerous, in addition to inadequate parking and luxury suites.

In reality, crime never was a significant problem in the area around Yankee Stadium, according to commanding officers over the years of the police station at the Forty-fourth Precinct headquarters, which is located a few blocks from the Stadium. A detail of about sixty-five policemen assigned to every game provided a presence at the Stadium, on nearby traffic routes, and at the 161st Street train station adjacent to the Stadium.

An aerial view of Yankee Stadium and its neighborhood in the Bronx.

"THE FIRST OPENING DAY GAME I PITCHED IN AT YANKEE STADIUM WAS IN 1996. THE SNOW IS WHAT STANDS OUT FROM THAT GAME. JUST TO BE PLAYING A GAME IN THE SNOW WAS AMAZING. I REMEMBER STANDING ON THE MOUND AND FEELING SNOW HITTING ME; IT WAS HITTING ME IN THE BACK OF THE NECK AND MELTING DOWN MY BACK. THE FANS WERE INTO THE GAME LIKE IT WAS A SUMMER DAY. THEY REACTED TO EVERYTHING. IT WAS VERY SPECIAL FOR ME. I WAS ONE OF THE YOUNGEST PITCHERS TO START A HOME OPENER, SO THAT WAS ONE OF THE BIGGEST STARTS I'VE EVER MADE." – ANDY PETTITTE

The Yankees celebrate after beating Atlanta's Greg Maddux in Game 6 to win the 1996 World Series.

Greg Maddux was at the height of his extraordinary career when the Yankees met the Atlanta Braves in the 1996 World Series. Maddux pitched twice at Yankee Stadium in the Series, winning Game 2 and losing the decisive Game 6 by a score of 3-2. Like many before him who had performed on his profession's biggest stage in its grandest arena, Maddux was both awed and appreciative.

"I'll have great memories of this place," Maddux said after Game 6. "Obviously, it hurts losing, but the atmosphere here is matched nowhere. It's exciting to be out there on that mound in front of people going freaky. It's wild. Even though we lost, in a while we're going to appreciate being in this place."

Nineteen ninety-six was Joe Torre's first year as Yankees manager, and he knew what Maddux was feeling. "There are ghosts here, and a rich tradition. You can sense it all around you," Torre said.

"When I became manager here, the first time I walked down the runway leading to the dugout from the clubhouse I thought of Ruth, Gehrig, DiMaggio, and all the others taking the same path. That's what the Stadium is all about."

★★★ **FIRST PERSON** ‖ **LANCE ARMSTRONG** ‖ ★★★

After winning my third Tour de France, I threw out the first pitch on August 1, 2001. It was my first time in Yankee Stadium, and to make it all the more interesting they were playing the Texas Rangers. "Rocket" [Roger Clemens] is also a Texan, but not someone I knew all that well. Since then, we have become quite good friends. We try to get together whenever we are in the same city.

My days of throwing a baseball are long over, and I was not very good to begin with. I was warming up with some of my friends for fear of embarrassment in the most famous ballpark in the world. I wouldn't call it a strike, but I think I did okay for a guy who rides a bike for a living.

You can for sure feel the energy when you step out onto the field. And the fans were great. Although I am a Texan, I spend a lot of time in New York, and I love the people and the energy. Like I said, it had been a long time since I threw a baseball. If you bounce one in front of the plate, that replay will show a lot.

I was still a bit tired from the Tour and the travel, but then a bit of adrenaline kicks in and you realize that people here in the United States were into the Tour and watched it. Then you head out into the world's most famous ballpark—it is hard not to get up for that.

COLLEGE FOOTBALL

❧ STEVE RICHARDSON ❧

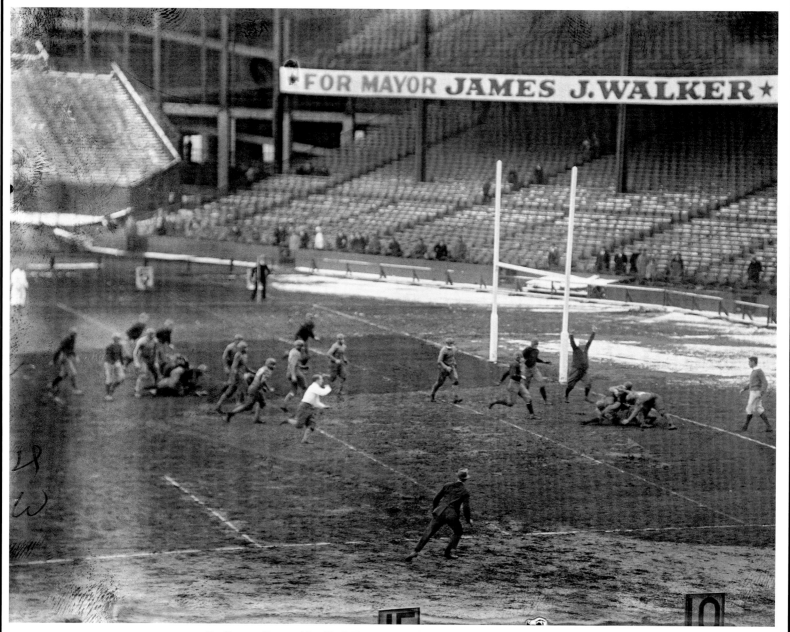

Fordham rolls over New York University, 26–6, at Yankee Stadium in 1925.

Yankee Stadium played host to college football games from 1923-1987, notably a long-running Army-Notre Dame series from 1925-1946, and games from 1968-1987 that usually involved Grambling State University and other historically black colleges.

Fordham University and New York University played a series of games at Yankee Stadium from 1923-1946. The 1936 NYU team defeated Fordham, 7-6. That Fordham team was famous for its offensive line, the "Seven Blocks of Granite," which included Vince Lombardi, who went on to a legendary coaching career with the Green Bay Packers. NYU used the Stadium as a secondary home field from 1923-1948, playing ninety-six games there and compiling a 52-40-4 record. Fordham went 13-5-1 at the Stadium.

The annual Army-Navy game was played at Yankee Stadium in 1930 and 1931 before being moved to Philadelphia. The Stadium also played host to a postseason game in 1962, the Gotham Bowl.

The gridiron at Yankee Stadium was positioned across the infield and up the third-base line. One end zone was along the first-base line, and the other was in left field. Temporary bleachers were installed in right field.

"It was a bumpy field," said Jerry Groom, a linebacker on the 1949 Notre Dame team that played North Carolina in the Stadium. "It was a typical baseball stadium. They didn't have turf down. We were playing on dirt and a little bit of sod. It was mostly just dirt around the infield. And

★ FIRST PERSON ★

CHARLIE WEIS

As long as I can remember, I've been going to Yankee Stadium.

I went to my first game there in the early 1960s when I was about four years old. My father used to bring me to games. I've sat everywhere in the Stadium. I've sat in the best seats in the house, and I've sat out there in the right-field bleachers. I remember sitting behind poles before they renovated Yankee Stadium the last time.

It's amazing to think of all the players I've seen play there over the years. I saw Mickey Mantle when I was really young. And then I saw the next stage of players, like Thurman Munson, Reggie Jackson, and that crew. More recently, I've seen Don Mattingly, Derek Jeter, and Alex Rodriguez take the very same field.

Charlie Weis is the head football coach at the University of Notre Dame.

the pitchers' mound, we would bump into. The season had to be over for the Yankees, and so the stadium was not prepared well for next season."

Buddy Davis covered some Grambling games at the Stadium for the *Ruston (LA) Daily Leader* newspaper. "The turf seemed to be chewed up," Davis said. "And everything seemed boxed in, like a cracker box. Both teams were on the same side of the field. I remember soaking up the atmosphere, watching the game, and covering football. With the monuments out in the outfield, it was sort of surreal watching a football game in Yankee Stadium."

For Notre Dame-Army games, Yankee Stadium crowds swelled to as large as 79,408 (the 1929 game), and ranged from seventy-three thousand to seventy-eight thousand during the 1930s and '40s. Notre Dame brought its team to New York City for a big payday. The Fighting Irish in those days sought games in large metropolitan areas and gained a following known as the "Subway Alumni."

Prior to the opening of Notre Dame Stadium in 1930, which seated about fifty-four thousand, the Fighting Irish only had field and bleacher sections in South Bend, Indiana. Notre Dame was better off financially playing at Yankee Stadium, even after 1930. Army, too, enjoyed a financial windfall from games at the Stadium, compared with playing at its home field, Michie Stadium, just up the Hudson River, which had

only sixteen thousand permanent seats when it opened in 1924.

The 1928 Army-Notre Dame game was one of the most famous of the series. Notre Dame was pitted against a powerful Army team that had steamrolled six straight opponents. Notre Dame coach Knute Rockne made his famous, "Win one for the Gipper speech" at halftime, and the Irish pulled off a stunning 12-6 victory.

Army didn't defeat Notre Dame from 1932 to 1943, but the 1944 and 1945 Army teams, featuring legendary running backs Doc Blanchard and Glenn Davis, beat Notre Dame by a combined score of 107-0. Each of those teams went on to win the national title.

The buildup for the 1946 Army-Notre Dame game was tremendous. Notre Dame coach Frank Leahy and some of his top players were back from World War II. The game was sold out in June, and media outlets requested a record number of press box seats. The teams were ranked first and second in the college football poll when they played. As the Notre Dame bus pulled up outside Yankee Stadium for the game, scalpers offered Irish players as much as two hundred dollars for each of their tickets. Too late—most of the players had previously sold their tickets for fifty dollars each.

"Army was the home team," said Joe Steffy, a guard on the 1946 Army team. "We would come out, and there would be a big cheer. But when

Notre Dame came out, it was like thunder; it was deafening. I looked up and asked, 'Who the hell is the home team here?' "

The game ended in a 0-0 tie.

Scheduling conflicts sent the 1947 game to the Notre Dame campus, and then the series was halted for a decade. Army continued to play at Yankee Stadium through the late 1940s and into the '50s and '60s against other opponents. The final Notre Dame-Army game at Yankee Stadium was a 45-0 victory for the Irish in 1969.

Notre Dame played twenty-four games at Yankee Stadium, compiling a 15-6-3 record. Army went 17-17-4 in thirty-eight games.

The inaugural Gotham Bowl was scheduled at the Stadium in 1960, but was cancelled because the organizers were unable to book an opponent for Oregon State University. The game was played at the Polo Grounds the following year, and then moved to Yankee Stadium in 1962, when Nebraska defeated the University of Miami, 36-34, in one of the most exciting college football games ever played at the Stadium. However, attendance was just 6,166, in part because of frigid weather and a newspaper strike in New York City, and the Gotham Bowl was never played again.

"It was fourteen degrees when we got to the Stadium, and by kickoff it was nine degrees," said Don Bryant, who was sports editor of the *Lincoln (NE) Star* and later became Nebraska's sports

(continued on page 208)

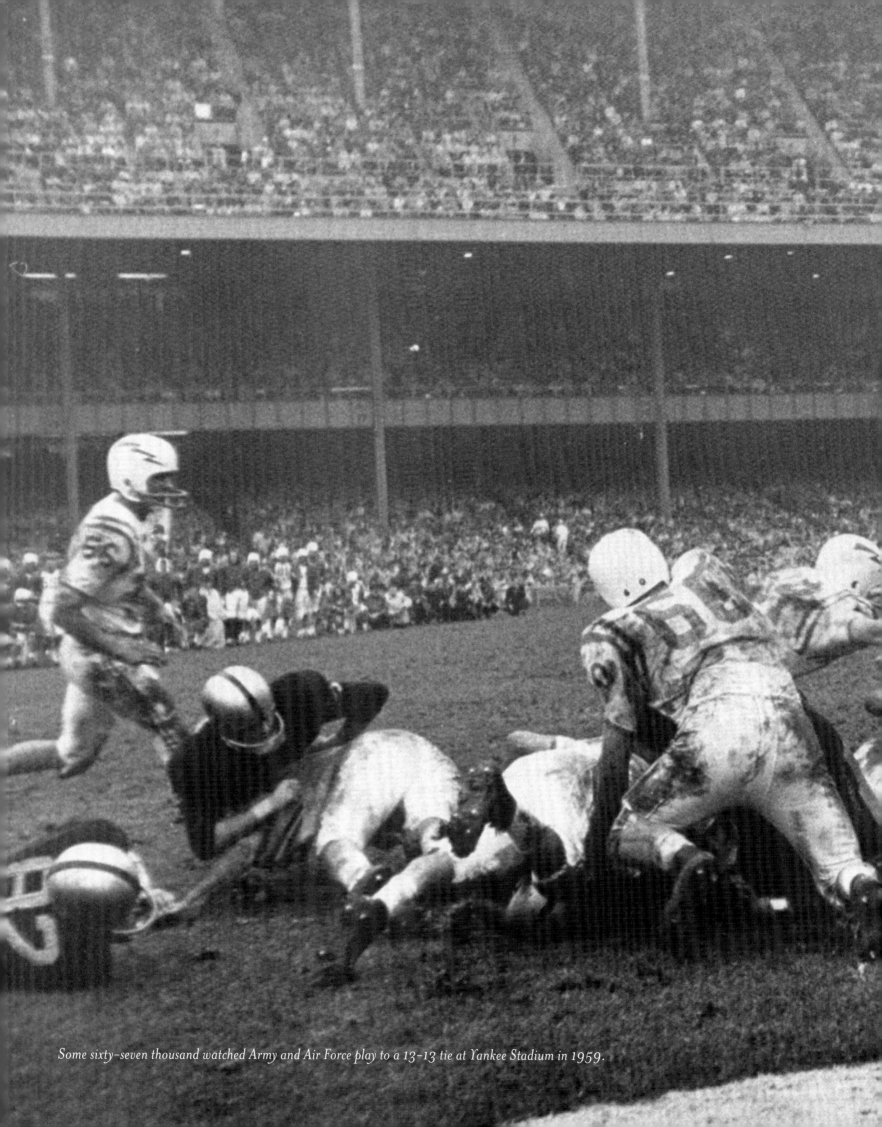

Some sixty–seven thousand watched Army and Air Force play to a 13-13 tie at Yankee Stadium in 1959.

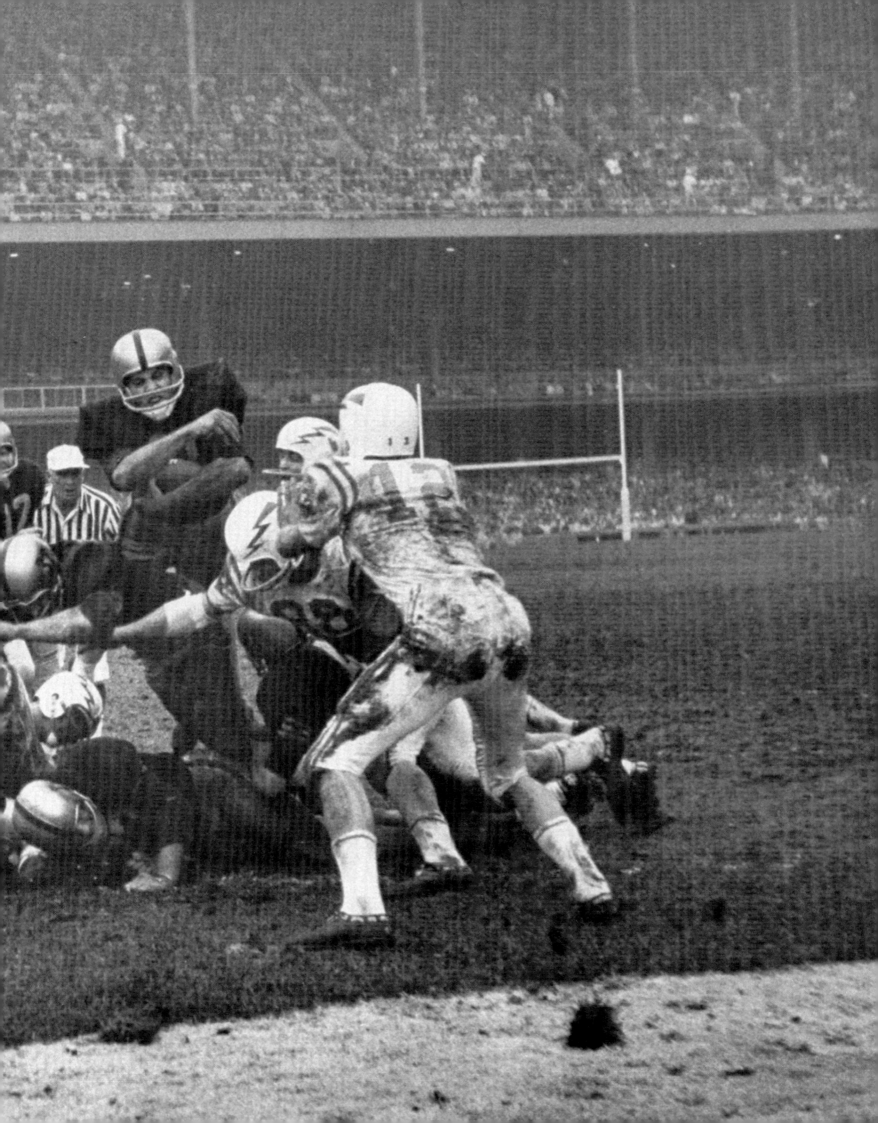

information director. "They played on frozen turf and had to wear tennis shoes. But it was one of the greatest games ever. In the fourth quarter, I remember being on the sidelines, and there was a garbage can with a fire in it where the cheerleaders were trying to keep warm.

"They shut the power off after the game. It was so cold in the press box, we went back to the hotel to file our stories."

In the late 1960s, Grambling State University publicist Collie Nicholson urged school officials to follow Notre Dame's lead in scheduling football games in large stadiums in big cities. Located in rural northwest Louisiana, sixty-five miles east of Shreveport, Grambling played in a thirteen thousand-seat home stadium. Playing at professional stadiums and becoming the "Notre Dame of Black College Football" could prove to be beneficial to Grambling both financially and in recruiting. The flamboyant Grambling Marching Band also could attract fans.

"We thought the market was there, if we

The crowd was sparse and the weather was frigid when Nebraska beat the University of Miami, 36–24, in the 1962 Gotham Bowl at Yankee Stadium. Just 6,166 people attended the game, and the Gotham Bowl was never played again.

made the proper contacts with sponsors and got guarantees," Nicholson said in 1992. "We could not only do what we set out to do; we could make money we had not even dreamed about."

Nicholson and legendary Grambling coach Eddie Robinson convinced Yankees officials that a Black college football game would draw at Yankee Stadium. Grambling's first game there, a 1968 match against Morgan State, drew sixty-four thousand.

That game grew into the New York Urban League Classic, which was established in 1973 and later renamed the Whitney M. Young Urban League Classic. The game was played at Yankee Stadium through the 1987 season, except for when the Stadium underwent renovations in 1974-1975. The fund-raiser game, which supports college scholarships for low-income New York City students, has been played in Giants Stadium in New Jersey since 1988, although the Yankees have continued to be an active supporter of the event.

★ ★ ★ **FIRST PERSON** ‖ **FRANK GIFFORD** ★ ★ ★

New York Giants running back Frank Gifford scores a touchdown against the Chicago Bears in the 1956 NFL championship game.

In my senior year at USC in 1951, we played Army at Yankee Stadium. New York Giants owner Wellington Mara was scouting for the Giants at that time. I played on both sides of the ball that day, and he ended up drafting me number one on the basis of that game. It was a wet field, and he liked how well I played on it. He called me a mudder after that.

Playing in front of the New York press helped me to get voted a consensus All-American. I knew I had to have a big game at Yankee Stadium. To be a consensus All-American, you had to own New York. That was the greatest showcase for me.

That was the first time I was in New York. After the game, we went to Manhattan and saw the musical *Guys and Dolls*. It was a once-in-a-lifetime trip. We beat Army at Yankee Stadium during the day, and went to our first musical that night.

When I think back on my college football career, which led to me becoming a professional football player and moving to New York, which led to me being in radio and television, and which led to me winning an Emmy—playing at Yankee Stadium against Army was extremely important. If I hadn't played there in my senior year, who knows where my career would have gone?

"The late 1960s and through the '70s was right in the prime of Grambling's big runs, some of the monster teams," said Michael Watkins, Robinson's grandson and director of Robinson's foundation. "With that kind of talent coming through, people wanted to see that kind of magic from the Black colleges."

Many of Grambling's greatest players, among them future NFL players James Harris, Frank Lewis, Charlie Joiner, Doug Williams, Sammy White, Dwight Scales, James Hunter, Matthew Reed, Trumaine Johnson, and Albert Lewis, played at Yankee Stadium.

Yankees owner George Steinbrenner made certain that Grambling was a regular participant in the Classic. Steinbrenner and the legendary sportscaster Howard Cosell both had great admiration and respect for Eddie Robinson. Cosell and Robinson became friends when ABC filmed a 1968 special report entitled, *Grambling College: 100 Yards to Glory*, and Steinbrenner helped underwrite the Classic after he became the Yankees' owner in 1973.

Some Black colleges were concerned that Grambling received an unfair share of national exposure from its frequent appearances in the Classic. One year, Morgan State and Florida A&M officials tried to convince Classic officials that their teams should be in the game, and Grambling should be left out.

As Watkins tells the story, officials haggled over the Classic participants in a meeting in New York. "The phone rings in the room, and my grandfather is called to the phone. It was Cosell, who asked, 'Eddie, how are things going?' 'I can't play,' Eddie said. 'What do you mean? You are Grambling,' Cosell replied.

"Howard gets Steinbrenner on the phone," Watkins says in retelling his grandfather's story, "and Steinbrenner tells Florida A&M and Morgan State, 'Eddie is in the game. I am paying for this. It is up to you, which one of you gets to play against Eddie.'

"That's how Grambling got in, and never left until my grandfather retired."

I WAS A YANKEES FAN AND A JOE DiMAGGIO FAN MY WHOLE LIFE, AND WHEN I WAS A ROOKIE WITH THE CLEVELAND BROWNS, YANKEE STADIUM WAS THE PREMIER PLACE TO PLAY IN THE COUNTRY—NO DOUBT ABOUT IT.

The look of it, the size of it, and the whole New York atmosphere set Yankee Stadium apart. That is what a stadium is supposed to look like. So when I played there as a rookie, it was quite an exciting event for me because of all the history that had taken place there. I had great admiration for the Yankees, the Giants, and the whole concept of playing in New York.

The Yankees were the most elite team in baseball, and our coach, Paul Brown, used to tell us that we should be the Yankees of football. Yankee Stadium was the epitome of what everything was about in sports. The Giants were a very good team, and the media coverage in New York was second to none. As a result, every time we played there, it was the biggest game of the year.

The crowd at Yankee Stadium was very respectful. They enjoyed the competition, and they enjoyed opponents' performances. They were sophisticated, so if you performed well, you might even have gotten a smattering of applause, even though you were trying to beat their team.

In the 1958 playoff game, the fans started coming onto the field with about a minute to go. It didn't cause a riot, but Paul Brown pulled us off the field. The referee told us that we had to finish the game, so Paul sent us out of the locker room to finish it.

I didn't think anyone was going to get hurt when we went back out, and fortunately nothing bad happened. It was just a funny thing to see.

The 1958 Giants defense was tough to play against because they were the smartest group in football. They knew all of our tendencies. We scaled back our offense because our coach was afraid of them. They played a team defense, and they all knew what they were doing.

Sam Huff was one of the smartest players ever to play the game, and he and I had a strong rivalry. I have a lot of respect for him. He could hit you hard, but more than that, he was always where he was supposed to be. Because of that rivalry, the games I played at Yankee Stadium are a big part of my football memories.

I was happy to have success at Yankee Stadium later in my career because the Giants had beaten us in some crucial games early on. It was a great accomplishment and a great feeling. The Giants were always well-coached, so we felt fortunate to score so many points against them in 1960 and 1964.

Yankee Stadium is the number one sports venue in America, because it is in New York City and the Yankees have always been such an illustrious organization. I grew up watching the Yankees on TV, and Yankee Stadium is the ultimate venue.

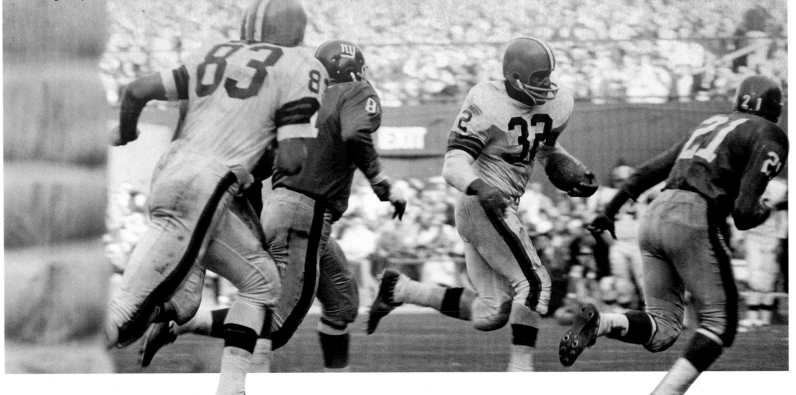

THE NFL

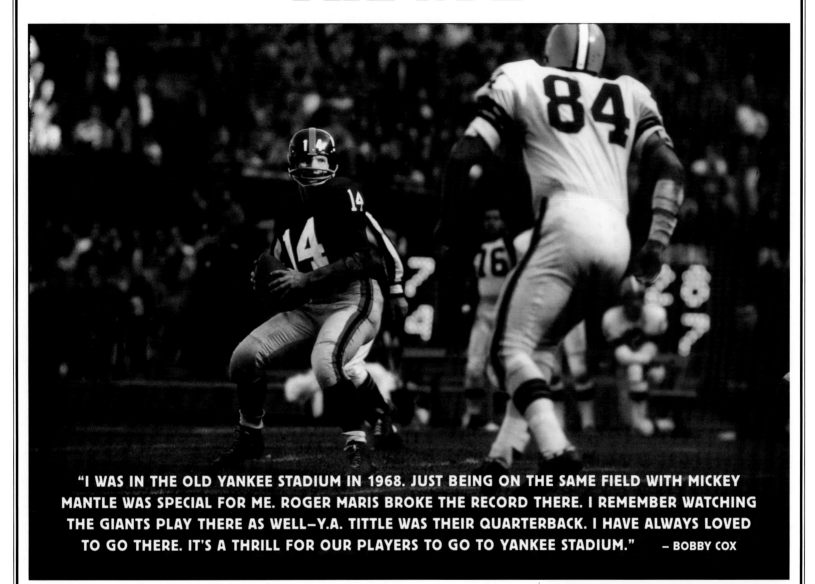

"I WAS IN THE OLD YANKEE STADIUM IN 1968. JUST BEING ON THE SAME FIELD WITH MICKEY MANTLE WAS SPECIAL FOR ME. ROGER MARIS BROKE THE RECORD THERE. I REMEMBER WATCHING THE GIANTS PLAY THERE AS WELL—Y.A. TITTLE WAS THEIR QUARTERBACK. I HAVE ALWAYS LOVED TO GO THERE. IT'S A THRILL FOR OUR PLAYERS TO GO TO YANKEE STADIUM." — BOBBY COX

The football New York Giants made their first season at Yankee Stadium a memorable one. But the Giants weren't the only National Football League team to make history on the Stadium turf.

The Giants called the Stadium home from 1956 through the 1973 season. On December 30, 1956, the Giants beat the Chicago Bears, 47-7, in the NFL championship game. Though they would play in six titles games in eight years, it was the only time the Giants won.

Two years later, the Giants and Baltimore Colts tangled in what is still called "The Greatest Game Ever Played." On December 28, 1958, the Colts edged the Giants in overtime, 23-17.

Vince Lombardi led the Green Bay Packers to an NFL championship in Yankee Stadium in 1962, when the Packers beat the Giants, 16-7, on December 30.

Two days earlier, a federal judge in U.S. District Court denied an injunction that would have allowed the game to be broadcast on television in New York City, upholding an NFL rule that blacked out games within a seventy-five-mile radius of the home team.

In 1972, Don Shula's Miami Dolphins beat the Giants during the regular season en route to the NFL's only perfect season.

"THE THING I ENJOYED MOST ABOUT THE GAME I SAW AT YANKEE STADIUM WAS THE FANS. THEY COME OUT THERE, THEY SUPPORT THE YANKEES, AND THEY WANT THEM TO PLAY THEIR BEST BASEBALL. BUT IF THE PLAYERS DON'T DO THAT, THEY LET THEM KNOW THAT THEY'RE NOT DOING THEIR JOB."

— JERRY RICE

"I GREW UP IN NEW YORK, AND I PLAYED AT NOTRE DAME, WHICH HAS A PRETTY GOOD STADIUM. WHEN I WAS TRADED TO THE GIANTS, I WAS REALLY LOOKING FORWARD TO PLAYING AT YANKEE STADIUM BECAUSE IT WAS IN MY HOMETOWN. THE FANS ARE THE BEST. THEY KNOW EVERYTHING—BASEBALL, FOOTBALL, WHATEVER IT IS. ONCE YOU'RE ON THE FIELD, THEY'LL NEVER FORGET YOU. TO THIS DAY, WHEN I WALK THROUGH NEW YORK CITY, PEOPLE STILL SAY, 'HEY, DICK, HOW ARE YOU?' IT'S AMAZING. IT'S A THRILL TO SEE BOB SHEPPARD AND HEAR HIM SAY, 'OLD NUMBER 22, DICK LYNCH.' WHENEVER I CAN, I STILL STOP BY TO SAY HELLO TO HIM. I KNOW THAT MY FAMILY ENJOYED WATCHING ME PLAY AT YANKEE STADIUM. ALL OVER THE WORLD, PEOPLE KNOW ABOUT YANKEE STADIUM, AND IT WAS A THRILL FOR ME TO HAVE HAD THE OPPORTUNITY TO PLAY THERE. I GET JUST AS MUCH OF A THRILL WATCHING GEORGE STEINBRENNER'S NEW YORK YANKEES PLAY THERE."

— DICK LYNCH

Dick Lynch (22), in a 1962 game against the Pittsburgh Steelers at Yankee Stadium.

IT WAS EXCITING TO TAKE MY TEAM INTO YANKEE STADIUM ON DECEMBER 10, 1972, TO PLAY THE NEW YORK GIANTS BECAUSE I WAS A BIG BASEBALL FAN GROWING UP.

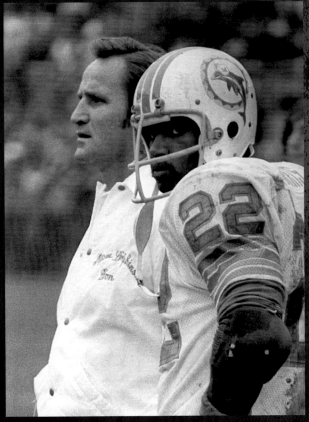

I followed the Yankees and knew all about Yankee Stadium. The Dolphins were 12-0 going into that game, and the Giants were a tough team. It ended up being close. Earl Morrall hit Paul Warfield late in the first half for a touchdown. Paul made a great catch, and that really helped us.

The fact that we were undefeated going into that game was really secondary for us. Our whole objective was to get to the Super Bowl and win it. If we happened to lose a game somewhere along the line, our goal would still have been attainable as long as we got to the Super Bowl. We lost the Super Bowl the year before. I was 0-2 in Super Bowls at that point, and you don't like people to say you can't win the big one.

We felt good after that game because we had only one regular-season game left and we were 13-0, but our goal the whole year was to win the Super Bowl.

We stayed at the Concourse Plaza Hotel in the south Bronx the night before the game. The field was very muddy that day. It wasn't a fast track. But in spite of the conditions, Warfield was able to make that big play, and Garo Yepremian kicked a late field goal when we had to have it. That was the difference-maker. We won the game, 23-13.

The Giants turned the ball over six times. They had more yards passing than we did, but we had more than two hundred yards rushing. That's what we did best, with Jim Kiick, Mercury Morris, and Larry Csonka. Mercury rushed for almost one hundred yards. That's what we set out to do against the Giants—and against every other team we played that year.

It was a big deal for me and our players to play a football game at Yankee Stadium—there's no question about it. Everyone knew about the monuments in deep center field. I made a special trip out there to take a look at them. That was something I had always heard about, and I had seen Mickey Mantle make a great catch back there years before.

I was a big Joe DiMaggio fan when I was growing up. After his career, he belonged to a golf club in Miami, and I joined the same club when I first came to the Dolphins in 1970. He was one of the first people I met, and I played golf with him a few times. That was a thrill for me. His fifty-six-game hitting streak is one of the great records in sports. Just like our 17-0 perfect season, which we are very proud of, DiMaggio's record will probably never be broken.

YANKEE STADIUM IS THE GREATEST STADIUM IN THE WORLD. IT IS A NATIONAL MONUMENT, JUST LIKE THE WHITE HOUSE OR THE UNITED STATES CAPITOL.

Everyone who ever played there is an honored athlete. Everyone knows where it is. The Yankees have played there for almost a century, and the Giants played football there during their greatest days.

Don Larsen pitched a perfect game in the World Series there, and the greatest football game was played there. Mickey Mantle, Yogi Berra, Joe DiMaggio, Babe Ruth, and Whitey Ford all played there.

If you talk to any Yankees or Giants players, they will tell you that those were the greatest days of their lives.

I was a rookie in 1956, and I lived in Flushing. The first time we had practice at Yankee Stadium, I couldn't find my way there, so I asked someone how to get there. The guy told me to take the train, and I said, "Where's the train?" I had never seen a train below ground. I thought every train went to Yankee Stadium, so I was traveling for two hours before I got there.

When I walked into the dugout that day, I thought of all the great Yankees who had played there. That is the only stadium I got that feeling from. I felt like I was a part of it, and that was a thrilling experience. It was like the ghosts were there.

I shared a locker with Mickey Mantle. I was from West Virginia, and he was from Oklahoma. We used to say, "Look at us. We're two country bumpkins, sharing a locker at Yankee Stadium."

I was on the cover of *Time* magazine when I was twenty-five years old. You had to have success in New York to get that type of notoriety. Look at all the newspapers in New York. You get so much good publicity in New York if you win, and so much bad publicity if you lose. I was blessed and privileged to play for the Giants at Yankee Stadium.

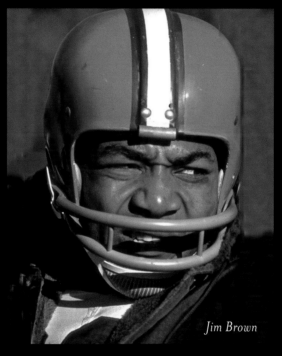

Jim Brown

We played the Cleveland Browns in a 1958 playoff game at Yankee Stadium the week before we faced Baltimore in the NFL championship game. Jim Brown was held to eight yards on thirteen carries, and we won the game, 10-0. I hit him so hard in the first quarter that I knocked him out. The tone for that game was set long before that hit. Before the season even started, we knew we had to beat the Browns. In order to be the best, you had to beat the best, and that was Jim Brown.

After watching film of him, our defensive coordinator, Tom Landry, said to us, "Gentlemen, you are going up against one of the greatest runners this game has ever had."

I knew how good Jim was because I had played against him in college. In fact, I broke my nose and got knocked out trying to tackle him in a game when I was at West Virginia University and he was at Syracuse University. I told coach Landry, "You don't have to tell me about Jim Brown. I know how tough he is to stop."

Coach Landry set up our defense to stop Jim, and I was his designated hitter, his hit man. We shut him down—we did it.

On one play in the first half, Jim took a handoff, and I didn't make it to the five hole because the center grabbed me by the foot. Jim came through that hole at full speed, and our safety, Dick Nolan, who weighed about 195 pounds, hit him head-on. He tackled Jim all by himself, but I thought Jim had killed Dick. Dick's eyes rolled back in his head. I ran over to him and said, "I'm sorry I couldn't get into the five hole, but you made a great tackle." Dick looked at me and said, "I didn't make a tackle. I just couldn't get out of his way."

The next week, we took on the Colts at Yankee Stadium. All the

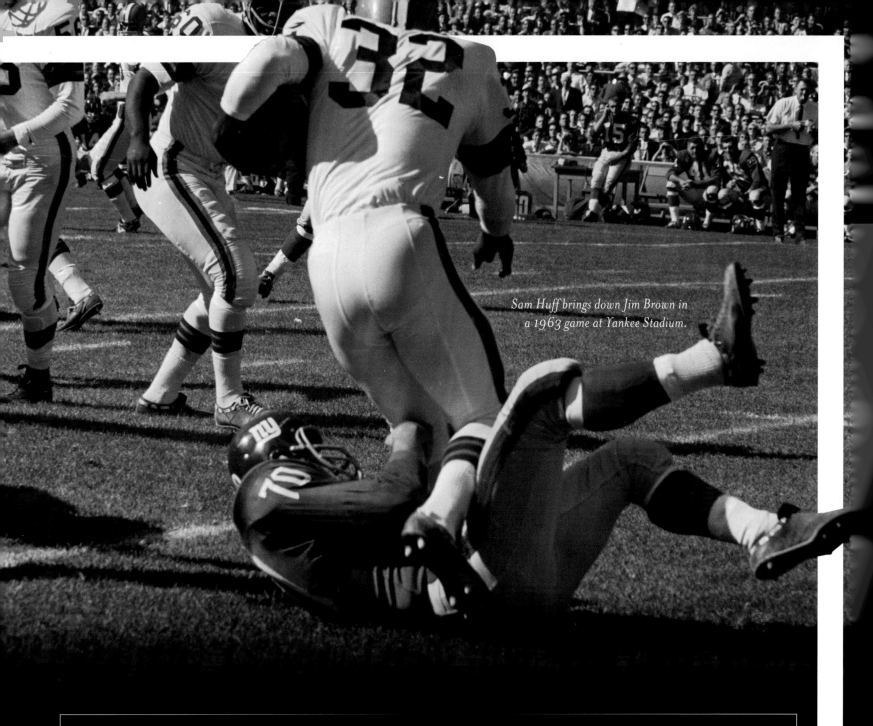

Sam Huff brings down Jim Brown in a 1963 game at Yankee Stadium.

> ## "GENTLEMEN, YOU ARE GOING UP AGAINST ONE OF THE GREATEST RUNNERS THIS GAME HAS EVER HAD." — TOM LANDRY

guys who played in that game, and all the writers from that time, say it was the best football game ever played. I had never heard of sudden-death overtime in any sport until that game. It was a 17-17 tie, and we all thought the game was over. Then the official came over and said, "We're going to tee it up in three minutes."

Because it was the first sudden-death game, because it was in Yankee Stadium, and because Johnny Unitas brought the Colts back, it was the greatest game ever played.

We were disappointed that we lost. We didn't know about the bump-and-run defense yet, so we couldn't shut down Raymond Berry — Unitas threw the ball to him all day. And when you thought they were going

to throw it, they handed it off to Alan Ameche.

After Frank Gifford was denied a crucial first down by a bad call, the Colts had to move the ball into field-goal range against us, and we were the best defense in the NFL. Unitas was able to do that, so you can't take anything away from him.

That is a game I will always remember.

After I was traded to the Washington Redskins, I got a standing ovation when I came out of the visiting locker room at Yankee Stadium in my first game back. Johnny Johnson, who was the Giants trainer, told me that the only guy who got a bigger ovation than me was Babe Ruth. It was the greatest ovation of my life.

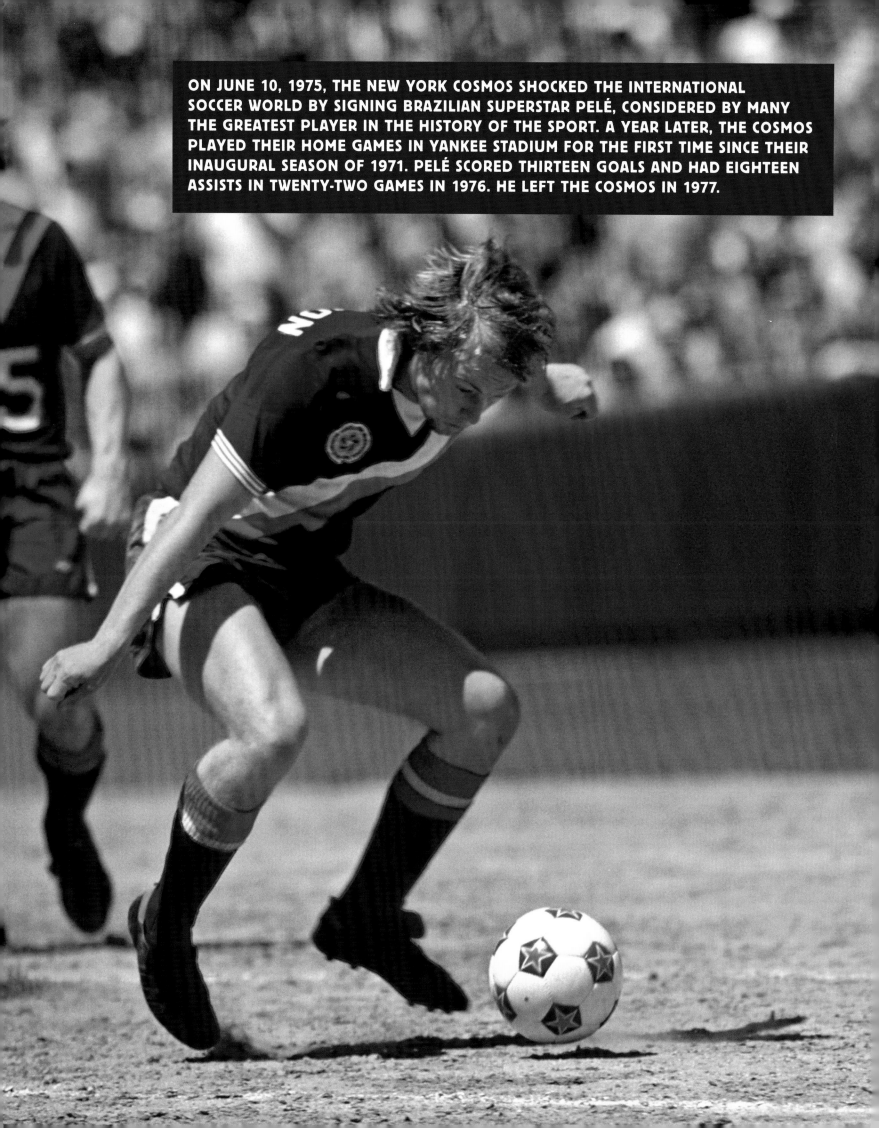

ON JUNE 10, 1975, THE NEW YORK COSMOS SHOCKED THE INTERNATIONAL SOCCER WORLD BY SIGNING BRAZILIAN SUPERSTAR PELÉ, CONSIDERED BY MANY THE GREATEST PLAYER IN THE HISTORY OF THE SPORT. A YEAR LATER, THE COSMOS PLAYED THEIR HOME GAMES IN YANKEE STADIUM FOR THE FIRST TIME SINCE THEIR INAUGURAL SEASON OF 1971. PELÉ SCORED THIRTEEN GOALS AND HAD EIGHTEEN ASSISTS IN TWENTY-TWO GAMES IN 1976. HE LEFT THE COSMOS IN 1977.

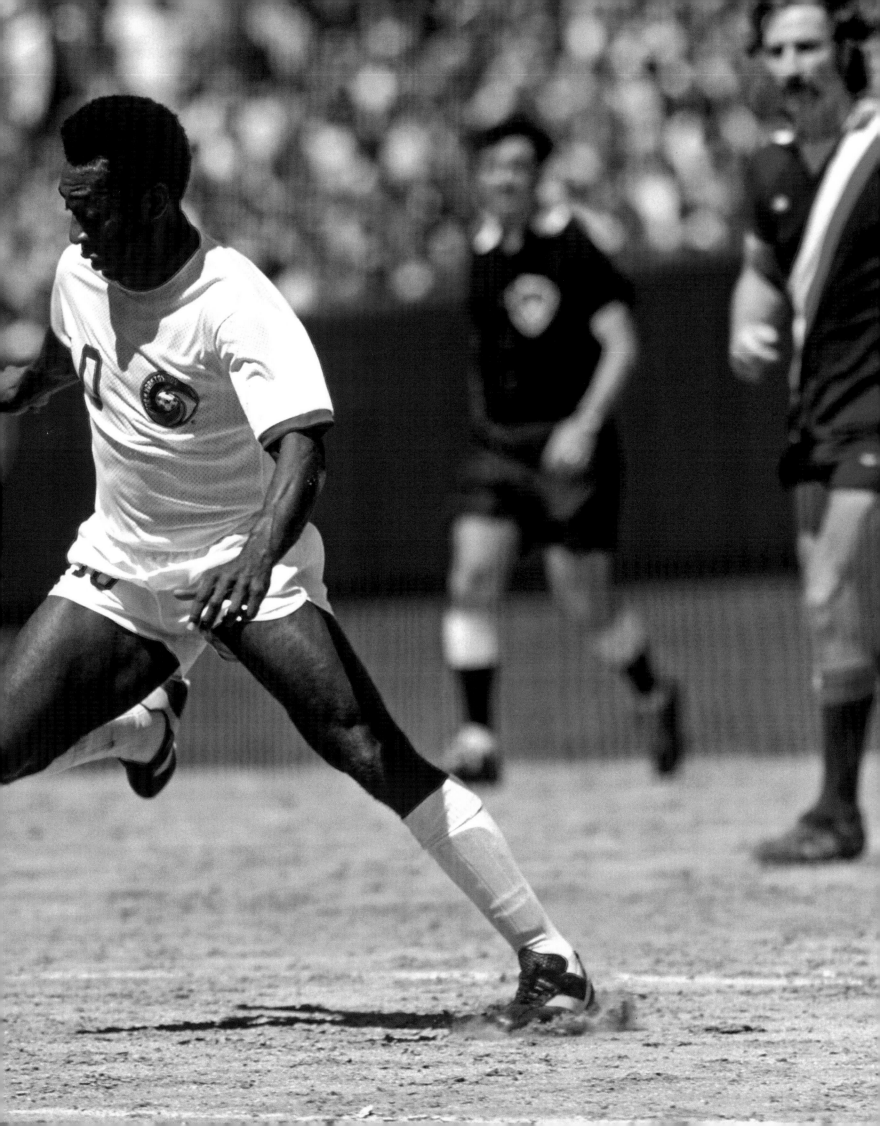

SOMETIMES FATE PLAYS A BIG ROLE IN PEOPLE'S LIVES. THAT IS WHY I WON MY 300TH GAME AT YANKEE STADIUM. IT WAS FATE.

After recording my 299th win, I lost my next two starts on the road. If you witnessed the way those games played out, you understand that I was meant to reach the 300-win mark at Yankee Stadium. In Detroit, I had a 7-1 lead in the fifth inning, and at Wrigley Field, I had a 1-0 lead when I came out of the game in the seventh. I think everything happens for a reason, and that achievement was no different.

To win my 300th game at Yankee Stadium, and to record my 4,000th strikeout on the same night is one of the special events that have happened in my career.

I really didn't feel any different before the game. I wasn't nervous at all. I wasn't thinking about the fact that I was going for my 300th win. I was just concentrating on pitching and trying to win the game. For me, it felt like any other game.

My bullpen session before the game was pretty clean. I was throwing hard. The weather wasn't that great, though. It was raining while I was warming up, and it rained a few times during the game. For the crowd to hang around to witness the entire game, and for them to be as excited as they were about it says a lot about Yankees fans. That wouldn't have happened anywhere else. It was a good game, the Cardinals were in town, and a lot of history had happened in Yankee Stadium. I'm very thankful that I got to be a part of that history.

In the second inning, I struck out Edgar Renteria with a high fastball. That was my 4,000th strikeout. Although it didn't seem like it, I was aware that it was number 4,000. Jorge Posada called time and walked out to the mound while the crowd gave me a standing ovation. It was a great moment. Because it happened in the middle of a game, it was hard to sit back and enjoy it. You're pretty much into what you're doing out there on the mound. I enjoyed it a lot more the next day.

I was glad I reached both milestones when Mel [Stottlemyre] and Zim [Don Zimmer] were on the coaching staff. Those guys had seen me go out there and try to accomplish great things. They really made it a special night.

The first time I kicked back and realized it was going to happen was when I got through the eighth inning. I came into the clubhouse and switched uniforms. Joe [Torre] was bringing in Mariano Rivera from the bullpen. You always feel pretty good when Mo is coming into the game. That usually means it's over. That's when I realized I was going to get number 300.

It was real emotional for me when I realized it was going to happen. It had been a number that the media had talked about me getting to for years. They made that number important to me when I was around the 250-win mark. There were a couple of times where I was going to shut it down and be done with my career, but they put a lot of importance on that number. They made me realize how difficult it was to get to 300, and what a great accomplishment it would be. It became more important for me to continue to work hard and try to grasp that number.

I've signed about every ticket from the game. That's what I enjoy the most about it—I got to share it with so many people. Of course, getting to celebrate it with my family and teammates on the field—in the pouring rain—after the game was more than I could have ever asked for.

I HAVE ABOUT TWENTY MILLION GREAT MEMORIES OF THE SPORTING EVENTS I HAVE ANNOUNCED AT YANKEE STADIUM. FIVE STAND OUT ABOVE ALL THE OTHERS.

My favorite moment is Don Larsen's perfect game in the 1956 World Series. It was outstanding. The reason that is my fondest Stadium memory is because he accomplished that feat in a World Series game. I also hold it in such high regard because it was against the Brooklyn Dodgers.

No one thought that Larsen was the kind of pitcher who would be able to fashion that type of performance. But there he was, pitching perfectly. The crowd seemed to catch on very early in the game. They weren't cheering, but instead they were holding their collective breath. As the innings went on, the tension grew. At the very end of the game, I was called on to announce Dale Mitchell as a pinch-hitter for the Dodgers. I had seen him before because he had played in the American League, and I knew he was a pesky hitter. I hated to introduce him that day because I thought, "He is going to spoil it." When the umpire, Babe Pinelli, called the third strike, there was not an immediate cheer, but rather a relief of breath and tension. Eventually, the crowd roared. That moment was breathtaking.

My second favorite memory is of Roger Maris hitting his sixty-first home run. There was a very tight race going on the entire season between Roger and Mickey Mantle. People were rooting on both sides. I was neutral, although because Mickey had gotten so much adulation over the years and Roger was so overlooked, there may have been a part of me that was pulling for Roger.

When Roger hit his sixty-first, I was so impressed by the moment. Because I spent so much time writing poetry and reading poetry, I composed a poem. I gave it to Mel Allen, who was sitting in the booth next to me. He looked at it and said, "Would you mind if I read it on the air?" I was happy to let him do that. The poem went like this:

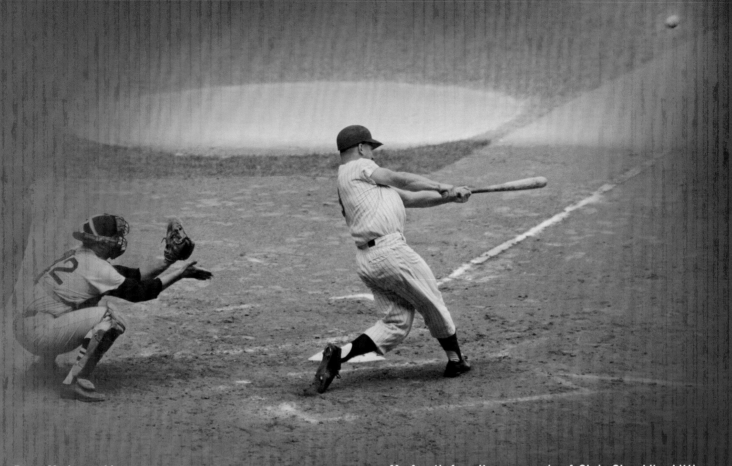

Roger Maris says his prayers
They've been pitching me low
They've been pitching me tight
I have grown so nervous, tense and paled
But my prayer is full of joy tonight
Thank you, Lord, for Tracy Stallard

I liked expressing my thoughts about Roger. He was deserving of the record, and he was an outstanding human being. He wasn't highly personable, but he was a good person.

My third favorite memory is of Reggie Jackson hitting three home runs on three successive pitches to him in the 1977 World Series.

Only Reggie could have done that. In all my years at Yankee Stadium, I have become closer to him than any other ballplayer. The atmosphere that night was tense and happy at the same time. Reggie is a bit of a show-off, but he had tremendous talent. The crowd was aware that he hit the first two home runs on consecutive pitches, so they were really pulling for him when he got up the last time.

The crowd was exultant because of how popular he was. Everyone knew him to be a performer. He strutted to the plate for that last at-bat. He was Laurence Olivier or John Barrymore, but he wasn't a ham. If he were clunky, he wouldn't have gotten away with that stuff. When you're good, you have privilege, and he was good in that last at-bat. That was an amazing accomplishment.

My fourth favorite memory is of Chris Chambliss hitting a home run into the right-field bleachers to get the Yankees into the 1976 World Series.

It looked like we were out of the game, but we were still so close. After Chambliss hit that home run, the crowd ran down the aisles and surrounded the infield before I could say a word. I have always been able to control the crowd by warning them not to go on the field, but there had been no indication that they were going to catapult onto the field so quickly that night. No one could stop them from taking over the field. An army wouldn't have been able to stop them. And there was Chambliss, elbowing his way around the bases trying to get to home plate.

The 1958 NFL championship game between the New York Giants and the Baltimore Colts is my fifth favorite memory of Yankee Stadium.

I had announced New York Giants football games for a long time, and before that I announced New York Yankees football games, but I have never seen a game like that one.

Baltimore had Johnny Unitas, Alan Ameche, Raymond Berry, and so many other Hall of Fame players. When the Giants punted to the Colts late in the fourth quarter, and the Colts had to go eighty yards to tie the game, I felt queasy. I thought to myself, "Unitas is unstoppable." And sure enough, it was: "Unitas to Berry...Unitas to Berry...Ameche through the middle...Unitas to Berry." And before you knew it, they were in field-goal range.

The rest, as they say, is history.

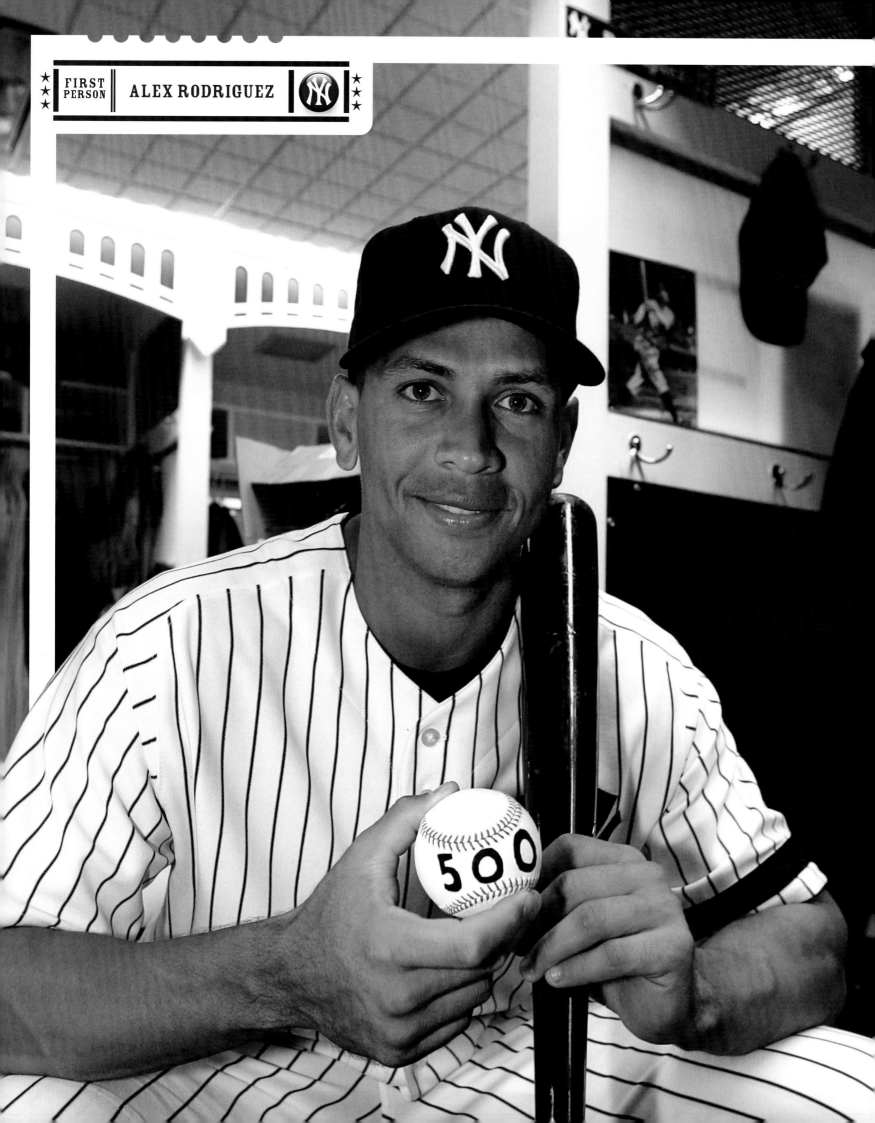

FIRST PERSON ‖ ALEX RODRIGUEZ

THE ENERGY OF THE FANS REALLY PUT INTO PERSPECTIVE HOW MUCH IT WOULD MEAN FOR ME TO HIT MY 500TH HOME RUN AT YANKEE STADIUM.

It seemed like they cared about it more than I did. I knew I was going to hit it at some point, but I really wanted to do it at home. With two days remaining before we went on the road, I really needed it to happen soon.

Every time I came to the plate, there were fifty-six thousand people screaming. They wasted a lot of camera flashes on me.

When I hit it [on August 4, 2007], I saw the path it was taking and thought it was going to go foul. I hadn't hit a home run in so long that I didn't know if it was going be a foul ball or a home run. But it came back, kind of like a fade in golf, and landed a few feet inside the left-field foul pole.

I wish I could shake every fan's hand and personally thank them for all the support they showed me, but my only way to thank them was to hit my 500th at home, and to do it in a winning situation.

I waved to my wife and daughter as I got to home plate, but I think they were still on the highway. Then to get that high-school-

like reception when I crossed the plate meant a lot to me. I have twenty-four great teammates, and they were all an important part of it.

When I was twenty-four years old, I didn't think about hitting 500 home runs, and I'm not going to start thinking about what my destination is now. I have a passion to play winning baseball, and to play baseball the right way. I'm just going to take it one step at a time.

But I can honestly say that to have hit my 500th home run at Yankee Stadium, in this beautiful uniform that I appreciate and respect so much, means the world to me. New York is a special place. I've had trials and tribulations here, but I've learned from them. I've had some great times, I've had some good times, and I've had some tough times. Maybe there is a happy ending for me somewhere.

YANKEE STADIUM AND BOXING

❧ BERT RANDOLPH SUGAR ❧

Yankee Stadium is at once a patch of ground and a state of emotion. And to some, a cathedral, where parishioners have come to worship pinstriped gods like Ruth, Gehrig, DiMaggio, Mantle, Berra, and hundreds more whose accomplishments have taken on epic proportions, made all the more so by having taken place in this equally epic structure.

From the very first day Yankee Stadium opened its doors to throngs rivaling the size of the World War I army Gallieni led out of Paris to the first battle of the Marne, it has been sports' high temple, the home of baseball's greatest stars and moments.

What most sports fans don't know—even those who consider themselves hard-core—is that Yankee Stadium was home to some of boxing's greatest moments.

Yankee Stadium was built with boxing in mind, as well as baseball. Return with us back to 1923, the year Yankee Stadium opened. Stories of the time had it that Yankees co-owner Colonel Tillinghast l'Hommedieu Huston laid plans to have a hydraulically operated ring built underneath second base during the construction of the Stadium. While there is a central truth to almost every myth, this is one that qualifies for inclusion in Gershwin's "It Ain't Necessarily So." Although there was a brick-lined vault installed under second base, it was not for a boxing ring, but instead to house the electronic, telegraph, and telephone connections for major fights and events that Huston envisioned becoming as much a part

of Yankee Stadium as baseball.

In an "if-you-build-it-they-will-come" scenario, major fights did come to Yankee Stadium, beginning three months after the first Yankees game was played there. On July

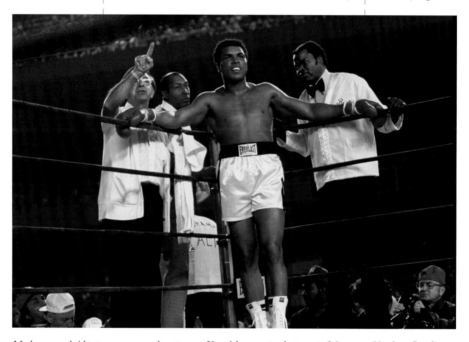

Muhammad Ali stares across the ring at Ken Norton in their 1976 bout at Yankee Stadium.

24, 1923, the Benny Leonard-Lew Tendler lightweight championship bout kicked off the Stadium's boxing history. The fight drew an estimated seventy thousand fans, and the ringside broadcast was one of the first in boxing history, made possible by Huston's second-base vault.

Over the next six decades, many of the greatest legends in boxing history appeared in the ring over second base at Yankee Stadium, including Jack Dempsey, Joe Louis, Sugar Ray Robinson, Rocky Marciano, Willie Pep, and Muhammad Ali. Many fights were classics, rivaling in excitement and memory the exploits of Ruth, Gehrig, DiMaggio, Mantle, and Berra.

One of the classics was a non-championship

bout between Jack Dempsey and Jack Sharkey on July 21, 1927. Dempsey, a year removed from having been defrocked by Gene Tunney, now wanted a warm-up fight before taking on Tunney again, something to prove the old fires were still burning. More than eighty thousand fans came to Yankee Stadium, pouring more than one million dollars into the coffers— the first million-dollar, non-championship fight.

For six rounds, Sharkey exposed Dempsey as a mere shell of his former self, raking him with a rapier-like left jab and going toe-to-toe with the famed "Manassa Mauler" and his devastating left hook, arguably the best in boxing history. For those six rounds, Sharkey proved that he could take the best Dempsey had to offer. In the seventh, Dempsey woke up the echoes, hitting Sharkey whenever and wherever he could, including more than a few times below the belt. As Sharkey looked somewhere in the direction of second base for referee Jack O'Sullivan, screaming, "He's hittin' me low," Dempsey threw his famed left, connecting solidly with his opponent's exposed chin. Sharkey fell, all the while holding his groin, his head shaking feebly in protest at the progressing ten-count. As Dempsey said later, "What was I going to do? Write him a letter of apology?"

The Dempsey-Sharkey fight was one of many great Yankee Stadium fights. What sports fan who hasn't yet fallen under the weight of his collected memories will ever forget the night

I'VE BEEN ON MORE ROADS THAN BOB HOPE AND BING CROSBY COMBINED.

I've seen my guys fight in Manila, Kuala Lumpur, Munich, Las Vegas, and New Orleans. And yet, one of my favorite fight sites was always Yankee Stadium. That's where I saw some of boxing's greatest fights, like Rocky Marciano–Archie Moore, Willie Pep–Sandy Saddler, Rocky Graziano–Tony Zale, and Ingemar Johansson–Floyd Patterson. My two favorite fights at Yankee Stadium, naturally, were two that my guys fought there, Carmen Basilio beating Sugar Ray Robinson (pictured), and Muhammad Ali beating Ken Norton. And you ask why it's one of my favorite stadiums? Hey, I went two-for-two there, batting 1.000.

Angelo Dundee, a boxing Hall of Fame trainer, has worked with fifteen world champions, including Muhammad Ali, Sugar Ray Leonard, George Foreman, and Carmen Basilio.

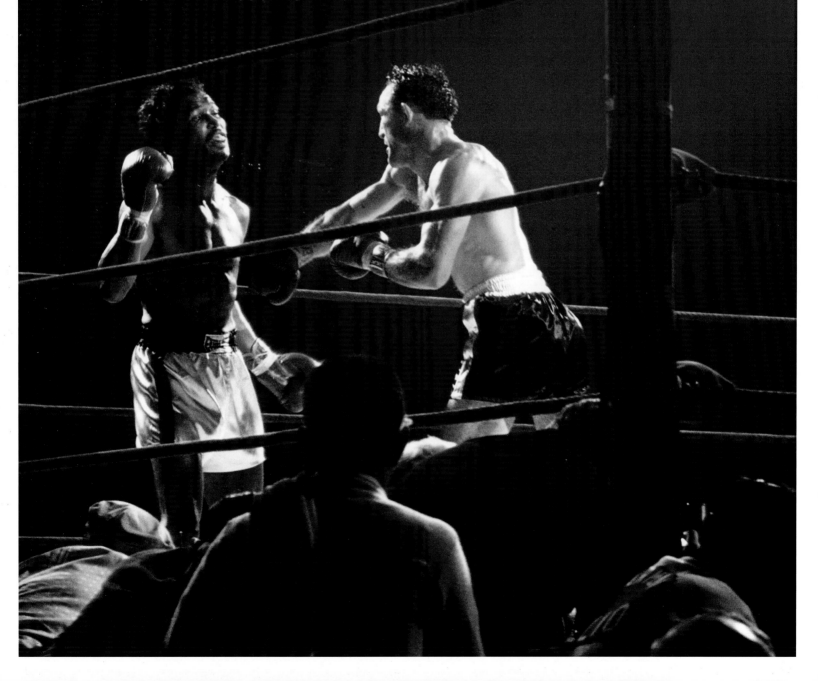

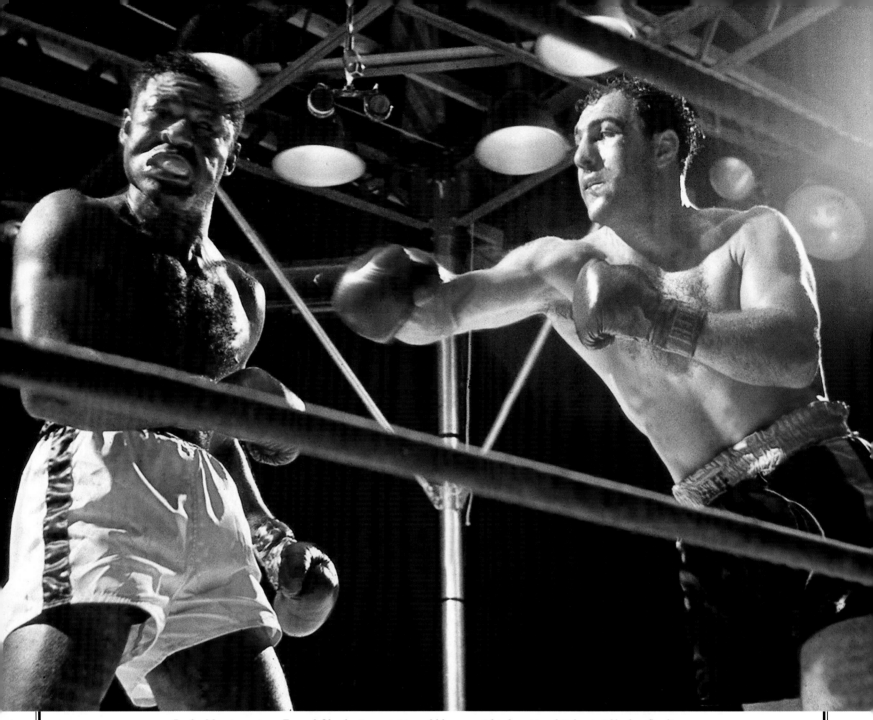

Rocky Marciano stuns Ezzard Charles in a 1954 world heavyweight championship bout at Yankee Stadium.
Marciano beat Charles twice within three months at the Stadium in 1954.

of June 22, 1938, when Joe Louis avenged his only loss by knocking out Max Schmeling in just 2:04 of the first round. Or the next year, when Louis battered "Two-Ton" Tony Galento into submission with a punch that drove Galento into the air and prompted sportswriter Bugs Baer to write, "They could have counted Tony out while he was in the air."

Or the night in 1946 when Tony Zale and Rocky Graziano staged one of the all-time great ring brawls, each knocking the other down before Zale crashed home a thunderous right under Graziano's heart in the sixth to drive "The Dead End Kid" down and out for the first time in his career. Or the night in 1952 when Sugar Ray Robinson fought both Joey Maxim and the heat,

losing to both in his bid for the light-heavyweight title. Or Carmen Basilio's valiant effort against Robinson in 1957, when he proved that a good little man could beat a good big man.

Or Rocky Marciano's last fight, in 1955, when he came back from a knockdown to knock out Archie Moore and preserve his DiMaggio-like string of forty-nine consecutive wins. Or the night in 1976 when Muhammad Ali eked out a controversial decision over Ken Norton. Any one of the thirty championship fights at the Stadium held a special memory for someone.

Of all the great moments in Yankee Stadium boxing history, my favorite is not a championship fight, nor even a fight, but a moment before a fight. On the night of May 20, 1927, as the two

combatants, Jack Sharkey and Jimmy Maloney, stood in the ring over second base awaiting their pre-fight introductions, ring announcer Joe Humphreys, without aid of microphone or megaphone, held his hand aloft and demanded silence from the crowd. In a voice that seemingly could be heard throughout the Bronx, he shouted over the din of the crowd, "Again, I ask you, silence, please! Young Lindbergh's in the air! God keep him safe across the seas. Let's bow our heads in prayer." With that, the crowd, as one, bowed their heads, their lips moving silently in prayer, and after a minute came up with a chorused "Amen!"

And you wonder why some consider Yankee Stadium part cathedral?

BERT SUGAR'S
TEN MOST MEMORABLE FIGHTS
AT YANKEE STADIUM

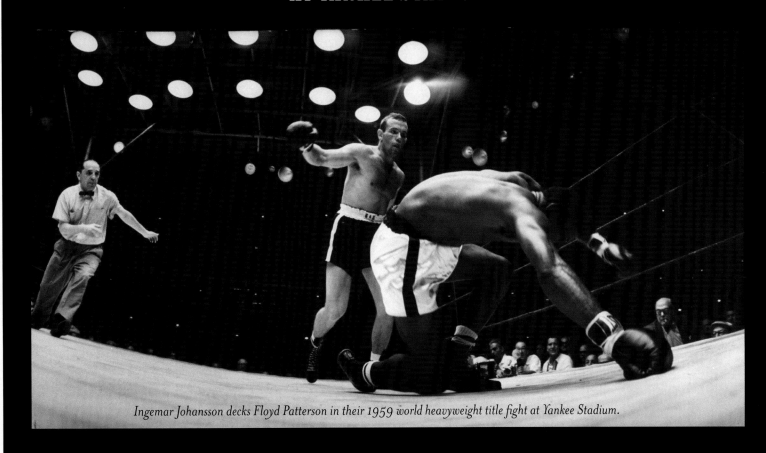

Ingemar Johansson decks Floyd Patterson in their 1959 world heavyweight title fight at Yankee Stadium.

1. **JOE LOUIS OVER MAX SCHMELING**, JUNE 22, 1938, KNOCKOUT, ROUND 1

2. **TONY ZALE OVER ROCKY GRAZIANO**, JULY 16, 1946, KNOCKOUT, ROUND 6

3. **ROCKY MARCIANO OVER ARCHIE MOORE**, SEPTEMBER 21, 1955, KNOCKOUT, ROUND 9

4. **CARMEN BASILIO OVER SUGAR RAY ROBINSON**, SEPTEMBER 23, 1957, DECISION, 15 ROUNDS

5. **INGEMAR JOHANSSON OVER FLOYD PATTERSON**, JUNE 26, 1959, TECHNICAL KNOCKOUT, ROUND 3

6. **JOEY MAXIM OVER SUGAR RAY ROBINSON**, JUNE 25, 1952, TECHNICAL KNOCKOUT, ROUND 14

7. **JACK DEMPSEY OVER JACK SHARKEY**, JULY 21, 1927, KNOCKOUT, ROUND 7

8. **MUHAMMAD ALI OVER KEN NORTON**, SEPTEMBER 28, 1976, DECISION, 15 ROUNDS

9. **SANDY SADDLER OVER WILLIE PEP**, SEPTEMBER 8, 1950, KNOCKOUT, ROUND 8

10. **JOE LOUIS OVER TONY GALENTO**, JUNE 28, 1939, KNOCKOUT, ROUND 4

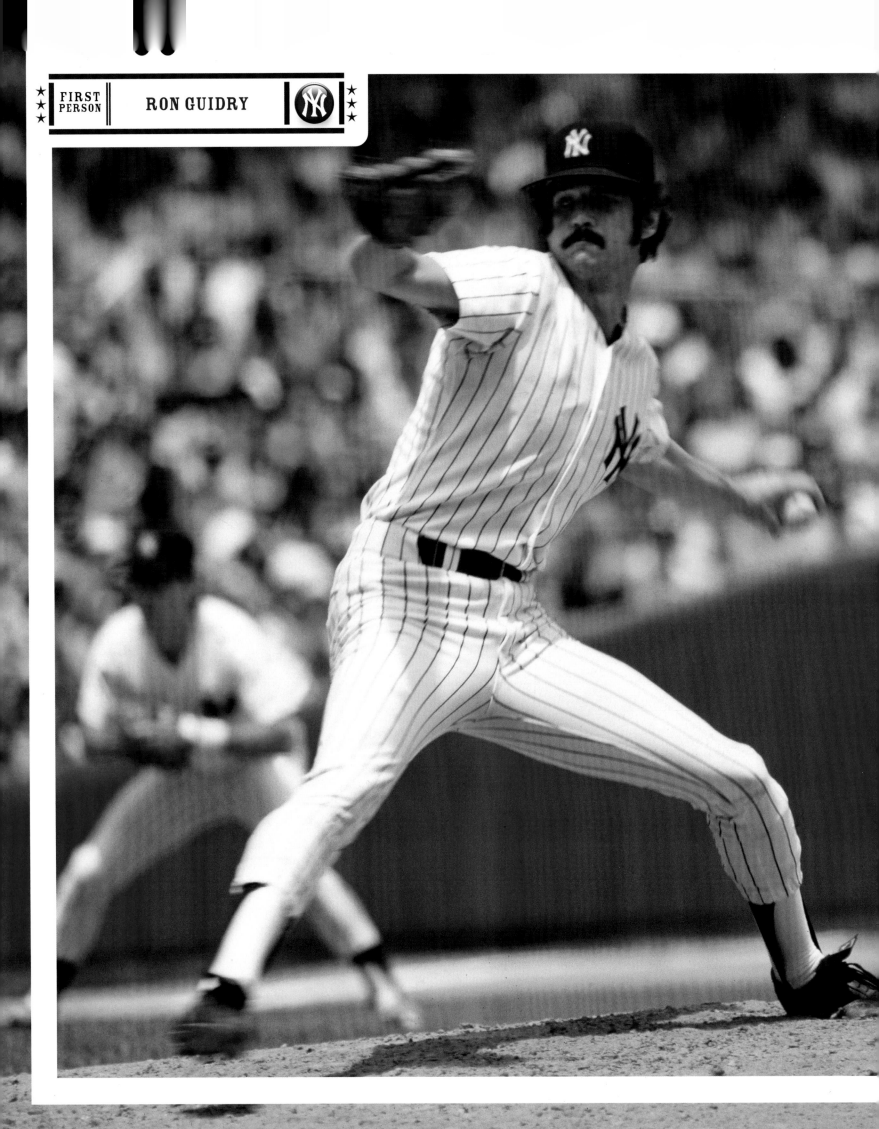

THE NIGHT I STRUCK OUT EIGHTEEN CALIFORNIA ANGELS IN 1978 MAY HAVE TURNED OUT FAIRLY WELL, BUT IT DIDN'T START OUT THAT WAY.

I was 10-0 going into that game. I went out to the bullpen about fifteen minutes before the game started. I only threw thirty pitches to warm up—I never threw more than that in the bullpen. There were three things I always looked out for when I warmed up. I wanted control, I always wanted my fastball to be alive, and I wanted my slider to sink. My slider was okay that night, but I couldn't throw the fastball in the strike zone. I was throwing fairly hard, but everything was up. I tried to get it down, but no matter what I did, I couldn't throw strikes with my fastball. I kept telling myself, "If you don't get that fastball down, they will hammer you."

By the time I completed my thirty-pitch warm-up, I had only thrown one fastball in the strike zone. When I was putting my jacket on, I asked Sparky Lyle, "What is the earliest you've ever gone into a game? Because they may be calling for you very early tonight." He said, "Don't worry. You're throwing the ball well, but you just have to get it into the strike zone."

The game started off, and before I knew it, I was behind on the first batter. With the count at three-and-one, I threw him a slider, which he missed. Then with a full count, I tried a fastball. It was up in the zone, and he led the game off with a double. I threw all sliders to the next batter, and he struck out on a failed bunt attempt.

I started the next batter off with a fastball. Again, it was about belt-high, and he hit a line drive that almost knocked my head off. I was able to knock it down and throw him out.

I struck out the next batter on three sliders.

I struck one guy out with sliders in the second inning. Then I was finally able to get ahead 1n the count with a fastball on the third batter. That was the first fastball I got into the strike zone.

After the second inning, I sat down next to Thurman Munson and asked him, "How did I throw that inning?" He said, "You've

MOST STRIKEOUTS BY YANKEES PITCHERS AT YANKEE STADIUM

RON GUIDRY	18
DAVID WELLS	16
DAVID CONE	14
RON GUIDRY	14
ROGER CLEMENS	13
MIKE MUSSINA	13
RON GUIDRY	13
ORLANDO HERNANDEZ	13
DAVID WELLS	13
JOHN CANDELARIA	13
JOE COWLEY	13
AL DOWNING	13
VIC RASCHI	13
ALLIE REYNOLDS	13
LEFTY GOMEZ	13

got nothing. I don't know how they are not hammering you. You've got to get the ball down."

We went out for the third inning, and something clicked. I was throwing the fastball harder, and it was staying down. I started the first batter off with two fastballs, and he missed both. Then I struck him out with the slider. I struck the next guy out with three fastballs. I was able to strike out the side that inning, primarily with fastballs.

By then, I had the Angels guessing at what I was going to throw. I was varying what I was starting each batter out with, and they had no idea what to expect.

When I would throw a fastball down the middle, they would take it. When I would throw a slider, they would swing at it—and miss it. They guessed wrong for the rest of the night, and they still couldn't touch the slider.

I struck out the side again in the fourth inning, and that's when the crowd really started to get into the game. People were cheering every time I had two strikes on a batter—that had never happened to me before in a major-league game. I didn't really notice what the crowd was doing that early in the game. It just sounded like a distant roar. It sounded like a battle that was far away. I had tuned everything out, so it sounded like it was far in the distance.

But by the sixth inning, I could hear the crowd getting louder. It sounded like it was getting closer to me. I thought of how distracting it must have been for the hitters because they had never experienced that before. I was having a lot of fun at that point.

There was a crescendo of applause every time I struck a batter out. Today, when the crowd is on their feet when a pitcher has two strikes on a batter, and somebody asks me, "Who started that crap?" I say proudly, "I did."